The Reinvention of Work

Also by Matthew Fox

*Sheer Joy: Conversations with Thomas Aquinas
on Creation Spirituality*

*Creation Spirituality: Liberating Gifts for the
Peoples of the Earth*

*The Coming of the Cosmic Christ: The Healing of Mother
Earth and the Birth of a Global Renaissance*

Original Blessing: A Primer in Creation Spirituality

Illuminations of Hildegard of Bingen

*Hildegard of Bingen's Book of Divine Works,
with Letters and Songs* (editor)

Meditations with Meister Eckhart

*Breakthrough: Meister Eckhart's Creation
Spirituality in New Translation*

*A Spirituality Named Compassion (and the Healing of the
Global Village, Humpty Dumpty and Us)*

*Western Spirituality: Historical Roots,
Ecumenical Routes* (editor)

*Whee! We, wee All the Way Home: A Guide
to Sensual, Prophetic Spirituality*

*On Becoming a Musical, Mystical Bear:
Spirituality American Style*

Manifesto for a Global Civilization (with Brian Swimme)

*Religion USA: An Inquiry into Religion and
Culture by Way of* Time *Magazine*

To Murphy —

To strength & joy in your work for justice —

The Reinvention of Work

A New Vision of Livelihood for Our Time

Matthew Fox

Matt Fox

HarperSanFrancisco

A Division of HarperCollins*Publishers*

Permissions appear on page x.

THE REINVENTION OF WORK: *A New Vision of Liveli-
hood for Our Time.* Copyright © 1994 by Matthew Fox. All
rights reserved. Printed in the United States of America. No
part of this book may be used or reproduced in any manner
whatsoever without written permission except in the case of
brief quotations embodied in critical articles and reviews.
For information address HarperCollins Publishers, 10 East
53rd Street, New York, NY 10022.

FIRST EDITION

Library of Congress Cataloging-in-Publication Data

Fox, Matthew.
 The reinvention of work : a new vision of livelihood for
our time / Matthew Fox. —1st ed.
 p. cm.
 Includes index.
 ISBN 0–06–062918–5 (cloth)
 ISBN 0–06–063062–0 (pbk.)
 1. Work. 2. Work—Religious aspects. I. Title
HD4901.F66 1994
306.3'6—dc20 93–38866
 CIP

94 95 96 97 98 ❖ RRD(H) 10 9 8 7 6 5 4 3 2

This edition is printed on acid-free paper that meets the American
National Standards Institute Z39.48 Standard.

To Tristan
(July 10, 1975–June 15, 1992)

my companion and co-worker for seventeen years,
who was a grace to all who knew him.
Whose work was play,
and was always connected to the Great Work,
and whose work was finished
on June 15, 1992, at 10:30 A.M.—
Thank you.

Everything gives pleasure to the extent that it is loved. It is
natural for people to love their own work . . . : and the reason
is that we love *to be* and *to live*, and these are made manifest in
our *action*. Secondly, because we all naturally love that in which
we see our own good.

THOMAS AQUINAS

Somewhere there is an ancient enmity
between our daily life and the great work.
Help me, in saying it, to understand it.

RAINER MARIA RILKE

What is work? What is beyond work?
Even some seers see this not aright.
I will teach thee the truth of pure work,
and this truth shall make thee free. . . .
All actions take place in time by the interweaving of
 the forces of Nature;
but the person lost in selfish delusion
thinks that he himself is the actor.

BHAGAVAD GITA

Contents

Acknowledgments

Many are the persons who have influenced and educated me in the writing of this book. Among them are the following: Those thinkers whom I have cited in the text and have acknowledged in the footnotes; students and listeners to my talks over the past few years who have given me feedback and challenged me on some of these ideas; my co-workers at the Institute in Culture and Creation Spirituality and at Friends of Creation Spirituality who themselves stay the course in what is sometimes challenging work conditions. Among these I wish to give special mention to Marlene DeNardo, Delores Rashford, Jim Conlon, Marie Devlin, Sue Espinosa, and Elizabeth Turner. A special thanks to my publisher, Tom Grady, and my editors at Harper San Francisco, Caroline Pincus and Priscilla Stuckey, and to Luann Rouff, who worked so diligently on this text. So too did Dan Turner and David Gentry-Akin, whose advice was invaluable, and Ken Canedo and Brent Cruz, whose perseverance in researching is deeply appreciated.

Job Crisis or Work Crisis?

To live well is to work well,
or display a good activity.

THOMAS AQUINAS[1]

A person becomes a flowering orchard. The person that does
good work is indeed this orchard bearing good fruit. . . .
Whatever humanity does with its deeds in the right or left hand
permeates the universe.

HILDEGARD OF BINGEN[2]

The debilitating aspects of contemporary work are a challenge,
a summons to deepen involvement and commitment—on the
part of women as well as men—to the work of reorganizing,
repatterning the structures of work.

MADONNA KOLBENSCHLAG[3]

When he wrote, "To live well is to work well, or display a good activ-
ity," Thomas Aquinas, the thirteenth-century saint and theologian,
laid out in clear words how deep the issues of work are to the human
species. Work touches life itself—"to live well is to work well." Good
living and good working go together. Life and livelihood ought not
to be separated but to flow from the same source, which is Spirit, for
both life and livelihood are about Spirit. Spirit means life, and both

1

life and livelihood are about living in depth, living with meaning, purpose, joy, and a sense of contributing to the greater community. A spirituality of work is about bringing life and livelihood back together again. And Spirit with them.

What an interesting definition of work Aquinas offers us: "to display a good activity." Work is part of our display, part of the parading of our beauty. It is the way we return our beauty to the community, and this is important both to the individual and to the community. Why? Because all beauty yearns to be conspicuous. Beauty and display go together; so, therefore, do beauty and work. Our work is meant to be beautiful, to increase the beauty of the world, of one another, of the worker.

The twelfth-century Benedictine abbess Hildegard of Bingen challenges our notions about work when she declares that "when humans do good work," they become a flowering orchard permeating the universe and making the cosmic wheel go around. She provokes our understanding of work in at least three ways: first, her statement presumes that humans *are* fruitful and flourishing when working; second, that we are about good work; and third, that our work affects the universe itself, that our work actually contributes to turning the "cosmic wheel." She presumes that we are not tied down to an anthropocentric (or human-centered) understanding of work and that the excitement and allure of "permeating the universe" with our work is giving us energy to do good work. Does this statement from Hildegard name our experience of work? Perhaps it leads us to wonder what work is and isn't in today's world.

Work vs. Job

Today close to one billion human beings are out of work. In the United States alone more people are unemployed than at any time since the Great Depression. In the European Common Market countries, official unemployment is approaching 13 percent. In the so-called Third World countries, as well as in pockets of American inner cities, Indian reservations, and in Ireland, unemployment ranges from 40 to 60 percent. At the same time, in the whole indus-

trial world, a large number of persons are overworked; they are, in the words of the thirteenth-century German mystic Meister Eckhart, "worked" instead of working, giving rise to the new addiction of workaholism. Of those who are employed, some work in jobs that are inimical to the health of our species and the planet, such as tearing down rain forests, killing endangered animals, selling drugs, or making armaments. Some politicians, looking for a quick fix, shout that we need "jobs, jobs, jobs." But such simplistic slogans simply do not cut deeply enough. They avoid the deeper questions that must be asked of work at this critical juncture in human and Earth history, for, as Lester Brown of the Worldwatch Institute concludes in his *State of the World* report, the planet has only eighteen years remaining unless human beings change their ways. Under the pressure of the world economic crunch that is creating a worldwide depression, the grave danger looms that we will seek only jobs—jobs at any price—and ignore the deeper questions of work such as how, why, and for whom we do our work.

What this kind of thinking misses is the truth that jobs are to work as leaves are to a tree. If the tree is ailing the leaves will fall. Fiddling with leaves is not going to cure an ailing tree; just as one cures an ailing tree by treating its roots, so we cure the crisis in work by treating the root meaning and purpose of work. We make jobs by strengthening our view of work, not by pasting leaves onto a tree. A critical understanding of work will give birth to jobs, but without the grounding that a theology of work can provide us, jobs themselves will continue to dry up, just as do leaves on a dying tree.

We dare not miss the truly radical and creative moment in which we live—one in which we are being asked to redefine work itself. There have been other momentous shifts such as this in human history. Consider the industrial revolution two hundred years ago or the agricultural revolution ten thousand years ago. Until the agricultural revolution the basic work of the human species was hunting and gathering; with agriculture it became cultivating crops and breeding animals. With the industrial revolution work itself was revolutionized. It moved from farm to city, from making clothes and growing food to buying clothes and buying food. Humans changed from producers to

consumers. Our models and ideals of work became factory oriented; the worker became an assistant to a machine. This idea was reinforced by the prevailing cosmology of Newton, namely, that our universe is a machine. Descartes reinforced this idea by teaching that our bodies and minds are machines as well.

In the Newtonian era, real labor meant making things by machine or fixing them by machine. (Even agriculture became agribusiness—an "industry.") The "iron horse" or steam-driven locomotive that spanned a continent caught the culture's imagination and became the symbol of nineteenth-century work. In the twentieth century, this symbol was domesticated in the automobile, and it came to serve the empire's ideology in the creation of war machines and so-called defense industries. War became the ultimate machine in motion, and war machinery became the engine that ran our economic systems and political rhetoric. Even efforts to address social ills have been pitched as a "war against poverty" or a "war against drugs." The Church too became machinelike, with a mentality of "dispensing of the sacraments." Nature and grace became so separated in the machine era that all sense of grace was believed to come from outside nature. Because in a machine nothing is holy, an institution—the Church—husbands what is holy and dishes it out.

Of course, entirely new professions sprang up in response to the industrial model of work. Entertainment, including professional sports and radio and television entertainment, offered the factory worker some needed respite after a day at the machine. And because the human psyche or soul bears wounds that machines cannot fix and a machinelike cosmos cannot heal, psychotherapies flourished. The healing professions became swamped by the victims of our machine consciousness; religion became a place of comfort and psychology a place where bits of the soul could be acknowledged as legitimate. The whole soul, however, was rarely treated at all. Mysticism and cosmology became highly suspect in this rational view of the world.

Entertainment industries produced "stars" of sports and cinema, who made millions of dollars for their work. Tabloids and tabloidlike gossip set up love-hate relationships with these stars, feeding the hungry souls of underworked, overworked, and nonworking citizens who

begged for distraction from the boredom of their lives and work. Economics, business, politics, and, of course, the media, which is a combination of all three, have been committed to keeping the machine going.

Today this paradigm is undergoing radical reevaluation. The system is not working. That is how a paradigm shift begins: the established way of seeing the world no longer functions. The work-machine is running out of steam, coming to an end, even in the so-called First World. The basics of human living, including work, health care, politics, education, and religion, are increasingly beyond our grasp. And so a new era is upon us. We are being challenged today—in light of the wounded Earth, the one billion unemployed adults, the billions of despairing young people who see no guarantees of either work or jobs, and the needs of other species around us—to redefine work. Our times need what the Bible calls *metanoia,* a change of heart, a change of ways. Scientist Rupert Sheldrake says as much:

> The recognition that we need to change the way we live is now very
> common. It is like waking up from a dream. It brings with it a spirit
> of repentance, seeing in a new way, a change of heart. This conversion
> is intensified by the sense that the end of an age is at hand.[4]

Changing our ways includes changing the way we define work, the way we compensate work, the ways we create work, and the way we let go of work and learn to infuse it with play and ritual. A paradigm shift requires a shift in the way we think about, talk about, and undergo work. We should not allow ourselves to be deceived that today's crisis in jobs is just about more jobs; it is not. The job crisis is a symptom of something much deeper: a crisis in our relationship to work and the challenge put to our species today to reinvent it. We must learn to speak of the difference between a job and work. We may be forced to take a job serving food at a fast-food place for $4.25 an hour in order to pay our bills, but work is something else. Work comes from inside out; work is the expression of our soul, our inner being. It is unique to the individual; it is creative. Work is an expression of the Spirit at work in the world through us. Work is that which puts us in touch with others, not so much at the level of personal interaction, but at the level of service in the community.

Work is not just about getting paid. Indeed, much work in our culture is not paid at all, for example, raising children, cooking meals at home, organizing youth activities, singing in a choir, repairing one's home, cleaning up one's neighborhood, listening to a neighbor or friend who has undergone a trauma, tending a garden, planting trees, or creating rituals that heal and celebrate. And yet, in a fuller critique of work, the question needs to be asked: How might these examples of good work be rewarded so that they are indeed counted in our understanding of the gross national product (GNP)? In pointing out the distinction between "job" and "work," we don't want to create an unnecessary dualism. Given a deep spirituality, one can turn even a job into work, re-envisioning its place in the whole.

The very word *job* fits the Newtonian parts mentality. In the garment district of New York City, the term *job work* used to mean "piecework," and the now obsolete word *jobbe* meant "piece." In a mechanical view of the universe, a job is all one can hope for. Job denotes a discrete task, and one that is not very joyful. The Middle English word *gobbe,* from which *job* is derived, meant "lump," and we think of the word *gob* when we see it. In his eighteenth-century dictionary, Dr. Johnson defined *job* as: "petty, piddling work; a piece of chance work."

In contrast, work is about a role we play in the unfolding drama of the universe. (The word *rolle* in Old French comes from the roll of parchment an actor reads from.) How readily the idea of work as a role fits a new cosmology, that of work playing a role in making the cosmic wheel go around. (The Latin word *rota* denotes wheel or cosmic mandala and is the basis for the word *rolle* in Old French.)

Work After Communism

Recent world events highlight the issue at stake when we talk about work. The collapse of communism gives us an opportunity to reevaluate our concept of work. This is in part because communism (or at least Marxist philosophy) had a definite (and sometimes appealing) philosophy about work, raising such important issues as alienation, exploitation, and work for everyone. In addition, communism's

demise leaves capitalism standing naked and alone for everyone to observe. What are its values with respect to the worker? The unemployed? The uninsured? The addicted worker? The gap between worker salaries and top management salaries? What is the relationship of top management and owners of industry (including the media industry and the defense industry) to government decision making, legislative law making, and the candidate anointing of the civic process? What is capitalism's relationship to the environment? To minority hiring and training? To work in ghettos where there are no jobs? To the educational agendas in schools that must in turn prepare students for their work? To retraining persons laid off from the war industry for work in other industries? To taxing corporations versus taxing the poor? To taxing the rich versus taxing the middle class? (Former President and Mrs. Bush paid taxes on 18 percent of their income in 1991, while middle-class Americans paid taxes on 38 percent of theirs.) What about the relationship between crime, violence, a burgeoning youthful prison population, and no work? Between the money that money makes and the money that workers make? In other words, capitalism itself is now under the limelight once again, as it was in the Great Depression. The lessons of get-rich-quick artists such as Ivan Boesky, Michael Milken, Charles Keating, and others must not be lost when we reflect critically on work in our world today. In our consumer society children follow the model of their elders and kill one another in the street for clothes and jewelry. Avarice is not restricted to the ruling classes. Indeed, perhaps consumerism has become the engine driving our economic world today, and if it has, does this necessarily mean that a kind of democratization of avarice has become the sole basis of our work?

Czechoslovakian playwright and former president Vaclav Havel warns of the spiritual disease engendered by a consumer culture—one in which a "desperate substitute for living" is represented as human life:

> In the interest of the smooth management of society, then, society's attention is deliberately diverted from itself, that is, from social concerns. By nailing a man's whole attention to the floor of his mere consumer interests, it is hoped to render him incapable of appreciating

the ever-increasing degree of his spiritual, political and moral degradation.[5]

Life becomes "reduced to a hunt for consumer goods," and freedom becomes trivialized to mean "a chance freely to choose which washing machine or refrigerator [one] wants to buy."[6] Consumer bliss has the effect of diverting people's energy away from the community to the self.

> People are thinking today far more of themselves, their homes and their families. It is there that they find rest, there that they can forget all the world's folly and freely exercise their creative talents. They fill their homes with all kinds of equipment and pretty things, they try to raise the housing standards, they make life agreeable for themselves, building cottages, looking after their cars, taking more interest in their food and clothing, and domestic comfort.[7]

Clearly, the price the community pays for consumerism is very steep.

Work and the Environment

Another dimension in our consideration of work today must be the environment. Lester Brown of the Worldwatch Institute explains that today every living system on earth is in decline. Who among us feels like working when we are sick? All work depends on healthy soil, water, air, bodies, minds, spirits. The environmental crisis tells us much about our crisis in work today. Brown points out that industrial countries the world over have, over the past few decades, declined in their work output as a result of diminishing natural resources. For example, in the United States, the GNP has effectively declined since 1979, its peak year. So too has the health of our soil, water, forests, and therefore our food and bodies. In other countries the reality is even more stark. For example, in the Philippines, Ethiopia, and Peru, deforestation and soil erosion have practically eliminated the soil completely. In Mexico City, entire industries are required by law to close down regularly because of the polluted air. Good work presumes good health—not only the human health of the worker but the

health of the environment that gifts the worker with everything from food to clothes, from moments of beauty and grace to hope in bringing new children into the world.

The environmental crisis, then, furnishes us with an opportunity and a responsibility to ask deeper questions of work. To ask how a spirituality of work might assist us in redefining how, why, and for whom we do our work. It also clearly opens the door for inventing new kinds of work—work that will develop sustainable energy, sustainable agriculture, and sustainable minds (that is, education) and spirits (that is, worship). Ours is a time for the emergence of totally new forms of work. The decline of a " defense" industry understood as war making can make way for the emergence of a defense industry whose task is to protect the Earth (a "green army," one might call it). This calls for: tree planting; soil preservation; water purifying; air cleaning; recovery of streams in cities; and recycling of wastes. Along with new rituals, all of these could constitute our new cottage "industries." Such industries would be small and people owned.

At bottom, the issue is one of spirituality, which is always about "all our relations," as the Lakota people pray. And work is clearly a deep partner in our relationships. We prepare ourselves for work by getting an education; we work; we recover from work; and we try to raise children who can successfully enter the work world. Clearly, work is at the center of adult living. This is one reason why the unemployed can so readily succumb to self-hatred and despair: not having a vehicle through which to express our blessing—the basic meaning of work—results in psychological violence to the self. The artist within, the *imago dei,* cannot express itself. It is tragic to separate living from livelihood, values from the workplace. But increasingly, this separation has been forced upon working people.

Some Shadow Sides to Work and No Work

The results of lack of work are spiritually devastating. When people lack work they lack pride; they lack an opportunity to return their unique gift to the community; they also lack the means to provide the taxes that make services possible in the greater community. Welfare

ought never be a replacement for work but a stopgap measure between jobs and education for new work. When people lack work, they also lack hope. The resulting despair eats into a community like an evil spirit, and the violent results can be seen everywhere: in self-hatred, increased crime, the drug trade (often the only jobs available), a bloating of the prison population, racism, resentment, fear, alcoholism, break-up of families, domestic violence, children born without stable and secure homes, lack of commitments, and abuse of God-given talents of mind, heart, and imagination. As Thomas Aquinas observed, "Despair is the most dangerous of all sins," for when despair takes over "all kinds of wickedness follows."[8] War within the self, between communities, and even between nations occurs when people are deprived of the pride that comes from authentic work. Those who are living in ghettos tell me that the young need jobs more than they need education. Once they get work their self-esteem can be restored and then they can see the value of education. When work is denied a people, hope is the first casualty. The goals of education—to better people and to encourage conscientious citizenship—cannot be realized in a situation of unemployment and the despair that accompanies it.

A recent study by the prestigious Canadian Institute for Advanced Research examined the connection between health care and unemployment and came to the startling conclusion that "medical services have little if any effect on national health levels." What most influences health is a work situation where people feel in control of their lives. This is why the wealthy outlive the poor; they are more in control of their lives and work. "Something is killing the great lower classes of the modern world, grinding them down before their time. The statistics show it's also killing the middle classes, who live longer than the poor but not as long as the rich."[9]

But the results of overwork or addictive work are equally devastating from a spiritual point of view. Society and children pay dearly for workaholism, which is, in psychologist Barbara Killinger's opinion, "a major source of marital breakdown."[10] Workaholism, says management consultant Diane Fassel, estranges us from our deepest

selves and prevents us from asking deeper questions about our vocations and purpose in living. "We don't ask the questions for two reasons: (1) we aren't doing our true work, and (2) in our society, few people have access to their right work. In the addictive society, you cannot afford to ask the questions." But Fassel also sees spiritual growth on the horizon for those who "bottom out" when they face their workaholism. "Fortunately, when the workaholic downward spiral is reversed, spirituality is one of the first things recovering people regain."[11]

Psychologist James Hillman raises the disturbing question of whether our preoccupation this decade with the "wounded child" can cut us off from a healthy adulthood. I believe his point is an important one, for while healing the wounded child is required for healthy adulthood, it is not enough. The young need elders and mentors; they need healthy adults around them. But what do adults do that is different from what children do? They work. A healthy adult does healthy work and integrates body, soul, spirit, and work. Thus a spirituality of work completes the healing of the wounded child *and* goes beyond preoccupation with our past histories; healthy work draws us into our future, into our destinies, into being history makers ourselves (and not just history healers).

The issues raised by the crisis in work around the world today are thus spiritual issues. They demand a radical critique of the way we have been defining work during the modern era, an era that is rapidly disappearing.

The Mystics and Work

The crisis in work today is so deep and so deeply felt the world over that we must go to some of our finest thinkers, the mystics (whom Carl Jung said represent the "best in humanity") to examine our presuppositions about work. Mystics are the poets of the soul. We owe it to ourselves to explore what they have to teach us about recovering a sense of the meaning of work. Today's scientific mystics are joining their voices to those of the mystics of old. Mystics constitute some of

the most radical thinkers we have. Why is this? Because they think in a context of awe and wonder, out of the experiential and right hemisphere of the brain and not just in terms of analysis and utilitarianism. They think in the context of a living cosmology and not merely from an anthropocentric, psychological, or sociological perspective.

For some time now I have felt that the mystics have more to offer us in a useful and practical way than we have been led to expect. If work is sacred—and I believe it is—and we have been living, during the Newtonian era, in a nonsacred, secularized, and manmade machine, then the desacralization of work lies at the heart of our alienation. The mystics can assist us in reclaiming the sacredness of work that "permeates the universe" for good and not ill. During the industrial era, our churches and synagogues have rarely taught us the wisdom of the mystics, and academic institutions, seminaries included, conspire to exclude right-brain or more mystical thinking altogether. Thus we seldom consider consulting the mystics when it is time to think deeply.

Mystical thinking represents a shadow, neglected side of Western culture, especially since the Enlightenment period. To think with the mystics is a radical thing to do, especially about a topic as germane to all our lives as is work. But to include mysticism in our discussion of work is to open the door to wisdom. And, as economist E. F. Schumacher observed, "We are now far too clever to survive without wisdom."[12] When it comes to the pressing issue of work and jobs in an era of postindustrialization, we can learn much from the wisdom of our mystical traditions.

This book, then, is an essay in Deep Ecumenism, which is about drawing forth the wisdom of all our mystical traditions of the world. The reader will hear not only from Western mystics such as Hildegard, Eckhart, Aquinas, Rilke, Heschel, and others, but from mystics of Eastern and Middle Eastern traditions as well, including the Hindu Scriptures known as the Bhagavad Gita, the Chinese Scriptures known as the Tao Te Ching, and individual mystics such as Rumi (a Muslim Sufi) and Kabir of India. I also call on the wisdom of contemporary scientists such as Rupert Sheldrake, Gregory Bateson, Erich Jantsch, Brian Swimme, Thomas Berry, Beverly Rubik, and

Fritjof Capra; they are mystics as well. It is time that we take all these great thinkers seriously on such an important topic as work.

Prophetic Work

Sometimes our work gets us into trouble. That's okay. In fact, I seriously question the spiritual and ethical life of anyone whose work has never gotten him or her into trouble—if no issues of conscience have ever emerged or no clash of values has been experienced with the on-going guardians of the status quo. After all, it was Jesus' work that got him into trouble. Christians who claim to follow in his footsteps ought to sentimentalize his crucifixion less and emulate his message more—that there are values worth dying for and that often the struggle between values will be found in one's work world. Today every profession requires prophets. If the planet is to flourish again, the paradigm shift will put new demands on business people and medical people, artists and economists, clergy and politicians, parents and children, blue-collar workers and white-collar workers alike. No industry, no office job, no church, no institution, no union will be exempt from a deep critique of its impact for generations to come on children and the environment. The prophet, by definition, "interferes," as Rabbi Abraham Heschel puts it, and one significant place for our interference is where we work and earn a living.

All work worthy of being called spiritual and worthy of being called human is in some way prophetic work. It contributes to the growth of justice and compassion in the world; it contributes to social transformation, not for its own sake but for the sake of increasing justice. Such work is, in a real sense, God's work. By it we become cocreators with a God who is both just and compassionate, a lover of beauty who desires that it be shared by all creation.

Gender and Work

Women and men are beginning to question their work in a deep way. Writer Madonna Kolbenschlag states, "Recovery of the spiritual sense of work is imperative if women are to be liberated rather than

automated by it."[13] Author and former corporate executive Susan Albert tells the stories of eighty women who left their successful mainline careers "in search for work that was more personally authentic and expressive of their feminine selves." She writes that the American "'career culture' leads us to develop 'false selves' that are nourished by career success and fed by the consumption for material goods."[14] Women who have learned to think for themselves and with one another appear more willing than have been most men to criticize the megasystem of corporate capitalism. Many men in fact profit from that system or imagine that they do.

Yet men too are undergoing soul seizures as the infinite array of consumer goods and addictive salary bonuses fails to speak to the deeper needs of the soul. Indeed, Robert Bly reports that of all the subjects of male oppression that arise in men's groups he has known, oppression at work is issue number one.

> Most men are much more obsessed with their work than their mothers. . . . Some of the most passionate talk [in men's gatherings] comes from men who feel they have walked up a blind alley in their job: the rationality is too dry, or the job has gone dead for them, or it leaves them no time to be with their family, or it is stupid and dishonorable. The emphasis falls on the soul damage that much contemporary work causes. One man said flatly, "For ten years, I have been involved in corporate crime." The men sat there silently for about five minutes after that.[15]

Dr. Larry Dossey seconds this observation when he points out that job dissatisfaction and the "joyless striving" that accompanies it are greater causes of heart attacks than high cholesterol or fatty diets. There must be a reason more heart attacks occur between 8:00 and 9:00 A.M. on Monday mornings than at any other time during the week.[16] There is; it is returning to work that one hates.

Work without meaning is deadly. In the United States, stress-related diseases such as ulcers, high blood pressure, and heart attacks cost the U.S. economy 200 billion dollars per year in absenteeism, compensation claims, and medical expenses. A recent report by the United Nations International Labor Organization labels job stress as

"one of the most serious health issues of the twentieth century." Calling job stress "a global phenomenon," the report found that blue-collar and women workers especially suffer from job stress. It recommends that individual workers deal with stress through relaxation techniques such as yoga, exercise, diet, counseling, and change of attitude; at the same time employers are urged to give employees more control over their work worlds.[17] People need a spiritual sense of work. If the mystical contribution to living is the radical thing that I believe it is—if it represents the repressed side of our civilization—then exposing oneself to it is a prelude to creative breakthrough.

Placing This Book in Context

Having finished this book, I realize in retrospect that it constitutes a creation theology of sacrament just as my *Coming of the Cosmic Christ* constituted a Christology and *Creation Spirituality: Liberating Gifts for the Peoples of the Earth* constituted an ecclesiology. Prior to these works, I wrote *Original Blessing* as a systematic treatment of the mystical/prophetic journey; *On Becoming a Musical, Mystical Bear* was a theology of prayer; and *A Spirituality Named Compassion* constituted a moral theology. *Whee! We, wee All the Way Home* was a treatise on practical mysticism, and my works on Meister Eckhart, Hildegard of Bingen, and Thomas Aquinas can be understood as studies of pre-modern thinkers and doers, mystics and prophets. I have been pursuing the tradition and praxis of a mystical-prophetic spirituality as found in the mystics and prophets of the creation tradition through the centuries. But I can now see that in the process of my discoveries, an outline of a postmodern systematic theology is also emerging—one based on Creation Spirituality rather than on theology as we have known it in the modern era. I can only say that I am as surprised as anyone at this development.

This book is in three parts. In the first part, I deal with work as non-action, the inner work of our species that has been so long neglected in our industrial work world. In this part, which I call "The Great Work and the Inner Work: Revisioning Work," I explore the nature of human work, first by examining the *via negativa* and work

(chapter 1); by introducing the new cosmology and its implications for work (chapter 2); by exploring the *via positiva* and work (chapter 3); and finally by exploring the *via creativa* and how creativity is the link between our inner work and our outer work (chapter 4).

In the second part, "The Great Work and the Outer Work: Reinventing Work," I apply principles that emerge from our exploration of "inner work" or non-action in part 1 to our "outer work" or actions. I offer examples of contemporary persons and movements that are beginning to reenchant our work by transforming various work worlds and professions. With the reinvention of work comes the reenchantment of work, for good work makes for joy. This pressing need—to invent and reinvent good work for our species today—corresponds to the *via transformativa* in Creation Spirituality. I offer examples of this transformation of work worlds ranging from the environment, farming, and politics (chapter 5) to education, youth, and sexuality (chapter 6) to health care, psychology, and art (chapter 7) to economics, business, and science (chapter 8).

The third part, "Ritual: Where the Great Work of the Universe and the Work of the People Come Together," surprised me. I had no idea when I committed myself to a project on a spirituality of work that it would culminate in exploring ritual and how reinventing ritual will help us reinvent work in our time. But I deeply believe this is the case and that the heart of the paradigm shift must be for the outer work of factory jobs of the industrial era to give way to the inner work on persons and communities alike—what E. F. Schumacher calls "putting our inner house in order." This constitutes the most basic work of the 1990s as we prepare to usher in a new millennium—one that requires a deep letting go of the old ways of living if this planet is to survive. There will be no environmental revolution without a rebirth of ritual, because in ritual we can deal with the grief issues of the community as well as with the great origin stories of our world. Is there any better way to put the unemployed to good work than by way of the healing and celebration that ritual work creates? In chapter 9, I discuss principles for reinventing ritual with special attention to the theology of the Sabbath, and I present examples of experiences I have had with effective rituals.

The concluding chapter, "Work As Sacrament, Sacrament As Work," surprised me again. I have never connected work and sacrament so explicitly before. Clearly, in a creation-centered spirituality, and given the new cosmology we have today, the primary sacrament is creation itself. (In the thirteenth century Thomas Aquinas said that "revelation comes in two volumes: the Bible and nature," and Meister Eckhart said that "nature is grace.") The universe, as the awesome expression of creation, is sacrament constantly bestowing its blessing and grace upon us. We are graced by the universe. Its work is sacramental, a revelation of divine grace. Therefore, our work—to the extent that it joins the Great Work of the universe—is also sacrament. Furthermore, I propose that the tradition of the seven sacraments furnishes us with a useful outline and conceptual framework for critiquing the beauty, grace, and morality of our various forms of livelihood. All work, I propose, constitutes an expression of one of the traditional seven sacraments, analogously understood. One might name the paradigm shift of our time as moving from machine to green or from machine to sacrament. We are talking about resacralizing our work worlds and therefore our whole world. This sense of resacralizing our world is not unlike the Eastern Christian understanding of redemption as *theosis,* the divinizing of the universe.

To bring spirituality to bear on our discussions of work is to bring out the mystical as well as the prophetic dimensions of work. Part 1 of this book thus constitutes the mystical side to work, at least up to chapter 4, which bridges the mystical and the prophetic; part 2 constitutes the prophetic side to work, discussing how to apply a mystical cosmology to the subject of reinventing our work—how to transform work itself. And part 3 explores the most fertile field for transforming our species and its civilizations by way of the transforming work that will in turn transform souls.

Hildegard of Bingen once wrote a letter in which she stated that she wanted above all else to be "useful." I hope, in Hildegard's words, this essay proves to be "useful" in the revisioning of work in an increasingly postindustrial era.

The Great Work and the Inner Work: Revisioning Work

Everywhere people ask: "What can I actually do?" The answer is as simple as it is disconcerting: We can, each of us, work to put our own inner house in order. The guidance we need for this work cannot be found in science or technology, the value of which utterly depends on the ends they serve; but it can still be found in the traditional wisdom of [humankind].

E. F. SCHUMACHER[1]

O dear friend
In search of
My Beloved,
I wandered
All over the earth
In far and distant lands;

But on meeting
With Him,
My own courtyard
Became the universe!

KABIR[2]

Offer to me all thy works and rest thy mind on the Supreme. Be free from vain hopes and selfish thoughts, and with inner peace fight thou thy fight.

BHAGAVAD GITA[3]

In the modern period, we are without a comprehensive story of the universe. . . . Thus we have at the present time a distorted mode of human presence upon the Earth.

BRIAN SWIMME AND THOMAS BERRY[4]

There are essentially two kinds of work: inner and outer. The inner work refers to that large world within our souls or selves; the outer is what we give birth to or interact with outside ourselves. The industrial revolution was essentially an outer revolution. Its engines and machines were cold and lifeless external objects. The philosophy of that period—derived from the work of Descartes and Kant, who were, in turn, inspired by Newton—taught us to relate to things as we would to machines—objectively. Much was gained by this new, objective relationship. Work became more efficient; a machine could do far more work than could a horse-drawn plow with a person behind it.

But much was lost also. Prior to the industrial revolution, work was more relational. To be successful as a farmer one had to relate well to one's farm animals; humans and animals were interdependent. One could not survive or thrive on subject-object relationships. While tilling the soil or picking vegetables could be both an inner *and* an outer experience, driving a tractor and repairing it or fixing a boiler and fueling it turned farmers' attention outward, since relating to another living being was not necessary.

The myth of work in the industrial era fed on this outer-directedness. The myth holds to this day. For example, if an automobile factory closes in Detroit (or, more likely, moves to Taiwan or to Mexico) or if a defense plant shuts down in California, the immediate response is, "We're devastated. We have lost our jobs." *But we no longer have to internalize the industrial-era myth that work is primarily about factories and industry.* Indeed, by paying attention to the question What are the

work needs of our time? we can actually launch new ways of doing work, of being workers, of making jobs, of compensating work. The heart of the matter lies in paying attention to the work that the industrial model practically ignores: our inner work. As economist E. F. Schumacher put it in the epilogue to his classic book, *Small Is Beautiful:* "Everywhere people ask: 'What can I actually *do?*' The answer is as simple as it is disconcerting: We can, each of us, work to put our own inner house in order." Putting our own inner houses in order will prove the key to reinventing work for the human species. And not only individuals have inner houses; the inner houses of our communities, our churches and synagogues, our economic and political systems, and our neighborhood and family relationships all need our attention at this critical moment in human and Earth history.

The lesson from the industrial revolution is this: work is not primarily about factories and industries. The human species has always worked; long before the industrial revolution there was plenty of work for humans. For the sake of the future, we must dismantle the war industry and redirect our economy toward sound and life-sustaining enterprises. If the government were to truly support this effort, losing one's job would not seem like the end of the world, for there is so much *new* work that needs doing. When people lament the loss of the competitive edge in the car industry to Japan and elsewhere, another question arises: What work might we do and be trained to do that is more useful at this time for our people? After all, the world hardly needs more automobiles. Cars are destroying our air and ozone protection layers and therefore endangering the future. The loss of dominance in certain industries might be a blessing in disguise, freeing us up for more pressing work in our time. But if that is so, then workers must be trained for this new work that God and the universe are asking of us.

What might this new work be? I am convinced that it is *work on the human being itself.* We might call this "inner work." We have lost our sense of an inner life; we have become so alienated from ourselves by work in the industrial era that abuse of alcohol or drugs or some other addiction is often the nearest thing we have to an inner life. Addiction is a larger industry in America today than automobile

production. The effort to combat addiction is also a rapidly expanding industry. But we cannot combat it without the tools of spirituality aiding our efforts to heal the inner child and to release the authentic adult. Scientist Peter Russell has written that we need a project to explore human consciousness today comparable to the Manhattan Project of fifty years ago. Just as we set about to discover the core of energy in the universe at that time—and managed to explode the atom—so today we need to explore the core of human energy. The models he suggests for exploring consciousness are Teresa of Avila and Francis of Assisi, who showed us by their lives and teachings that there *is* a mystic inside every one of us.

I am proposing that we have a direction for redefining work in the nineties, for reinventing work, and for making work possible for all. It is the work the universe is asking of us—work on our own selves, our own species. Why is this so pressing? Because we are the problem; we are the ones who are destroying our own habitat and that of other species by our blindness, greed, envy, violence, and rapaciousness. These *spiritual sins* are destroying the planet and creating despair in the young. (Aquinas teaches that spiritual sins are far more serious than carnal ones, but churches have seldom followed his lead on this.) Therefore we need spiritual work. And spiritual workers.

The new era in work, the postmodern and postindustrial era, will be an era of doing our inner work. This is how we can put people to good work today.

We need a massive investment of talent and discipline in our inner lives. When we do this we will find some solutions for the overwhelming issues of violence and self-destruction, of internalized oppression and external acts of oppression, of the sexism, racism, homophobia, and fear that overwhelm our species and that are played out from generation to generation in acts of abuse—physical, emotional, sexual, and religious. All the sources of injustice are not to be found in systems alone. Within our psyches lie clues to our resistance to justice.

Having proposed a distinction between inner and outer work, we do not want to create a permanent split between them. A third kind of work—that of bringing inner and outer together—will also be re-

quired. That task will assist the process of converting jobs to work and of inventing new work. Once one has a spiritual center from which to work, no work (provided it is good work) is alienating; no work is just a job. A person who sweeps floors can, by knowing the meaning of his or her task and appreciating its contribution to the cosmic community's history, sweep floors as an act of sacred work. (Of course, to say this is not to endorse exploitation of workers with demeaning work conditions or unjust compensation.) But if one's work is useful and not harmful it can always be holy work and part of one's meditative discipline—provided one is aware. This is not a new idea but a very ancient one. In its healthy periods, the monastic tradition taught it, as did the Shaker movement at its zenith. We praise God by our work. And this in turn gives our work grace and purpose. As writer Wendell Berry points out, all work contains drudgery; the issue is whether it holds meaning or not. If we do our work from our center, from our Source, it will always hold meaning. The meaning will itself "breakthrough" (Eckhart's word) on us from time to time, but the meaning will always be present to us even when it is hidden or shrouded in silence.

In bringing together outer and inner work we are contributing to a cosmology, a making whole, a putting of order into our lives and that of our species. Mystical philosophers like Hildegard of Bingen, Thomas Aquinas, and Meister Eckhart all state that the soul is not in the body but the body is in the soul. This implies that our inner work is not an *inward* work but a *deep* work. Eckhart uses the term *innermost depths of the soul.* But these innermost depths radiate out to wherever our soul extends, that is, into the realms of knowledge and love and wonder and grief that our consciousness touches. Here psyche and cosmos are one. Here the dualism between us and the cosmos is erased. Here is where the healing of the deep wounds we received during the modern era begins. As cosmologists Brian Swimme and Thomas Berry put it, "In the modern period, we are without a comprehensive story of the universe. . . . Thus we have at the present time a distorted mode of human presence upon the Earth." When that distorted mode of human presence is healed work itself will be healed. And healing that distorted mode of presence will itself constitute good work.

On a recent sunny afternoon I sat on a hillside overlooking the beauty and glory of San Francisco Bay, and I realized anew that San Francisco does not contain one's soul; one's soul contains San Francisco. And still the soul wants to travel further—and has. Our souls are very large. That is why we need a cosmology large enough to contain them and to begin the sacred process of satisfying them. In all this we begin to become "flowering orchards" whose work "permeates the universe."

I | The Pain of Work: Work As Nothingness and Lamentation

Work, by its very nature, [is] about violence—to the spirit as well as to the body. It is about ulcers as well as accidents, about shouting matches as well as fist-fights, about nervous breakdowns as well as kicking the dog around. It is, above all (or beneath all), about daily humiliations. To survive the day is triumph enough for the walking wounded among the great many of us.

STUDS TERKEL[1]

People must be so empty of all things and all works, whether inward or outward, that they can become a proper home for God, wherein God may operate.

MEISTER ECKHART[2]

Do your work, then step back.
The only path to serenity. . . .

He who clings to his work
will create nothing that endures.

If you want to accord with the Tao,
just do your job, then let go.

TAO TE CHING[3]

Everywhere I go it seems people are killing themselves with work, busyness, rushing, caring, and rescuing. Work addiction is a modern epidemic and it is sweeping our land.

DIANE FASSEL[4]

Know therefore what is work, and also know what is wrong work. And know also of a work that is silence: mysterious is the path of work. The person who in his or her work finds silence, and who sees that silence is work, this person in truth sees the Light and in all his or her works finds peace.

BHAGAVAD GITA[5]

Most of us can agree with Terkel: the daily grind of work can sometimes grind our souls to dust. Work can be a blessing and work can be a curse. In chapters 2 and 3 we will discuss work as it connects to the work of the universe and work as enchantment, delight, and joy. But here we will look at the ways in which work is demanding, frustrating, disturbing, disappointing, heart wrenching, and mysterious. In work we are emptied as well as filled; we are rendered tasters of nothingness as well as of ecstasy. We cannot renew our work worlds until we acknowledge what is *not* working and admit to the holes in our lives, in our souls, in our collective psyches, in our communities. We need to admit to the experience of nothingness, the boredom, the addiction, the inhumanness that leads to inhumaneness, the compulsive behavior, the fact that while our outer selves may be satisfied or we may be paid decently, our inner selves yearn for something far greater. "The objects of the heart are truth and justice," says Thomas Aquinas.[6] If we are not being served truth and justice as regular fare at work, then no matter how well we are fed materially, we will starve spiritually. Our work must make way for the heart, that is, for truth and justice to play an ever-increasing role in our professional lives. Without that heart-food, we will surely die of starvation of the spirit, and all the promotions and fat paychecks in the world will not assuage the feeling that we are dying in the soul.

Work As Lamentation

We are indeed *homo faber,* a species content only if we have work. But the jobs we do don't always fulfill our dreams. And when our work lacks dignity, so do we. Indeed, certain work threatens to kill the spirit. As economist E. F. Schumacher observes,

> The modern world takes a lot of care that the worker's body should not accidentally or otherwise be damaged. If it *is* damaged, the worker may claim compensation. But his soul and his spirit? If his work damages *him,* by reducing him to a robot—that is just too bad.[7]

In the introduction to his series of conversations with workers, Studs Terkel asserts that work can be painful, can be a matter of "surviving the day," can make us ornery, angry, frustrated, violent, hateful, and humiliated. This is evidence of how deeply work resides in our souls and affects us there; it lies in as deep a place as unemployment itself. Recently I received the following letter from a major union group in Canada:

> People here are exhausted. So many of our friends in the labor/ environment movement are in a state of near-terminal burnout: individuals self-destructing in all sorts of ways, families tearing themselves apart. Lately it's felt almost like a war zone. We hear of another tragedy nearly every day: deaths, breakdowns, AIDS, assaults, divorces, drink, and every variety of stress disorder.[8]

Schumacher connects our machine cosmology to the denigration of work in our lives:

> If we continue to teach that the human being is *nothing but* the outcome of a mindless, meaningless, and purposeless process of evolution, a process of "selection" for survival, that is to say, the outcome of nothing but *utilitarianism*—we only come to a *utilitarian* idea of work: that work is *nothing but* a more or less unpleasant necessity, and the less there is of it the better.[9]

Implicit in Schumacher's criticism of work is his belief that a new creation story that tells of the sacredness of the cosmos can displace

the utilitarianism of a mindless cosmology and help to reinstate an exciting and vigorous philosophy of work. Schumacher believes that there is a distinction between *good work* and *bad work* and that society and individuals alike must become critical of what work does to the worker. Again, he sees this issue as one of ideology and cosmology, a question of whether a machine ideology will be allowed to dominate our understanding of work. "The question of *what the work does to the worker* is hardly ever asked, not to mention the question of whether the real task might not be to adapt the work to the needs of the worker rather than to demand that the worker adapt himself to the needs of the work—which means, of course, primarily to the needs of the machine."[10] Schumacher believes that industrialism actually "stunts the personality" because it renders "most forms of work—manual and white-collared—utterly uninteresting and meaningless." The purpose of modern industrialism is not to create satisfying labor but to eliminate labor, thus stamping labor "with the mark of undesirability. But what is undesirable cannot confer dignity; so the working life of a laborer is a life without dignity." One might say that a machine universe turns our work world into a spiritual wasteland, an experience of nothingness. "Mechanical, artificial, divorced from nature, utilizing only the smallest part of [human] potential capabilities, [industrialism] sentences the great majority of workers to spending their stimulus to self-perfection, no chance of development, no element of Beauty, Truth, or Goodness."[11]

Feminist Perspectives

Gender also plays a role in a critique of work. Women are writing many of the most interesting and most critical studies on work these days,[12] and I think that's because women have been ostracized from the mainstream work world for so long that they have a clearer vantage point from which to witness it all. They can see the toil of work and the price we all pay for it. And because in recent times so much of their work has been centered around the home, women tend to be less clock oriented (babies and little children have a knack for ignoring clock hours!).

Furthermore, women's exclusion from mainline work (and mainline theology, for that matter) has tended to make them less invested in it. This distance gives them, as it does other oppressed people, the freedom to have a sense of play about work, to keep their egos disentangled from the questions of work style and work identity that go with being a man working in an all-male system to support a patriarchal ideology. Women are more willing to criticize not only the work world but its support system, its economic ideology, and its business praxis.

Many women have been doing their inner work for some time, not only by forming discussion groups and other underground ways of communicating but also by listening to their inner selves. Many women also stay closer to their own biological realities—which are indeed cosmic realities—than do many men, and so women may look more to nature, including their own, for lessons and less to anthropocentric agendas. Those work worlds where women have been encouraged to excel, such as homemaking and parenting, nursing and teaching, are, if one examines them carefully, closer to nature's work than are most manmade and male-defined jobs in our culture. Fewer "rules" and greater demands on creativity, process, and experience characterize these kinds of work. Even when women choose to leave these work worlds and enter less familiar territory, they often take with them the lessons learned and the skills developed in these more nurturing tasks. The result is that women often have the potential to transform workplaces and ideologies of work.

Feminist philosophies, in many respects, "fill in the blanks" left by dominant Western philosophies about work. Many feminisms value interdependence as opposed to dependence, co-dependence, or rugged independence, and this interdependence not only leads to authentic compassion but also bears witness to a basic law of the universe. Many feminisms also insist on staying in the practical realm, and this emphasis on personal relationship moves discussions of work and unemployment from the head to the gut, where compassion stirs things up and moral outrage can lead to authentic transformation. And most feminist philosophies reject dualisms of inner/outer, either/or, and being/doing in favor of a nondualistic and creative

dialectic, which also contributes to a definition of work that is all-encompassing. In feminist visions of the world there's room for artists and poets and dancers and singers. The mystical dimension—the realm of awe, wonder, and ecstasy can assume its rightful place. Feminists also insist on our eco-relationships, and by doing so they feed the imagination with new kinds of work that can defend our planet's well-being and thereby our own.

Men's Movements and Work

Now that women have opened up soul issues, men are beginning to listen to their own stories. Accordingly, the men's movements are beginning to raise the questions of inner work that men have neglected for far too long. Some men are exploring this notion of inner work; they are beginning to lament what bad work does to their souls. And as more men commit themselves to doing work in the home and to tending babies, as they hear the questions that their partners, daughters, mothers, and women friends are raising, their attitudes toward work and self are bound to change.

For example, Paul Kivel, a cofounder of the Oakland Men's Project, in his book *Men's Work: How to Stop the Violence That Tears Our Lives Apart,* relates stories of male violence and of the healing of male violence. Male violence, he points out, is invariably directed initially toward the self and is then reenacted toward partners, children, and others:

> The question of why men were violent had to encompass why
> we were violent toward ourselves. Suicide, sexual assault, battery,
> murder—these are clearly violent acts. But alcohol and drug use,
> emotional and psychological intimidation and abuse, and dangerous
> sports and hobbies are also violent. Workaholic patterns that lead to
> heart attacks; chronic neglect of our bodies that can lead to early
> death; failure to get help or medical care that leads to preventable
> deaths; and cutting off wives, partners, children, and friends so that
> intimacy is destroyed—this is also violence. These are common ways
> for men to respond to their own pain and abuse.[13]

Wisely, Kivel avoids merely psychologizing men's issues. Rather, he puts it this way: "As men we have two responsibilities: The first is to eliminate our own abusive behavior in whatever form it takes. The second is to be a community worker."[14] Notice what is being said about work here: the inner work men do on their violence and its causes should in turn lead to beneficial work in the community. Here we have a sound example of how inner work creates new work in the community, which will in turn—because it is preventive—eliminate the need for some of the excessive punitive "work" that prisons now do.

E. F. Schumacher elaborates on how bad work leads to a life without dignity.

> It is a great evil—perhaps the greatest evil—of modern industrial society that, through its immensely involved nature, it imposes an undue nervous strain and absorbs an undue proportion of [our] attention. . . . There is no attention left over for the spiritual things that really matter. It is obviously much easier for a hard-working peasant to keep his mind attuned to the divine than for a strained office worker.[15]

Schumacher makes it clear that future generations of workers must be taught to resist bad work.

> How do we prepare young people for the future world of work? . . . We should prepare them to be able to distinguish between good work and bad work and encourage them *not to accept* the latter. That is to say, they should be encouraged to *reject* meaningless, boring, stultifying, or nerve-racking work in which a [person] is made the servant of a machine or a system. They should be taught that work is the joy of life and is *needed* for our development, but that meaningless work is an abomination.[16]

Schumacher spells out three purposes of human work—guidelines to "good work"—in the following fashion:

> First, to provide necessary and useful goods and services.
> Second, to enable every one of us to use and thereby perfect our gifts like good stewards.

Third, to do so in service to, and in cooperation with, others, so as to liberate ourselves from our inborn egocentricity. This threefold function makes work so central to human life that it is truly impossible to conceive of life at the human level without work.[17]

If we are involved in providing necessary services, perfecting our gifts, and liberating ourselves and others at work, we must expect some opposition to our work from time to time.

In addition, troubles within the workplace itself can occur. Our work can also threaten others; it can get us in trouble. At work we may be forced to interact with persons whose company we do not enjoy and with whose values we do not agree. Work can be a place of irritation and of misunderstanding, of competition and of frenzy. It can rob us of our spirit and oppress our souls. In short, work can be an authentic experience of the *via negativa*. It can lead us into the dark night of the soul.

Regarding this aspect of work the mystics say: enter in. Embrace the dark. Don't run from the pain and suffering that work entails. Look for the meaning behind it, the gift that it gives. Look at the pain, the pains of labor. Bringing something new and worthwhile into the world is always difficult. Burdens are indeed a part of our existence. No one escapes them. The test is whether the burdens that accompany our work are greater or lesser than the joy that results from it. Here we encounter a fine line between healthy sacrifice and unhealthy masochism. Work can lead in either direction, and a genuine discernment of the spirits is necessary.

For example, one often hears someone say, "I work to take care of my family and so I don't stop to ask whether I like the work or not." It may be that we burden our families unnecessarily by making them the excuse or reason why we hate our work. Our families can become an external referent for our addiction to unhealthy work or to trying to fulfill an unhealthy definition of who we are. For example, many men have been taught that their masculine identity is synonymous with their success as a breadwinner. A forty-five-year-old machinist put it this way: "Being a man means being willing to put

all your waking hours into working to support yo
ask for time off, or if you turn down overtime, it me
you're a wimp."[18]

has be
low

Making Choices About the Work We Do

I know families who have sat down together and decided that they would be willing to decrease their income at work in order to enhance the quality of life there and at home. The results in these cases were often exhilarating for the family, because home became a happier place for everyone. Behind some parental compulsion to bring home exaggerated amounts of pay is often a flight from the joy of living life here and now in the family—as if the future were more important than the present.

Spiritually speaking, such thinking is a grave heresy. Jesus taught that the "reign of God *is* among you," meaning *now,* at this time. We ought to be enjoying it! The *via negativa,* when it stands by itself, denies the *via positiva,* or delight; and such a situation is always a sign of a negative spirit at work. We don't live in order to work or even so that our children may go to college, as commendable a goal as that may be. *We "live in order to live," as Meister Eckhart put it. And we ought not to postpone living because of work or because of our plans for buying something with the money we make.* Making a living and having a financial plan to take care of our dependents is part of life. But we must be certain to recognize the difference between authentic sacrifice and self-imposed masochism. The ultimate gift that adults pass on to the young, after all, is a sense of values. And the primary value in life is not in the things we buy with the money we earn; the primary value in life is in living life fully. If we do not pass this value on to our children because we are too busy working "for them," then we are probably passing on not only a subtle guilt but also a destructive message of how not to enjoy life. If we cannot pass on to our children memories of our times of *via positiva* as a family, then clearly work

come too important to us. The *via negativa* ought not be al-
ed to stand alone in our spiritual journey.

In trying to discern whether our work is healthily sacrificial or
sickly masochistic, we can apply this rule of thumb: *Is there room in our
life and work for the other three paths of the creation spiritual journey (that
is, delight, creativity, and transformation) as well as the* via negativa? If the
answer is no, then we are not doing healthy work. We are, in Eckhart's
words, "being worked instead of working." We are addicted to work
rather than mystics-at-work. If we are not doing healthy work, we are
setting ourselves up for compulsive living, for unhappiness, for cyni-
cism, even for heart attacks—indeed, for work as lamentation.

Work As Addiction: The Limits of Work

Another dimension to the shadow side of work is addiction. Addic-
tion is in many respects a sin of the spirit, for it is about seeking the
infinite where it cannot be found and cannot satisfy. In her study *The
Overworked American,* economist Juliet B. Schor offers a structural
analysis of the workaholism that penetrates American life. She ana-
lyzes, for example, the "squirrel cage of work and spend" that a con-
sumer society traps us in and that an economic system like
capitalism—when it is merely about profits—encourages. Con-
sumerism, whose origins she traces to the America of the 1920s, is
built on the premise of "dissatisfaction. No matter how much one
has, it is never enough. The implicit mentality is that the next pur-
chase will yield happiness, and then the next."[19] And this is why the
industry of advertising, the effort to stimulate our appetites and make
needs of wants, is such a potent force in a society of consumers.

Notice what is being said about work here—that work itself does
not bring happiness. It is only the goods that the money from work
can buy that (supposedly) bring happiness. Already, then, our work
world is being judged a failure from the point of view of spirituality.
If we can find no satisfaction in the work we do, then we are indeed
set up for the "squirrel cage"; we are set up to seek escape in our free
hours. Going shopping is one of those escapes, as is watching televi-

sion, and Schor points out that in those societies with the most compulsive work hours in the world—the United States and Japan—people watch the most television. "Happiness," Schor points out, "has failed to keep pace with economic growth," and consumerism is ⌐ addictive. "Like drug addicts who develop a tolerance, con—⌐ additional hits to maintain any given level of satisfaction. ⌐ cycle develops within our psyches as well as within the culture as a whole: habituation sets in and we begin to take for granted items that were considered luxuries just a generation ago—automobiles, personal computers, color TVs, even indoor plumbing, refrigerators, and vacuum cleaners. This habituation might be the dark side to what biologist Rupert Sheldrake calls the *morphic field,* the organizing principle that contains a kind of cumulative memory and tends to become increasingly habitual. As one neighbor begins to consume we all begin to consume. Says Schor, "The whole story is that we work, and spend, and work and spend some more."[21]

In her book *Working Ourselves to Death,* management consultant Diane Fassel observes,

> Everywhere I go it seems people are killing themselves with work, busyness, rushing, caring, and rescuing. Work addiction is a modern epidemic and it is sweeping our land. . . . I call it the cleanest of all the addictions. It is socially promoted because it is seemingly socially productive. . . .

Not only office workers or executives are workaholics; housewives and children can be as well. Nor, in Fassel's understanding, is the workaholic addicted to just a job; the unemployed, underemployed, or retired can also be workaholics. And not only compulsive work but also work anorexia or the refusal to work is part of this disease. Some think that the cure for workaholism is not working at all, but "the avoidance of work is as much a compulsion of workaholism as overworking is."[22]

Fassel names the primary characteristics of workaholics: multiple addictions, denial, self-esteem problems, external referencing, inability to relax, obsessiveness. In addition, the games workaholics

must play result in: dishonesty, self-centeredness, isolation, control, perfectionism, lack of intimacy, self-abuse, physical and psychological problems, and spiritual bankruptcy. Fassel believes that

> spiritual bankruptcy is the final symptom of workaholism; it usually heralds a dead end. It means you have nothing left. . . . Fortunately, when the workaholic downward spiral is reversed, spirituality is one of the first things recovering people regain.[23]

Workaholism creates dysfunctional families where emotional intimacy is at a premium, where children learn early to be workaholic, and where resentment simmers. In addition, a workaholic workplace becomes dehumanized and will reward relationships that do not enhance the community. Stress, burnout, and collapse result, and with them extra costs for the organization (in increased workers' compensation premiums and disability payments, for example). Thus everyone suffers when workaholism prevails.

But that is not all. According to Fassel, when the workplace rewards workaholism, our very understanding of what we mean by work suffers. And when this happens an entire culture can become diseased.

> Because work addiction keeps us busy, we stay estranged from our essential selves. An aspect of that estrangement is that we cease asking ourselves if we are doing our right work. Are we actually doing our true work, performing tasks or pursuing vocations that are good for us, for our families, and the universe?[24]

Fassel is clearly speaking of a deep spiritual malaise when she talks of our being estranged from our essential self (what Eckhart calls our "true self" or "inner self") by the work we do. And she hints at why we tolerate such abuse when she points out that from a societal point of view workaholism keeps us so numbed that we do not ask the spiritual questions of our work.

In her book *Workaholics: The Respectable Addicts*, psychologist Barbara Killinger tells us that workaholism feeds violence and

"power trips" because "[the] workaholic ... gradually becomes emotionally crippled and addicted to control and power in a compulsive drive to gain approval and success."[25] This situation is particularly frightening since workaholics are often rewarded in our society and thus gain the power to dictate behavior in their professions, workplaces, and institutions. Killinger suggests we deal with the addiction of workaholism by keeping play, meditation, and spiritual praxis as integral parts of our lives. Workaholism, she adds, is also a major cause of "marital breakdown."

Letting Go and Work

If addiction is the problem, then letting go holds much of the solution, and letting go is one of the spiritual practices that mystics teach us. The *via negativa* consists in part of learning to let go. "We sink eternally from letting go to letting go into God," Eckhart says.

The ability to let go must be applied to our work worlds as much as to other aspects of our lives. The cycle of work and spend is not merely a psychological problem; it reveals the dark side of our economic philosophy: "Work-and-spend is driven by productivity growth," Schor warns, and it occurs when workers are trapped into full-time employment. A survey done in 1989 revealed that 80 percent of Americans would sacrifice career advancement in order to spend more time with their families.[26] Thanks to the feminist movement, more and more men—50 percent at the last count—would be happy doing more housework and more parenting if they could cut back on their hours at the job. But the current setup—the forty-hour workweek, for example—prevents this letting go. Schor suggests that sabbatical or free time ought to be something we get not only with social security and retirement, but also "while [we] are still young and throughout [our] lives." For this to happen we must break the work-and-spend cycle by (a) altering employers' incentives; (b) improving wages for the lowest-paid workers; (c) creating gender equality so that work at home is truly understood *as work;* (d) preempting the

automatic spiraling of consumption; and (e) establishing time as a value in itself independent of its price "so that it can no longer be readily substituted for money."[27] Schor sees a role for lawmakers and government as well as for businesses, unions, and concerned citizens groups in bringing about this transformation, just as these groups fought for a forty-hour workweek earlier in this century. Schor says that by forfeiting some salary but being compensated in time, the average American worker could, by the year 2002, be working 340 fewer hours per year on a 6.5 (rather than 8) hour workday. In other words, American workers would reap two months more of vacation per year.

If a worker's real income were to rise by 4 percent a year, and if all of it were channeled into time off, after ten years the annual work year would be close to 1,300 hours—a total gain in free time of over 600 hours. This worker could go to school one semester per year, take a four-month vacation, or follow a five-hour daily schedule year-round.[28] More work would be available for the unemployed and the underemployed. We'd have time for the more spiritual work of art, education, and volunteering, and we could work with the family, the young, and the aged. Partnerships would stand a better chance of surviving if unburdened by the conflicts of two full-time jobs. We would have more quality time to spend with our children, and we might see the levels of drug abuse and other forms of self-hatred among the young decline. The quality of education would improve because home life would improve.

Western Europeans already work a shorter workweek than we do, and no shortage of productivity follows. American workers work eight weeks more per year than German or French workers and eleven more than Swedish workers. Test after test demonstrates that employees with shorter shifts are more productive, more loyal to their companies, and more efficient on the job.

Since 1948 the productivity of the U.S. worker has more than doubled, which means that we could be working a four-hour workday or only six months per year and we'd still produce at 1948 levels. "Or, every worker in the United States could now be taking every other year off from work—with pay." But instead we have fallen into

consumer addictions, spending more time shopping than any other people on Earth and spending a higher percentage of the money we earn. "In 1990, the average American owns and consumes more than twice as much as he or she did in 1948, but also has less free time." Leisure time in America has declined by one-third since the early 1970s. We are spending "less time on the basics, like sleeping and eating. Parents are devoting less attention to their children. Stress is on the rise, partly owing to the 'balancing act' of reconciling the demands of work and family life." Schor points out that the Aboriginal peoples, "in the race between wanting and having, . . . have kept their wanting low—and, in this way, ensure their own kind of satisfaction. They are materially poor by contemporary standards, but in at least one dimension—time—we have to count them richer."[29]

Native American sister Jose Hobday's Seneca mother taught her that "if you want to keep your peace and be in a happy mood, give whatever you are doing the time it takes to make it complete." Hobday points out that no Native language she knows of contains words either for "late" or for "work." *Work* is a "divisive word," for it cuts us off from our play and our heart's passion. Hobday's father used to say, "Try many things. When you find what you love, do that. *Then* figure out how to make a living with it."

> "Work" is such an important word in this society. Yet, my mother was right—it is divisive. Breaking society up into duty and earning, having and wanting—that can be bondage. The Native way is more freeing, more celebratory. You get all the "work" done—meeting the needs of housing, feeding, clothing, transporting, etc. But you do it in harmony, in union with all Creation and the life cycles.[30]

How much like the Hindu Scriptures Jose Hobday sounds! Listen to the Bhagavad Gita on work:

> "I am not doing any work," thinks the person who is in harmony, who sees the truth. For in seeing or hearing, smelling or touching, in eating or walking, or sleeping, or breathing, in talking or grasping or relaxing, and even in opening or closing one's eyes, one remembers: "It is the servants of my soul that are working."[31]

One of the mystical teachings from the *via negativa* is that it is time to learn letting go. We must let go of stereotypes about work that we as individuals and as a culture have accepted: stereotypes about forty-hour workweeks, about what is and is not socially acceptable, about what a "real man" is, about work being outside the home but not inside it. We must let go of false polarities about time versus work and play versus work, and we must let go of outmoded ideas about the need to consume and to thereby remain dissatisfied and about an economic system that drives its workers into dissatisfaction and consumerism. The *via negativa*—the shadow side of work—is indeed a school for learning wisdom.

Encountering the *via negativa* in our work requires that we dive more deeply into the work. The first response to the darkness in our work may be to quit. But that may not be the wisest route to take. Here again the mystics have much to teach us: much of our work can be transformed when we ourselves are transformed in our attitude toward work or toward the people or situations that make work a burden. I want to tell a story about myself at work.

After working for four years as chairperson of the religious studies department in an undergraduate college, I was beginning to get a bit ornery with the work. As I thought about my experience, I realized I was getting bored. I had taught many courses, but I did not want to continue repeating them. Yet the students needed the basic courses that the department offered. So I resigned. My heart said that I should work at the graduate level and more specifically on spirituality. I resigned, not knowing what work would follow, if any. As it turned out, another college heard of my resignation, called me, and invited me to bring them a new design for a master's program in Creation Spirituality. New work was born for me. I am still involved in that work, though now in a different city and at a different school.

Notice the catalyst here: boredom. A person ought to tolerate only so much boredom at work. For one thing, being bored at work is not fair to other workers or those who receive our work; in my case, it would not have been fair for other classes of students to encounter me as a teacher if I was bored with what I was teaching. The art of teaching is at least 75 percent enthusiasm—getting students ex-

cited enough about learning that they go out and educate themselves. There was no way I could justify boredom as a "sacrifice" I was offering to future generations of learners or to those who depended on my income at work. Yielding to boredom comes from a failure to trust the self, the universe—God, if you will—to provide alternative work. Boredom is a sin against the Spirit; the Spirit is never bored and never boring. Boredom is a sign that letting go may be in order.

When it comes to letting go in our work, the Tao Te Ching advises the following:

> Do your work, then step back.
> The only path to serenity. . . .
>
> He who clings to his work
> will create nothing that endures.
> If you want to accord with the Tao,
> just do your job, then let go.[32]

When Schor talks about more "leisure time," when Fassel talks about our reluctance to let go of work, when Hobday talks about learning to confuse play and work, and when the Tao talks about just doing your job, then letting go, all are shedding light on the theological meaning of Sabbath. We have lost a sense of Sabbath in our lives—a sense of joy and delight, a sense of what we do when we come face-to-face with the mystery of existence itself. Jesus berated his religious tradition for legalizing the Sabbath and making the strict code of laws surrounding the Sabbath be the object of veneration rather than the miracle of the people themselves. "The Sabbath is for the people, not the people for the Sabbath." But in our day we have reversed the process. Today the issue is not the Sabbath and its laws; we have effectively done away with them. The Sabbath serves, in our secularized society, as one more shopping day—perhaps *the* shopping day of the week, and thereby religion not so subtly legitimates the idolatry of work and spend that a consumer economy demands of us. We think that what we buy makes up for all we suffer. Were we to return to the wisdom of Jesus' saying, we might paraphrase him thus: "Work is for the people; people do not exist for work."

A radical letting go is part of our experience of the mystery of God. It is part of the spiritual journey. Can we let go of our boredom at work and still remain at work? Can we, in other words, work on the boredom, applying some principles of inner work to the issues of boredom? Can we change the structures at work that render us bored? We have seen this happen in some industries in which, for example, instead of one worker applying bolts all day in a factory assembly line, teams of workers are given the responsibility for assembling entire sections of cars. What invariably results is deeper satisfaction at work, and employer and employee alike prosper from this change. The same thing needs to happen in other professions, including teaching and health care; we need to move from a narrow perspective to a broader one. In teaching, for example, when we consciously choose to educate the right hemisphere of the brain as well as the left, both student and teacher are exhilarated by the change. Doing circle dances together, displaying one's heart as well as one's head, or becoming joint citizens of a cosmos where we learn from other creatures is good medicine for all.

In health care too we need a broader perspective. The caregiver now is taught to guard against too much "attachment" to "terminal" patients and thus becomes increasingly isolated. Instead of building up walls of self-protection against the grief and hurt involved in health care and thus inviting burnout, we might change the nature of the work itself, introducing activities such as gardening, painting, dance, poetry, and ritual among patients and caregivers alike. In this way, the wisdom of the dying would be passed on to the living, and life would expand for all.

Instead of a burden with a paycheck at the end of it, work *can* become a holy space where burdens get recycled and the Spirit moves. Work can become a place where grief is dealt with, not just on an individual basis but in a community setting, which is, after all, the most natural place for us to deal with grief. There is an "inner life" in every community and every place of work. We need to pay attention to that inner life—to honor it, celebrate it, and release its powers of healing and forgiveness and ecstasy and merrymaking. As poet

Rainer Maria Rilke put it, "Grief is so often the source of our spirit's growth."[33] We need to learn from grief and let it be our teacher.

Letting go applies not only to our work worlds but also to our inner lives. The ancient wisdom of the Bhagavad Gita speaks eloquently to this issue:

> What is work? What is beyond work? Even some seers see this not aright. I will teach thee the truth of pure work, and this truth shall make thee free. Know therefore what is work, and also what is wrong work. And know also of a work that is silence: mysterious is the path of work. The person who in her work finds silence, and who sees that silence is work, this person in truth sees the Light and in all her works finds peace. One whose undertakings are free from anxious desire and fanciful thought, whose work is made pure in the fire of wisdom: that one is called wise by those who see. In whatever work she does such a person in truth has peace: she expects nothing, relies on nothing, and ever has fullness of joy. . . .
>
> He is glad with whatever God gives him and has risen beyond the two contraries here below; he is without jealousy, and in success or in failure is one: his works bind him not. He has attained liberation: is free from all bonds, his mind has found peace in wisdom, and his work is a holy sacrifice. The work of such a person is pure.[34]

The Dark Night of the Soul and Work

In speaking of the *via negativa* we are also speaking of the relationship between what the mystics call the "dark night of the soul" and our work. Our work carries us into a dark night of the soul—not just a personal dark night but our community's dark night as well.

For example, the Earth's population is growing younger and younger, while those making decisions about lifestyle, income distribution, job creation, military investment, and religion are growing older and older. One thing the young have over the old is stronger bodies: they can run faster, hit harder, and absorb more physical pain. Some of the elders are quite wise and are busy as minist-- counselors or as politicians urging the young to vent t

constructively. But that is not enough. As far as we know, the present generation of young people in the United States is poorer, as compared to their elders, than any generation of children in the history of our species. And what is more, they will inherit the most polluted planet that our species has ever beheld. Furthermore, they will inherit a greater financial debt than any other generation. This means services will be cut and the young will be paying the bills for those elders whose avarice has known no limits.

Elders must do more than caution calm and the redirection of outrage. They must offer alternatives. The best idea I have heard about this comes from an African healer and drummer, Onye Onye-maechi, whose dream is to construct African villages in this country. Such villages would be places where young people could go to escape the violent streets of our inner cities. There they could learn wisdom from African spiritual roots, touch their cultural depths, and develop self-discipline under the guidance of some wise elders. This would be inner work, but it would be inner work for the community as well as for individuals, for all our efforts on behalf of community in America are on trial at this moment in history.

Equality, justice, fairness—all this is missing in our culture. The young know it; they feel it; they may lack the language to express it other than "making noise" and doing violence. But as a nation what is clearly missing is this inner work. The rage we are witnessing—in street violence, drug addiction, and so forth—is part of the rage of grief, and we have not grieved as a nation for the dark realities of racism and slavery, of economic injustice and greed. Indeed, we are in denial about all these realities. A juror who explained the decision to exonerate the police officers in the Rodney King case gave ample evidence of this, saying the scene we all witnessed on videotape had nothing to do with race. We will remain in denial until we do the grief work that allows us to enter the darkness. Only by entering it can we acknowledge it and thereby empower ourselves to move beyond it.

And not only inner-city youth are in despair because the adults are in a denial that serves their own interests and greed. Consider sui-

cide rates among teenage Native Americans on Indian reservations. Have we grieved the 500 years since Columbus's arrival on these shores?

Opening the Collective Shadow, Unleashing Truth

The chaos in which our country now finds itself—once again—can be a creative chaos, an opening of our collective shadow, an unleashing of truth, provided we are willing to take advantage of this opportunity. We must become truly critical of the systems that keep so many out of touch with justice and economic fairness. Healthy work lies at the heart of the remedy for this failed promise. People without work are in despair; to be in despair is to lack reverence for self and others. When this happens, violence often results. The key is found in the analysis of Brazilian bishop Dom Helder Camara. In his book *The Spiral of Violence* he points out that what we see on our television sets as violence—people looting and police attacking them—has a prior act of violence behind it: *injustice.* The fact of this injustice is seldom reported in our media and seldom referred to by our politicians. (On the eve of the riots in central Los Angeles, the then-president of the United States was at a fund-raising dinner, raising nine million dollars for his reelection. Was this reported in your newspaper?) Add in the fact that the media in this country has a built-in bias precisely because it is an integral part of the power structure and is therefore invested in continuing to deny the plight of the poor, and you begin to understand the underreporting of injustice.

Clearly the chaos of our culture, and specifically of its work world, is on display. The lack of opportunity for work has everything to do with the riots in our inner cities, but so does the lack of integrity in the work of media, politicians, business people, and the economic structures of this civilization. Work that reinforces adultism, racism, sexism, unemployment, poverty, avarice—is this human work? Is this authentic work? Can we afford for it to continue?

Paul Kivel writes about the work that men need to do in our culture. "Men don't suddenly appear in life armed and dangerous," he

writes. "It takes years and years of training to turn boys into violent men."[35] It also takes conscious effort and deliberate *work* so that men can be men again and let go of learned violence. Such inner work is not without its price, as Kivel testifies in the introduction to his book:

> This is a book about men breaking a cycle of violence that endangers all of us. It was not an easy book to write because breaking that cycle is a painful process. . . . I decided to write this book to expose on a deeper level the terribly destructive training men have received. We've been trained to be soldiers—in our families, in our neighborhoods, on the job, overseas.[36]

But the work on the inner person that is so important to ending societal violence also translates into the *inner work of the community*. As Kivel puts it:

> As we understood more deeply what male violence is about, we moved toward a bigger challenge. We not only aspired toward lives free from violence, we also wanted to create lives that were healthy, intimate with others, and models for our children. We aspired to help build stronger communities and to nurture the natural environment. . . . It is up to us, as men, to reweave the fabric of our lives into something strong, vibrant, and nurturing, unflawed by the presence of violence.[37]

The work going on in the inner-city Glide Memorial Church in San Francisco shows how a community that deals with the shadow side of its soul can indeed bring about hope and resurrection. In his book, *No Hiding Place: Empowerment and Recovery for Our Troubled Communities,* Pastor Cecil Williams tells story after story of how his parishioners—crack addicts, abused women, abused and abusive men—find their souls again; find community again; find good work again by so bottoming out that Spirit enters their lives. Often they then reach out to assist street people who are as lost as they themselves once were. Those who were once addicts can be put to work to fight what Williams calls "the new slavery—the slavery of addiction."[38] Disagreeing with the strategy of the Bush administration's "war on drugs," Williams knew that more prisons were not the an-

swer. At a meeting in Washington, D.C., with drug czar William Bennett, Williams recalls the following story:

> I raised my voice and shook my fist, "You are interested in a policy of enforcement. We are interested in a public health policy that puts priority on recovery and treatment programs." I knew then that the black community had to face Crack on our own, using the tools of faith and resistance that broke down slavery and public racial discrimination in earlier generations. The Feds were not fighting our war. . . . Drugs were not the real enemy; addiction was. The war to be won was against addiction. And the way to fight addiction was to offer recovery programs—offer support, jobs, and a new, empowered way of living.[39]

Williams and his parishioners knew that hard work with the wounded souls of addicts and with the community of their church and neighborhood was the only route to liberation from the slavery of drug addiction.

We have much to let go of: racism, adultism, classism, denial, addictions, violence, definitions of gender roles. And this spells *work*. There is so much work to be done in our time, but it is primarily work on ourselves—work on our better selves (the *via positiva*) and work on our shadow selves (the *via negativa*). Once we start paying attention to the inner needs of our species, we will see that there is no shortage of work. There is work to be done on the inner needs of our communities as well, with their capacity for joy and celebration (the *via positiva*) as well as their need for sharing grief, anger, outrage, and sorrow (the *via negativa*). Where are all the workers? They are among us. But we need to invite one another to this work.

Homeless in the Soul

Perhaps it is time to pay closer attention to the ways we speak of things *inner*. For example, when we say "inner cities" we may be speaking of more than a ghetto encampment in our downtown areas. We may also be saying—without realizing it—that the crisis is an *inner* crisis, a soul crisis, a crisis not just in a certain section of town

but in the entire soul of a nation. Interestingly, the mystics have often pictured the soul as a city. The need for inner work *and* for external work (or jobs) in our "inner cities" is a need all feel whether employed or not, whether inner city or not. Because we let this need fester, it builds up inside all of our souls and is expressed in fear, denial, and more violence. Williams and Kivel remind us that we have to work on the "inner city" of our wounded souls if we are to put the social "inner city" to good work again. And we would do well to remember that wounded souls are not just those in the inner city who have too little but also those who have too much.

Perhaps there is also a connection between the reality of homelessness on our city streets and the reality of homelessness in our souls. We lack a cosmology, a sense of universe as home and thus a sense of ecology. *Eikos* in Greek means "home."

It is clear from the examples given above that where our work is service oriented—geared to relieving ignorance, physical pain, unemployment, sexism, neglect, emotional pain, boredom—we are trying to do something about the dark night. But work is also capable of creating the dark night—when, for example, our work contributes to the devastation of the planet, to the despair of the young, to hoarding when we ought to be sharing, to control and power games instead of celebrating, to putting people down instead of lifting them up, to injustice instead of to justice.

The industrial revolution has increased the horror of work at the same time that it has forbidden us the language and the myths to name it for what it is. For example, the new weapons of destruction that we have created in this century are seldom examined for what they are. We cover up the real nature of their work with names like "the Peace Maker" for ballistic missiles and "Trinity" for nuclear submarines and "Patriot" for missiles that destroy civilians in Iraq and "victory" for wars that kill 100,000 civilians. We do not allow ourselves to feel the depths of our own destructive works. And how could we, since our reigning philosophy teaches us that we have no depth, that we are machines dealing with other machines, that in warfare we're not killing living beings constituted of depth and mystery but only, in effect, killing other machines? The machine paradigm finds

its apogee in military machines. But there it also confronts its inability to move beyond itself, for if we are machines living in a machine universe, how could we ever creatively break through this enclosure?

Rationalism does not deal with the shadow side of our spiritual nature any more than it deals with the divine side of our spiritual nature. In other words, a Cartesian view of the world exonerates us from our evil acts. In a remarkable essay on evil called "Thriller," Czech playwright and former president Vaclav Havel writes, "The modern age treats the heart as a pump and denies the presence of the baboon within us. And so again and again, this officially non-existent baboon, unobserved, goes on the rampage, either as the personal bodyguard of a politician, or wearing the uniform of the most scientific police force in the world." Havel indicts the old paradigm's thinking about evil when he says that "it has put its full weight behind cold, descriptive Cartesian reason and recognizes only thinking in concepts."[40] This entire "rationalistic bent,"

> having given up on the authority of myths, has succumbed to a
> large and dangerous illusion: it believes that no higher and darker
> powers—which these myths in some ways touched, bore witness to,
> and whose relative "control" they guaranteed—ever existed, either
> in the human unconscious or in the mysterious universe. Today, the
> opinion prevails that everything can be "rationally explained," as they
> say, by alert reason. Nothing is obscure—and if it is, then we need
> only cast a ray of scientific light on it and it will cease to be so. This,
> of course, is only a grand self-delusion of the modern spirit.[41]

Our generation, Havel believes, has passively accepted a "mass insanity that has nothing in common with any form of rationality."[42] We have made pacts with some demonic forces, among which are a capacity for environmental and human degradation. We need to face the shadow side of our souls if we are to cease the denial, tear asunder these pacts, and recover a sense of healthy living and working. Proof of his words can be seen in the suffering of our planet today—and the implications of this suffering for future generations. Many of the world's crises of disease, famine, and floods are due to deforestation, soil erosion, air pollution, ozone depletion, water degradation, and

warming of the climate. We are losing soil at the rate of twenty-four billion tons per year—the amount of soil used by all the wheat farmers of Australia; since 1945, we have lost an amount of topsoil equivalent to the area of the entire nation of India. Water tables worldwide are falling dramatically; in Chapala, Mexico, the third largest freshwater lake in Latin America has fallen from a depth of 30 feet to a depth of 9 feet, the surface has shrunk from 465 square miles to 330 square miles, and the whitefish are all gone; Mexico's cities and farmers are draining the lake. Around the world, ground-level ozone is reducing crops by 5 to 10 percent annually; soil erosion is on the increase, with the soil of Ethiopia and Peru almost entirely gone.

All this is happening while population increases and food consumption outpaces food production. Human health is everywhere being affected by the degradation of our planet. In Czechoslovakia there has been a 60 percent increase in cancer since 1970; in Moscow 300,000 persons are being treated for radiation sickness; in Los Angeles as well as in Calcutta thousands of children are diagnosed with permanent respiratory damage by the age of ten; in Mexico City every citizen, including every baby, is breathing the equivalent of two packs of cigarettes a day because of the fouled air; in Australia skin cancer is epidemic especially among teenagers because of the hole in the ozone layer; and in the United States there are 200,000 new cases of cancer yearly and cataracts are on the increase. Immune systems are breaking down among nonhumans as well as among humans.[43]

What a responsibility we bear in doing our work! By our work we either assist one another in our journey through the dark night of the soul, eventually being present for the possible lifting of that veil, *or* we help put people and creation itself into a pit of darkness from which they may never recover. Was it not workers, after all, who built the ovens in the concentration camps and worker-politicians who conceived of the evil "final solution" in the first place? Our work can bring out the divine or the demonic in us. The problem is that in most of our lives our work is both light and shadow, both from the angels and from the demons. No single work is exempt from its evil consequences. Hitler was elected and supported by everyday citizens. None of us escapes the possibility of contributing to the demonic. Nor

do we escape the possibility of contributing blessing through the work we undertake. Even accompanying persons on their journeys into the darkness is an important work. And daring to go into the dark ourselves by dealing with our own woundedness and broken-ness is a necessary and significant work.

Work As Healthy Nothingness

Nothingness has a positive dimension to it, and even suffering can help create a positive attitude of letting go and being emptied. Free-dom is often the result of these emptying experiences. The nothing-ness we encounter in life and in work may in fact emerge as a spiritual center, a holy void, an original source through which our work can reconnect to its origins. As the Tao Te Ching puts it:

> All things are born of being.
> Being is born of non-being.[44]

The source of things is a deep, dark mystery. Being is indeed born of nonbeing, surprise from doubt, light from darkness, joy from sorrow, hope from despair. Even the most everyday kinds of work can be seen as a joining together of space—nothingness—and our hands at work. The Tao Te Ching recognizes this in the following passage:

> We join spokes together in a wheel,
> but it is the center hole
> that makes the wagon move.
>
> We shape clay into a pot,
> but it is the emptiness inside
> that holds whatever we want.
>
> We hammer wood for a house,
> but it is the inner space
> that makes it livable.
>
> We work with being,
> but non-being is what we use.[45]

Learning to fashion space and emptiness, nonbeing and nothingness, into form is at the heart of healthy work. It is an indispensable means of returning to our source and incorporating our work into it. Rilke celebrates holy emptiness when he explains that passion alone does not make us workers; the emptying that follows on passion needs also to be integrated into our beings, our work, and our adulthood. Says Rilke:

> . . . Young man,
> it is not your loving, even if your mouth
> was forced wide open by your own voice—learn
>
> to forget that passionate music. It will end.
> True singing is a different breath, about
> nothing. A gust inside the god. A wind.[46]

Nothingness—the experience of the *via negativa*—is a necessary requirement for healthy work. Inner work pays attention to both passion *and* emptying. As Rilke puts it elsewhere, "Know the great void where all things begin."[47] All things, we are told, begin in a "great void" that constitutes an "infinite source" awakening our own intensity. There is no intensity in our work without the connection to our empty origins. We need to give it our "perfect assent," to say yes to nothingness, yes to emptiness, yes to darkness, and to incorporate all theses yeses into our work. Facing nothingness can mean the beginning of whole new life. The womb is empty before it fills with new life; our minds are empty before they see the world anew; the pupil of the eye is empty—as is the lens of a camera—in order to take in "all things"; a mirror is empty before something passes before it and is reflected therein. When our souls are emptied, it may be the beginning of learning who we truly are, how original we are, how distinct from, yet deeply connected to others, we are.

Solitude and our experience of emptiness prepare us for honest listening. After all, our ears too are essentially empty spaces into which sounds are funneled. In this context Meister Eckhart praises the inner person who has learned to listen by being emptied and accepting the experience of nothingness:

The inward person is not at all in time or place but is purely and simply in eternity. It is there that God arises, there God is heard, there God is; there God, and God alone, speaks. "Blessed are they that hear the word of God" (Luke 11:28) there.[48]

When Eckhart uses the term *eternity* he is thinking about child-hood—the time before we knew about time—when we all played "in eternity." In God, he says, "eternal and being young are the same thing." A child's capacity to be utterly receptive, openly listening, is a capacity we can regain. That is why Eckhart talks about our listening to this *word* of God. Through listening our *work* finds a new and more ancient starting point, a starting point that corresponds to the void where, as Rilke assured us, "all things begin." Eckhart believes that we can return to a state of utter freedom such as we experienced "when we did not yet exist." Moments of meditation are such mo-ments of return. This is what it means to be "poor in spirit." Out of this emptiness and nothingness God can work in us. Eckhart puts it this way:

> God does not desire that people reserve a place for God to work in. Rather, true poverty of spirit consists in keeping oneself so free of God and of all one's works that if God wants to act in the soul, God's self becomes the place wherein God wants to act—and this God likes to do. For when God finds a person as poor as this, then God operates God's own work and a person sustains God in him, and God's very self is the place of the divine operation, since God is an agent who acts within Godself.
>
> Here, in this poverty, people attain the eternal being that they once were, now are, and will eternally remain.[49]

Eckhart urges us not to make an object or even a person or an imaginary companion of Divinity. Rather, Divinity becomes the very *place of our operation;* Divinity is more a space and a presence than a projection of our minds. In this presence we work. The work we do makes us radically young; it connects us to our origins in the past, the eternal now, and our future. Eckhart urges us to "follow the way of our unborn being"; he is assuring us that we are as free now as before we were born. The emptying process puts us in touch with what is

not yet born; it puts us in touch with the images in us that yearn to be born. It is the way of creativity. Work that starts in emptiness can end in creativity. Thus, it satisfies.

When nothingness and emptiness become part of our work, then our work joins the great work of creation and we become great ourselves. As Eckhart puts it:

> The inward person attains her full amplitude *(spatiosissimus est)* because she is great without magnitude. This is the person the apostle commends to us in Colossians (3:10f.): "Putting on the new [person] which is renewed in the knowledge of God after the image of the One who created [her]; where there is neither male nor female, Gentile nor Jew, . . . barbarian, Scythian, bond or free: but Christ is all in all."[50]

The notion that we can attain our "full amplitude"—that we can be godlike after the image of the Creator of the great work of the universe, that we can experience the Christ who is "all in all"—is good news to those who have done their inner work. It is a challenge to all who haven't yet done so. When we undergo our inner work of enchantment and of nothingness we are put in touch with a promise that Eckhart made to us earlier—that if our inner work is great our outer work will be great, for in it is contained all cosmic dimensions and experiences. For "the inward work always includes in itself all size, all breadth and all length."[51]

Notice that Eckhart's description of work encompasses the Four Directions. Our work takes on cosmic significance when it is inner work, a work connected to the origins of the universe. Therein lies its dignity; therein lies its power; therein lies its reward.

The Sufi poet Rumi praises the connection between work and nothingness when he points out that the worker seeks out what needs working: we work at what needs work. Therefore a special relationship exists between the worker and nothingness, a relationship to which we must become more attuned if we are to create healthy work. Rumi says,

I've said before that every craftsman
searches for what's not there
to practice his craft.

A builder looks for the rotten hole
where the roof caved in. A water-carrier
picks the empty pot. A carpenter
stops at the house with no door.

Workers rush toward some hint
of emptiness, which they then
start to fill. Their hope, though,
is for emptiness, so don't think
you must avoid it. It contains
what you need!

Dear soul, if you were not friends
with the vast nothing inside,
why would you always be casting your net
into it, and waiting so patiently?

This invisible ocean has given you such abundance,
but still you call it "death,"
that which provides you sustenance and work.[52]

Emptiness and nothingness are part of the great work of the universe, and, indeed, they feed our yearning for work. The universe absorbs all death and recycles it, whether the death of stars or supernovas, of spouses or friends. Death is a return to our origins, and it marks the end of our work. But death also brings about a melting of our work into the great work of the universe and into the work and work lives of all our ancestors. The communion of saints is a communion of workers. A life and livelihood well lived—wherein work has been good work—is celebrated in death when our work finally joins the great work of the universe in a splendid union. For as Eckhart said, "No one has missed me in the place where God ceases to

become." When becoming ceases, all is still. Ultimately, our work is mystery and in death mystery rejoins mystery.

Conclusion: The Non-action of the *Via Negativa*

In exploring the *via negativa* of work in this chapter we have been exploring the inner work of lamentation. In our work we experience letting go, the dark night of the soul, and healthy nothingness. In many respects we have also been exploring the dimension of non-action or purposelessness to our work. The Tao Te Ching underscores the importance of the inner work as non-action when it says,

> Practice not-doing,
> and everything will fall into place.[53]

Non-action may be another name for our inner work. Our action must be built on non-action and flow from it. When we operate at the level of non-action, we are operating at the level of being. True being precedes true action. But what is non-action? And how do we practice it?

Non-action is expressed in two ways: awe and enchantment; and suffering and nothingness. We do not make awe, awe comes to us. We do not manufacture suffering, suffering comes to us. These experiences of non-action correspond to the *via positiva* and the *via negativa*. In this respect we can agree with Meister Eckhart about the necessity to "work without a why," for all awe is without a why. "God does all the divine works just for the sake of working," Eckhart advises.[54] The Bhagavad Gita also teaches us to work without a why:

> Set thy heart upon thy work, but never on its reward. Work not for
> a reward; but never cease to do thy work. Do thy work in the peace
> of Yoga and, free from selfish desires, be not moved in success or in
> failure. Yoga is evenness of mind—a peace that is ever the same.
> Work done for a reward is much lower than work done in the Yoga
> of wisdom.[55]

This letting go leads to a purity in our work:

When work is done as sacred work, unselfishly, with a peaceful mind, without lust or hate, with no desire for reward, then the work is pure. But when work is done with selfish desire, or feeling it is an effort, or thinking it is a sacrifice, then the work is impure. . . . In liberty from the bonds of attachment, do thou therefore the work to be done: for the person whose work is pure attains indeed the Supreme.[56]

Much of the wisdom we need to deal with the negative in work comes from our experience of the *via positiva,* for as Rilke advises us: "Only in the realm of Praising should Lament walk."[57] It is now time to consider the *via positiva* dimensions of work. We will do this in the following two chapters.

2 | From Machine to Green: How a New Cosmology Helps Us Revision Work

F or somewhere there is an ancient enmity
between our daily life and the great work.
Help me, in saying it, to understand it.

RANIER MARIA RILKE[1]

A ll actions take place in time by the interweaving of the
forces of Nature; but the person lost in selfish delusion
thinks that he himself is the actor.

BHAGAVAD GITA[2]

T he outward work can never be small if the inward one is
great, and the outward work can never be great or good if
the inward is small or of little worth. The inward work always
includes in itself all size, all breadth and all length.

MEISTER ECKHART[3]

G od works at the heart
of all activity.

THOMAS AQUINAS[4]

W omen were relegated to an inferior caste . . . most
dramatically with the coming of industrialization. "Women's
work" was segregated from significant human activity.

MADONNA KOLBENSCHLAG[5]

> By the end of the twentieth century, the destruction left by the wars between nations was dwarfed in significance by the destruction of the natural systems by industrial plunder.
>
> BRIAN SWIMME AND THOMAS BERRY[6]

> The new physics presently rests like a pea under the collective mattress of humankind, disturbing tranquil sleep just enough to begin to change how people think about the world.
>
> LEONARD SHLAIN[7]

> The collective evolution of humanity is interwoven with the evolution of life, even with the evolution of the universe. . . . Work, typical activity of the human, down to its technical and economical substratum, is a factor of true socialization and a principle of communal life. The worker, however, must be a member of this community.
>
> M. D. CHENU[8]

A cosmological perspective on work can show us that all creatures in the universe have work—the galaxies and stars, trees and dolphins, grass and mountain goats, forests and clouds, chickens and elephants—all are working. The only ones out of work are human beings. The very fact that our species has invented unemployment ought to give us pause. Unemployment is not natural to the universe; it contradicts cosmic laws. It is also not healthy. That we settle for unemployment, especially when there is so much good work to be done, points up the fact that we do not live in a healthy world. By undergoing an awakening in cosmology—an awakening to the sense of the whole—we can bring about an awakening of our imaginations, which will, in turn, free us to reinvent work, create good work, cease compulsive and addictive work, and create possibilities of work for others.

Wherever there are people, there are needs to be met and thus work to be done. We need to eat, to be clothed, to be educated, to be treated with affection, to be played with. We need laughter and purpose and healing. We need to be invited to stretch our minds, hearts, and imaginations, which are all, according to Thomas Aquinas, "infinite" in their capacities—infinite and therefore spiritual. In short, we

all need inner work and work that opens the doors of interdependence, of wonder, and of possibility. We need these things far more than we need thirty brands of toothpaste or forty styles of watches. If we paid attention to these basic needs, we would have work for everyone.

The lack of a cosmology creates violence in people's lives. This is especially true of young people, for the young have an intrinsic sense that they are citizens of a universe, of the entire home of God. If they are denied work in that home, they are denied a place in the universe itself. Such a huge and devastating loss will display itself in gratuitous violence. Violence among our young—and even the proliferation of gangs—is an effort to tell the universe: "Hey, we're here." It is an effort to *display,* to use Aquinas's word, one's presence and therefore one's work. When Aquinas says that "to live well is to work well or display a good activity," we must consider its opposite as well: when we cannot work well we will be tempted to display a bad activity. For in a real sense we are all here to display—to put our souls forward, to put our beauty forward.

When work is lacking and unemployment reigns, people learn that *they are not needed in the universe.* Feeling unneeded, in turn, engenders self-hatred and the deadening of the self found in alcohol and drug abuse, crime that leads to prison, and other forms of self-punishment. Cosmic loss creates cosmic devastation in the soul. Alcoholism and abuse increase with rising unemployment, not just in response to the frustration and pressure we feel when we cannot pay our bills, but also out of the spiritual torment we suffer from the message that we are not needed by the universe, that our time here will not matter—in other words, that our presence is not precious.

Older people also talk of the need to "feel needed." They too need to have work in the universe and the purpose and dignity that come with that work. Our souls are very big; they can take in the cosmos and even the news of an expanding cosmos, which is to say that, like the cosmos, our souls expand. And when they are allowed no cosmic outlet, which is one of the purposes of work, our souls become cosmically dulled, cosmically wounded, and often cosmically violent. All of us want to make our contribution to the cosmic work before we leave this Earth.

Being without work means more than just being without a job, as critical a situation as that may prove to be for one's self-esteem and ability to pay the bills. Being without work means being without a place in the universe; it means being cosmically homeless. Being without good work means being a noncontributing citizen of the universe. It is like being in a circle dance but not dancing; when one person refuses to move in a circle the whole dance comes to a halt. These are feelings we entertain not only when we are out of a job but when we are out of work.

One Great Work in the Universe

A cosmology teaches us that there is only one work going on in the universe, the "Great Work" of creation itself—the work of creation unfolding, the work of evolution or creativity in the universe. The poet Rilke speaks of "the great work" and of the gap we feel in our work lives, cut off as we are from the Great Work:

> For somewhere there is an ancient enmity
> between our daily life and the great work.
> Help me, in saying it, to understand it.

Just being able to name the reality of a Great Work in the universe has the power to restore our dignity and to restore dignity to our work. The last line of this passage from Rilke also contains a kind of *prayer,* the hint of a personal *presence* in the universe that attends to our honest yearning to understand. The Great Work is the Great Mystery. We need prayerful help in understanding so great a mystery.

The ancient Scriptures of India celebrated this same sense of the one Great Work of the universe. In the Bhagavad Gita we read:

> If ever my work had an end, these worlds would end in destruction,
> confusion would reign within all: this would be the death of all
> beings. . . . All actions take place in time by the interweaving of the
> forces of Nature; but the person lost in selfish delusion thinks that he
> himself is the actor.

Perhaps so much destruction, confusion, and death of all beings is taking place today because we have indeed lost the sense of the one work and imagine, in our anthropocentric arrogance, that we are the sole actors in the drama of the world's work. As the Gita puts it: "The victory won by the person of wisdom is also won by the person of good work. That person sees indeed the truth who sees that vision and creation are one."[9]

Out of a Newtonian worldview we think of ourselves merely as parts of a piecemeal universe—components in a big machine with each cog doing its "own thing," usually in competition with other objects wanting to do their own thing. Because we lack a cosmology— an experience of the whole—our lives have become fractured and broken, as have our hearts. We have lost a sense of community, and our efforts at work seem at best self-serving. Instead of recognizing what is really a cosmic hole in our souls, we think that perhaps money will plug the hole, and so we strive for bigger paychecks. Our cosmic energy seeps away; work becomes lonely and alienating. We have become strangers to the Great Work.

I know that in my work the sense of community connection is paramount. I have never, in fact, signed a contract for more than one year at a time because I want the community itself—my students and the participants in my lectures and workshops—to be the ones to tell me by their presence, "Yes, you have work we can use; we ought to be working together." During the Middle Ages, students at the first universities paid the faculty directly, and teachers who did not connect with the students learned from their empty classrooms that they ought to find another profession.

It takes time and effort to meditate on the message that the whole universe is involved in birthing one Great Work, for it is not the message we get from our educational systems or work worlds. For the last several hundred years we have been operating on the supposition that there are many individual pieces of life we call work. For example, in universities we teach that there is a work called business and another called art and another called music and another called sociology and another called psychology. As professionals we

are similarly grouped: one person is in business, another is a lawyer, another a nurse, another a teacher, another a machinist, another a graphic designer, another a gas station attendant, another a waiter. Specialization certainly has its place, but it can also cause separation and alienation. By using specialized language, for example, each profession creates an elitism that keeps others from learning from its work. A parts mentality fits the Newtonian paradigm, but it belies the truth of *interdependence,* which lies at the heart of our current view of the universe—a view that, not incidentally, the mystics of old endorsed most heartily, as we shall see shortly.

And so we need a new cosmology—one that leaves behind a piecemeal approach to work and brings us together, one that brings about the interdependence that we feel and know is behind all things in the universe. After all, every breath we take makes us interdependent; all breath connects us to molecules breathed thousands of years ago by Muhammad or Buddha or Jesus or Sara or Hildegard. In work there is more togetherness than competition, more interdependence than independence. These are startling statements to our Western ears, raised as we are with a Darwinian sense of competitiveness and a Newtonian parts mentality. But the recognition of interdependence is part of the paradigm shift that we are undergoing today.

Consider another example of the oneness of work in the universe. A runner runs; she is breathing deeply. Where does her energy for this work come from? The food she has eaten is processed and recycled as proteins and carbohydrates that furnish the energy for the work of running. And the food comes from the soil, which has been worked on interdependently by the sunshine and the rain and the worms and the nutrients of the soil. And the sun, rain, and nutrients were born of supernova explosions, of the birth of galaxies, stars, elements of the universe, and even of atoms, billions of years in the past. If we consider the big picture, we can see that there is only one work in the universe. The universe itself is a single ongoing drama, and we and our work are part of it. All energy is one; indeed, *energia* is the Greek word for work.

Physicist Erich Jantsch puts it this way:

Meaning emerges from a sense of connectedness. If we ask somebody for the meaning of his ambitions, his hectic life and his grabbing, we usually hear that it is not for himself, but for his children, that he suffers all this. This is already an act of self-transcendence. . . . The need for meaning proves to be a powerful, autocatalytic factor in the evolution of human consciousness—and thus indeed of the evolution of [humankind] and the universe.[10]

Our work is interconnected to God's work. Meister Eckhart says, "God and the soul are very fruitful as they eternally do one work together." Eckhart teaches that we do this one work "eternally" with God by becoming one with God—"the 'he' of God and the 'I' of me share one 'is' and in this 'isness' do one work eternally."[11] Thomas Aquinas also teaches that God works in our work when he says, "God works at the heart of all activity." All activity of the universe is God at work—not on its periphery but at its heart.

Eckhart goes even deeper into the mystery of our interrelatedness with the Divine in work when he says that if we humans are emptied fully enough, "God operates one's own work and a person sustains God in oneself, and the Divinity itself is the place of one's operation, since God is an agent who acts within itself."[12] In this sense our work is neither just our work nor even our co-work with God; it is a sacred space, a temple, we might say, where God operates the divine work on the world. In our creative moments we often feel this— the presence of a mystery greater than ourselves actually emerging from our work.

Origins of Work

Where does work come from? If we are all doing, in some way, one work, then we ought to search for a common origin. And this the mystics have done. The poet Rilke writes about the source of our work:

Be—and yet know the great void where all things begin,
the infinite source of your own most intense vibration,
so that, this once, you may give it your perfect assent.[13]

If Rilke is correct in saying that "all things begin" from an "infinite source" and a "great void," then clearly our work exists in common with all other work in the universe. In our work we are never alone; just the opposite. In our work we are in communion with all other beings. But we must give this communion our "perfect assent," as Rilke advises. We must join the Great Work of the universe. We are the species that can choose to enter this Great Work or to settle for far lesser works instead. We can, for instance, make our sole work strengthening our nation-states or earning money at Disneyland or keeping others down or tearing down rain forests or hoarding or making war. But when our work joins the Great Work of the universe it always expresses intercommunion. We are working out of our common origin, a shared source. The Tao Te Ching puts it this way:

Just realize where you come from:
this is the essence of wisdom.[14]

If knowing our origins is the essence of wisdom, then it is also the essence of wise work. A new creation story is essential for our species, for it has the potential to awaken our wisdom. Is this why all ancient tribes (including the Israelites, who gave us the creation stories of the Bible) have kept themselves together with their creation stories? Because a common origin story lends meaning to our work and to our being in the world. In it we can also find meaning in our relationships with the other creatures, for it is not just humans who share common origins; all creatures do. This is the teaching of today's creation story from science, namely, that we all come from a single tiny flame that from its origins fifteen billion years ago expanded for 750,000 years. But this is also the teaching of our mystical traditions. For example, the Tao Te Ching says

Each separate being in the universe
returns to the common source.
Returning to the source is serenity.

Notice the teaching here—that all beings share a common source. The teaching continues:

If you don't realize the source,
you stumble in confusion and sorrow.
When you realize where you come from,
you naturally become tolerant,
disinterested, amused,
kindhearted as a grandmother,
dignified as a king.
Immersed in the wonder of the Tao,
you can deal with whatever life brings you,
and when death comes, you are ready.[15]

Notice what we are promised here: peace, harmony, kindness, and the overcoming of the fear of death.

Meister Eckhart also comments on the power of our returning to our origins when he writes that our work "draws all its being from nowhere else but from and in the heart of God."[16] He is saying that our work has being; it exists. One might say that *we* give it existence (although it would be more accurate to say that God gives it existence along with us), but the source of its being comes from its capacity to receive and draw being from and in the heart of God. Work draws being out of the God-heart. This makes our work sacred indeed.

But if our work comes from the heart of God, then its origin is compassion—which names the essence of God. "Every work in a creature supposes the work of compassion and is grounded in it as in its root, the power of which preserves all things and works powerfully in them." Furthermore, "whatever God does, the first outburst is always compassion."[17] This means that the origin of all creation, the origin of all work, the origin of all being, is compassion itself. This is important knowledge, for if compassion is the origin of all things it is also the end of all things, since the beginning and the end are closely linked.

The essence of compassion is interdependence. If our work is an interdependent work with the universe, then indeed compassion is its "ground" and "root" and the very "power which preserves all things and works powerfully in them," as Eckhart puts it. But Eckhart is saying more than simply that our work stems from compassion; he is also saying that we *are worked on by compassion*. Compassion works

on us and affects our work, imbuing it with itself. "The theologians and the Scriptures teach that in every work which God works in a creature, compassion goes with it and ahead of it, especially in the inwardness of the creature itself." That God works in us, especially in our "inwardness" and in the work that we do, happens because compassion imbues us with its own likeness. If God's nature is compassion itself, then compassion lies at the heart of our truth as images of God. We are images of compassion being worked on by the compassion of God, for "the fullest work that God ever worked in any creature is compassion."[18] God's fullest work is the work of the universe: compassion.

If we could actually experience what Eckhart is describing, namely that our work comes "from and in the heart of God," it would create a wonder-filled world in which to live. Work would be a joy, a pleasure, a celebration, even an enchantment. That is how Eckhart sees it, for he says that when we are "united with God and embraced by God, grace escapes the soul so that it now no longer accomplishes things with grace but divinely in God. Thus the soul is in a wonderful way enchanted and loses itself."[19] Work can be ecstasy; we can become lost in it, and when we do, enchantment takes over. How do we get lost in our work? By being so embraced by God that our work is done "divinely in God." At such a time "grace escapes the soul"—a rich phrase indeed, suggesting that we let off steam, we display the grace that is pulsating through us when we work.

If the origin of work is the same as the origin of the universe— which is after all *the* work in which we live, dwell, and have our being—then it is little wonder that our work comes "from and in the heart of God." We dwell within the heart of God; why would we not work from there as well? Eckhart says that our work comes both "from" and "in" the heart of God. We are *in* God's heart along with our work; but the work springs *from* God's heart, as all work, all creation, of the universe has so sprung. Since there is only one work in the universe, then clearly our work too springs from the same holy source.

Divinity also operates within our hearts. Thomas Aquinas teaches this when he says, "God, who makes the heart, knows it. . . .

God knows the heart. Therefore, also its works." And again, "One who knows the cause knows the effect. But the cause of all human effects is the heart."[20] Moreover, it is the Holy Spirit itself who "moves the heart to work."

> Just as a river moves sand and stones, so the Holy Spirit moves the heart to work. There are some rivers that move slowly, but this one is not of that ilk, for it moves swiftly, as the psalmist says, "the force of the river." There are two reasons for this, first because the grace of the Holy Spirit flows suddenly through the heart—Acts 2 says: "suddenly a sound was made from heaven"; and in another way because it is by the force of love that the Holy Spirit moves the heart. Isaiah says: "He came like a violent river."[21]

This Holy Spirit who works through our work and moves our hearts to work is the same Holy Spirit who was said to move over the waters at the original creation of the world. It is the same Spirit who ignited the first flickering light of the original fireball and the primal fire of Pentecostal flame.

If compassion is essentially about interdependence, and if compassion is the origin of the universe's Great Work, then our participation in that work requires a work world that honors interdependence. This is the teaching of today's science, that our world is radically, even primordially, interdependent. It is also the teaching of our greatest mystics.

Eckhart envisions our work as moving from Word to Birth to Work. For what is creative "flows out but remains within." Our authentic work too is creative and flows out of us but remains within. It comes from a deep inner place, from the innermost part of our being—so deep that it never truly leaves us altogether. It is so close to us that it *is* us. This is how Eckhart also images the Word of God in relation to the Creator God: it too flows out but remains within.[22] The link between origin and work is creativity, just as the link between God as Creator and God as Word is the act of constantly birthing the Word.

Solitude is often a way into the inner source, a way into our own hearts, God's heart, and the hearts of others. Often our work comes

from a deep place of solitude. Perhaps if it comes from anywhere else it is not truly work but merely "being worked" or having a job. Work comes from the depth of our silence connected to the silent suffering, the silent needs, and the silent joy of others. Did silence precede the so-called Big Bang? Did the silence in the universe precede its birth? I have been told by a scientist that the so-called Big Bang was not a bang at all—that it was all done in silence, for the ingredients for sound were not yet present. Can we touch the origins of anything without silence and solitude? Can we imitate the origins of the universe without both solitude and silence? Can we enter the "heart of God" and work both from and in that heart without silence and solitude? I suspect that all authentic work, like the work of the universe itself, requires both silence and solitude.

Today's Scientific Paradigm Shift and Its Implications for Work

Today science is rediscovering the mysteriousness of our universe and is generating a new creation story. This new cosmology reinforces the awareness of the one work of the universe and our relation to it. It is this new creation story, say some, that will provide us with the mythology to move our civilization. Key to this new origin story is the kinship that all beings share given that we all come from the original fireball. This is one of the etymological meanings of *religion,* to bind us back (*re-ligio*) to our common origins. Never has this mystical meaning of religion—to return us to our origins—been more accessible than now, given this new creation story. So, what is this new cosmology, and what are some of its implications for work?

One scientist discussing the new cosmology is the British biologist Rupert Sheldrake. He describes seven key areas of the paradigm shift and concludes that in this shift "materialism has transcended itself through modern science." As we read each of his points we will ask, Has our understanding of work, then, also transcended itself through modern science, especially considering the degree to which work has been overly materialistic, and to the extent that it is based excessively

on an industrial view of the world? Following are the seven areas of change in our scientific worldview as named by Sheldrake:

1. The principle metaphor for the world, for the past 300 years, has been that of *machine*. This is an anthropocentric metaphor, for only humans make machines. We have been told that both world and body are machines. In his 1747 essay, *Man the Machine*, French philosopher Julien de La Mettrie declared, "Let us then conclude boldly that man is a machine, and that the whole universe consists only of a single substance [matter] subjected to different modifications."[23] Brian Swimme and Thomas Berry make the point that even our language was rendered machinelike by modern science, denuded of cosmological and even anthropomorphic images. "A language stripped of all anthropomorphism was sought. . . . Anthropomorphic language was abandoned in favor of mechanomorphic language."[24] This isolating of the physical powers of the universe proved a very powerful tool for success in the mathematical and natural sciences.

In contrast, the new metaphor for the world is that of cosmos *as organism*. The universe grew and continues to grow from its origin as a small fireball. Therefore the most accurate metaphor for the universe is an organism—an embryo or a seed that becomes a tree.

Lessons for work: If the universe is a machine, then machine-work best mirrors the work of the universe. Moreover, if our bodies and minds are also machines, then to treat them in a machinelike manner in our places of work is altogether appropriate. And if the worker is a machine, then he or she can be treated as one. However, if the world is an organism, then work too needs to be organic. It must spring from an inner, hidden "seed" of mystery and creativity, and it must be involved in some kind of growth or creative process. Authentic work connects us to the creative habits of the universe.

2. The universe and the bodies in it are *inanimate and purposeless*. Things are soulless, without soul. In the same essay quoted above, La Mettrie proclaimed:

> The term "soul" is therefore an empty one, to which nobody attaches any conception, and which an enlightened man should employ solely to refer to those parts of our bodies which do the thinking. Given only

a source of motion, animated bodies will possess all they require in order to move, feel, think, repent—in brief, in order to *behave,* alike in the physical realm and in the moral realm which depends on it.[25]

In contrast, the new model posits that the universe and its bodies operate within "fields" or places of attraction which, like desire itself, are altogether vital in the universe's scheme of things. Just as magnets attract each other through fields of energy, so too is attraction or what the ancient thinkers called "final cause" important to the ongoing work of the universe.

Each new pattern of organization, whether molecules, galaxies, or crystals, involves the appearance of a new kind of morphic field, which in a cumulative fashion through repetition renders these organizations more habitual. The term "soul" then takes on a new meaning when it is understood as a field of attraction between animate beings.

Lessons for work: If the universe and its contents are inanimate and purposeless, then work consists primarily of pushing reluctant parts into place. Work is pushing, work is drudgery, work is conflict, work is not intrinsically rewarding. Thus compensation must be derived from outside work itself. Incentives such as paychecks and expected pay increases are therefore key. Desire, final cause, love, attraction—these are not necessary to work.

If, however, the universe is indeed about attraction, about desire and final causes (that for the sake of which we do things), then work—far from being a drudgery of pushing, forcing, and outside compensation—is defined primarily by what we love. "Where your heart is, there also your treasure will be found," as Jesus put it (Matt. 6:21). Work has more to do with the heart than we have been led to believe during the machinelike worldview of the past three hundred years. *We are best motivated for work not by being pushed into it or by outside compensation but by inner desire.*

3. The atoms that make up all matter are essentially *inert.*

In contrast, the new paradigm teaches that atoms are *structures of activity* located in fields of energy. Physicist Fritjof Capra describes the atom as "a scenario of dance," and physicist Brian Swimme calls the atom "a self-organizing system" and "a storm of ordered activity."[26]

Lessons for work: If the stuff of matter is inert, then work is boring: it is pushing around inert stuff. It holds no surprise, no mystery, no spontaneity, and outside compensation is necessary or we wouldn't work. However, if atoms are themselves dancing and moving and structures of activity located in fields of energy, then all work is a kind of choreography. To work is to rearrange, invent, make possible, invite the dance of the atoms, the music of fields of energy. Work is full of surprise and wonder.

4. The Earth is dead.

In contrast, the new paradigm teaches that Earth is "Gaia," a living organism. Non-Westerners have always understood this, as have some Westerners such as Hildegard of Bingen and the Celts.

Lessons for work: If the Earth is dead, then as workers we are walking among the dead; we are shuffling dead matter around; we are free to dispose of Earth as we please, for there are no feelings involved in the destruction of trees or soil or water or ecosystems. But if the Earth is a living organism, then all our work should reverence the Earth. Work has moral implications: either we are honoring the Earth and respecting its life systems or we are choking it, destroying it, committing murder against it. Ecocide may be a human option— for a while. But only for a while, for if we indulge in it to a great degree, then we will in fact destroy our own homes, our own nests, and we will be committing not only ecocide but our own suicide as a species.

5. All the forces of the universe, including its Earth systems, are determined and *predetermined.*

In contrast, the new paradigm respects *chaos.* Freedom and spontaneity are everywhere in nature—for example, in weather systems and in the solar system. It is now acknowledged that most of the matter in the universe is utterly unknown to us. It has powerful gravitational effects, but its constitution, which may include exotic particles unlike anything we have been able to detect, remains unknown. The Hubble telescope has confirmed that at least 93 percent of the matter of the universe is "dark matter," or what Sheldrake likes to call "the cosmic unconscious," which is never determined. Like our own mysterious depths, its ways are undetectable.

Lessons for work: If the forces of Earth systems and the universe are determined, then our work will appropriately follow the same pattern. Boredom will necessarily result. Thus outside rewards, such as ever-larger paychecks, or punishments, such as coercion, will be in order. If, however, the universe includes chaos and freedom, spontaneity and dark matter, then our work needs to include these elements as well. Authentic work will mirror the surprises of the universe's work. All work will include space for freedom and spontaneity. Where precision work does not allow this, the human at work must find ways to experience it; the workplace will have to consciously make up for the loss of spontaneity and chaos. Work will honor the mystery within the depth of the person, just as we are learning to respect the mystery within the dark matter of the universe itself.

6. Knowledge is disembodied and preferably *objective.* Seeing from the outside is the ideal way of experiencing truth. As Leonard Shlain points out, fundamental to Newton's philosophy was a "dispassionate detachment from human relationships." This was almost required at the time, given "the *argumentum ad hominem,* or subjective, mentality that dominated the preceding age."[27]

In contrast, the new paradigm celebrates *participation* of observer and observed. Relationship is the key to knowledge, and creativity is the key to the whole cosmos.

Lessons for work: If truth comes to us primarily at a distance and from the outside, then our work too will reflect a distancing of ourselves from the objects of our work. Distance, not participation, will mark our work worlds. If, however, the universe best reveals itself through relationship and participation, then all work is about relation making or relation healing of some kind. And creativity must be integral to all human work as it is to all work of the universe.

7. All of nature is controlled by eternal laws like mathematical laws. God, the supreme engineer or mathematician in the universe, set these laws in eternal motion.

In contrast, the new paradigm teaches that laws themselves evolve even as the universe evolves. Thus, in Sheldrake's words, laws are better defined as "habits" of the universe. If something happens in

a species in one part of the world, it happens easier in that species in another part of the world; nature holds an inherent memory or habit. This perspective comes closer to grasping nature's ways than speaking of "eternal laws."

Lessons for work: If the universe, in its machinelike regularity, is run by mathematical laws of which God is the guardian, then work too will bear the same kind of rigidity and absoluteness. Work will be either about implementing such laws or about fitting into them. Of course, much work in our century has focused on recovering from such laws; therapy professions have responded to the victims of this view of the work of the universe. However, if the universe is essentially run by "habits," that is, by evolving patterns of behavior born of repetition and trial and error, then human work ought to mirror this paradigm by developing habits of memory and action.

Interestingly, this is exactly what the thirteenth-century mystic Thomas Aquinas taught—that art and knowledge and all morality are essentially about developing habits, which we call virtues, in the human person. (He derived much of this teaching from Aristotle.) We will consider the implications of this more fully in chapter 4.

The worldview we hold makes a difference in how we relate to the world we live in. French philosopher Paul Ricoeur teaches us that psyche and cosmos are essentially the same thing in the human person: "To manifest the 'sacred' on the 'cosmos' and to manifest it in the 'psyche' are the same thing. . . . Cosmos and Psyche are the two poles of the same 'expressivity.'. . ."[28] This is also the teaching of the mystics such as Kabir of fifteenth-century India, who sings,

> O dear friend
> In search of
> My Beloved,
> I wandered
> All over the earth
> In far and distant lands;
> But on meeting
> With Him,
> My own courtyard
> Became the universe![29]

In other words, the world we think we live in (cosmology) *is* the world we live in. That is how important our worldviews are. During the Newtonian age we not only thought we lived in a machine, we behaved accordingly. Our psyches *and* our cosmos were machinelike. The industrial revolution seized this worldview, and capitalism provided the economic engine to promote it. The shift occurring today is of the same dimension: If we think we live in an interconnected universe, an organism unfolding the one Great Work of a trillion galaxies, all of it in motion and expanding, then we will start living in such a world as well. And our work will change accordingly. We will discuss such changes in part 2 below.

In his book *Steps to an Ecology of Mind,* scientist Gregory Bateson offers his interpretation of the paradigm from the industrial era that we are leaving behind:

> The ideas that dominate our civilization at the present time date in
> their most virulent form from the industrial revolution. They may be
> summarized as:
>
> a. It's us *against* the environment.
> b. It's us *against* other [humans].
> c. It's the individual (or the individual company, or the individual nation)
> that matters.
> d. We *can* have unilateral control over the environment and must strive
> for that control.
> e. We live within an infinitely expanding "frontier."
> f. Economic determinism is common sense.
> g. Technology will do it for us.[30]

By implication, Bateson is proposing that the work of the future will be friendly toward the environment and will accept the environment's friendliness toward us; it will be interdependent rather than competitive and bellicose toward other humans; it will not exaggerate individualism or jingoism, sectarianism or nationalism but will have a planetary worldview about it; it will not be about controlling the environment; it will not fall into the fallacy of an infinitely expanding mode of thinking about a finite reality, namely the Earth and its gifts to us; it will not succumb to economic determinism; it will look for its

values and its creativity beyond technology alone. We will engage these principles as we discuss the reinvention of work in part 2 of this book.

From this brief reflection on the paradigm change in science as seen by Sheldrake and Bateson we see how we can re-envision the work of the universe. We have also been able to see how the issue of our work as relating to the "one work of the universe" is profoundly affected by which paradigm we choose to guide us. It is evident that our economic systems and work systems of the past few centuries have been operating out of a machinelike cosmology, which has taught purposelessness, inertness of atoms and things, the dead Earth, determinism; disembodied and "objective" knowledge, eternal laws. It is also clear that to opt for a cosmos that is organic demands a changed view of work: where attraction, desire, and final causes serve as magnets in a field of energy; where atoms are structures of activity (and are therefore *at work,* as is the whole universe); where Earth is Gaia, a living organism; where chaos, freedom, and spontaneity have their place; where participation and creativity are the essence of the work of the universe; and where habits rather than eternal laws operate throughout all being.

Surgeon Leonard Shlain warns of the implications of the new cosmology for all of us when he writes, "The new physics presently rests like a pea under the collective mattress of humankind, disturbing tranquil sleep just enough to begin to change how people think about the world."[31] It is now time to pay attention to this "pea," for our sleep is, appropriately, being disturbed.

As we shall see, the mystics of the world have intuited many of the truths of the new paradigm of work and world that we have been discussing. That may be one reason why societies built on these more mystical worldviews, such as those of Aboriginal peoples, had neither unemployment nor the alienation that comes from boring, trivial work—work that demands extrinsic compensation. Consumerism was not an addiction in those societies, nor did consumer addiction provide the basis of their economic systems.

Exploring Our Inner Work More Deeply

Rilke has said that "a work of art is good if it has sprung from necessity. In this matter of origin lies the judgment of it: There is no other." Origin is the source of our judgment on our work. What are its motives? What purpose has brought it into being? Who has called if forth? And for what end? Whom is it serving? Is it necessary? True work, like true art, needs to spring "from necessity." An urgency calls forth our work.

But how can we be sure that the necessity itself is authentic? Here too we need to examine more deeply the meaning of our work as inner work. For Eckhart there can be only one reason we resist working from a deep place, and that is that we have settled for outer work and have ignored inner work.

Too often we work for outside rewards alone or we work from an outside threat. In work that is motivated from the outside— through either rewards or punishment—lies the death, literally, of work. Eckhart says, "If a person's work is to live, it must come from the depths of him or her—not from alien sources outside oneself— but from within."[32] Notice what he is saying: our work takes on a life of its own. Work lives! Think about it. Our work is alive; it is something we give birth to; in this respect it is like our children (and our children *are* our work). To say that work lives is also to say that work can make life happen. Work lives and work brings life. Our work even outlives us at times; it is bigger and longer lasting than we are; it is, to use Eckhart's word, "eternal."

Or at least work *can* live. But it takes some effort on our part to work "from the depths" rather than from alien or outside sources. Consider too how all addiction, as Anne Wilson Schaef teaches, comes from "external referencing." Our addictions are so often an effort to please some outside source.

Another example of outer work is work done only for a paycheck. Such work is so intrinsically unsatisfying that we will keep doing it only for bigger and bigger paychecks. (I am speaking, of

course, of those who earn enough to live decently, not of those whose low wages are a real injustice. The fact is, however, that the two groups—those who earn more than enough and those who earn too little—are intimately related. By urging those who earn an excess to let go we are opening up possibilities for those who make too little.) Inner work speaks to the inner person and awakens *and* satisfies that inner self.

Psychologist Otto Rank points out that the purpose of the guilds in the Middle Ages was not so much for "profit gain as for the recognition of their personality-types as an accepted group by the community. A carpenter, a blacksmith, a baker or butcher represented a definite type of personality above and beyond their civic functions as members of a community." What was the result of the recognition that guilds offered the worker? "Work became just as much a vital factor in the building up and maintaining of one's personality as did any religious, political or individual ideology. In this sense, humans work primarily for their own self-respect and not for others or for profit." For this reason, Rank believes that a flight from work is symptomatic of a flight from our inner self: "A disinclination or resistance to work indicates some fundamental lack in the personality [and] camouflages the deeper resistance to accepting the self, as a definite personality that is afraid to give in return lest it lose its autonomy. For the person who is working for the sake of his own satisfaction, the money he gets in return serves merely as fuel, that is, as a symbol of reward and recognition, in the last analysis, of acceptance by one's fellowmen."[33]

How do we move from outer work to inner work? From the outer person to the inner person? One way is to enter into work as process—as the *way*—not as product. When the Christ of John's Gospel says, "I am the Way," we ought to sit up and take notice: this is a different message from "I am the Alpha and the Omega" (though not necessarily a contradictory one). To say "Christ is the Way" certainly glorifies our work! It puts the divine cloak on the path we take and does not distract us from the path to a goal. It teaches that our *work itself is a holy journey* and that it is not the pot of gold at the end

of the work that justifies the journey. It tells us that our work is the temple in which we dwell: to "con-temple" or play with the Divine can be a part of our work and not just our religious exercises.

Eckhart teaches us about letting go of goals in work when he says, "Do not aim at reward or blessedness, neither this nor that. For such works are truly fully dead. Indeed, I say that even if you take God as your goal, all such works which you do with this intention are dead and you will spoil good works." What do we do instead of being goal oriented in our work? "Enter into your own ground and work there and these works which you work there will all be living."[34]

We are to enter into our depths, our ground, our mystery and hiddenness, and work from there. But the "there" that Eckhart names is a radical and mysterious "there." It is even frightening at times. It is the "there" of nothingness, of no goals and no rewards. "For God to make something in you or with you, you must first make contact with this nothingness." Nothingness as applied to work means no outside goals; the work must be its own reward, its own grace. "The just person does not seek anything with her work, for every single person who seeks anything or even something with her works is working for a why and is a servant and a mercenary. Therefore, if you wish to be conformed and transformed into justice, do not intend anything in your work and strive for no why, either in time or eternity." It is when we can learn to work without a why that we know we are working from our inner selves. If our work is a work of love it needs to be without a why, for love "has no why. If I had a friend and loved him because good and all I wished came to me through him, I wouldn't love my friend but myself. I ought to love my friend for his own goodness and for his own virtue and for everything that he is in himself." The same is true of work: we love it for its own goodness, virtue, and nature. And in that process it becomes an expression of our love. In this way we learn to "love God for the sake of loving God and do all our work for the sake of working."[35]

When we work from a deep spiritual place we do so without an extrinsic purpose in mind. We work for the sake of working and love for the sake of loving and live for the sake of living. Eckhart observes,

If anyone were to ask life over a thousand years, "Why are you alive?" the only reply could be: "I live so that I may live." This happens because life lives from its own foundation and rises out of itself. Therefore it lives without a reason so that it lives for itself. Whoever asked a truthful person who accomplishes deeds from his or her own foundation, "Why do you accomplish your deeds?" that person, if he or she were to reply correctly, would say only: "I accomplish so that I can accomplish."[36]

Eckhart is introducing us to a practical methodology in this passage. Ask your work, "Why are you working?" Ask your role, "What role are we playing in the world?" Notice, let us not ask *ourselves* that question but *our work* and *our role*. Let work speak. Let work take responsibility for itself. Let work stand up and be counted. Give work its dignity of being, its nobility in being among us, for it is everywhere even when we may feel out of work or overworked.

Work, like life, arises out of itself from its own foundation. The energy for work lives in the work itself. Therefore we can say that we work for the sake of working, just as we live for the sake of living. Like life itself, work contains its own reward. It entices and it bursts forth; it bubbles up within us, and it makes demands upon us. Like our sexuality, work demands our respect. We need to honor it, to give it room, to give it space, to give it a place where its power can roam, an arena where its passion can burst forth. One reason we are urged to work without a why is that this is how God works and we, who are images of God, are to be godlike in our work. Eckhart says, "God loves for God's own sake and does all things for God's own sake, that is, God loves for the sake of love and acts for the sake of action.... Therefore, whoever is born of God as a son or daughter of God loves God for God's sake, that is to say, loves God for the sake of loving God and does all one's work for the sake of working."[37]

Working without a why means letting go of all superficial enticements to our labor and working out of our innermost selves. "You should work all your works out of this innermost ground without a why. Indeed, I say, so long as you work for the kingdom of heaven, or for God, or for your internal happiness and thus for something out-

ward, all is not well with you." The result of working superficially and not from our inner selves is dead works. Instead of bringing life into the world by our work we bring stillborn objects into the world. Instead of enchanting the world by our work, we render it dull, boring, and therefore violent. Life begets life, but life comes from our innermost beings, not from outside sources or forces. Eckhart says, "Those deeds which do not flow from within your inner self are all dead before God." On the other hand, "if your works are to live, then God must move you inwardly, in the innermost part of the soul, if they are really to live. There is your life and there alone you live."[38]

Working from the outside rather than the inside can invite death. Our work can also be a source of death. Think of the operators of gas ovens in the Holocaust in Germany: were these persons working? Think of the sadistic torturers in the Inquisition: were these persons working? Think of our tearing down of rain forests: is this work also? Yes, all of this is work. It is death work, and Eckhart analyzes what makes it death work. "All works are surely dead if anything from the outside compels you to work. Even if God were to compel you to work from the outside, then such works would surely all be dead."[39] For Eckhart, work is moved by itself from within. Work and life are almost identical. Perhaps this helps to explain the despair felt by young and old alike when they do not have work or do not "feel needed." They lack life—their own. Without work we lack access to our very life, access to our very being. Indeed, for Eckhart being and action come together. Authentic work flows from authentic being.

> People never need to think so much about what they ought to do,
> but they should remember what they are. Now if people and their
> ways are good, their works might shine forth brightly. . . . For works
> do not sanctify us, but we should sanctify the works.[40]

True work comes from our being. We need to pay ample attention to our being, and in that process holiness itself will flow from being to work. By connecting being and work we make goodness possible in our work, for goodness and being are interchangeable. Eckhart advises us to dive into our being, our ground, our depths,

our inner selves. This is a radical alternative to compulsion or addiction or superficial living, which would have us try to be satisfied living from the outside.

Eckhart calls for a mixing of the inner and the outer, of reality with inwardness. He seems aware of how we might prefer denial, escape, or flight from the inner self to undergoing this process. Part of the inner work is discovering just how it is that "all things have for an inward person an inward divine mode of being."[41] If all things have an inner being, then we miss them—we miss the excitement and beauty, the grace and freedom, the uniqueness and surprise of things—if we relate to them in just an "objective" manner. Yet this is what we will do if we have not performed our own inner work. If we are escaping our inner being then we will project this superficiality onto other creatures. All our relations will be tainted by this superficiality.

Our inner work is expansive. Indeed, when our inner self connects to our work and our work to our inner self, the work knows no limit, for the inner self knows no limit. That is why Eckhart can say that "the inward work is God-like and Godly, and it suggests the divine attributes in this respect." And what are these attributes? "The outward work can never be small if the inward one is great, and the outward work can never be great or good if the inward is small or of little worth. The inward work always includes in itself all size, all breadth and all length."[42] There is no limit to the size of our work—except the infinite Spirit itself. Here we come across one more reason our work deserves to be called spiritual: because it challenges the limits of things and stretches for the infinite, that is, the spiritual, horizons of reality. For this reason also it is important that every person have work: work is one of our most important sources of tasting Spirit—the infinite breadth and length of things. Without work we lack Spirit in our lives. When Spirit or a true infinite is lacking we can readily turn to the shadow infinite—the violence that misrepresents itself as a spiritual experience. Violence takes over as a replacement of Spirit when true Spirit is not allowed its proper place in soul and society. Violence and other addictions seem to fill a void in the soul, though the filling is temporary and superficial— and ultimately un-

satisfying. The size of the inner person is very great, as Eckhart sees it. "The inward person attains her full amplitude because she is great without magnitude. This is the person the apostle commends to us in Colossians (3:10f.): 'Putting on the new person which is renewed in the knowledge of God after the image of the one who created her.' "[43]

Now it becomes clearer why Eckhart speaks of our work being done "eternally with God," for when our work truly springs from our inner self and our ground it is an eternal work. It follows that our work comes from an altogether new place when it can emerge from our source and simplicity, which is to say, from our inner person. For "the inward person is the new person, the heavenly person, in whom God shines."[44] To make contact with this new person in whom God shines is to reinvigorate our approach to work. Indeed, it is to allow Divinity to shine in history and in our communities. Work itself begins to shine with the presence of the divine radiance. Our work becomes the body of Christ entering the world. It becomes the child of God birthed by us. Our work becomes the Cosmic Christ given to the world. This is why the Sufi mystic Rumi advises us:

> Work in the invisible world
> at least as hard
> as you do in the visible.[45]

From Machine to Green (or Sheen): The Great Paradigm Shift of Our Time

Since today we are moving from one work world to another, from one way of seeing livelihood to another, it seems useful to compare the paradigm or worldview we are leaving to the one that beckons us. If we do not see the paradigm shift that is taking place all about us we will suffer from bewilderment. When we do see it we can say, "Aha! Now I understand" (as Rilke prayed to understand why our daily work is so often cut off from the Great Work). Then we can get on with our work. We can ask radical questions of work, and we can contribute to reinventing it.

I delineate this paradigm shift as moving "From Machine to Green (or Sheen)." Sheen represents the photons or light waves we now know exist in every atom in the universe. The machine era was the era of industrialization, the era of the Enlightenment, the era of a parts mentality, the era when atoms and Earth were inert and objectivity was the standard by which we were to relate to reality. It was an era of determinism, of absolute mathematical laws, of God as lawgiver of these eternal laws. It was an age of obedience to these laws and the powers that spoke for them. It was an age that was anti-mystical, anti-child (sweatshops robbed children of their experience of childhood), and anti-art. After all, who wants a mystic (the divine child in each of us wanting to play in the universe) fouling up the machine? Machines are for adults. Adult humans invent them and use them. The machine era did not honor beauty as an important philosophical or theological category; efficiency counted more. The machine era gave us jobs more than work, for it honored outer work more than inner work. Since it was anthropocentric, taking humans as the measure of truth, it was incapable of connecting us to the inner work of the universe.

In the machine era we saw our relationship to Divinity—if it was acknowledged at all—as something distant and aloof: God is "out there," and we related to God theistically. If God is the great lawgiver in the sky, then God is difficult to contact. The patriarchal suppositions of the age of the machine took it for granted that God was male, adult, and judgmental, a keeper of the eternal laws. Given these images of Divinity, it is little wonder that the machine era birthed a uniquely European phenomenon called *atheism,* which is, by definition, a simple rejection of the theistic God. "No theism, thank you" was the response of many in this era to the distant and abstract Deity. The sense of the sacred was rare to come by even for those who claimed to believe, for anthropocentrism, adultism, and patriarchy all banish the sense of awe, wonder, and mystery that form the basis for a sense of the sacred. In a machine-ruled universe the psalmist's advice to "taste and see that God is good" is hardly possible. Wisdom is of little account in such a way of seeing the world; knowledge is what

matters. The knowledge explosion and its offshoot, the information explosion, characterized our intellectual efforts in this era.

A species that has lost its sense of work and how its work relates to the Great Work will kill itself over an ever-diminishing pool of mere jobs. As the Tao Te Ching puts it:

> When rich speculators prosper
> while farmers lose their land;
> when government officials spend money
> on weapons instead of cures;
> when the upper class is extravagant and irresponsible
> while the poor have nowhere to turn—
> all this is robbery and chaos.
> It is not in keeping with the Tao.[46]

When the real work is ignored, war machinery will be required to defend the few winners in a society of regular unemployed, or "losers." War, including the selling of weapons at home and abroad, becomes the pseudo–Great Work. A war spirit takes over the language and vocabulary of a nation. Everything is cast in terms of winners and losers. Life becomes a sports contest. Enchantment disappears. As the Tao Te Ching puts it:

> When a country is in harmony with the Tao,
> the factories make trucks and tractors.
> When a country goes counter to the Tao,
> warheads are stockpiled outside the cities.[47]

And weapons are stockpiled not just outside the cities in our day, but inside as well; we are controlling our youth and defending ourselves from them with guns and prisons. When the true law breaks down—that of the Tao, that of cosmic wisdom and justice—then only warheads can save us from one another.

The industrial era cut women's work off from what Madonna Kolbenschlag calls "significant human activity." Shopping replaced growing and making. In addition, native peoples were often thrown into unemployment on their reservations. Sentimentalism of both women and native peoples set in, and such a mythologizing of the

mother/homemaker role took place that women often failed "to see work as a necessary component of identity and autonomy."[48] Kolbenschlag argues that the industrial revolution radically changed women's attitudes toward work:

> The dissociation of home and work disrupted the integral relationship of women with the commonwealth and isolated her in a privatized sphere of domestic responsibility. . . . Social mobility reduced the female role to an ornamental and utilitarian one. . . . The ethos of capitalism viewed the "leisured woman"—the woman emancipated from work—as the first fruits of "progress."[49]

Placing the "leisured woman" on a pedestal actually restricted women's roles in society and created a rift between working-class women and leisured women. "By implication, it denigrated the role of the working-class woman, driven by necessity to work."[50]

The machine era has also been a *dry* time, for no machine oils itself. The friction that machines cause within themselves and among other machines requires outside oiling. Spiritual dryness and soul dehydration are endemic to our industrial era, and what they have wrought affects the Earth's soul around the globe. Yang, or exclusively male, energy is dry; it is fire that leads to burnout: too much heat, too little wetness.

But now the machine era is coming to a rapid close. It has fouled the air, poisoned our waters, killed our rain forests, torn holes in the ozone layer, destroyed our soil and the art of family farming, rendered our young violent and self-destructive, dried up our souls, and sent adults wandering for meaning, bewildered and soulless. It has trivialized religion. And religion abetted this trivialization by abandoning its mystical tradition, which was a Cosmic Christ tradition, in favor of Jesusolatry among the anxious and an exclusive quest for the historical Jesus among liberals. (Of course, much has been accomplished by the quest for the historical Jesus, including the newly rediscovered emphasis on Jesus as prophet and the realization of which words of the gospel ascribed to Jesus are truly his and which came from the faith community. But since much of that work is completed, the age that beckons us is that of the Cosmic Christ in tandem with

Jesus the Liberator and prophet.) The machine era so desacralized everything that even education became boring and too expensive.

The machine era has also managed to bankrupt itself. We cannot afford industrialism any more. As Thomas Berry points out, the age of industrialism could occur only once on this planet, for it presumed many situations—such as cheap raw materials—that simply will not repeat themselves. Indeed, so-called Third World countries need to think deeply about trying their best to bypass the industrial era and move directly to what Hazel Henderson calls the "solar age" or what I call the green era.

What are some basic characteristics of the green era? First, the whole is appreciated anew for the wonder it is: all "parts" are connected to each other and to the whole, a whole that goes back some fifteen billion years. It is all connected because the universe itself began as one entity, like an organism, not like a machine with its discrete parts. Atoms are patterns of energy and Earth is alive. Things do have souls—principles of animation—and participation and creativity mark the key paths by which we learn and relate deeply to reality. Because the green era is cosmological, it will honor inner work and connect us to the inner work of the universe. It will provide real work, not just jobs, for all. In this era, chaos will be honored and with it the spontaneity and freedom that serve the creative process.

God is feminine as much as masculine in the green era, and instead of being apart and elsewhere, the Divine is within all things as all things are within the Divine. Panentheism marks the age and with it a reawakening to the sacredness of all matter and energy: "Isness is God," as Meister Eckhart put it. Play returns with its companion, Eros. The mystic in every one of us is welcomed and indeed needed; so too the child and the artist, for these are the ones who are not afraid to let go and taste the unselfconsciousness of our holy origins and to delight in the universe once again. The universe is mystery again, and only adults who honor their mystic child will truly fit in. Beauty is recovered as a proper name for God (Aquinas said God is "a fountain of total beauty"[51]) and a proper test of the morality of our actions. Atheism melts before the astonished minds of scientists, as they rediscover the dignity of their vocations in the newly found

wonder of cosmic time and space. And wonder reigns in the acceptance of the anthropic principle, defined by biophysicist Beverly Rubik as the idea that "the universe has been a set-up for life from the very beginning."

Descartes began his philosophy with doubt. It seems that only humans have the luxury to doubt in this universe. In contrast, Thomas Aquinas and the creation tradition begin philosophy with wonder. The new paradigm honors the childlike experience of wonder more than the self-conscious experience of doubt. The wonder is at creation and at its *source,* whereas the previous paradigm looked at creation and earth more as a *resource* for carrying out human exploitation and agendas.

In the green era the sacred is everywhere: in the dance of the tiniest atom and the splendor of all one trillion galaxies, in every organ of our bodies and every thought nourished by the cosmic habit of photosynthesis that feeds our brains. Reverence is called for as we stand before all things, which contain what Aquinas calls the "divine sheen" or "a reflection of God's own luminous 'ray,' which is the fountain of all light."[52] In other words, the Cosmic Christ—the photons or light in all things—beckons us to reverence all things and take nothing for granted. Wisdom is returning by way of feminist agendas, a living cosmology, Eros, and even science itself, wherein we find mind everywhere in the universe. We await a wisdom explosion—wisdom schools and rituals to usher in this age. Instead of the art of war, this era will celebrate the art of the sacrament of the universe; the art of living, of working and putting each other to good work; the arts of healing, celebrating, and forgiving. Instead of the dryness of machines, we will enjoy the wetness of nature. The oil *within* all things, the wet, green, creative juices *within* all things, will be honored again. Because the theological word for wetness is *Christos* or the oiled one, "the anointed one," this era will awaken the quest for the Cosmic Christ—for the divine oil "glittering and glistening" in every being, as Hildegard put it.

Mysticism will replace Jesusolatry in religious circles, and it will be an age of Deep Ecumenism, wherein the wisdom or Cosmic Christ traditions of all world religions will offer us ways to pray and

enter into the sacred mystery of the universe and of our own souls. Education will pay attention to the right hemisphere of the brain, where awe and mysticism happen, and to the body, as well as to the left brain, where analysis happens. In this way wisdom can be developed and women's traditions and native traditions not only will be honored, they will provide us with paths to human healing and ecological justice. The new era will be the era of Creation as Sacrament, the Green (or Sheen) Era. A summary of this paradigm shift follows.

Conclusion:
The Paradigm Shift at a Glance

Machine Era	Green (Sheen) Era
Modern era	Postmodern era
Industrial revolution	Environmental revolution
Large-scale technologies	Intermediate and small technologies
Enlightenment	Ecological era
Atoms are inert	Atoms are patterns of relations
Earth is inert	Earth (Gaia) lives
Things are soulless	Things live by a principle of animation (soul)
Learn by objectivity	Learn by participation and creativity
Outer work	Inner work
Things are determined	Chaos, spontaneity, freedom are everywhere in the universe
Universe as machine	Universe as mystery
Laws of universe are eternal and absolute	Laws of universe are habits that are evolving
God is Supreme Lawgiver	God plays in the universe
God is out there (theism)	God is in all things and all things are in God (panentheism)

(Continued on next page)

Machine Era	Green (Sheen) Era
God does not exist (atheism)	God's presence is experienced by all (mysticism)
Anthropocentric	Cosmological
Begins with doubt	Begins with wonder
All reality and experience are secularized	All reality and experience are sacred
Efficiency counts	Beauty counts and is a divine name
Looks to Earth for its *resources*	Looks to Earth for its *sources*
Rationality reigns (no myths)	Big myths abound, including those of evil, of possible healing, and of sacred origins
God is male	God can be imaged as female as well as male, and in other ways too
Patriarchal, hierarchical	Partnership, interconnection
Pursuit of knowledge	Pursuit of wisdom
Quest for the historical Jesus	Quest for the Cosmic Christ
Sentimentalizing of Jesus in Jesusolatry	Jesus is a prophet who liberates by interfering with injustice
The art of war machinery	The arts of living fully
Dry	Wet
Jobs (if you can get them)	Work for all (relates to the Great Work of the universe)
The universe is a machine, the worker serves the machine.	The universe is a sacrament, the worker is a priest or a midwife to a graced universe

3 | Exploring Our Inner Work: Work As Enchantment

This book is about a search, too, for daily meaning as well as
daily bread, for recognition as well as cash, for astonishment
rather than torpor; in short, for a sort of life rather than a Monday
through Friday sort of dying.
STUDS TERKEL[1]

In work, do what
you enjoy.
TAO TE CHING[2]

They all attain perfection when
they find joy in their work.
BHAGAVAD GITA[3]

Always rejoice in the good
work that you do.
THOMAS AQUINAS[4]

Work is an integral part of being alive. Your work is your
identity. It tells you who you are. . . . There's such joy in
doing work well.
KAY STIPKIN[5]

E very angel is with his whole joy and his whole bliss inside me and the Godself with all the divine bliss. Yet I do not perceive this.

MEISTER ECKHART[6]

M y occupation: Love.
It's all I do.

JOHN OF THE CROSS[7]

To believe that our work is integral to the one Great Work of the universe is one thing, but to *experience* it as such is often another. Having treated the *via negativa* of work in chapter 1 and the cosmic setting for work in chapter 2, we will consider here a more in-depth treatment of the *via positiva,* that is, the role of joy in work.

Work is a mixed bag. We all have our good days and our bad days at work—as we do with all our other relationships to self, others, and God. Mountains and valleys, peaks and pits mark our various journeys in life. For work to be authentically human it must be, as Studs Terkel puts it, "about a search, too, for daily meaning as well as daily bread, for recognition as well as cash, for astonishment rather than torpor; in short, for a sort of life rather than a Monday through Friday sort of dying." Terkel's language and message in this passage are profoundly spiritual. A sort of life rather than a sort of dying is the very definition of Spirit after all; spirituality is about living in depth. Our search for meaning in our work, for recognition, for astonishment or wonder or awe is another way of saying that our work deserves to be a mystical experience. Yet Terkel reports that many persons he interviewed about work showed "an ambiguity of attitude toward The Job."[8] Clearly joy is not what we always experience at work.

Part of the suffering that we undergo in our work worlds is legitimized by a theological worldview that I call the fall/redemption tradition, which teaches that work is the punishment we have inherited from Adam's fall. Theologian Dorothy Soelle calls this the "curse tradition." In this tradition work "is separated from the goodness of

tilling and keeping, from the dignity of co-creating, from the responsibility for the goodness of creation. In the 'curse tradition,' work is punishment."[9] But the two great garden stories in the Hebrew Bible—that of Genesis and that of the Song of Songs—are not about work as curse so much as work as delight. Adam is placed in the garden "to till it and keep it" (Gen. 2:15). And theologian Phyllis Trible comments that "since the garden of Eden is a place of delight, to till and to keep it is to foster pleasure." Respect, reverence, and worship are key to this work of tilling and keeping. Madonna Kolbenschlag comments on the positive theology of work found in the biblical tradition: "The idea of work as a 'command to self-transcendence' is rooted in the Judeo-Christian heritage. Greco-Roman, biblical and medieval sources alike confirm this consciousness."[10] French philosopher Henri Arvon concurs: "Christianity conferred a new value on work.... Human work, *ars humana,* reflects and prolongs the divine creation, *ars divina.*"[11]

Yet all too often, Soelle comments, Christian theology has looked on work as "*only* the result of sin.... Orthodox Christianity has tended to disparage human work as a curse, as irrelevant to our salvation, as lowly in comparison with the magnificent works of the creative God. In the course of Christian history, God's magnificent work in creation has been used to humiliate, to belittle, human beings."[12]

In this setting work does indeed become sinful and part of our alienation from the Earth. When taken out of context, Genesis 3:17 sounds very much like a curse: "Cursed is the ground because of you; in toil you shall eat of it all the days of your life; thorns and thistles it shall bring forth to you." Work, like sexuality, is complex. Through it we can redeem or we can destroy; we can liberate or enslave. Biblical spirituality teaches that the prophetic call for justice applies to work: work itself needs liberation; it needs sanctification; and it needs celebration. This teaching is especially evident in the Song of Songs. There the image of working the vineyard—such a common biblical theme—becomes a metaphor for all our relationships. There an erotic love is celebrated between lover and beloved and lover and her work. As Soelle puts it:

The image of the vineyard in the Song of Solomon stands for erotic pleasure and lovemaking. This image also functions in the Bible as a symbol of peace in the abiding relationship between Israel and its God (Isa. 5:1) and as a symbol of economic justice, looking to the time when the planters shall enjoy the fruit of the vine and the oppressors shall be driven away.[13]

The New Testament upped the ante on the connection between pleasure and work. There the vineyard imagery is enriched in the story of Jesus at the wedding feast at Cana (his first public "sign" or work), in his taking of the cup of wine and blessing it at the Last Supper, and in the resurrection story, where the garden motif returns. Indeed, the Easter story is a third garden story. There the risen Christ is encountered as a gardener. It is not only Jesus who is resurrected but also the garden of Eden and its workers. The work of the empire—in this case the Roman empire that crucified Jesus—is to kill. But the work of the Spirit is to resurrect. All is resurrected, even work itself.

To explore more deeply the missing aspects of work—such as joy—it is useful to call upon the creation tradition. This rich spirituality gives us a map by which we can name and understand our journey. Our culture is bereft of such maps, since inner work has not been a priority for us except in terms of recovery and therapy. We have a fix-it model in our machine culture but no health model (just as we have a fall/redemption model in religion but pay little attention to a health model of spirituality). What does healthy work look like? When is work enchanting? In this chapter we will consider the *via positiva* of work.

Joy and Work

In his television interviews with Bill Moyers, Joseph Campbell popularized the saying "follow your bliss." From the viewpoint of Creation Spirituality, if there is no bliss in our work, no passion or ecstasy, we have not yet found our work. We may have a job, but we do not yet have work.

Thomas Aquinas says that "sheer joy is God's and this demands companionship." What we learn from this is that all of creation exists

because of the "sheer joy" of God. The work of creation was a work of joy whose whole purpose was to bring more joy into existence. This not only gives us permission to find joy in work but charges us with a responsibility to do so. Joy is an essential source of motivation in our work. Meister Eckhart put it this way:

> God is never weary of loving and working. . . . God loves for the sake of love, works for the sake of work, and therefore loves and works uninterruptedly. God's work is God's nature, God's being, God's life, God's happiness.[14]

Studs Terkel spoke with Kay Stipkin, who started a bakery cooperative that has helped reshape her neighborhood. As a result of her labors, many have been reawakened to the joy in their work. She shares her philosophy of work:

> Work is an essential part of being alive. Your work is your identity. It tells you who you are. It's gotten so abstract. People don't work for the sake of working. They're working for a car, a new house, or a vacation. It's not the work itself that's important to them. There's such joy doing work well.[15]

We have a right to and a need for joy in our work. If joy is good enough for God and powerful enough to have been the cause of the universe, then clearly joy is integral to our work too. "There can be no joy in living without joy in work," Aquinas warns us, for clearly much of our living is about our work. There is no creation without some joy. Love draws us to work. Aquinas teaches that work presumes love when he writes, "Virtue always works for good, indeed for good well performed, that is, voluntarily, readily, pleasurably, and firmly—these are the characteristics of virtuous activity, and they cannot be present unless you love what you are aiming at."[16] Love assures us that our work will be voluntary, ready, pleasurable, and firm. In addition, the pleasure we take in work ensures that we do better work.[17] Thus we see that pleasure blesses the work, not just the worker.

Another dimension to pleasure and work is the experience of zeal. Zeal, Aquinas teaches, arises from our experience of beauty and

love, from our undergoing the goodness in things. To undergo the goodness of things, to taste their blessing, is what the *via positiva* is about.

To sustain our work we must experience deep elements of joy and the goodness of things. Let me give some examples. In my work I love to write. Why? I cannot say for sure. I cannot articulate all the reasons; there is too much mystery for me in the act of writing to be able to or even to want to dissect the joy I feel in doing it. I remember the first time I said to myself, "I am a writer. I am a writer because I am happiest when I write." I was twenty-nine years old and living on a Basque farm in southern France, writing my doctoral thesis. Writing delights me because it is a way to learn, and I find learning itself to be an ecstatic experience. Writing allows me to put my thoughts in some kind of order and to communicate them to others, who in turn give birth to new thoughts. What joy there is in such mutual creating! Even in solitude, writing is an ecstatic experience, for by reading thoughts back to myself, a kind of mirror emerges that gives me an understanding of things at a deeper level. When I read what I write, I learn new things from it. Wonder meets wonder and amazes me. All this constitutes the *via positiva* in my work as a writer.

I also experience joy and delight in my work as a teacher. I love watching students grow and watching them watch themselves growing. Their knowledge expands, they articulate their own mystical experience and prophetic struggle more deeply, and they begin to recognize that they are not alone, that other mystics before them have struggled and can offer them assistance by naming the experience. All these experiences give me delight as a teacher. I love students who teach me things—maybe by questions they ask or questions they resolve or experiences they share or arguments they put forward. I define learning as $1+1=3$: my thoughts (as teacher) are added to their thoughts and, in the best situation, new thoughts are born. Learning is thus a creative act. It is healthy and thoroughly renewable, and no one can ever take what we learn from us. I love to watch what students do with their learning, say, one, two, or five years after they leave my classroom. It gives me a sense of history and of taking part in the ongoing stream of wisdom flowing into future generations.

I also love to watch faculty grow and get excited ("blissful" one might say), enthusiastic, and energized by teaching in the model of education we have devised at the Institute in Culture and Creation Spirituality (ICCS). I love to interact with other teachers, working out ideas and solving problems in spirituality and science, spirituality and environment, spirituality and psychology, spirituality and art, or spirituality and politics. I love it when, as happened recently, one of my fellow teachers takes me aside to instruct me. In this case it was a painter insisting that I paint with her. What fun! *Via positiva indeed!*

I also enjoy the lecturing I do. I like speaking to different kinds of audiences—to doctors and hospital workers, therapists, teachers, parents, young people, college students, ministers and priests, artists, and scientists. I love encouraging groups to take the new paradigm into their work worlds and see these worlds as base communities for transforming society and history itself. I love to affirm people in their spiritual journeys—to demonstrate to them that they are indeed creatures with mystical possibilities and prophetic responsibilities. When we sponsored a workshop in the fall of 1992 on renewing forms of worship, I was truly moved by what we accomplished—by the way in which the faculty grew together as a group; by the final ritual that we all created; by the lack of self-consciousness that we were able to generate; by the diversity of backgrounds—religious, professional, age, lifestyle—represented at the event. All this is the *via positiva* in my life, in my work.

I recently met a person who told me that he and his partner decided they were "only going to do work that we love. If that means we make 500 dollars a year, so be it; if it means we make 50,000 dollars a year, so be it." I asked him how it was going. "It's changed our lives," he said. No doubt! Pleasure has a way of changing our lives, and pleasure is what is experienced in the *via positiva*. I have met many, many people over the years who have quit their work because it was no longer providing them with an authentic *via positiva,* because the joy was no longer present. Invariably they learned a much deeper trust of the universe and of themselves by taking the risk of leaving a familiar and often secure work world for an unknown one. Some people confuse security with pleasure, but security is not what

the *via positiva* is about. Ecstasy is not about security; it is about feeling a sense of transcendence, a sense of deep meaning and connectedness in how we spend our time and energy at work. Work deserves to be an ecstasy. Work can be awe inspiring: seeing people come alive in our presence, seeing genuine healing occur between groups, seeing our hands make something useful, participating in gathering the wheat and the food from the harvest all fills us with awe. Beauty and work are not alien to one another; indeed, all our work is meant to be about making beauty in some capacity or other. But where there is awe and beauty there is also terror, just as the universe and its work are both awesome and terrifying. Rilke put it this way:

> . . . For beauty is nothing
> but the beginning of terror, which we still are just able to endure,
> and we are so awed because it serenely disdains
> to annihilate us. Every angel is terrifying.[18]

Awe includes dancing with terror. *It is lack of awe that bores us,* and we ought to fear lack of awe more than we fear terror. Terror is built into awe.

When Studs Terkel interviewed many different people about their work, he too found how basic the *via positiva* was to healthy work. He quotes a Brooklyn firefighter who before becoming a firefighter worked in a bank:

> The firemen, you actually see them produce. You see them put out a fire. You see them come out with babies in their hands. You see them give mouth-to-mouth, when a guy's dying. You can't get around that shit. That's real. To me, that's what I want to be. I worked in a bank. You know, it's just paper. It's not real. Nine to five and it's shit. You're lookin' at numbers. But I can look back and say, "I helped put out a fire. I helped save somebody." It shows something I did on this earth.[19]

When this worker can say, "That's what I want to be," he is naming a dream, a vocation, a mysterious calling that gives him ecstasy. When we find ecstasy in work we find also the strength to endure the struggle in work. The work of the firefighter is not easy, but notice that his *via positiva* includes a resurrection experience as well: want-

ing to "show something I did on this earth" is like the artist who, as Otto Rank said, wants to leave behind a gift. It is also like Aquinas's connecting work to *display*. This fireman wants to leave something behind; he wants to display some of his passion, passion for what is "real." He has found the underlying love of his work. He has found some *via positiva* in being a firefighter. My guess is that he is probably a very good one.

Our work is meant to be a grace. It is a blessing and a gift, even a surprise and an act of unconditional love, toward the community—and not just the present community that may or may not compensate us for our work, but the community to come, the generations that follow our work. Such important issues are raised by paying attention to the grace, or lack thereof, caused by our work. I remember doing a ritual on the sacredness of the body with a biophysicist. She showed images of our internal organs and explained with each image how that organ served us. After she had presented the lung, for example, the group bowed to the lung and chanted a thank-you in Latin to the lung and its Maker. We did this for twenty-six organs of the body. When we finished there was a deep silence in the room. I invited responses, and a man stood up and spoke: "I have been a doctor for twenty-five years. This is the first time in my life that I have experienced the sacredness of the body. You must take this ritual to every medical school in the country, telling the young people that *this* is why one becomes a doctor."

Notice the logic here. A veteran in his profession was suggesting that were we to rediscover the sacredness of the body, our medical profession could become less competitive, less greedy, and less expensive. The key is beginning with the sense of joy and sacredness. If all of us, beginning with health care workers, paid attention to the *via positiva* in our work, might we devise some imaginative ways of providing medical support for all our citizens?

After this same ritual a woman stood up and said, "I have been a drug addict and an alcoholic, and if anyone had led me through this ritual when I was young, I never would have abused my body." Ritual is indeed about reawakening the sacred in the most ordinary things of life: finding the extraordinary in the ordinary and the

ordinary in the extraordinary. We all have bodies in common. Perhaps if we had more rituals to *honor* our bodies and to make us aware of our holy insides, we would abuse them less. And thus we would abuse ourselves and one another less.

Our work is meant to be a gift, a grace, a blessing. But we need to meditate often on whether this is so, how it is so, and how, as our work and work worlds evolve, we can struggle to make them more graceful. In this meditation we touch the depths of our work, its deeper spiritual significance and how it contributes to our delight at living and being. When we touch our own delight we can then be instruments of delight for others as well. Then our work is truly "enchantment," as Meister Eckhart puts it. We are fellow enchanters in this world. Our work sings its song to the hearts of others. It elicits a response, and in this response a new work is born. The singing of the universal work goes on, and we contribute to it as well as receive it. In this mutual response we are uplifted in our work. Indeed, community is born of such work, for community is essentially what its etymological meaning suggests: a shared task based on a common vision expressed and undertaken in our work. If there is only one work in the universe, then we are *already* a single community—provided we are all about the Great Work in some fashion.

The sense of responsibility that arises from work and our response to it is deeper than duty or guilt. This deeper sense of responsibility is a response of *gratitude* born from awe and wonder. The wonder of our work, of our being able to contribute to the work of the universe, fills us with gratitude and can arouse gratitude in others. Consider, for example, the work of our parents. Perhaps they are retired or deceased now. We can still reflect with enchantment on how wonderful it was to smell the aroma of freshly baking cookies in the kitchen or freshly cut grass in the yard; or to feel the warmth on a cold winter morning when one of them went downstairs to stoke the fire in the furnace; or to enjoy the food around the dinner table. In short, we carry the fruits of the labor of previous generations with us in our memories but, more deeply, in our very genes and DNA. The work of our ancestors blesses us, graces us, and fills us with gratitude. We can

do the same for subsequent generations because we have been shown the way—the way of holy work, the way of work as *via positiva*.

When work moved from farm to city, from land to concrete, from hands to machine—in short, when the industrial revolution redefined the meaning of work for us—much was lost. Perhaps the greatest loss was the sense of cosmic wonder, of interrelationship with the universe, with nature, with the stars and breezes and plants and animals, that was integral to workers on the land. As a farmer once told me, "Every small farmer is a mystic." What was lost was the mysticism of the *via positiva,* and no paycheck can make up for that loss; no consumer orgy, no infinite number of trips to the shopping mall can make up for the loss. The poet Rilke puts it powerfully:

> All we have gained the machine threatens, as long
> as it dares to exist in the mind and not in obedience.

When I read these lines, I am reminded of Jesus' saying that the Sabbath exists for people and not people for the Sabbath. Rilke is saying that machines and technology exist for others "in obedience" and ought not to take over our minds, for we do not exist for machines. Our technology must be subject to a greater vision. Rilke continues:

> Nowhere does it stay behind; we cannot escape it at last
> as it rules, self-guided, self-oiled, from its silent factory.
> It thinks it is life: thinks it does everything best,
> though with equal determination it can create or destroy.

> But still, existence for us is a miracle; in a hundred
> places it is still the source. A playing of absolute
> forces that no one can touch who has not knelt down in wonder.[20]

Wisely does Rilke point out that the only solution to the idolatry of the machine, which "thinks it is life" and imagines that it alone knows how to work best, is the recovery of wonder and the reverence that experiencing wonder instills in us, the need to kneel down in its presence. Wonder comes ultimately from the gift of existence itself— the primary miracle and the source of all else that is wonderful. A

return to the *via positiva* is required if we are to recover our minds, which themselves have been overrun by the machine—*and* if we are to recover our reverence for being, which is "more glorious" than that of machines. There is of course something gratuitous, unconditional, gracelike about being. The farmer knows this or at least learns it, as Rilke observes:

> In spite of all the farmer's work and worry,
> he can't reach down to where the seed is slowly
> transmuted into summer. The earth *bestows*.[21]

The earth *bestows* the gift of ripened seeds and successful work onto the farmer's efforts. The *via positiva* is in many respects a way of non-action rather than action. All work is meant to be of that kind—a kind of *bestowal,* a grace, a gratuitous fit of our gifts to others' needs and their gifts to our needs. Such is the interconnection that work signifies. We are free to ignore this sense of bestowal, to dismiss it, or to deny it. Yet it forms the basis of all our action, all our good work, and we ignore it at our peril. The Bhagavad Gita celebrates this same connection between work and joy, work and reverence, when it says,

> They all attain perfection when they find joy in their work. Hear how
> a person attains perfection and finds joy in [their] work. A person
> attains perfection when [their] work is worship of God, from whom
> all things come and who is in all.[22]

If all things come from God, then even work has God as its source. Perhaps especially our work comes from God.

Work As Call, Vocation, or Role

Here we come face-to-face with the mystery of *vocation,* or calling. Somehow the universe, the Maker of the universe, the Source of existence, calls us to be participants, at the level of our being, in the work of the universe. If we respond, the universe will also, as Goethe comments:

> Concerning all acts of initiative (and creation) there is one elementary
> truth, the ignorance of which kills countless ideas and splendid plans:

that the moment one definitely commits oneself, then Providence moves too. All sorts of things occur to help one that would never otherwise have occurred. A whole stream of events issues from the decision, raising in one's favor all manner of unforeseen incidents and meetings and material assistance, which no [human] could have dreamed would have come his way.[23]

The call must be heard with an open heart. If we are being called, who is doing the calling? Thomas Aquinas teaches that Providence itself, the governing principle of the universe, allocates our various vocations to work. Our vocations are part of the ordering principle of wisdom in the universe. He writes,

> Since many things are needed for the human being's life, for which one person could not suffice of himself, it is necessary for different jobs to be done by different people. For some should be farmers, some have care of animals, some are builders, and so on for other tasks. . . . Now, *this division of various tasks among different persons is done by divine providence, inasmuch as some people are more inclined to one kind of work than to another.*[24]

Notice how Aquinas indicates we find our calling: by our natural inclinations, by that which we enjoy doing, are equipped to do, and feel joy in doing. Recently, I met a thirty-three-year-old man who gave up a 60,000-dollar-a-year job and a comfortable lifestyle simply because his work did not reach his heart. He went on a kind of pilgrimage, which brought him to where he now lives in a spiritual community and teaches healing through the process of rebirthing. Though he was immensely successful at his previous work he felt called *to a deeper work in spirituality, and though that meant two years of poverty and exile he is now "overjoyed" in the work he does.*

In our time, we workers are being called to reexamine our work: how we do it; whom it is helping or hurting; what it is we do; and what we *might be doing* if we were to let go of our present work and follow a deeper call. We should meditate deeply on Aquinas's theology, learning that it is *Providence itself* that is calling us to deeper work. I meet many people today who are indeed letting go of their work (as well as their jobs) to find new work, a work in the New Creation.

Nora Watson, a staff writer for a health magazine, comments, "I think most of us are looking for a calling, not a job. Most of us, like the assembly line worker, have jobs that are too small for our spirit. Jobs are not big enough for people."[25] The Bhagavad Gita underscores the importance of call or vocation when it teaches, "Greater is thine own work, even if this be humble, than the work of another, even if this be great. When a person does the work God gives [her], no sin can touch this person."[26]

The importance of responding to our vocation as workers is underscored by Paul when he says that truly the only sin in life is our refusal to do the work we have been called to do. Biblical scholar Krister Stendhal makes the point that what Western religion has called Paul's "conversion" on the road to Damascus was not really a conversion so much as a call to a new assignment, a new work.

> Rather than being "converted," Paul was called to the specific task—made clear to him by his experience of the risen Lord—of apostleship to the Gentiles. . . . In Galatians Paul describes his experience in terms of a prophetic call similar to that of Isaiah and Jeremiah. He felt hand-picked by God after the prophetic model to take the message of God and Christ to the Gentiles. . . . Again, we find that there is hardly a thought of Paul's which is not tied up with his mission, with his work. The "I" in his writings is not "the Christian" but "the Apostle to the Gentiles." That is why I say call rather than conversion.[27]

Is the prophetic call that Paul experienced not what we too experience in our work? As Rabbi Heschel says, there lies in all of us a prophet. If spirituality means to live our lives as mystics *and* prophets, then we need to pay attention to the prophetic call that we all receive. This means to live our lives as mystics *and as responders to a call.* Thus Isaiah writes about his vocation: "The Lord called me from the womb, from the body of my mother he named my name. . . . I will give you as a light to the nations, that my salvation may reach to the ends of the earth" (Isa. 49:1). And Jeremiah says, "Before I formed you in the womb I knew you, and before you were born I consecrated you; I appointed you a prophet to the nations" (Jer. 1:5).

To respond to the call is to obey. This act of obedience—this listening with an open heart and responding responsibly—is an eschatological sign. It is a sacrament in the literal sense of that word: our work is a sacrament; our vocation is a sacrament; the changing of our vocation under the influence of the Holy Spirit is a sacrament. It is a mystery, a silent mystery that calls us from some deep and uncontrollable place to take risks, to let go, perhaps to change lifestyles. Why? Because of the future or, better, the jeopardy of the future, the very real possibility of there being no future. The eschatological is by definition our response to the future. The ecological crisis today suggests to many observers that there is no future for our species on this planet and no future for the planet so long as our species refuses to change its ways. But this is where vocation enters—a voice from the future calling persons to believe in a future. A voice from the young and the yet-to-be-born asking adults to change their ways and therefore to start living as if there were a future. Belief is not primarily about dogmas but about action. If we believe in a future, we will act like it; and included in this activity may well be a whole new way of working in our world, our relationships, our professions, and our churches and synagogues.

Thomas Berry makes the point that people today are looking in work for *a role*. This is an important observation. A role may be a less individualistic and a more cosmic way of envisioning our work in the world. Webster's Dictionary talks of the "functional relationships" implicit in the word *role*. Our quest for roles to play in the world is a quest for relationships. Work as role fits a postmachine cosmology very well. Questions we might ask of our work then are the following: What role does my work have me play in the Great Work and in the work of my community and my species at this time in history? What role am I equipped to play? What role most attracts me? A role is like a process; it evolves; it stretches and reaches and alters. We play roles; we do not just fit into boxes called our work worlds. A role has a sense of play to it but also a sense of seriousness: it implies destiny and provident wisdom in a greater view of things. It implies participation in a drama; as we have seen, the origin of the word *role* is the

Old French *rolle,* which referred to the roll of parchment on which an actor's part was written. Drama is the news of an unfolding creation story. Everyone has a *role to play* in that drama, and that role *is* our work.

It is also telling that the parent to the French word for *role* is the Latin *rota,* which means wheel. Again, a cosmic role is implied: our playing on the cosmic mandala or sacred wheel constitutes our work. As the Bhagavad Gita puts it, "All actions take place in time by the interweaving of the forces of Nature; but the person lost in selfish delusion thinks that he himself is the actor."[28] The drama is larger than we imagine. We are not solitary actors in it. Our roles are cosmic roles in a cosmic drama. Our work is a cosmic work.

It is a great joy to be able to play a role in a cosmic drama. It is an exercise in enchantment—a *via positiva* experience indeed! Our work can be cosmic roles in a time of an emerging cosmological awareness. But the roles we are asked to play today must begin not with *acting* but with *being.* Work as being needs to precede work as action. Meister Eckhart supports us in this shift of awareness; he says that when he returns to the godhead from which he came no one will ask him what he has been doing because no one will have missed him there, where unity is so perfect. We will not be judged on our work so much as on our being. "Think more about who you are and less about what you do," he counsels, "for if you are just your ways will be just." The invitation to move from doing to being is one of the powerful contributions of a spirituality of work. To look at our work from the point of view of our *being* gives a new context to our entire discussion of work; it gives us the imaginative freedom to start over in our assessment of work and nonwork. We can see work differently. What does our work do to our being? What does it do to other people's beings? And to other species' beings? What demands are other beings making on our work; what are rain forests and whales and birds asking of us today about our work? What kind of work are the children to come asking us to perform today? What kind of work does my deepest being desire to do?

Work, Death, Eschatology, and Resurrection

Work is about the future. Therefore it is about fulfilling dreams, achieving promises, and entering into mysteries greater than ourselves and greater than our own work. This makes work eschatological. Good work is about hope. It brings hope and awakens others to hope. Work also challenges our sense of hope by putting us in touch with our sense of despair; it touches a sense of the "last things." Death is mysteriously connected to work. It is a sad thing to hear someone say at the death of another, "His or her work was unfinished." It is a blessed thing to be able to say, "His or her work was finished." Interestingly, Jesus on the cross is reported to have said, "*Consummatum est,*" or "It is finished." His work was complete, although by all human standards it appeared incomplete and unfinished. There is something haunting in the implication that somehow death interrupts our work or appears to do so.

Work and life are so deeply meshed with one another that when one ends the other comes to an end also. Thomas Aquinas wrote that "when we delight in our work and the whole life of a person is ordered to it, then it is called our life."[29] Yes, our work is often our life: the artist's work, for example, is often the artist's life. Our passion for living can be our passion for working and vice versa, as if we have only one passion. As mentioned, Otto Rank defined creative work as the desire "to leave behind a gift." Leaving behind implies a leave-taking. One reason we work is because we will one day leave this life.

Work and death go together not only because work ends when this life ends, but more profoundly because our work is ultimately an eschatological act. Studs Terkel, commenting on the workers he interviewed for his book *Working,* writes, "Perhaps immortality, too, is part of the quest. To be remembered was the wish, spoken or unspoken, of the heroes and heroines of this book."[30] Terkel names for us another connection between work and death: the issue of immortality, of having made a difference in this world, of wanting to be remembered, which is also about resurrection.

Work is an expression of our hope, of our belief in the blessing of life. Why else leave a gift behind? Why not instead leave problems or bills behind (which is in fact what our culture is currently doing to its children and grandchildren)? Leaving a gift behind implies *gratitude,* and gratitude is ultimately what our work is about. All authentic work is a thank-you for being in the cosmos, our home, where so much work is taking place. As Meister Eckhart says, "Becoming fruitful as a result of a gift is the only gratitude for the gift."[31] Our work is a thank-you for being participants in work—the cosmos's work, our species' work, our own work, God's work. As a young man lost and then found in the Temple (and the Temple stands for the universe), Jesus said, "I must be about my Father's business." Our coming of age consists in coming to understand our connection to our "Father's" business, that is, to the creating of the universe.

Thus work is decidedly *not* a human invention as such. It is a cosmic activity, indeed *the* cosmic activity. There is only one work in the cosmos, only one Word or *Dabar* or creative energy: that one work is God's work. Humans are invited to participate in the cosmic work. As a species endowed with the freedom to make choices, we can opt out of this work and settle either for an exclusively anthropocentric work or for nonwork or unemployment. If work is a mystery, then our hearts must listen for our call to work.

The surprising and therefore transcendent element in our work is that we never really know when it is finished or indeed whom or what it affects. Why was Jesus able to say his work was finished? What was his work? Why did it get him into so much trouble? Did it kill him? If so, was it worth it? When is work bigger than death? What about Martin Luther King, Jr.'s work—is it bigger than death also? Rumi, the great Sufi mystic and poet, wrote a poem about resurrection day and work:

> On Resurrection Day
> God will say,
> "What did you do
> with the strength and the energy
> that your food gave you

on Earth?
How did you use your eyes?
What did you make with your five senses
while they were dimming and playing out?
I gave you hands and feet as tools
for preparing the ground for planting.
Did you, in the health I gave,
do the plowing?"
You will not be able to stand
when you hear those questions.
You will bend double with shame,
and finally acknowledge the glory.

.

Then you will turn to the right looking to the prophets
for help, as though to say,
I am stuck in the mud of my life.
Help me out of this!

And they will answer,
those kings,
"The time for helping is past.
The plow stands there in the field.
You should have used it."
Then you will turn to the left,
where your family is,
and they will say,
"Don't look at us!
This conversation is between you
and your creator!"[32]

This poem sounds suspiciously like the parable of Jesus con-
demning the one who buried his single talent and praising those who
multiplied by good use their multiple talents (Matt. 25:14–30).

Eschatology is about hope. Work is meant to be about hope.
When are we happier than when our work is a joy to us and others?
At this time in history, with the dawning of a new millennium, we
are at a crisis of eschatology. Signs are everywhere in our society—

despair, pessimism, and inertia—which all counter the hope that a living eschatology brings. They are the denial and refusal to look at the shadow side of culture and of soul.

Work is about eschatology both because it is about death or the "last things" and because it is about life or what we believe about life in the future (including after we are gone). From this point of view, work is indeed about what we leave behind. It challenges us to consider whether or not we want to leave behind a gift.

Those without work are excluded from the eschatological adventure with the greater community. This leads to self-hatred and violence, for there swims in every human's soul intimations of gift giving as well as intimations of the finiteness of our presence on Earth. In short, we all dream dreams of good work. When the eschatological is allowed no space in which to expand, no heart-place in which vocation can be attended to, then violence readily sets in. Violence bears signs of the eschatological—of being something greater than ourselves. It includes the cosmic forces known as Powers and Principalities. Violence might be called a pseudo-eschatology whose presence is exaggerated in a historical period like ours wherein hope is so rare and pessimism reigns.

Eschatology—believing in a future that is life giving—is not only about death. It is also about play. For in reality, none of us knows what the future holds. So we can choose to imagine it either in nihilistic terms (if we do this, all work stops) or as a playground of possibilities for our species and our loved ones (if we do this, creativity can begin anew and with it unpredictable discoveries of work and work making). Indeed, when fantasy and playfulness return to our sense of eschatology—and therefore our sense of work—the Spirit, the gift of surprise, of the transcendent, returns.

"Praise," says African spiritual teacher Onye Onyemaechi, "takes all of you. Give it all away. Hold nothing back." When we give our work away as praise, it returns; it returns as Spirit, as strength, as comforter, as hope. When we understand this, we understand the connection between work and resurrection. Work itself can be a difficult and ascetic spiritual discipline (*ascecis*), a sweat-of-the-brow ex-

perience, an incursion into the *via negativa,* and a hint of the shadows that accompany death itself. But it can also be a *via creativa*—indeed all cosmic work is of this kind—and then work becomes an eschatological story of hope and new life.

Play, surprise, the Spirit: these are eschatological elements of work. Any work lacking these elements is neither truly human work nor true work in the universe. Who could have predicted the making of the eye by the universe? the invention of water on this planet when it was only rock? the emergence of life? The work of the universe is permeated by surprise. Our work must be of the same sort. It can be surprising to the extent that we truly live in the universe, that is, in God's temple and not just in the "manmade" worlds of what Eckhart called the "merchant mentality."

If God is, as Aquinas puts it, "Life, *per se* Life," then those who want to respond to God have no choice but to choose life. "I put before you life and death. Choose life" (Deut. 30:15). But to choose life is to opt for a future for our planet, for our children and theirs, for all the species that render this planet so amazing and so beautiful. It is an eschatological choice, an act of hope. It is a response to the call to choose life from the One who is "Life, *per se* Life." Any work that operates out of a source other than a life source is less than divine; it is not the cosmos's work. It is the way of pessimism, not that of New Creation. It expresses a belief in death, not in the power of resurrection.

Conclusion: No Other Work in View

The grounding of our work in the *via positiva,* in the joy of being, the joy of living, and the joy of working, is an essential part of revisioning work. It constitutes a return to our origins and therefore assures a connection between our work and the work of the universe—a work that is not indifferent to joy but in fact flows from the "sheer joy" of the Creator, as Aquinas puts it. Joyful work puts us in touch with what Eckhart calls "every angel with his whole joy and his whole bliss inside me and the God's very self with all of its bliss" that is also inside us. Perhaps the sixteenth-century Spanish mystic John of the

Cross captured this in his poem "The Spiritual Canticle" when he wrote that a lover is willing to sacrifice all for some good work—indeed, for the *only* work of the universe:

Forever at his door
I gave my heart and soul. My fortune too.
I've no flock any more,
no other work in view.
My occupation: love. It's all I do.[33]

4 | Creativity: Where Inner and Outer Work Merge

> But when can *we* be real? When does [God] pour
> the earth, the stars, into us?
>
> RAINER MARIA RILKE[1]

> Through good works one puts forth the image of the heavenly
> person in themselves.
>
> THOMAS AQUINAS[2]

> The Tao is called the Great Mother:
> empty yet inexhaustible,
> it gives birth to infinite worlds.
>
> It is always present within you.
> You can use it any way you want.
>
> TAO TE CHING[3]

> Fundamentally, we work to create, and only incidentally
> do we work to eat.
>
> WILLIS HARMAN AND JOHN HORMANN[4]

The poet Rilke asks the question "When can *we* be real?" I propose that we are *on the way* to being real when we pay attention to non-action, that is to the *via positiva* (awe) and the *via negativa* (darkness) in our lives. But we don't actually *become* real until we abandon ourselves

to creativity, until the Spirit that made the heavens and the Earth can flow through us and effect its New Creation through us. We become real when our work joins the Great Work. We become real when our inner work becomes work in the world; when our creativity, born of deep attention to both enchantment and nothingness, serves the cause of transformation, healing, and celebrating. In other words, we become real when our work becomes compassion expressed in creative ways that surprise and that effect change. This can only happen to the extent that we act out of non-action. That is when the Divine "pours the earth, the stars, into us."

Cosmology and Creativity

Rilke's question, "When does God pour the earth, the stars, into us?" is a striking way of putting the issue of work and creativity: the issue is one of our becoming real. It is when our creativity has an opportunity to manifest itself in our work that we do indeed become real. Rilke notes that our becoming real is tantamount to our undergoing the holy experience of the earth and stars "poured into us." But this is precisely what happens in creativity. The birthing energy of a constantly birthing cosmos, the fire energy of the original fireball, the sun energy of the process of photosynthesis, the expansion energy of our expanding universe all work in us when we too give birth.

In Rilke's image of the Earth and stars pouring into us we are struck by the need for a renewed relationship between cosmology and work. If first the Earth and stars are poured into us, does it follow that the Earth and stars are also poured into our work? And perhaps even *from* our work? If this cosmology were true, could work ever be boring again? Could life ever be boring again? Would there ever be unemployment again? Would anyone be "out of work"?

Meister Eckhart says, "Announce the word, pronounce it, produce it and give birth to it."[5] We exist not just to receive in non-action but to give back actively from what we have received. What we give birth to is nothing less than "the word," that is, the Logos, the Wisdom of the universe's one work, of which we are an integral part.

Each of us comes into the world with a unique history, a unique pattern of DNA, and therefore a unique way of viewing the world *and* of uttering what we see. And we do see things differently. If the proverbial story of the blind men naming an elephant each from his own perspective is valid, how much more so would all men and women attempting to name being, to name the glory of existence, to name our story in the universe. Our creativity is not a cute thing for weekend dabblers in the arts; it lies at the essence of who we are. We are all creators, and therefore we all have work—good work—awaiting us.

There is a natural progression from the *via positiva* and the *via negativa* to the *via creativa* in our work. Our inner work of enchantment awakens our passion and energy for work, for response, for saying yes. Our inner work of nothingness and grief awakens our awareness of how much work needs to be done, of how many beings are suffering because we are not working wisely. When these two experiences come together in our work of creativity, we are led into the Great Work.

Creativity is the link between our inner work and the outer work that society requires of us. Creativity is the threshold through which our non-action leads to actions of beautification, celebration, and healing in the world. Creativity is both an inner work *and* an outer work.

Creativity is sometimes difficult to discern in our work. Our society does not often reward creative work. During the machine era our loss of a heart connection to the cosmos was a blow to our creative imaginations, as Rilke points out:

> The New, my friends, is not a matter of
> letting machines force out our handiwork.
> Don't be confused by change; soon those who have
> praised the "New" will realize their mistake.
>
> For look, the Whole is infinitely newer
> than a cable or a high apartment house.
> The stars keep blazing with an ancient fire,
> and all more recent fires will fade out.[6]

Notice the poet's respect for the cosmos here and how it encourages our handiwork. He senses the truth of what we considered in chapter 2—that the whole is the deeper source for our work. For him it is clear that our creativity and handiwork are related more to the whole that is always new and to the stars blazing with their "ancient fire" than to mere machinery. An era of anthropocentrism has distorted work. It is the more ancient fire—fire from the heavens and our relationship to the heavens—that will inspire our work, setting us and it ablaze.

During the era of the industrial revolution, creativity was marginalized and often considered suspect. It still is. Recently I heard that the New York public school system has eliminated art classes from its curriculum because of budget cuts. The notion that art is a luxury item to the minds and spirits of children—that it can be dropped like a sugary dessert from our diets—contradicts the laws or habits of the universe as we now know them: the universe is intrinsically creative, always begetting, always birthing, always doing new things. What a pity that our human-devised work worlds, including that preparation for work that we call education, have yet to realize the *intrinsic value of creativity.*

Creativity does not need to be justified by its product, though marvelous products are indeed birthed by it. Creativity is its own reward, its own work. Therefore it deserves to be called a "grace" and not a work. In creativity, as in undergoing the *via positiva* and the *via negativa,* we learn anew what it means to "work without a why," as Eckhart puts it. God "works for the sake of working," and it is when we work for the sake of working that we know we are involved in creative work; our creativity smiles on us and extends to us its own illumination and reward. Eckhart ends one of his most amazing sermons with the statement that he does not care if anyone understood him or not; he would have preached the sermon to the offering box if there had been no one in church. This is the confession of an artist who feels compelled to share his inner truth no matter what the consequences. Such work is clearly work "without a why."

Without opportunities for expressing their creativity, people are unlikely to ever find happiness in their work. In their book *Creative*

Work, Willis Harman and John Hormann discuss the importance of creativity and work.

> All of history supports the observation that the desire to create is a fundamental urge in humankind. *Fundamentally, we work to create, and only incidentally do we work to eat.* That creativity may be in relationships, communication, service, art, or useful products. It comes close to being the central meaning of our lives.[7]

We are all images of God, images of the Creator *par excellence,* images of the Artist of artists, the Source of all creativity in the universe. To deny that image in us is to deny our deepest rewards from work. It is to reduce work itself to machinelike activity. It is to reduce human beings to machines. This is the model of humanity that we have been operating under for the last three hundred years or so— the idea that our minds as well as our bodies are not creative organisms but machines.

The *via creativa* puts the lie to all that. It teaches us that work is indeed our way of creating, of birthing our deepest images. Our deepest contribution to the community lies in that to which we give birth. Along with its antimystical bias, the machine-dominated civilization has denigrated the value of creativity. We valued only what could be done by the eyes—quantifying and reading and writing. But we undervalued the things the heart can know and do, including the work of creativity that emerges from the heart's experiences of both awe and ecstasy, grief and nothingness. Rilke names the work we must attend to now:

> Work of the eyes is done, now
> go and do heart-work
> on all the images imprisoned within you; for you
> overpowered them: but even now you don't know them.
> Learn, inner man, to look on your inner woman,
> the one attained from a thousand
> natures, the merely attained but
> not yet beloved form.[8]

Rilke is talking of work in this passage, a new kind of work that awaits us and is demanded of us. This is the "heart-work" of releasing

all the imprisoned images within us, images that, because we were repressing them, we never really knew. The images of the machine era were not those of mutuality but of control and dualism. Within the inner man, Rilke counsels us, there can be found an inner woman (and within the inner woman, an inner man) and no doubt thousands of other mysteries as well. In our deepest selves even the sexual stereotypes are rearranged. We need to pay attention to our inner worlds; there lies our work for the future. To pay attention to our inner worlds means to honor our grief and our joy, our *via negativa* and our *via positiva* experiences. "Nowhere, Beloved, will world be but within us," Rilke observes.[9]

When we manifest the inner work we are truly working. Our imaginations are well constructed for this purpose. We take in a problem or concern from the world around us and we ponder it, we live with it, we "turn it over in our heart," as Mary was said to have done, we sleep on it, and we dream about it. Eventually, if we are lucky, we respond to it. Something is born of the problem we have faced, ingested, and wrestled with. The outer work becomes an inner work for a while and then moves out into the world again to contribute its share of healing and truth. Otto Rank names the experience of the creative person when he notes that "the highest type of artist is [the one] who can use the typical conflict of humanity within [oneself] to produce collective values, which, though akin to the traditional in form and content—because in principle they spring from the same conflict—are yet individual, and new creations of these collective values, in that they present the personal ideology of the artist who is the representative of his age."[10] In other words, as representatives of the age in which we live, if we are living with our hearts and minds open, we will indeed take in the struggle and conflict of our times. Our creativity will do its best to wrestle with those conflicts so as to produce some kind of resolution or hope.

According to Rank's analysis, the work of the artist "reveals his struggles in love and life, which in the productive type spring from the impulse to create, and not vice versa. This conflict arises from an intensification in him of the general human dualism," which is the struggle between living and working. We are all, it seems to me, expe-

riencing an intensified struggle around the human condition. But the conflict need not be a negative thing; indeed, it is part of the journey to creative work; it is part of the journey of the *via negativa.* "Only through his inner conflict, the artist gains the courage, the vigour, and the foresight to grasp the impending change of attitude before others do so, to feel it more intensely, and to shape it formally."[11]

We take an inner issue—one that comes by listening to our own images—and work on it, constructing a form for it, squeezing it, shaking it, pruning it, coloring it, and dreaming on it, and then we offer our work to the community at large. It is our inner work becoming an outer work that, we hope, strikes a chord with the community. This is the work of the artist. It is the work of each of us.

We can do this imaging again; not only that, we must do it, for the machine world that we are now leaving behind has nearly robbed us of our imaginative powers. Even television, one of its most provocative inventions, has rendered our imaginations less fertile and our creativity less evident. We have become increasingly passive before machinelike entertainment monsters. Rilke cautions us about the price we have paid for this state of affairs and how the New Creation can only begin from within us.

> Nowhere, Beloved, will world be but within us. Our life
> passes in transformation. And the external
> shrinks into less and less.
>
>
>
> Temples are no longer known. It is we who secretly save up
> these extravagances of the heart. Where one of them survives,
> a Thing that was formerly prayed to, worshipped, knelt before—
> just as it is, it passes into the invisible world.
> Many no longer perceive it, yet miss the chance
> to build it *inside* themselves now, with pillars and statues:
> greater.[12]

Rilke finds hope in our powers of creativity; we are able to build inside ourselves temples, "extravagances of the heart," that are greater than the external temples we still visit as museums. Rilke advises us not to underestimate our powers of imagination. We build what we want there—temples or Titan missiles; extravagances of the

heart or extravagances of our greed and fear. We ought not to miss the opportunity to birth what we can of greatness, to join our creative work to the Great Work of the universe. Chartres cathedral, after all, first existed as an "extravagance of the heart" in the human imagination.

In the *via creativa* we often realize for the first time that our life is our work, that the "call" we spoke of in chapter 3 is a call to our deepest self to come forward; it is a call akin to Jesus' calling Lazarus to walk out of the tomb and have his bandages removed for all the world to marvel at existence restored, life resurrected. Otto Rank comments that, for the artist,

> [one's] calling is not a means of livelihood, but life itself. . . . The artist does not practice his calling but *is* it. . . . The artist needs his calling for his spiritual existence.[13]

We all need our calling for our spiritual existence; we need work that is more than a livelihood, that is life itself. As Thomas Aquinas observed, "to live well is to work well, or display a good activity." Living and working go together, and our work is about *displaying* the beautiful, displaying our being, displaying our truth, displaying life, and therefore displaying God, the life giver.

Aquinas anticipates our discussion of work as non-action and action when he says that "work is of two kinds—exterior and interior," and "the interior act of the intellect is to consider truth."[14] *What Aquinas calls our "interior" work is the work of the* via positiva *and* via negativa—paying attention to the inner truth of what we experience. We consider truth through "the interior act of the intellect." This is work—especially in our time when so many images and messages come to us from the outside, from television and radio, from newspapers and magazines. *One needs to be still and be true to one's own experience.* This is the "interior act of the intellect," the non-action of the *via positiva* and the *via negativa*. And here lies the power of creativity and art as meditation, for we *listen to the truth of our experience* and then utter it in simple symbols and expressions. By doing so we carry on the work of our truth, putting it into form, articulating it for others to behold and to criticize.

Creativity As Revelation

All creativity is revelation. "The purpose of a word is to reveal," Eckhart tells us.[15] There seems to be, within the heart of every person, a desire to be a source oneself of the revelation we have received; we want to be revealers, breakers of the news. We want to tell the story, the divine story, the story bigger than ourselves that we have been graced to breathe in even if for "a barely measurable time between two moments"[16] when we were granted a sense of being. At such privileged moments, or epiphanies, we feel every connection made in the universe; the Lakota people pray for "all our relations." At such times we come alive, fully alive, so fully inspirited that our "veins flow with being." But even the holiest of stories cannot be told—cannot become our work—until it has been worked on within us. "Even the most visible happiness can't reveal itself to us until we transform it, within."[17]

This passion to become part of the revelatory history of the universe was intuited by Aquinas, who observed that "revelation comes in two volumes: the Bible and nature."[18] Consequently,

> One has every right to call God's creatures God's *words,* for they express the divine mind just as effects manifest their cause.... Each creature is made as a witness to God.... Each creature's beauty is a witness to the divine wisdom.[19]

Meister Eckhart echoed that notion with his statement that "every creature is full of God and is a book about God." *We* are nature; *we* are volumes of revelation and books about God. Part of the passion that urges us to create, to display, to tell our story, is the passion of divine revelation itself. Divinity is seeking to be revealed everywhere. "Every creature is doing its best to express God,"[20] says Meister Eckhart. Revelation is not restricted to books or to the past; the Spirit blows where it will. Our work, when it is truly born from our inner work, will be another chapter, even another Bible, in the history of the sacred literature of our species. Like the prophets in the Bible our work will "uproot and plant"; it will liberate and challenge; it will offer rest and authentic peace. We, because we are nature

and to the extent that we live out our authentic nature, are indeed one of the "volumes" of revelation. Like any book we need to be opened up, to be read, to be grasped, to be known. Our work is such an opening up, such a revelation.

Co-creation and the Spirit

We can begin to feel now why Studs Terkel says, "Our jobs are too small." The vast reductionism that the machine worldview thrust on us has extracted a heavy toll. If our work is small it is not revelatory; it contains no mystery, no deep passion coming from an unnameable source, no wisdom, no real truth. It is drudgery without meaning; it is sweat without purpose; it is duty without play; it is toil alone that bears no fruit. It lacks newness, energy, and hope for the future. It is not eschatological; it is not adventure; it is not bigger than we are, calling us to expand as the universe is expanding. When our work is small it can never satisfy souls that yearn for the vast vortexes of the divine, that derive new life from the wild works of life, new truth from the sacred wilderness of our experiences. When our work is too small it lacks Spirit. As Eckhart puts it,

> Consider the divine spirit in the human soul.
> This spirit is not easily satisfied.
> It storms the firmament
> and scales the heavens
> trying to reach the Spirit that drives the heavens.
> Because of this energy
> everything in the world grows green,
> flourishes,
> and bursts into leaf.
> But the spirit is never satisfied.
> It presses on
> deeper and deeper into the vortex
> further and further into the whirlpool,
> the primary source
> in which the spirit has its origin.
>
>

This spirit seeks to be
broken through by God.
God leads this spirit
into a desert
into the wilderness and solitude of the divinity
where God is pure unity
and where God gushes up within the Godhead.[21]

Our work deserves to go beyond the tame and out into the wilderness. This is another way of saying that we must include the Spirit in our work. Spirit does not like safe and cozy harbors. It is known to "storm the firmament and scale the heavens," to reach for that which moves the heavens, to "press on deeper and deeper into the vortex" in search of its origin. Spirit seeks to be broken through by God, who can lead it from desert to the solitude where God "gushes up within the Godhead." Clearly, Spirit, like beauty, brings terror with it. Awe awakens the awesome.

To say that we are co-creators with the Spirit is to say that a wild and mysterious thing happens when we go about our work. Whether the work be handing out safe sex information, helping the homeless build their own habitats, planting a garden, learning a song, raising a child, teaching adults, or policing the streets, all of it contains more mystery than problem, more revelation than can ever be controlled. Spirit may erupt at any moment and from any genuine act of creativity. As Aquinas puts it, when we seek by our words to arouse others to love, it is the Holy Spirit who brings this about, "making use of the human tongue as an instrument. But it is the Spirit who perfects the work within." Indeed, it is the "Holy Spirit [that] moves the heart to work," and it does so "by the force of love."[22]

This same Spirit, the Spirit that "hovered over the waters" at the beginning of the world and over the waters of Mary's womb in her act of New Creation, is committed to a work of co-creation with us. We are partners in the Great Work of the universe. In a real sense the Spirit depends on us, and by our powers of work, we are blessed with a godlike quality. "All secondary causes, by the fact of being causes, attain the divine likeness," Aquinas comments. Indeed, "secondary causes are the executors of divine Providence."[23] What is a

"secondary cause"? That's us! All creatures are secondary causes when God is understood as the primary cause—the cause without a cause. But we are "executors of divine Providence" and "governors of the world." Is it any wonder that we often run from our creativity? That we settle for allowing others to exert their creativity *over* us rather than asserting our own creativity? It takes deep inner work to make us strong enough to face our own responsibility as co-creators. Preparation time is necessary. We must steel ourselves for the effort. We must fill up and be emptied. We must travel life's deeper passages.

In a real sense it can be said that Western Christianity has a feeble theology of the Holy Spirit. To the extent that it has ignored its mystical tradition Christianity in the West goes on and on about redemption, sin, and morality but has little or nothing to say about the Spirit. This is where our creation mystics surprise us so powerfully! They do not hold back in naming the experience of the Spirit, whom Eckhart calls the "Great Transformer." If we ignore the *via creativa,* we ignore a theology of the Spirit. The Holy Spirit is the first gift in our spiritual lives. As Eckhart puts it, "The first gift which God gives is the Holy Spirit; in that gift, God gives all of the divine gifts: that is the 'living water,' 'whomever I give this to will never thirst again.' This water is grace and light and springs up in the soul and rises within and presses upward and leaps up, into eternity." Notice the energy in this gift, the vitality in it. Like creativity itself it will not be kept down; it "springs up," "rises within," "presses upward," "leaps up." Yet we also give birth to this Spirit; "There flows from us God and the Holy Spirit."[24] Just as Mary gave birth to the Cosmic Christ in the person of Jesus, so we give birth to the Christ when we give birth to the depths of ourselves, when we participate in the Great Work of creation in the universe. Thomas Aquinas recognizes that "through good works one puts forth the image of the heavenly person in themselves."[25] This "heavenly person" is our inner self, our true self; it is also a manifestation of the Cosmic Christ.

The Spirit for Eckhart is not only water but also wind and fire. Indeed, it is the wind that fans the "spark of the soul" that burns incessantly in all of us. This spark "is hidden something like the original outbreak of all goodness, something like a brilliant light which inces-

santly gleams, and something like a burning fire which burns incessantly. This fire is nothing else than the Holy Spirit." It is the Holy Spirit that returns us to our sacred origins, "into the ground, the beginning, where the Son has his being" in the Creator. To the godhead we are returned. "The Holy Spirit brings the soul to that eternal image from which it has flowed out, that model in accord with which the Father has made everything, that picture in which all things are one, the breadth, and the depth in which all things attain their end."[26]

"Grace comes with the Holy Spirit," Eckhart comments; grace is "not a stationary thing; it is always found in a becoming. Grace makes the soul God-like."[27] Our creativity is grace and grace is our creativity.

The Tao Te Ching expresses the experience and responsibility of being co-creators in the following way:

> The Tao is called the Great Mother:
> empty yet inexhaustible,
> it gives birth to infinite worlds.
>
> It is always present within you.
> You can use it any way you want.[28]

Even these brief comments on the Holy Spirit show us how vital is a theology of the Spirit to understanding creativity. Through a theology of the Spirit we reclaim our creativity as intrinsic to the Great Work of the universe. Our creativity is simply a participation in the ongoing birthing of Divinity and universe all about us.

The Fruit of Our Labor: How Our Work, Connected to the Great Work, Births God in the Universe

Eckhart and other mystics propose a preposterously wild idea—that to work is to bring forth God. All work, we might say, is divine childbearing; it is bearing the son and daughter of God into the world. Eckhart asks the question "What help is it to me that the Father gives birth to the Son unless I too give birth to him? It is for this reason that God gives birth to his Son in a perfect soul and lies in the maternity

bed so that God can give birth to him again in all the divine works." If God's desire is to birth God's child "in all the divine works," then the unfolding of the universe is this birthing process. God is born from the works of the universe—and *we* are such works; and our works are also works of the universe. God becomes and "waxes and wanes" as creatures express God.[29]

Eckhart equates creativity with *gratitude* when he declares that "becoming fruitful as a result of the gift is the only gratitude for the gift."[30] God actually "becomes fruitful" within us in our work. Our work is a bearing of the divine fruit, a coming to fruition through God's collaboration with us. Just as lovers express their gratitude for one another when they give birth to children, so too our creativity shows our gratitude. Authentic work comes from a deep place of gratitude. Indeed, work is about gratitude; it is the expression of our gratitude for being here. If we have no work it is likely that we have no way to express that gratitude.

What is this fruit that we bear? "The fruit is of good size. It is no less nor more than God's self."[31] The fruit of our work is the bringing forth of Divinity. How often do we engage in such divine birthing? Is it once in a lifetime? Hardly. According to Eckhart, this work is more common than we imagine. "Every day the soul bears fruit a hundred times or a thousand times or countless times, giving birth and becoming fruitful out of the most noble foundation of all." This "noble foundation" is the key to all our work, the source and origin of it all. Once again we see why returning to our origins is so important for authentic work. For here is the origin of the divine Word as well. "Indeed, the soul bears out of the same foundation from which the Father begets his eternal Word." There is only one work in the universe because there is only one origin, one foundation.

The key to carrying on this one work of the universe is returning to the one origin of the universe. To do this we must work from inside out. We must go within. "Whatever can be truly expressed in its proper meaning must emerge from inside a person and pass through the inner form. It cannot come from outside to inside of a person, but must emerge from within."[32] Our work is like that; if it comes only

from the outside it will not partake of the one work of the universe. Eckhart is describing creativity here.

When we work from within, the Holy Spirit is accomplishing its work within us: "The work that is 'with,' 'outside,' and 'above' the artist must become the work that is 'in' her, taking form within her, in other words, to the end that she may produce a work of art, in accordance with the verse 'The Holy Spirit shall come upon thee' (Luke 1:35), that is, so that the 'above' may become 'in.' "[33]

Once more we are being instructed about the value and power of an *inner* dimension to our work. If the work is inner, the Holy Spirit can assist it. The promise that accompanies such work is awesome: "Wait only for this birth within yourself, and you will discover all blessing and all consolation, all bliss, all being and all truth. If you neglect this, you will neglect all blessing and all happiness."[34] Our work—when it comes from deep within—constitutes the treasure that lies hidden in the soul, as Jesus speaks about in the Gospel of Matthew (13:44). We need to till the soil in order to bring this treasure forth, as Julian of Norwich put it:

> Be a gardener.
> Dig and ditch,
> toil and sweat,
> and turn the earth upside down
> and seek the deepness
> and water the plants in time.
> Continue this labor
> and make sweet floods to run
> and noble and abundant fruits
> to spring.
> Take this food and drink
> and carry it to God
> as your true worship.[35]

Our work becomes our true worship; the grapes and wine our gardening produces, the wheat and bread our labor produces all represent the Body of Christ. There is no Eucharist without our labor. In fact, Eucharist *is* our labor, our thank-you for being here. It is in our

work that we become Mothers of God bringing the divine child into the universe. We birth new and never-before-seen Christs. We are parents to the Cosmic Christ. Our work need never be boring! Because it involves Divinity and the universe, the fruits of our labor never end. This fulfills the promise of Christ in John's Gospel: "You will bear fruit, fruit that will last" (John 15:16).

What is the alternative to reintegrating work and cosmology? It is still more anthropocentrism and the arrogance—and boredom—that accompanies them. And unemployment follows as well. When humans cut themselves off from the greater work of the universe, our work worlds become very small. Even though an immense amount of work needs doing there are millions of "unemployed" not being put to good work. Humans cut off from cosmology lack the energy and the imagination to reinvent work. They succumb to the spiritual sin of *acedia,* the inertia that "refuses to begin new things" (Aquinas), such as new ways of defining and implementing work. I am increasingly convinced that one of humankind's most grievous sins is our anthropocentrism. By cutting ourselves off from the rest of creation, we are left bereft of awe and wonder and therefore of reverence and gratitude. We violate our very beings, and we have nothing but trivia to teach our young. Rabbi Heschel says that sin is "humanity's refusal to be who we are." If this is the case, then anthropocentrism is a grave sin. None of us is by nature anthropocentric; none of us lives by the labor of human beings alone. We are thoroughly part of a Greater Work, part of the sun and stars, the elements and wind, the atoms and the ecosystem, the plants and the animals. This is true not only of humans as biological organisms but also of our very souls, for the beauty of creation nourishes our expressions of wonder in poetry, music, art, dance, and ritual. Hope accompanies a return to the Great Work.

Conclusion: The Dignity of Our Work

We began part 1 with a quote from E. F. Schumacher about "putting our inner houses in order." In chapter 1 we explored the inner house of darkness, nothingness, pain, and letting go; in chapter 2 the inner

house of cosmology; in chapter 3 the inner house of joy, delight, and enchantment; and in this chapter the inner house of creativity. Exploring the inner house of the human shows us much to be amazed by. Our souls, that is, our awareness and our passions, our ecstasies and our pain, are not tidy and small. We, like the rest of the universe, are expanding and are great in size—"magnanimous," Thomas Aquinas calls us, which means literally, "large souled." There is great dignity to our being, great dignity to our work of exploring that inner being and expressing it.

At this time in history we must pay particular attention to our own dignity. Without an awareness of that dignity we will not have the courage to be co-creators. We will settle masochistically for having other people make our worlds for us. Aquinas marvels at how God has made us godlike by our capacity for causality.

> Things were made like God not only in being but also in acting. Whatever causes God assigns to certain effects, God gives them the power to produce those effects. . . . The dignity of causality is imparted even to creatures.[36]

We are dignified by our powers of causality, by our powers of work. In our co-creating we not only reveal ourselves but also imitate God. Our work is an expression, a displaying, of our dignity. When we work, the divine wisdom is at work.

The opposite of wisdom is folly. Folly can use creativity just as readily as wisdom can. Our creativity must be critiqued and tested against realities of the shadow side of our culture and our psyches. Creativity needs to be released on the side of wisdom, not on the side of folly. The spiritual path and the praxis of healthy work do not end with the praise of creativity. Creativity must be exercised on behalf of justice, compassion, and celebration. Creativity must be put to use to relieve us of unemployment, despair, racism, sexism, and other forces that prevent wisdom and encourage folly. We will consider this work of transformation in the following chapters.

The Great Work and the Outer Work: Reinventing Work

A person works in a stable. That person has breakthrough. What does she do? She returns to the stable.

MEISTER ECKHART[1]

Action is greater than inaction: perform therefore thy task in life. Even the life of the body could not be if there were no action. . . . Both renunciation and holy work are a path to the Supreme; but better than surrender of work is the Yoga of holy work.

BHAGAVAD GITA[2]

It is no longer possible to believe that any political or economic reform, or scientific advance, or technological progress could solve the life-and-death problems of industrial society. They lie too deep, in the heart and soul of every one of us. It is there that the main work of reform has to be done—secretly, unobtrusively.

E. F. SCHUMACHER[3]

The action of transformation, imbued by the action of creativity, must emerge ultimately from the power of non-action. Transformation needs to derive from the non-action of awe and grief, the *via positiva* and the *via negativa*.

We have considered the basics of healthy work and discussed what has been missing and indeed trivialized in our souls and in our work worlds—how our imaginations have been truncated during the three hundred years since Newton. It is now time to propose some solutions. What kinds of work can we actually do? What is the work—as opposed to just the jobs—that our planet needs today? What are the work needs of our youth? our unemployed? our selves? What kind of work should we be educating people for, and what kinds of educational models do we need to bring this education about?

E. F. Schumacher, as we have seen in part 1, gives us a substantive starting point when he declares that we can each "work to put our own inner house in order." The inner houses of our own beings are out of order; the inner houses of our nation-states and our work worlds are disordered. The inner house where our notions of race, gender, and sexuality reside is out of order. As long as things are so deeply out of order, our human work cannot join the Great Work of the universe. Cut off from this source, we will perpetuate despair, unemployment, militarism, avarice, racism, sexism, and injustice. In short, there will be no authentic work available, only jobs and their increasing scarcity. We will fight each other for the few jobs remaining, and our walls will get thicker, our moats deeper, our drawbridges of orthodoxy and fear more numerous.

This is why Schumacher says, simply and directly, that *the proper work for our species at this time in history is work on ourselves.* This is a radical and disturbing idea: we do not *need* a lot more machines. The disappearance of car factories may not be the end of our nation's economy after all. What is it we truly need? Schumacher elaborates,

> It is no longer possible to believe that any political or economic
> reform, or scientific advance, or technological progress could solve
> the life-and-death problems of industrial society. They lie too deep,
> in the heart and soul of every one of us. It is there that the main work
> of reform has to be done—secretly, unobtrusively.

What we need is to explore our beings, our heart and soul, our inner selves, the causes of the violence in which we engage. This is the arena for inventing new—and often ancient—forms of work. Once we acknowledge this need, we will derive the means and the energy to create new work. The leaves of the tree will emerge, provided we plant a healthy tree at the right time in the right place. *When our work becomes real our jobs will follow suit.*

When is work real? Work is real when it is necessary. Schumacher advises us that the work most needed today is work on the inner life of our species. Much of the necessary work today will be to clean up the mistakes and oversights of the industrial era. A good example of this is the environmental work that will be required if we are to return waters, soil, air, forests, food chains, and habitats to health again. But the industrial revolution polluted not only the soil but our souls as well. Our souls have shrunk through being told that our lives are lived inside a cosmic machine where wonder, awe, mysticism, joy, childlikeness, play, and art are not welcome. Thomas Aquinas warned us that a "shrinking of the mind" is what causes acedia or inertia or the "refusal to begin new things."[4] It feeds despair and cowardice; it feeds boredom, restlessness, and titillation.

It is not money but need that creates work. Right work will in turn create more work, provided we have answered the questions of need correctly. What work is the universe asking of us at this time? What work is the Earth asking of us at this time? What work are the other species asking of us at this time? What work are the youth asking of

us? What work are the future generations of humans asking of us? What work are our hearts asking of us? We don't need just any kind of work or any kind of job at this moment in history. What we need is the right work for the right times.

Schumacher is saying that our *outer work* must, more than ever before, flow from our *inner work*. Jobs will be created through paying more attention to our inner work—that of individuals as well as that of the community at large, for our communities also have inner lives. This inner life has for too long been neglected or passed over in favor of outer work alone. Our times call out for work on the human species itself—its despairing and depressed, often self-hating and destructive youth; its racist, adultist, sexist, apathetic adults; its tired institutions of education, religion, politics, economics, and art. Who says there is no work?

The outer work of going to war—of military bases and war-making hardware, of huge armies and weapons research—has preoccupied much of the job market during the period of the nation-state. As Vaclav Havel puts it, the "impersonal power" of our times has become linked to a " 'cosmological' conception of the empire (identifying the empire, as the sole true center of the world, with the world as such, and considering the human as its exclusive property)."[5] If this ideology was ever justified, it is clearly no longer the case today. The end of the Cold War can unleash new energies based on a richer and indeed more accurate cosmology.

Instead, however, we are seeing resistance to recycling financial investment, scientific expertise, and imaginative resources into the renewal of the human spirit. The renewal needed encompasses education, youth, environment, and the relief of burdens of abuse and pain that so often lead to addiction and self-hatred; it includes the art of creating work as well as jobs; and critiquing the professions and work worlds. We will treat each of these areas in turn in this part.

An authentic spirituality of work will address unemployment. It is telling that people who live in a cosmology do not have unemployment. There was no unemployment among native peoples. Anthropologist Marshall Sahlins suggests that the hunters and gatherers were the "original affluent society."

The world's most primitive people have few possessions, but they are not poor. Poverty is not a certain amount of goods, nor is it just a relation between means and ends; above all it is a relation between people. Poverty is a social status. As such it is the invention of civilization.[6]

Where does unemployment come from? It comes from the same place that poverty comes from: social structures and ideologies that lead relationships to fail. Our unemployment crisis is a novelty of modern civilization. All our work worlds, from so-called blue collar to professional, have been tainted by the limits of our civilization's philosophy of work. The failed relationships of that civilization—one that climaxed in the work of war—are now coming home to haunt us with the end of the Cold War and the end of military-based definitions of work.

We can be sure that a paradigm shift will occur whenever the necessities of life are beyond the reach of most citizens. This is happening in our culture today. Health care, education, law, business, economics, politics, and religion are not reaching the people who need them the most. We must critique our professions and suggest ways out of their impasses. The professions themselves exemplify failed relationships in many cases. Our professions are collapsing under the weight of the paradigm shift. Seeing them through the lens of a machine universe is one thing; seeing them through the lens of the green, organic, universe to which we are inexorably linked is another.

In part 2 we will explore the reinvention and reenchantment of work by examining the professions. In our culture professionals make many fundamental decisions about employment, unemployment, and the quality of the work experience.[7] Part 2 is about ideas, resources, movements, and people of courage and imagination who have dared to begin moving their professions to better work. Given the dire straits in which we all live, these stories can help to awaken the prophet in each of us to offer alternatives to our work worlds. We can realize that we are not isolated in our work dreams, that we are not alone in our deepest desires to make our professions live again and be true to their deepest moral and spiritual potentials. The word *community,* after all, means "to work on a common task together."

The task needed in every profession, and indeed by every citizen today, is to return wisdom to our work. We do this by returning to the essential meaning of our profession—a meaning that originally had to do with serving others. *Enchantment* is not a word we often associate with our work, yet Meister Eckhart promises that, when we return to our origins, all our work becomes a source of enchantment. An authentic spirituality will assist us in creating good work.

Workers should ask themselves, How can my work create good work for others? In this part of the book we ask, How can the new paradigm of the green revolution and Creation Spirituality assist in creating good work and in transforming our work worlds at this critical time in planetary history? In the following five chapters, we explore specific examples of work worlds that are changing under the impetus of the paradigm shift from machine to green, from job to work.

Is it controversial to suggest that our professions have in great part lost their enchantment? How happy are people at their work? I recently spoke to a masseur who told me that much of his work is with professionals and that he often goes to offices to give fifteen-minute massages to employees. He told me how blessed he feels to be doing this work because "most of the people really hate their work." Studies show that as businesses come under greater economic pressure, workers are often compelled to work fifty- and sixty-hour weeks just to keep abreast. The laying off of fellow employees has a chilling effect on one's sense of security in the workplace, and compulsive work habits are easily induced under these circumstances.

All our professions are collapsing today under the weight of a paradigm shift for which they are unprepared. The dean of a law school recently confessed that only 6 percent of his graduates will find a job in law this year. Is the real reason that we do not need more lawyers? Might it be instead that we do not need more of the kind of lawyers practicing the kind of law that we are accustomed to? We do need laws to defend the environment, to defend our children, to defend the poor instead of lobbying for the powerful. Perhaps the crisis lies in the kind of work our society is offering its workers.

Because our academic institutions and the education profession itself has not engaged in adequate self-criticism, none of our professions—generated as they are in academia—is prepared to embark on the necessary paradigm shift. Our professions are not generating the new forms that correspond to the demands of a postindustrial era. (Certain individuals within the professions are working toward this end, but the professions as a whole have yet to catch up.) How can we instill a sense of enchantment and vocation in the professions today? How can we move our professions toward incorporating the new cosmology?

Meister Eckhart says, "A person works in a stable. That person has a breakthrough. What does she do? She returns to the stable." Returning to our work world with a new worldview is renewing. We are called to *infiltrate* our work worlds today, bringing them from machine consciousness to green consciousness. This work on work itself is deeply subversive. It demands more of us and more of our professions. It is, in Jesus' metaphor, a putting of new wine into *new* wineskins—not settling for the old forms.

How do we go about this paradigm shift within our work worlds and professions? The first step in the reenchantment of our professional lives is this: to pay attention to our inner life. The revolution in our professions will take place when we apply the criteria of a healthy inner life to the work world itself. Just as a return to our origins gives us perspective on our being, so too we need to remember the origins of the professions themselves. All the professions, no matter how far they may have strayed from their original purpose, were rooted at their origins in the inner life of the community. They began as expressions of the spiritual and corporal works of compassion that the prophets wrote about. We can redeem the professions by returning to the best hopes they hold out for serving others.

In this part we will examine particular professions so that we see spirituality being applied to our various work disciplines. In every profession today there are persons striving to make sense of the transformations occurring all around us, striving to bring new wine into old wineskins, striving to awaken the spiritual from within. This is

very good work indeed, bringing the good back to our work. It is at the core of Christ's advice in John's Gospel to be "in the world but not of it." We can be in our professions without being of them, that is, without selling our souls to them. Indeed, that is how we must operate if our work worlds are to help solve the problems of our advanced industrial society. My treatment will not be exhaustive. Rather, by offering a glimpse of individuals trying to bring about the paradigm shift within their work worlds, the reader's own prophetic imagination may be stimulated regarding his or her own profession.

Carl Jung once said, "Only the mystic brings what is creative to religion itself." I would expand that observation to say, "Only the mystic brings what is creative to her or his own profession." It is this mystical awakening that offers hope for our work worlds. Because the prophet is the mystic in action, our mystical awakening can arouse in all workers a new willingness to do what prophets do—to interfere! Many individuals and movements within our work worlds are carrying on the prophetic task. Inspired by the new cosmology, they are creating new roles and new possibilities for workers. Learning from them, all of us can contribute our own spiritual imagination to a reenchantment of our particular professions, a reenchantment that would make them more vital and more just.

This effort to reinvigorate work with spirituality is a very ancient practice in our spiritual traditions. The Bhagavad Gita, the ancient Scriptures of India, put it this way:

> Action is greater than inaction: perform therefore thy task in life.
> Even the life of the body could not be if there were no action. . . .
> Both renunciation and holy work are a path to the Supreme; but
> better than surrender of work is the Yoga of holy work. It is not
> right to leave undone the holy work which ought to be done. Such
> a surrender of action would be a delusion of darkness.[8]

Holiness does not consist in non-action. It consists in the appropriate action undertaken with a purity of intention. The reinvention of work requires first discerning which actions are appropriate today, and then undertaking these actions with a pure attitude. As the Gita puts it,

One who does holy work . . . because it ought to be done, and surrenders selfishness and thought of reward, that person's work is pure, and is peace. This person sees and has no doubts: he surrenders, is pure and has peace. Work, pleasant or painful, is for him a joy.[9]

5 | The Environmental Revolution and the Reinvention of Work, Including Farming and Politics

In harmony with the Tao,
the sky is clear and spacious,
the earth is solid and full,
all creatures flourish together,
content with the way they are,
endlessly repeating themselves,
endlessly renewed.

When [humanity] interferes with the Tao,
the sky becomes filthy,
the earth becomes depleted,
the equilibrium crumbles,
creatures become extinct.

TAO TE CHING[1]

Ecology is functional
cosmology.

THOMAS BERRY[2]

The Environmental Revolution by definition depends on an extraordinary amount of social change, a compression of history—squeezing centuries of change into decades.

LESTER BROWN[3]

Industrial farming is a
manifest failure.

WENDELL BERRY[4]

The political leader must know to some extent the things
belonging to the soul, as the physician who treats the eyes
and the whole body must study something about the eyes and
the whole body.

THOMAS AQUINAS[5]

In chapter 1 we discussed how Earth is suffering in our time. An ecological awakening leads to a reinvention of work. Lester Brown, head of Worldwatch Institute, compares our historical epoch to the industrial revolution, which reinvented work in radical ways in the eighteenth century, and to the agricultural revolution, which reinvented work ten thousand years ago. The environmental revolution, says Brown, "is in the most fundamental sense a social revolution; the product of changing values, of seeing ourselves again as a part of nature, of recognizing our dependence on the earth's natural systems and resources and on the goods and services they provide."[6] This definition of the environmental revolution is tantamount to calling it a spiritual movement—one that challenges our values, that teaches us to see differently, and that teaches us authentic humility, that is, our dependence on the Earth (the word *humility* comes from *humus* or earth).

An environmental revolution assists us in reinventing work because ecology and cosmology go together. Consider that the word *ecology* comes from the Greek word for "home" (*eikos*). An ecological awakening is an awakening about our true home. And our true home is the universe itself. Our home is being fouled by the way we live and the work we do. In trying to preserve this home and cleanse it, we are doing both ecological and cosmological work (Earth is part of the history of the whole universe after all). Thanks to the new creation story, we are once again experiencing the enchantment of our unique home in the cosmos. This is why Thomas Berry can say that ecology is functional cosmology.

Ours is a time for viewing the sacred, not as an object to be found above us or beyond us or outside us (this is theism), but as flowing around us and "through and through us," as the thirteenth-century mystic Mechtild of Magdeburg put it. Finding divinity around and through all things (recovering a theology of the Cosmic Christ) is an essential part of the environmental awakening. It alerts us to the sacredness of all things and to their intrinsic rights and privileges.

The Earth is calling all of us to take a critical look at the work we do and the work we are not doing. This calling constitutes the new vocations of our generation, the new "roles" we must play. In our efforts to move from the industrial to the environmental era, time is not on our side. Two years ago Lester Brown predicted that we have twenty years left, and no longer, to turn things around. This means the countdown has now advanced to eighteen years. The issue, says Brown, "is how to accelerate change on a scale not previously seen except when mobilizing for war. The Environmental Revolution by definition depends on an extraordinary amount of social change, a compression of history—squeezing centuries of change into decades."[7]

In what way is our work called to participate in this environmental revolution? In what way would responding to this invitation result in a new era of work so that new jobs and new ways of working could be created? According to Brown, many people must be actively involved before the environmental revolution can happen. "Saving the planet is not a spectator sport," he says, and "unless more of us become environmentally active, both as individuals and as organized groups, the Environmental Revolution will not succeed. Success depends on overcoming human inertia, vested economic interests in the status quo, and some of the structural impediments of society."[8]

Green activist Jonathan Porritt, biologist Rupert Sheldrake, rain forest defender John Seed, and others underscore the need to connect earth work and spirit work. Recently I conducted a workshop at an Earth/Spirit conference in Portland, Oregon, during which we examined our Cosmic Christ tradition and did circle dances to bring home the microcosm and macrocosm connections in our bodies and

psyches. Afterward a thirty-one-year-old man came up to me and said, "I have been an ecological zealot for eighteen years. I am not at all interested in religion, but I came to this conference out of curiosity about the title. This workshop has been a complete eye-opener for me. It is so radical—getting activists to dance. I can hardly wait to take this back to my fellow activists. It will reenergize them." Two months later I ran into this young man again, and he had indeed taken the circle dances back to his people.

Some peace activists still think anthropocentrically and fail to see the connection between their passion for justice between peoples and the need for justice toward the earth. They belittle environmental issues as "middle class." Yet the 1992 Earth Summit in Rio de Janeiro demonstrated decisively just who is paying the dearest price for ecological devastation. *It is the poor who suffer first from ecological disaster.* The so-called Third World is quite aware of the degradation being foisted on it by the wealthier nations. For example, according to the Environmental Protection Agency, 75 percent of the toxic waste dumps in the United States that fail to comply with the agency's regulations are in black or Hispanic neighborhoods. The largest toxic dump in the United States is in Emelle, Alabama, an utterly impoverished city that is 80 percent black, and the highest concentration of dumps like these is in Chicago's black South Side. Half of the country's black and Hispanic people live in neighborhoods with toxic dumps. Two million tons of radioactive uranium have been dumped on Navajo land, and as a result Navajo teenagers have 17 times the national average of sexual-organ cancer. Each year, over 300,000 Hispanic farm laborers suffer from illnesses related to pesticides. Pollution-related asthma is killing African Americans at five times the rate it kills white people. Forty-four percent of urban black children are at risk from lead poisoning.[9]

Clearly, environmental work and social justice work go hand in hand. Ecological issues can potentially unite people in the struggle for their own survival. Is this not what all healthy politics is about? We need to achieve as broad a consensus as possible in order to restore

right relationships. Environmental work holds the potential to move our politics beyond the dualisms of the modern era into a mentality of interdependence upon which authentic justice can be constructed.

We as a species need to reclaim our capacity for connecting to the Great Work—to our spiritual capacities for healing and compassion. It is work that entire generations of people can commit themselves to wholeheartedly. I recently met a woman from Iowa who organized volunteers to plant trees. They planted 45,000 the first year and expect to plant 200,000 this year. A healthy Earth is a prerequisite for healthy food, healthy bodies, and healthy children and grandchildren. It is also a prerequisite for healthy work. The Tao Te Ching says:

> In harmony with the Tao,
> the sky is clear and spacious,
> the earth is solid and full,
> all creatures flourish together,
> content with the way they are,
> endlessly repeating themselves,
> endlessly renewed.

> When [humanity] interferes with the Tao,
> the sky becomes filthy,
> the earth becomes depleted,
> the equilibrium crumbles,
> creatures become extinct.[10]

Evil, Ecology, and the Great Work

We humans do have the capacity to destroy the natural order of things, but, as Hildegard of Bingen warned eight centuries ago, because we ourselves are part of that order and thoroughly interdependent with it, nature itself will punish us for our injustice. Vaclav Havel understands the connection between the neglect of the Great Work and the evil we perpetrate on creation. He describes how, as a young boy, he walked through fields smelling the smoke spewed into the air by industry.

Each time I saw it, I had an intense sense of something profoundly wrong, of humans soiling the heavens. . . . That "soiling the heavens" offended me spontaneously. It seemed to me that, in it, humans are guilty of something, that they destroy something important, arbitrarily disrupting the natural order of things, and that such things cannot go unpunished.[11]

Havel's analysis of how industrial ideology and practices offend right relationships reminds one of the paradigm shift we discussed in chapter 2, for Havel too sees the issue as one of how we perceive the world and relate to it:

To me, personally, the smokestack soiling the heavens is not just a regrettable lapse of a technology that failed to include "the ecological factor" in its calculation, one which can be easily corrected with the appropriate filter. To me it is more the symbol of an age which seeks to transcend the boundaries of the natural world and its norms and to make it into a merely private concern, a matter of subjective preference and private feeling, of the illusions, prejudices and whims of a "mere" individual. *It is a symbol of an epoch which denies the binding importance of personal experience—including the experience of mystery and of the absolute—and displaces the personally experienced absolute as the measure of the world with a new, man-made absolute, devoid of mystery, free of the "whims" of subjectivity and, as such, impersonal and inhuman. It is the absolute of so-called objectivity: the objective, rational cognition of the scientific model of the world.*[12]

Havel sees our "soiling of the heavens" as the price we pay for lacking a community cosmology. To turn this "rational cognition of the scientific model of the world around" will itself create new and *good work*. One way to turn it around is to value again the mystery, the wonder, and the beauty of the natural environment and to honor its right to exist—in other words, to learn reverence and awe of nature once again and to experience the mystical life that all beings share.

The industrial era has offered us no tools for dealing with the reality of evil. An era that denies cosmology denies the reality of evil and in doing so actually brings about cosmic evil. A machine is a machine; in itself it does not allow for the vastness either of awe and

wonder *or* of evil brought about by misuse of our creative imaginations. What has resulted from our excessively rationalistic worldview has been a "mass insanity that has nothing in common with any form of rationality."[13] This observation parallels the views of psychologist Otto Rank, who says that what is killing our civilization is excessive rationality. When we deny the nonrational or the mystical—including the potential for cosmic evil that we all carry within us—the ironic result is that the work we create for ourselves is a sadistic work, one that carries on the work of the cosmic shadow and wallows in the swamp of our wounded psyches. Greed, control, and other forces of destruction become allied to this shadow work. As Havel puts it:

> With the burial of myth, the barn in which the mysterious animals of the human unconscious were housed over thousands of years has been abandoned and the animals turned loose—on the tragically mistaken assumption that they were phantoms—and that now they are devastating the countryside. They devastate it, and at the same time they make themselves at home where we least expect them to—in the secretariats of modern political parties, for example. These sanctuaries of modern reason lend them their tools and their authority so that ultimately the plunder is sanctioned by the most scientific of world views.[14]

Yes, the "most scientific of world views" can actually be plundering the very stuff of science—the Earth and its forests and lands, as well as the minds and souls of human beings. This way is the way of vice and folly. But Hildegard of Bingen warned us to "Know the Ways," meaning know the ways of vice and folly *and* the ways of virtue and wisdom. And once we know, we must make the appropriate choices. Let us now consider the ways of virtue and wisdom that are fitting for an era of an environmental revolution.

Ecological Virtues

Thomas Aquinas understood human morality to be essentially a creative act—one of creating ourselves and our communities by way of virtues or powers (in Latin *virtus* meant both virtue and power). He says, "Human virtue is a participation in the divine power."[15]

Aquinas and other philosophical ancestors wrote at length about virtues of all kinds—civic, domestic, intellectual, and moral. But today we must also be about what I call *ecological virtues.*

Ecological virtues are habits that allow us to walk lightly on this Earth and therefore to pass on its blessings of health and wholeness, of goodness and beauty, to future generations. Because we have been so oblivious of these virtues during the industrial era and the urbanization of our lives and souls in this century, it is important that we pay heed to them now. We will find that in doing so, whole new kinds of work are created.

Virtues evolve as our culture and historical context evolves, including the evolution of our economies. If we glance at the history of economies during the past thousand years, we find something like the following:

Early Middle Ages: The feudal system holds *land* as the basis of its economy and culture. The culture is organized around the interests of the lord: knights protect the land, serfs work the land, and monks live and pray on the land.

Late Middle Ages: Capitalism emerges to displace land with *portable money,* and this in turn advances the possibilities of trade and travel and the interconnecting of Europe with the East, the Middle East, and, beginning in the sixteenth century, with the Americas. In this context gold, silver, and slaves all serve the interests of the monied classes.

Modern era: Capitalism links up with science, technology, and industry to create a new enterprise of industry, which now almost exclusively determines jobs. Marxism arises to protest the objectification of the worker in this context but itself succumbs to sins of bureaucracy and industrialism, and, in the context of the nation-state, so grossly developed by the wars of the twentieth century, Marxism's idealism is lost.

Contemporary era: Multinational corporations, often superseding the nation-state, operate beyond any moral and legal boundaries, establishing themselves as the epicenters of wealth and therefore the

dispensers of jobs. Jobs shift from one country to another, depending on who bids for the lowest wages and the fewest environmental protections. The result is that the industrial base of the northern countries is seriously eroded, but the ecological base of the southern countries is laid waste even more.

What we regard as wealth today is grossly anthropocentric; nor is it valuable in the long run, for even billionaires will have to live under the same failing ozone level as the rest of us. I propose that we begin to understand wealth in a new way. This new definition will not use gold, silver, slaves, money, land, real estate, or buildings as the basis of value. Rather, wealth will be measured by the *health of the planet* and the health of all the deeply interdependent species on it: soil, forests, air, waters, plants, animals, birds, fishes, crops, and humans. The environmental revolution requires a new definition of wealth, even a new kind of currency—one not backed by gold in a bank but by health on the planet—money, if you will, that is redeemable as healthy Earth systems.

To get to this level of consciousness, we as individuals and communities must embrace lifestyles that witness to ecological virtue. Living these virtues will prepare us to reinvent the very basis of wealth and economics. After all, the word *economics* does not mean the study of the mystery of money or the mystery of the stock market or the pathology of greed, even though this is how it is usually taught in departments of business and finance at our universities (which themselves are often bought and kept by industrial, monied interests). Economics means the *management of our households*. Our basic household is the Earth itself.

We have been allowing the definition of wealth to be controlled by the wealthy: those who own the media, the banks, and industry; those who serve on the boards of our universities, banks, legal firms, political parties, corporate sponsors of the media, and multinational corporations (which ought to be called supranational corporations). Their definition of wealth is very clear: stocks, bonds, gold, silver,

treasury notes, money, real estate. I propose that this definition of wealth is historically determined and historically passé. We, as a species, need to redefine what wealth is, who owns it, and how it is distributed. If real wealth resides in the health of this planet, then no one owns it. Rather, everyone derives its benefits *and* shares the responsibility for its maintenance. The proper distribution of this wealth has already been allotted by nature itself, but humans have often usurped the inbred justice of the planet. Laws are necessary to safeguard justice among humans and between humans and nonhumans. The realm of responsibility for the authentic wealth of this planet is addressed by the ecological virtues and the work they spawn.

Here are some examples of the ecological virtues that our generation must start cultivating. Practicing these virtues will not only form the backbone of the environmental revolution, it will also form the basis of the practice of Creation Spirituality, a creation-centered mysticism that is also prophetic and socially transformative. And practicing these virtues will also create new work and new jobs and will, I believe, provide the basis for redefining wealth itself.

Vegetarianism or semivegetarianism

The facts are now out on the price the Earth and the poor are paying to continue the meat addiction of rich countries. Twenty times more people can be fed from an acre of land if they are eating a vegetarian diet than if they are eating a typical American meat-oriented diet. The water required to raise livestock for a meat eater is 4,000 gallons per day; for a vegetarian, it is 300 gallons per day. Over 50 percent of the total amount of water consumed in the United States goes to irrigate land growing feed and fodder for livestock. In addition, "the livestock of the United State produces twenty times as much excrement as the entire human population of the country," and animal wastes produce ten times the total amount attributable to the entire human race. Indeed, "the meat industry single-handedly accounts for more than three times as much harmful organic waste water pollution as the rest of the nation's industries combined!"[16]

Vegetarianism or semivegetarianism is not a moral *option;* it is rapidly becoming a requirement. It has everything to do with the health of the planet and with respecting animals and other non-human forms of life.[17] One study has found that if North Americans alone would cut back just 10 percent on our meat consumption, sixty million people around the world who are currently starving would have food to eat. Just a 10 percent cutback. Not such a big deal. Every North American currently taking meat for granted in his or her diet could do it immediately. How about a 20, 50, 75, or even 100 percent cutback? All these options are available to us! We are capable of letting go if we are motivated deeply enough.

I envision this letting go taking place not in the context of guilt but of rituals. For example, we could adopt the archetype of the golden calf of our spiritual ancestors and erect papier-mâché golden calves in our town squares, on our campuses, and at our sports stadiums. We would gather around these calves and vow to one another—in sacred pledges we would help one another keep—to let go of the amount of meat consumption that our conscience told us was appropriate, whether 10 percent or 100 percent or something in between. Then we would light the calves and dance around the bonfire, cementing our vows. This would not only save rain forests and soil, water, and good air, but it would also enliven our souls and create community. It would raise our community esteem, for by this spiritual act we would be committing ourselves to the health and wealth of future generations on this planet. We would experience the empowerment that comes with a sacrifice that is shared. Our generosity would not go unrewarded. Joy would follow.

Author Jeremy Rifkin traces the beginning of the beef industry to our loss of the sense of the sacredness of generativity, a sacredness that was symbolized for humans by cattle. Having secularized our relationship to cattle, we "transformed the bovine into a productive resource to be manipulated." He believes that rejecting beef can amount to rejecting the entire industrial paradigm: "Our changing relationship to the bovine, from one of revered generativeness to one of controlled productivity, mirrors the changing consciousness of

Western civilization as it has struggled to define itself and its relationship to both the natural order and the cosmic scheme." He predicts that a spiritual awakening will follow from this letting go of beef. "The elimination of beef will be accompanied by an ecological renaissance, a grand restoration of nature on every continent." And he predicts that justice will result toward the poor. "More agricultural land and more grain will be potentially available to the poor," many of whom will be able to leave the crowded cities to return to small farms. All this sounds like spiritual transformation, for "restoring nature, resacralizing our relationship to the bovine, and renewing our own being are inseparably linked. They are the essential elements of a new postmodern sensibility, the harbingers of a new earth-centered awareness."[18]

The process of eliminating beef from our diets will create work for ritual leaders and for new chefs and workers in food industries who will teach us to prepare vegetarian meals.

Recycling

When we recycle, we participate in the spawning of new industries while cleaning up the messes from old ones. Above all, as awareness of its value grows, recycling creates new forms of citizenship and of family interaction. Children, I find, are especially aware of its importance. After all, they are the ones who will profit from it the most, for children and grandchildren will lose the most if we do not pass on a healthy Earth. Thus recycling opens avenues of communication between generations and offers healthy work to the young. No citizen, family, or community can afford to ignore the imperative of recycling. In cities with recycling programs, new jobs are created—some for the very poor and disadvantaged who can operate some of the equipment—and at the same time money is saved and land is spared from the burden of becoming landfill. It is estimated that at least 30,000 people are already employed in the United States just in the recycling of aluminum. This amounts to twice the employment by the aluminum production industry itself! To increase the current recycling of aluminum to its full potential could create 375,000 new

jobs in the United States. Studies indicate that "recycling creates far more jobs than do either landfills or incinerators."[19] Looking at the waste in New York City, one study reported:

> An improved materials recovery program could boost the recycling rate in New York City from 18 percent to 75 percent. Pursuing that route instead of burning waste would both save money and create new jobs. At about $500 million, the cost of building an incinerator is three times that of recycling facilities that can handle the same amount of trash. Even a more modest goal—recycling one quarter of the city's waste by April 1994 as mandated by law—would create about 1,400 jobs, or more than four times the number generated if the same volume of waste were incinerated.[20]

Of course, we have not yet found a way for the recycling of our more sinister human trash, such as nuclear waste. Deep ecologist Joanna Macy has the best idea I have heard yet: Instead of burying nuclear waste "out of sight, out of mind" in the Earth or in the ocean depths, leaving to future generations for thousands of years the legacy of our neglect and thoughtlessness, we ought to construct above-ground "temples" of the stuff. These sites would be managed twenty-four hours a day by quasi-monastic communities of volunteers who would give a year or two of their lives to live at this "sacred site" to watch over it. They would bear witness to what our species has done and is capable of doing when we do not practice mindfulness and pay attention to everything, including our waste products. They would call attention to the shadow side of our natures. Evil would not be swept under the rug but would be visible. We would all be required to admit its presence among us. It might keep us more honest.

While volunteers would staff these sacred sites, part of the holy task of the members of the community would be to serve as guest brothers and sisters to pilgrims who would visit. Young and old alike could come to reflect with the monastic community on the power and the responsibility our species holds within itself and to meditate on humanity's capacity for both evil and goodness. Such communities would provide good work indeed, not just for their immediate members, but also for the ongoing education of the culture as a whole and for the sake of future generations.[21]

Bicycling

If we were to construct bicycle paths in all cities, more of us could use bicycles to get to work, run errands, and for enjoyment. European countries are far ahead of the United States in this regard. Bicycles are a far cheaper way to get exercise than sports clubs. They don't emit noxious fumes, they don't burn nonrenewable energy resources, and they don't require the fighting of wars over the ownership of these resources. A commitment to bicycling also generates jobs. According to Lester Brown in *State of the World,* "A 1988 assessment found that the number of jobs created in building urban bike paths compares favorably with that in highway construction."[22]

Author Bill McKibben comments on the spiritual advantages of bicycling. A bicycle, he believes,

> is every bit as technological as an electric car, and as a significant minority of people have discovered, it's endlessly more elegant. On a bicycle you see the world around you—you notice the hills that a car obliterates; you see neighborhoods at a pace that makes them real, not a blur. You save gas, of course, but you also hear your body again. TV can't appreciate this kind of elegance.[23]

Public transportation

While some people lament the decline of the American automotive industry, with many American manufacturers moving operations overseas, the fact is that there are already six hundred million automobiles in the world, and they are a principal cause of air pollution and even of the disappearance of the ozone layer. Do we really need many more automobiles in the world? I would put the automobile pretty much in the category of military bases: the fewer the better. I made this point at a talk I gave in East Lansing, Michigan, where thousands of workers had been recently laid off by the closing of the automobile plants. Surprisingly, instead of being ridden out of town on a rail, I received a standing ovation. People are not stupid. Only those politicians or business people blinded by the narrowness of their focus on immediate money gratification can afford to be in denial and refuse to face facts. The rest of us, trying to breathe the air and live our lives, know that things must change.

Of course we have to retrain our automotive workers and re-design the factories where they have been working. What better way than to convert auto factories to public transportation factories? Or to convert truck manufacturing plants to plants that build rail systems, which are far more ecologically sound? What about reinstalling trolley systems in our cities? These are far cheaper to build than subways; they can run quietly and cleanly, and riding on them can even build community. Up until the end of the Second World War most of our cities had trolley systems, and their demise is directly linked to Detroit and the oil corporations, who needed to guarantee markets for their products. Public transit systems generate more jobs than do the automobile and truck industries. For example, in Germany they have found that "highway construction generates the fewest jobs of any public infrastructure investment." One billion deutsche marks (about 580 million dollars) spent on highways yields 14,000 to 19,000 jobs, while the same investment put into railway tracks produces 22,000 jobs, or 23,000 jobs if put into light rail track construction.[24]

I suggest that our true "defense" industry is in public transportation and other ecological virtues. By practicing these we defend something most worthy of defense: our planet. Let us defend our food chain, our air, water, forests, soil, bodies, imaginations, spirits, plants, animals, and the children to come.

Creating sustainable energy alternatives

Our environmental catastrophe is also an opportunity—above all, an opportunity for invention and creativity. An explosion of human imagination, engineering, and invention is needed to get us out of the corner into which we have painted ourselves. All this creativity will create good and needed work. Instead of relying so heavily on fossil fuels—which must be transported to us from around the world, thereby endangering sea life and habitats through shipping and pipelines—we need to develop solar energy, wind energy, thermal energy, and other alternatives that are clean burning and renewable. Much progress has already been made in these fields at the level of research, but their presence is still barely felt among us. At the level of implementation they are just in their infant stages.

For example, wind power has been most highly developed in the state of California where, under former governor Jerry Brown, tax incentives encouraged the construction of a windmill farm. This farm generates enough electricity to serve the electrical needs of four million people. The 17,000 wind turbines in California constitute a one-billion-dollar industry. California's wind farms represent more energy production than all the other states put together, and yet the state of California ranks nineteenth among the states in terms of amount of wind received. Imagine what energy could be generated on wind farms in states like North Dakota or Nebraska, which are far windier than California. Furthermore, thanks to human creativity, advances have now been made in the technology of windmills so that what used to cost fifty cents per kilowatt-hour is now costing only five cents per kilowatt-hour, making wind power thoroughly competitive with gas and oil. The advances have been made by installing in each windmill a small computer that guarantees that the windmill will always face into the wind at just the right angle to use all of its energy. Similar progress is being made on solar energy as well. Using renewable resources is good, environmentally sound work. Why not start up these industries in poor countries, thus bypassing the industrial phase of their evolution?

Studies demonstrate that these new energy industries create more jobs than our present energy industries. For example, the generation of one thousand gigawatt-hours of electricity per year in a nuclear power plant requires 100 workers; in a coal-fired plant, 116 workers. But to create the same amount of energy in a solar thermal facility requires 248 workers and 542 on a wind farm.[25]

There are many other ways to cut back on our energy needs while providing jobs. For example, weatherizing our homes and workplaces would provide work in which people could create their own small businesses. Being in business for oneself can prove preferable to being dependent on multinational automobile corporations for one's livelihood. An Alaskan study has found that "weatherization creates more jobs per dollar of outlays than any other type of capital project." In fact, it creates three times as many direct jobs as highway construction.[26] It is estimated that six to seven million jobs

per year would be generated in the United States if we made a public commitment to weatherization. Keep in mind that weatherizing would cut down dramatically on our use of energy, thus saving money in many sectors of both our personal and public economy.

Researchers have just developed a light bulb that can last eighteen years, fit into ordinary sockets, and use 75 percent less electricity than conventional bulbs. Known as the "E lamp," it holds "enormous potential for dramatically reducing the nation's thirty billion dollar annual lighting bill and allowing utilities to build fewer polluting power plants at a time of mounting concern over global warmings."[27] Lighting currently consumes 25 percent of all electrical power in the United States and accounts for up to 40 percent or more of electricity bills in businesses. Thus a changeover to this item alone would cut our overall electrical costs by 30 percent.

Another piece of good news applies to the transportation arena. There now exists the technology to create an electric car that gets 125 miles per gallon of gasoline. That is to say, it takes one gallon of gas to recharge the battery for every 125 miles the car is driven. Unlike most prototype battery-driven cars, this one runs on the kinds of batteries we already use, and part of its genius is that each time the car is braked the battery is recharged. This car also performs favorably with gasoline-driven cars. When one remembers that electric cars are free of noise and pollution, one can begin to see how useful and revolutionary such a car would prove to be, especially for city driving. (An issue that needs to be addressed regarding battery-driven cars, however, is the amount of lead and toxic acid pollutants that these cars would generate. At least one study finds that they would create twice the amount of hazardous waste as a gasoline-powered car.)

These are just a few examples of how human ingenuity, applied to environmental issues, clearly makes good work. Ingenuity and creativity are themselves ecological virtues in our time.

Organic farming and bringing back the family farm

Vice President Al Gore, who grew up on a farm, points out that every hour, eight acres' worth of prime topsoil floats past Memphis.

In Iowa what used to be rich topsoil sixteen inches deep is now eight inches deep. One reason for this is people taking a short-term view:

> People who lease the land for short-term profits often don't consider the future. From fence row to fence row, they strip-mine the topsoil and move on. And even if you own the land, it's hard to compete in the short term against somebody who doesn't care about the long term.[28]

We continue to put into the soil, the waters, and the plants pesticides whose effects we are ignorant of, just as we did in Vietnam with Agent Orange. Our "nearly invisible poisons" constitute for Gore "a symbol of how carelessly our civilization could do harm to the world, almost without realizing its own power."[29]

Geologian Thomas Berry says, "Industrial agriculture is no longer the participation in the productive cycles of the natural world; it is the extinction of the very conditions on which these productive cycles depend."[30] And poet-farmer Wendell Berry has declared that "industrial farming is a manifest failure." Farming is not an industry; it is a mystical relationship, a union and communion of human with weather, soil, rain, seeds, plants, animals, wind, and air. In the past few decades it is the world's soil that has paid the highest price for our machine-oriented cosmology.

Vaclav Havel begins his essay "Politics and Conscience" with a reminiscence of his boyhood experience of walking through the countryside and seeing the smokestacks "soiling the heavens" with their pollution. In that essay he criticizes all politics that merely plays out anthropocentric power, all politics that substitutes the empire for true cosmology, "identifying the empire, as the sole true centre of the world, with the world as such, and considering the human as its exclusive property."[31] One example Havel gives of the price we have paid for excessive rationality is our elimination of the family farm:

> Thirty years after the [industrial] tornado swept the traditional family farm off the face of the earth, scientists are amazed to discover what even a semi-literate farmer previously knew—that human beings must pay a heavy price for every attempt to abolish, radically, once for

all and without trace, that humbly respected boundary of the natural world, with its tradition of scrupulous personal acknowledgement. . . . With hedges ploughed under and woods cut down, wild birds have died out and, with them, a natural, unpaid protector of the crops against harmful insects. Huge unified fields have led to the inevitable annual loss of millions of cubic yards of topsoil that have taken centuries to accumulate; chemical fertilizers and pesticides have catastrophically poisoned all vegetable products, the earth and the waters. Heavy machinery systematically presses down the soil, making it impenetrable to air and thus infertile; cows in gigantic dairy farms suffer neuroses. . . . The fault is not one of science as such but of the arrogance of man in the age of science.[32]

It is estimated that, given the rate at which industrial farming is ruining the soil, the United States will be importing food (from God knows where) early in the next century. If industrial farming is such a manifest failure, why not stop doing it? If the United States government were to shift its subsidies from giant conglomerate industrial farms to small-scale organic farms, many, many jobs would be regained, for the Earth can employ many people when it is not being turned into an industrial highway. Furthermore, families that commit themselves to healthy agriculture can themselves be healthy families, for it is always a joy for children to grow up in relationship to nature. Small towns that are currently dying because they depend on farming communities around them would flourish again. Cheap housing would be available because housing typically costs less in these towns. Good work would flourish. The food raised in organic farming would contain far more healthy nutrients than the food we now eat, full of pesticides as it is. Thus our bodies would be healthier, and we and our children would flourish both in mind and soul. As a result of better air and healthier food, no doubt our medical bills—and perhaps the cost of our medical insurance—would decline.

Economist E. F. Schumacher writes, "When food production is done on a sort of family scale, intensively, then the output per acre is on the average five times as high as that of a well-run farm." This means that reinstating the family farm would increase food produc-

tion by 500 percent—and still leave the soil healthy for future generations of humans.[33] How many persons might be put back to good work by returning to family farming, to raising families on the land, to reinvigorating our small towns no less than the soil itself? How many citizens, for example, whose ancestors migrated north for industrial employment during the Second World War and afterward, might rediscover their roots in the healthy work of returning to a family farm? Perhaps the government could encourage small-scale farming through tax incentives and subsidies, just as it has encouraged industrial agriculture for several decades. This kind of encouragement could prove to be a wise investment in the future health of farmers and consumers alike. It could also contribute to the physical and mental health of young people, who could learn, through work on the soil, the kinds of disciplines and love of living that one is hard-pressed to learn in the inner cities of our nation. Surely farming is a virtue worth cultivating in our people again. To do so we must reclaim farming from the machine mentality, from industrial mindsets and entrepreneurs.

Planting trees

Trees preserve the topsoil and help to clean the air for us, for trees are constantly recycling carbon dioxide and other would-be toxins. I referred earlier to the woman in Iowa, whose volunteers have now planted over 300,000 trees. Planting trees is fun work that old and young, whole families and entire communities can engage in together. It can be done in cities as well as in towns and in the countryside. We all need trees; we are all blessed by trees. We can make new relationships with trees—which were, after all, the first creatures to stand upright.

Gardening

Besides the obvious benefit of producing delicious food and delectable colors by way of vegetables and flowers, gardening educates the young about important truths of interdependence and earthiness. It is also wonderful therapy for those of any age dealing with anger,

frustrations, or grief. The Earth is vast and very receptive: it gladly absorbs our anger, grief, sorrow, and hopes. Indeed, some Native American traditions practice a ritual of burying anger in stones in the Earth. Relating to the Earth renews our psyches. Gardening can be done in the inner city where the rubble of torn-down buildings conceals good soil, or it can be done on top of tenement houses and apartments, where the sun and rain fall regularly. Gardening in the tough areas of cities, for example in the waterfront district of Bristol, England, has been known to generate a whole new spirit among the people living there. It can make community happen. What grows in a garden is not just plants but the human spirit itself.

Why is it that the Bible begins its teaching about human beings with a garden story? Why is it that the setting for the cosmological love poem of the Song of Songs is a garden? Why do the Christian Scriptures celebrate Christ's resurrection in a garden? Indeed, in one account Christ is disguised as a gardener. The very word *paradise* comes from the Persian word for "garden." Gardens teach us interdependence and groundedness and therefore wisdom. They call us back to our roots, for we are all Earth, standing on two feet and eating Earth itself. An African proverb says, "Treat the Earth well. It was not given to you by your parents. It was lent to you by your children." Gardens are not ours to own; they are lent to us—as are all beauty and all health—by future generations. As Marilyn Barrett puts it in the conclusion to her book *Creating Eden: The Garden As a Healing Space:*

> In my own garden, I've seen how each tender shoot, each full blossom, and each withered leaf play a role in the harmony and survival of the garden as a whole. In my own life, I've seen how the garden's wisdom teaches me how to survive. The problems and obstacles I face and the disappointments and losses I experience are as important to my balance and well-being as my joys and successes. We need to break ground for a new world garden. We need to view the earth's resources in terms of long-term care, thinking the way a gardener thinks, with the future in mind, preparing for the cycles of growth yet to come.[34]

The author is telling us that there is something eschatological about a garden. It holds a future vision and a future reality for us and those to come. All authentic work does that.

Making our own entertainment

It is time that we take back our entertainment hours from the captains of the entertainment industry. Think about how much of our leisure time we surrender to professional athletes and their corporate sponsors rather than to our own needs for exercise and relaxation. I have felt for many years that if I had children and a television set I would insist on putting an empty box next to the set; for every hour my children watched television they would have to spend an hour creating their own play with the empty box. We need to take up activities that truly engage us with ourselves and others—music, painting, poetry, dance, massage, cooking, hiking in nature—not to pursue prizes or with a mentality of judgment but rather as we would approach prayer itself, for that is what these actions are: acts of meditation and art as meditation.

There is healthy work to be had in taking back responsibility for our own entertainment. Neighborhood festivals, city festivals, holiday festivals and outings, festivals with the elderly and the disabled, festivals with those different from ourselves as well as within family gatherings—all this is about making good work. It is the practice of ecological virtue.

Studying

Using, developing, and exercising our minds; learning the new creation story from science; reading with both heart and mind the great mystics of our heritage; studying the facts about what is happening to the Earth's systems; learning the new science and relating its lessons of interconnection to the spiritual teachings of East and West about compassion and interdependence; studying ways that societies can be transformed—all this is part of practicing ecological virtue. One does not have to put down the left hemisphere of the brain in order to pay attention to the right. Hildegard of Bingen proclaimed

that "all science comes from God";[35] Thomas Aquinas insisted that "a mistake about nature results in a mistake about God."[36] Our minds are ours; no one can erase what we, by our hard-earned efforts, learn over our lifetimes.

Yet our minds, like everything else, are subject to environmental pollution. When we internalize our own oppression and begin to believe the worst things others say about us—about our race, ethnic group, gender, sexual orientation, class, or status within a group—we have been thus polluted. When we sit passively, hour after hour, in front of a television set, our minds get polluted. Our minds are wondrous, *"capax universi,"* capable of the universe, to quote Aquinas. Our minds deserve healthy exercise. We should use them to read, to attend lectures and art shows, to use libraries, and to engage in hearty conversation. They must not be wasted.

Community organizing

Surely it is an ecological virtue to instruct the community and draw wisdom from it, to gather grass-roots groups for their own empowerment and the enhanced wisdom of the greater community. The ecological crisis is not just about destroying forests and arable land, but also about dumping toxins in poor hamlets of the southern and southwestern United States. It's about officials of northern nations who bribe officials in southern nations for permission to dump nuclear and other waste; it's about the pollution generated, for example, by bus terminals in Harlem. It is about trash on the streets and about creating jobs that deal with the causes as well as the symptoms of indiscriminate dumping. Practicing ecological virtues means opening up the creeks that run through our cities but that have been covered over by cement and debris. It is about cleaning the beaches and parks and about learning authentic and long-lasting habits of recycling. For this to happen, as many community groups, classes, and interest groups as possible need to be organized. In the process of organizing we can expect new coalitions and new participation among neighborhood people to emerge. We can ritualize the cleanups, thus connecting our work to the Great Work. We are all facing the ecological disasters; no one is exempt.

We all suffer when Earth suffers. As we saw at the recent Earth Summit in Rio, some surprising coalitions can be forged out of the Earth crisis. Richer countries, whose lifestyles are doing so much to bring about the degradation of the planet, can learn from poorer ones. The creation of new nongovernmental organizations (or NGOs), political organizing, civil disobedience, and the drafting of transnational laws and agreements are all examples of how we are waking up to the ecological virtues. Once we are awakened, much more is sure to follow.

Stabilizing population

Vice President Al Gore has written, "No goal is more crucial to healing the global environment than stabilizing human population."[37] The explosion of human population, especially in the latter half of this century, has deeply affected all other Earth systems and creatures on this planet. In the last forty-five years the human population has increased to 5.5 billion people, and in the next forty-five years it will double again. It is estimated that 94 percent of that increase will occur in the developing countries, where poverty and environmental degradation are most severe and where the population of young adults will be the most concentrated. At the rate things are going, in thirty years Kenya, whose current population is 27 million, will have 50 million people; Egypt's 55 million will swell to 100 million; and Nigeria, with 100 million people today, will have 300 million by the year 2020.

How do we limit human population? By raising literacy rates and education levels, by addressing sexism and raising the status of women, by lowering infant mortality rates, and by guaranteeing ready access to birth control techniques, to name but a few examples. One of these birth control techniques is the spiritual practice I will discuss in the next chapter; through intelligent instruction, these techniques could be made available to all young people around the planet. Limiting human population has become a major virtue for ecological survival for our species and for the planet itself. As scientists from the United States National Academy of Sciences and the American Academy of Arts and Sciences put it in a joint statement in

1988: "Arresting global population growth should be second in importance only to avoiding a nuclear war on humanity's agenda. Overpopulation and rapid population growth are intimately connected with most aspects of the current human predicament, including rapid depletion of nonrenewable resources, deterioration of the environment (including rapid climate changes), and increasing international tensions."[38]

Now that the end of the Cold War has put nuclear catastrophe more or less on the back burner, it may well be time to put issues of stabilizing human population on the front burner of personal and governmental virtue building.

Politics

I was told recently by a progressive politician that the only interesting thing happening in politics is "spirituality and the environment." There is hope in this observation, for it demonstrates that politicians are getting the message about the Great Work of our time, and some are responding by bringing the work of politics into that Great Work. That is as it should be, for politics itself is a great work. Aquinas sees politics as the fulfillment of the command to "love your neighbor" on the greatest scale possible. He writes that in politics we consider "the ultimate end of human life" and that there is something godlike about politics so conceived. "Certainly it is a part of that love which should exist among human people that a person preserve the good even of a single human being. But it is much better and more divine that this be done for a whole people. . . ." Aquinas believes that to bring about real politics, the politician must know more about the human soul than physicians do about the body! Furthermore, "the obligation of a political leader to study the soul whose virtue he or she seeks is greater, because political science is more important than the science of medicine."[39]

Workers in the political arena are ripe for a new paradigm that will redefine their work. Congresswoman Pat Schroeder says that when the people lead, the politicians will follow. That is a hopeful statement, but it is not enough. In many respects a healthy politician—one

who is committed to taking leadership from the community—has to both follow and lead. A politics that has been totally secularized and totally anthropocentrized will never lead anywhere but backward, for the paradigm of secularization has been tried and has failed. A politician who does not engage in some kind of spiritual practice is not in a position to lead, for she or he is not in a position to know what is going on in the world—defined either as inner or outer. A politician with only an outer life will be buffeted by the winds of self-ish propaganda and money grabbing and will become a pawn for the power brokers of a discredited machine-age mind-set instead of serv-ing the people. I think that a test of authenticity we need to put to politicians is this: Are you promising a future without sacrifice? *Sac-rifice* is not a word that drops often from politicians' lips, but until it does, we do not have the truth before us. Letting go and learning healthier ways of living will be major elements of our culture's future as we learn to live with less, to live more simply, and to live with greater environmental virtue. Without some letting go we will have no reason to celebrate as a people, and despair will continue to in-crease.

The virtues I have listed in this chapter as ecological virtues are all political virtues as well. Their fulfillment or failure will largely spell out our future as a people, indeed, as a species. They are the pol-itics of the future, and young people with hopes and ideas ought to flock to the life of politics in order to renew it and its work environ-ment so they serve the environmental revolution. Work in the politics of the future ought not to be masked in tired rhetoric about altruism, for it is not altruistic. Rather, it is about survival and justice.

It is in politics that people come together and are heard. Here they set the priorities for their common life and for the living out of shared values. The promise offered by the environmental revolution must not be cut short. For example, California state senator Tom Hayden points out,

> The laws governing California's coastline and forests regard them
> as "resources" with only utilitarian value. Even 700-year-old red-
> woods have no inherent value under our law. In this widely observed

doctrine, jobs and development can come only from the systematic exploitation of natural resources. But this path has failed. . . . After 30 years of protests and politics, I am more convinced than ever that a moral vision—an "Earth Gospel" appended to our religious traditions—is needed for a sustainable future. . . .[40]

At the same time, given the new paradigm's emphasis on interdependence and participation, it is important that we not allow our politics to be defined solely in terms of "professionals" such as politicians or elected government officials. We need to move politics away from mass media—and the massive expense of playing the media game—toward local representation and local debate. Politics is too important a work to be left to an elite. All of us ought to be able to free up a certain number of hours per week to commit to political work, whether that means organizing, listening to the elderly, encouraging young folks, visiting prisons, continuing our education, debating the issues of the day, cleaning up our parks and unburying our creeks, or making friends with neighbors. Politics is increasingly about relationship, and it is everybody's concern.

Many of us were surprised when then-senator Al Gore published his book *Earth in the Balance: Ecology and the Human Spirit,* and we were surprised again when he was chosen by Bill Clinton to be his running mate. In his book, Gore takes a courageous stand on renewing the vocation of politics by way of an ecological and indeed a cosmological spirituality. He writes about the crisis in political life:

> Civilization is now capable of destroying itself. . . . Just as Samuel Johnson said that the prospect of hanging in a fortnight serves to concentrate the mind wonderfully, my work on nuclear arms control served to concentrate my mind on some of the larger purposes of politics. . . . Ecology is the study of balance, and some of the same principles that govern the healthy balance of elements in the global environment also apply to the healthy balance of forces making up our political system. In my view, however, our system is on the verge of losing its essential equilibrium.[41]

If our politics has lost its essential equilibrium—just as the Earth itself because of our industrial civilization—what is the cure to our ailment? It is, in Gore's words, spirituality.

In the end, we must restore a balance within ourselves between who we are and what we are doing. . . . The need for personal equilibrium can be described in an even simpler way. The more deeply I search for the roots of the global environmental crisis, the more I am convinced that it is an outer manifestation of an inner crisis that is, for lack of a better word, spiritual. As a politician, I know full well the special hazards of using "spiritual" to describe a problem like this one. . . . But what other word describes the collection of values and assumptions that determine our basic understanding of how we fit into the universe?[42]

Needless to say, it is a sign of deep hope that a politician with a sense of ecology, cosmology, and spirituality can now enter the so-called mainstream of politics. Leadership may be just around the corner.

In the final chapter to his book Gore offers an authentic political agenda when he outlines a "Global Marshall Plan" for preserving the Earth. He sees the overall goal as "the establishment, especially in the developing world—of the social and political conditions most conducive to the emergence of sustainable societies."[43] His plan has five strategic objectives:

1. The stabilizing of world population.
2. The rapid creation and development of environmentally appropriate technologies.
3. A comprehensive and ubiquitous change in the economic "rules of the road," by which we measure the impact of our decisions on the environment.
4. The negotiation and approval of a new generation of international agreements that are sensitive to the vast differences between "developed" and "developing" nations.
5. The establishment of a cooperative plan for educating the world's citizens about our global environment.

There is great hope and great challenge in revisioning the work of politics as Gore has done. The young are sure to be challenged and excited by the prospect, and the profession of politics is changing as a result. As increasing numbers of women are elected to higher office

we can expect these changes to accelerate. Havel, Hayden, and Gore are just the first generation of political prophets to announce the way. Waves of prophetic movements are gathering energy to enter the world of ecological and cosmological politics.

Responsible investing

Still another ecological virtue is investment with a conscience. Persons and institutions with money to invest ought not to leave their moral decision making to accountants, lawyers, or banking bureaucrats. They need to ask themselves: What are our values? What values do we want to support? What groups enhance those values today? How can my (or our) monies support healthy and health-bearing groups and organizations? The Social Investment Forum estimates that 500 billion dollars are now being invested by United States citizens in areas of specific ethical, social, or environmental concern that also bring financial return. This phenomenon is happening in Germany and the United Kingdom as well. One example of an American enterprise that has flourished is the South Shore Bank of Chicago. By the end of 1989 its total assets reached 185 million dollars, and it had loaned 130 million dollars to over 7,000 local business people and residents in Chicago's poor South Side community. Their repayment rate was over 98 percent. Its nonprofit subsidiary had trained 2,218 people and found jobs for 2,734; it had rehabilitated 376 units of housing for the lowest income residents.[44]

Clearly the time has come for unleashing the ecological virtues—habits that our species can learn to practice that will in turn allow us to pass on a beautiful planet to subsequent generations of creatures. Powerful and entrenched interests will resist such virtue; some always do. That is why vigilance, study, organizing, and keeping a clean heart and a clear mind are all part of the struggle. This work—so obviously linked to the Great Work, the harmony that working with the Tao promises us—will require courage, or "large hearts," on the part of us all. It will require letting go of food and automobile addictions and other habits of contemporary society that are dysfunctional. But new work will be generated in the process of letting go of the old.

6 | Reinventing Work: Education, the Young, and Sexuality

L earning is holy, an indispensable form of
purification as well as ennoblement.

RABBI ABRAHAM HESCHEL[1]

W hat strikes me most [after a visit to Sri Lanka] is that
Sarvodaya [a self-help movement in Sri Lanka] does not
regard unemployed youth as a liability—as most societies do,
where they are a drain on the economy and can be volatile and
destructive. Somehow Sarvodaya has been able to turn them
into an asset.

A WORLD BANK OFFICIAL[2]

E xcept in the modern world, sexuality has everywhere and
always been a hierophany, and the sexual act an integral
action and also a means of knowledge.

MIRCEA ELIADE[3]

In this chapter we want to apply transformative thinking to the work
that needs to be done in education, with youth, and with our sexual-
ity. According to scientist Thomas Kuhn, education is "all-important"
at a time of paradigm shift. But the issue arises: what kind of educa-
tion serves the paradigm shift the best? If we are to connect our daily
lives to the Great Work of the universe, as Rilke puts it, then clearly

we need to put our inner houses in order, especially the inner houses of our youth, of education, and of sexuality. In addressing these needs, we will indeed be inventing and reinventing much work.

Education

We might say that our era is in need of *wisdom schools,* as opposed to the *knowledge factories* that have characterized education during the industrial era. It is difficult to overestimate how many new jobs and how much new energy could be generated by making this shift alone. A wisdom school would honor the heart and body, the right brain of awe and wonder, as much as it would the analytic or left brain. It would therefore honor the artist by inviting her to teach not just art but life—to teach images that are within all of us. By eliciting images through art as meditation, a wisdom school would pay attention to people's pain, grief, and anger as well as their desires and dreams. When people can express the truths that are in them, they are truly learning.

In the learning process we gain many things: self-love and an awareness of our own dignity; insight into our gifts as well as our limits; social relationships to others in the work world and beyond; a sense of connectedness to human history by way of exposure to litera-ture, history, art, and science; skills for communicating, organizing, designing, and healing. And, by extension, living wisdom enters a community through education as well.

Education, from the Latin word *educere,* means "to lead out." It is the way that our species leads the best out of our children and adults alike. Unlike other species, we are not programmed by our DNA; we have to be mentored and challenged; we have to undergo practice and exercise to lead our wisdom out. And our compassion. And our skills in bringing both to the practical order. But it is in-creasingly clear that models of education we have established during the industrial era are not adequate for a postindustrial era. If it is to once again live up to its task of leading wisdom and compassion out of our species, education will need some basic and deep remodeling. In other words, it needs some *work.*

Studies demonstrate that education creates more jobs than almost any other investment. According to the Campaign for New Priorities, every billion dollars of taxes spent on defense creates 25,000 jobs. But the same amount of money directed to mass transit creates 30,000 jobs; to housing, 38,000 jobs; to health care, 40,000 jobs; to education, 41,000 jobs.[4] These statistics do not include the health care savings we realize when people feel good about themselves. (Studies in Canada indicate a direct correlation between education and longevity.) Nor do they include the amount we save on prison building and police enforcement when people do not have to turn to crime to express themselves or get money, or the money saved on welfare when persons, through education, can move from welfare to work.

The first task in remodeling education is to understand it as education *for work* and not merely *for jobs*. If we are to educate our young to enter a postindustrial workforce (because the definitions of work offered up in the industrial era are no longer adequate for our time), then we may need to borrow from more ancient—that is, preindustrial—forms of education. David Purpel, professor of education at the University of North Carolina, asks the basic question: what are we working hard to make happen in education? He feels we have trivialized education through "the evasion or neglect of larger, more critical topics and the stress put on technical rather than on social, political, and moral issues." Thus he is critiquing the so-called value-free mentality of the modern era and daring to bring the "prophetic tradition" (his words) into the debate about education, along with commitment to "compassion, creativity and justice." Purpel is himself accomplishing a prophetic task within his profession, urging it to move from a machine model to a greener one. He feels we lack a "mythos" or "overarching belief system" in our education efforts.[5]

One lesson we can learn from preindustrial peoples is the power of storytelling. I am struck by how important storytelling is among tribal peoples; it forms the basis of their educational systems. The Celtic peoples, for example, insisted that *only the poets could be teachers*. Why? I think it is because knowledge that is not passed through

the heart is dangerous: it may lack wisdom; it may be a power trip; it may squelch life in the learners. What if *our* educational systems were to insist that teachers be poets and storytellers and artists? What transformations would follow!

Education on a mass scale *is* the new work. Our minds never know too much. Our minds want to be stretched to experience the infinite, another word for which is *Spirit*. The mind yearns for Spirit; it yearns to be always new, to be young, to be learning, to be alive. Minds—all minds—have a right and desire to be stretched, to know wisdom itself, whether they are seven-year-old or seventy-seven-year-old minds. A Native American friend of mine tells me that he is often invited into public high schools to speak about Native American ways and wisdom. But he is forewarned that he must not use the word *spirit* because that would violate the separation of church and state. "But I'm an Indian," he tells me. "I can't speak about life without speaking of the Great Spirit and the other spirits of creation." I ask him how he handles it. He says, "I use the terms *spirit* and *Great Spirit,* and then I leave the classroom quickly and never return to the same school twice."

What folly our culture has gotten itself into, censoring the word *spirit* so that our young do not hear it! We don't seem to realize that when people are deprived of the experience of Spirit and the ways to this experience, they will, out of necessity, seek alternative and sometimes dangerous pseudo-routes to the Spirit, such as drugs, alcohol, premature sex, and religious cults. A culture that outlaws Spirit is inviting addictions—addictions that hide the cosmic loneliness people feel, addictions that derive from immature efforts to find Spirit on one's own or with one's peers. Adults who are afraid of Spirit ought not be designing schools for our children. Besides, what does Spirit have to do with separation of church and state when it is seldom part of either? Certainly, European theology and seminary training has seldom developed a theology of Spirit and has in great part ignored the teachings of our mystics. Those who imagine that Spirit is somehow owned by the churches have probably not been to church lately.

Education today can be reworked, reinvented, and re-formed using the cosmology that is emerging from the new creation story.

(See chapter 2, where we provided an outline of this cosmology.) We must educate about awe—awe of our universe, awe of our planet and its eighteen-billion-year story, awe of the creatures with whom we share this planet, awe of our species with its amazing capacities for creativity as well as for destruction. We must educate to put our inner houses in order, as Schumacher puts it—in this case the inner house of the community at large as well as of individuals. Today we share the same creation story no matter what our particular lineage, race, ethnic roots, religion, gender, social class, or species. Awe is something we humans experience in common; it is an energy source for each of us individually as well as for the community as a whole. With awe released, we have the energy to begin new things; we have the courage to let go; we have the joy to enter in. In releasing awe, we reawaken mysticism. This is the kind of education we so badly need today. Theodore Roszak makes the point that "during the Enlightenment, mystical ('enthusiastic') experience was targeted for ridicule as the worst transgression against reason and science."[6]

The question arises: can education do something about this inner spiritual aridity? And if not, is not every other attempt to improve education an idle effort? a superficial reformation? Is not every effort at education doomed to fail if it leaves out mysticism? leaves out Spirit? leaves out consciousness? If, as so many philosophers and religious traditions claim, Spirit is an indispensable power for the human, then how can we have human education without it? How will we ever learn to revere Earth and its creatures? How will our young be empowered?

Several models of wisdom schools already exist to point the way toward refashioning education. There are Waldorf schools, based on the teachings of Rudolf Steiner; Montessori schools; and the Institute in Culture and Creation Spirituality (ICCS) that I helped create some eighteen years ago. In all of these models the need for cosmology is recognized—the need for some form of meditation that allows us to internalize cosmology. Since I know our model the best, I will reflect on it in relation to needed reforms in our educational system.

The key to education at ICCS is threefold. First, we teach the new creation story from science. This story tells us of the wonder of

our bodies, our food, our planet, our cousin creatures. It must be told again and again by scientists as well as by artists, who are our mystics. It affects us all.

Second, we teach art as meditation, for art is the language of mysticism. In art as meditation, we unearth and honor the latent images in all persons. In art as meditation, persons become empowered from within; they learn to resist images coming exclusively from the outside. They pay attention to their inner work, since one cannot lie to inner images, whether they be images of wonder and awe, on the one hand, or images of grief, sorrow, and rage, on the other. All images need space in which to breathe. That is the work of art as meditation: to let our images breathe, to give them life, to bring them out so the community can help us interpret and critique them and so that the images can in turn give life to the community.

Of course art as meditation includes the body: there is no art without the body. And so education at ICCS honors the body by including it in our learning process. Consider the sweat lodge, for example (and I do not believe we will ever educate properly without it). There the body is teacher and the body is tested. Circle dances, drumming, and massage as meditation are additional ways we can learn from and with the body.

Third, we teach left-brain knowledge about the spiritual heritages of West and East as well as skills for implementing compassion in our society. Compassion is understood as living out of the cosmic law of interdependence. It is celebration because we find ourselves in a gratuitous universe; unconditional love has brought us here. Justice making and other types of healing are forms of compassion because we all live in human societies that yearn for healing from many kinds of injustice. *Compassion is the goal of education in the ICCS model.* It is also the starting point, not only because the mystics teach compassion ("whatever God does the first outburst is always compassion," Meister Eckhart observes[7]), but also because scientists teach this same truth today. Consider that our universe can best be imaged as an organism; an organism is an interdependent entity. If the foot hurts, the whole body hurts. That is the truth of the universe story as we are learning it today.

If we understand education to be preparation for work (and not just jobs), we must ask: what work today would be the most useful? What work would be the best investment, and therefore what educational models would serve us best? I propose that the most useful work for our times will be not the destructive work that factories make for us but the constructive work of compassion. The effects of compassion as the primary goal of education will flow everywhere into society. Compassion will be manifested in persons volunteering to teach literacy to adults, in persons teaching about our bodies, our diets, and our health care. Compassion can be brought to an analysis of the economic relations between rich and poor, and it can offer solutions for bridging the economic gaps between us. Compassion can take young artists and imbue them not only with the techniques of their craft but also with the reasons why they love their craft in the first place. Compassion will commit itself to *inventing* work.

Education can begin to deal with passions of rage and sorrow as well as dreams and desires. We must make room for grief work in our education today, for so many of us have been wounded in our own lives, and the Earth's wounds are all around us. Unlike the models we have inherited from Western Europe of the past few centuries, the model of education as compassion honors people of color, for the educational traditions of these persons never succumbed to defining truth only as head knowledge ("clear and distinct ideas," in Descartes's words). Furthermore, this educational model cannot be faked; only adults who have been shaped and reshaped by it are prepared to share it with other generations. The work in education that I propose is a matter of teaching about our inner selves, our inner houses, both as individuals and as communities. Since we have been neglecting this work for centuries, it has the potential to be a "growth industry."

We have secularized and anthropocentrized education; we have removed Spirit from it and with it cosmology and our feelings for the non-human world. In thus reducing education to a training ground for mere jobs (not work), we have lost our energy for it. But our spiritual heritage, as represented by Rabbi Abraham Heschel, teaches that "learning is holy, an indispensable form of purification as well as ennoblement." Notice: both purification (we might call this "discipline")

and ennoblement come from learning. Learning is an ecstasy, a spiritual experience. It is not merely a "preparation for life. Learning *is* life, a supreme experience of living, a climax of existence.... Termination of education is the beginning of despair."[8]

If learning is itself a spiritual discipline, can education be renewed without the dimension of spirituality? Heschel names the goal of education, first and foremost, as "education for reverence." Reverence follows on awe; but it begins with our experiences at home:

> The mainspring of tenderness and compassion lies in reverence. It is our supreme educational duty to enable the child to revere. The heart of the Ten Commandments is to be found in the words: *Revere thy father and thy mother.* Without profound reverence for father and mother, our ability to observe the other commandments is dangerously impaired. The problem we face, the problem I as a father face, is why my child should revere me. Unless my child will sense in my personal existence acts and attitudes that evoke reverence—the ability to delay satisfactions, to overcome prejudices, to sense the holy, to strive for the noble—why would she revere me? ... To educate means to cultivate the soul, not only the mind.[9]

Heschel proposes that old age "be regarded not as the age of stagnation but as *the* age of *opportunities for inner growth.*"[10] He suggests that homes for the elderly include directors of learning in charge of intellectual activities.

Thomas Aquinas warned, "There is nothing more dangerous than teaching that would cast people into the pit of despair."[11] *I suggest that whenever we teach anthropocentrism we teach despair; and whenever creativity—integral to our forms and lessons of education—is ignored, despair is being taught; and whenever we succumb to a machine cosmology and fail to replace it with a green cosmology, we are teaching despair.* We should not be surprised when the young act out their despair and self-hatred on society at large. The human animal is vulnerable to the teachings of the elders, and if the elders teach despair the young will imbibe it and give it back in their own way. The Tao Te Ching teaches that to "know one's origins: this is the essence of wisdom."[12] Until the young are blessed with an educational message and format that allow them to revel in their origins, they will not

taste the wisdom they seek. And all of us will pay the bitter price for their despair and cynicism.

In this section we have responded to Schumacher's question, "What can I actually do?" with a straightforward answer: what we can do is reinvent education. We can make it more worthy of our species, more sensitive to the Earth and other species, and more aware of our whole brain (left and right) and of our bodies and hearts. We can make it more effective, with a common goal: to build compassion.

Fashioning a Gift for the Young

All the issues of work I am addressing in this book affect youth both directly and indirectly. It is the young who have most of the nightmares about the future of this planet. It is they and their children and grandchildren who will inherit a planet less blessed and less beautiful than the one inherited by previous generations. They are the ones who will pay the price for soil erosion, deforestation, desertification, poisoning of the waters, holes in the ozone, nuclear and chemical waste dumping, depletion of a variety of species, and the other debts of the generations before them. A recent report has found that between 1979 and 1991, the juvenile population in detention facilities in the United States increased by almost 30 percent.[13] Poverty of the young breeds violence and despair. Adults could make their own lives richer by working with the young and seeing this commitment as a way of creating new work. It is time that adults saw their role in life as one of fashioning a gift for the young.

Working with Despair

Kids today have much going for them even given their despair and nightmares. Most importantly, they are not in denial; they cannot afford to be. They know what is going on, what is happening to them and around them. Many are in the dark night of the soul, and that is not a bad place to be. Despair, as the Hindu Scriptures teach, can be a yoga, a pathway to the Divine. Monk and theologian Bede Griffiths writes, "Despair is often the first step on the path of spiritual life and many people do not awaken to the Reality of God and the experience

of transformation in their lives till they go through the experience of emptiness, disillusion and despair."[14] As all the mystics teach, the *via negativa* is sometimes necessary for a while. It has much to teach us, mostly about wisdom rather than mere knowledge. The young frequently undergo grief work by themselves either by acting out their rage and anger or by covering it up with drugs, alcohol, or shopping, or by forming gangs that have their own, often harrowing, ritual demands. We adults should be wise enough to join them in alternative and healthy rituals of grieving.

Working with despair and grief will help to put the inner houses of our youth in order. Resolving grief and despair can be preventive medicine, eliminating the need for prison, for if the young do not have authentic outlets for their grief, including rage, sorrow, and transcendence, they will eventually display it in violent behavior. The fact that they are doing so today—and filling our overcrowded prisons faster than we can build new ones—is evidence that we are failing to address their needs. Instead of building more prisons for our young adults, we ought to prevent the violence that makes prisons necessary by taking seriously this new work of leading the young through their grief.

For example, why not pilot a project that I would call "Flights of Passage" that would take a planeload of inner-city youth to a place such as Ghana for six months where they would be exposed to village life, to supervision by elders, and to ancestral roots and spiritual traditions. This would constitute an uprooting (part of any rite of passage) from one's current home and might fill these young souls with imagination, hope, and inner discipline. Such an experience would amount to prison prevention, for there is every likelihood that these youngsters would return as young adults and could become leaders in their communities.

Youth, Spirituality, and Holism

There is a second, more hopeful, dimension to being young today. The young have a holistic worldview. I have observed this personally in many conversations with people in their twenties: they are less tainted by a dualistic view of the world than people in Western civi-

lization have been for centuries. When it comes to religion, for example, many of the most thoughtful young adults are really postdenominational. They want spiritual experience and the ethical responsibility it implies, but they are not committed to the us-versus-them ideology that has accompanied so much of the history of institutional religion. The present generation is less affected by a dualistic or Piscean view of the world (Pisces being symbolized by two fishes swimming in opposite directions). Instead, they were born into an Aquarian consciousness, that is, a view of the world as one great ocean, one great whole (cosmology), in which we swim, live, and have our being. Let me give a few examples.

In my work as a spiritual theologian, I meet young women and men who doubtless would have chosen to be nuns or monks or priests in the previous era of society and church. But they don't choose to do so today. Why not? Is it a lack of generosity or idealism? By no means. These people are generous but with their feet on the ground; they are idealists but realists too. They know that authentic power does not and cannot lie in institutions that no longer appeal to the heart and soul of their own generation. Are mere sociological changes going to stem the tide of empty seminaries and convents? Certainly not. If, however, these were places of spiritual learning, if they could reinvent themselves as leaders among wisdom schools, they might offer great service to the upcoming generation. The good news that I experience is that the most talented and creative of our young people believe that they can be mystics and prophets in the world. To do so, they feel they can and must undergo the same vagaries and testings of the spirits in all the relationships—social, intimate personal, sexual, work, and citizen relationships—that their peers undergo.

Adults must realize that the Piscean age and its social inventions are now behind us. An Aquarian view of nondualism—that one can be a monk and be married or a mystic in intimate relationship or a prophet who is also a mystic—seems far closer to the lifestyle and teaching of Jesus Christ than great monastic settlements. I am convinced that the Spirit is at work in many of our youth today precisely around the issue of vocation. They are searching hard, and many are

receiving genuine answers to their call. They are on paths that will indeed reinvent work, as we will consider later.

On a recent lecture tour in the Netherlands, I was asked, "Tell us, why are the young so interested in Creation Spirituality?" I was surprised by the question, for I did not know where the woman asking it (a Dutch Catholic sister in her sixties) got her information. Why, indeed, are the young interested in Creation Spirituality? Now that I have had more time to reflect on the issue, I believe I understand it better. I propose that young people want to participate in a Great Work. They don't want their lives to be trivial or trivialized. They don't want their souls to be shrunken to fit into a tidy box or a procrustean bed called Jobs. They are picking up news about the universe daily in the media, and they sense that they are indeed part of a vast and amazing story—the universe story. They seek beauty. That is what they want their life's work to be: a search for infinite beauty, a search for Spirit.

The Need for Adventure and Dreams

The young want adventure, and they have a right to it—inner adventure, spiritual adventure, mind and heart and body adventure. Adults ought to be at work providing such adventure, whether it be through theater or by challenging the young to climb mountains and roam the prairies, master mathematics or video production, or put out forest fires or repair car engines. Recently I saw a young man from the inner city interviewed on television. He was fighting forest fires, and he said it was the first job of his life. There was a pride and dignity about him. Previously he had served time in prison for murder.

The young need and deserve to be challenged. They too need to put their inner houses in order. Try putting youth in a sweat lodge, where they face death together, chant for their lives, pray through their bodies, and sweat out emotional, bodily, and spiritual toxins; adults will find good work in this kind of leadership. How about vision quests? And rites of passage? Without rites of passage we don't grow up. We become arrested adolescents and violence builds up inside of us. I see this kind of inner work as one of the growth indus-

tries of the nineties—this putting our inner houses in order, adult houses *and* youth houses.

I also believe that the young need to learn discipline; there is no substitute for it. Soaring for the infinite requires acknowledging limits, developing inner disciplines. The primary gift that adult workers need to share with the young is practices of discipline that allow the inner search to go on in depth. What about dreams? Where are the adults who should be paying attention to the dreams of the young and carrying this wisdom to the rest of us? Are we teaching our young people to learn from their dreams? To interpret them, trust them, and grasp their revelatory nature? To display them in drama, video, poetry, dance, and paint? In the teaching of inner disciplines lies work for adults and work preparation for the young.

All this inner work I am describing offers avenues for participating in the Great Work of the universe. It is every young person's conscious or unconscious wish to get lost in such greatness. And why not? We only pass by this place once. It takes great souls to participate in the Great Work. Homes, schools, churches, synagogues, even the entertainment world have to imbibe the new cosmology. Here is work that the adult community must take seriously, and, again, the work really begins with adults. If our own souls are shrunken and small, we are a part of the problem and our young people are doomed to wander the earth reinventing the wheel and falling more deeply into despair. But if the adults can *get to work* about the realities of the soul awakening in our young, then there is hope—and work—for us all. We should be taking the young into communities and training them to be spiritual leaders. They could then become teachers for their peers.

Youth As Workers

Youth should not be looked at as objects for work but rather as workers themselves. They have much to teach one another and older persons as well. Young people can work, for instance, with the very young, baby-sitting them or teaching them anything from sports to computers. Consider, for example, the immensely successful experiment undertaken by the Sandinista government in Nicaragua before

it was undermined by the U.S.-funded Contra war. There the government sent literate teenagers into villages and farm communities to teach illiterate adults. The results were amazing. This literacy "peace corps" of teenagers was responsible for reducing the illiteracy rates from 80 percent of the population to 13 percent of the population in just two years! These statistics, of course, tell only part of the story; the rest is less easily measured. Lines of communication opened between the young and the old; wisdom passed from the older to the younger; the young no doubt felt a sense of empowerment and fulfillment; and all experienced community among differing generations. Have we tried anything comparable in the United States, where a recent study found nearly 50 percent of our society to be functionally illiterate?[15] How much would our insurance rates and medical costs tumble if we were to train young people in basic nursing skills so they could care for the ailing and visit with the aged?

Respecting and Honoring Youth

The impressive accomplishment of youth and government alike in Nicaragua raises important questions about how readily we trivialize our young, render them passive and dependent, create consumer monsters of them, or make them into carbon copies of our own adultist fantasies and unresolved adolescent urges. Think, for example, of the sexism of cheerleading or the machismo and organized violence we teach in many adolescent sports. Think also of the entertainment industry and how readily it takes the passions of the young and exploits them for its own greed and sensationalism. What a serious sin adultism is! How readily we make objects of our young people to serve our own unexamined inner needs! Great is the abuse and exploitation that take place when adults see things only through the lenses of their own values.

In her book *Dharma and Development,* Joanna Macy reports on Sri Lanka's self-help movement known as Sarvodaya and on its successful efforts to enlist the youth instead of seeing them as problems. In respecting and honoring the youth, all other levels of society are blessed.

From the outset Ariyaratna [the founder and president of Sarvodaya] chose to work with and through the young in challenging his society to "awaken." The first shramadana, or collective labor project, was led by sixteen and seventeen-year-old students; and all the shrama-danas and projects that followed focused on the powerless elements of society, which include not only women and the landless and poor, but school dropouts and little children as well. . . . One builds *janashakti* (people's power) not only from the grassroots up, but also from the infant up.[16]

The youth were good workers in the movement, and their effects went far beyond their own age group. They used drama and skits to educate the people. "In village after village I saw the commitment and idealism of the children drawing adults into the Movement," Macy reports. A World Bank official noticed the same thing: "What strikes me most [after a visit to Sri Lanka] is that Sarvodaya does not regard unemployed youth as a liability—as most societies do, where they are a drain on the economy and can be volatile and destructive. Somehow Sarvodaya has been able to turn them into an asset."[17]

In our time and culture the young are adept at electronics, and they are hearing a new creation story at the same time that they feel deeply the apocalyptic threat to creation. Perhaps they can lead us in work based on interactive video that has a spiritual base to it and in ritual that uses these technologies. This is in fact what is happening in Sheffield, England, where a community of twenty-some-year-old artists, with the permission of the Anglican bishop, is creating "virtual worship planetary masses" that draw six hundred young worshipers each week. As one participant has put it, "This is not worship for the young; it is worship by the young." When the young are ignored, much is lost—not only in the evolution of the young but also in the evolution of the society as a whole.

Sexuality

Anthropologist Mircea Eliade warned us of what havoc the modern era has wreaked with our understanding of sexuality when he wrote, "Except in the modern world, sexuality has everywhere and always

been a hierophany, and the sexual act an integral action and also a means of knowledge." Sexuality is meant to be one of the sacred experiences of people's lives—provided we know we live in a sacred cosmos.

All spiritual traditions celebrate sexuality as a sacred act of the universe—a hierophany—by which we are indeed connected to the Great Work all around us. The Song of Songs devotes itself to this truth. It is as cosmological as it is beautiful, and it tells all lovers that their love is a holy, mystical act in communion with all the other sacramental acts of the universe. In human love, as depicted in this book, the true Sabbath is reenacted: the delight of creation; the delight God takes in creation and creation takes in God; the emerging of all of creation—animals and plants, stars and moon—to share in the joy of lovers. A new creation or re-creation story, a redemption of the story of the Garden of Eden, is offered in the Song of Songs.

Sexuality is part of the Great Work of the universe. We know this because the universe invented it and approved it or, in Thomas Aquinas's words, sexuality is "a great blessing." Sexuality is a power that, like any power, requires that we honor and respect it, first within ourselves, then in others, and finally between self and another. But if we have no spiritual ways by which to honor the power within, we will never honor it in others but will instead use them and sexuality for works that are not worthy of the Great Work of the universe.

Today young and old alike need to be reeducated about sexuality. A machine era has left us without passion and Eros in our lives, and so sexuality has been relegated to the periphery—to closet pornography and video allurements. Sexuality has been banished from the sanctuary, swept under the rug by religion in a futile attempt to try to repress it. This is not only strange but dangerous, for one way all of us are connected to the Great Work of the universe is through sexual experience. At least, this ought to be the case. In our culture the mystical and cosmological discoveries that sexual love offers often become deeply polluted by consumer sex, addictive sex, compulsive sex, abusive sex, or neurotic sex. A culture with no cosmology—with no spiritual practices that teach the young inner discipline and cosmic

interconnection—dissipates the power of sexuality and turns it into something negative: an escape, a weapon, an addiction, and, in the time of AIDS, an early death or perhaps a solitary existence.

It is my experience that today's young people want the truth about sexuality. The first honest thing we need to say about sexuality is that it is a sacred power with which we are all blessed. Thomas Aquinas said that of all the powers of our souls—nutritive, augmentative, and generative—the greatest is our generative power, for it makes us most like God, who is "supremely fecund." The *via creativa,* the third path of Creation Spirituality, is concerned with sexuality insofar as it is about generativity and creativity, not only the literal act of generation—of conceiving and birthing children—but the deeper acts as well. And those deeper acts include blessing a relationship, sharing intimacy, self-discovery and other-discovery, sharing cosmic grace, playing and wrestling with the Cosmic Christ in the joy and sensuousness of giving and receiving love, and educating one another and the next generation about how to play in the world with wisdom.

Because sexuality in its fullest form falls under the *via creativa,* it presumes the experiences and disciplines of the *via positiva* and *via negativa* that precede it. In other words, sexuality cannot substitute for the *via positiva* experienced in other realms of awe and wonder besides sexual experience, and it cannot fill the void left when we ignore the nothingness of the *via negativa.* Healthy and wholesome sexuality presumes the disciplines of letting go, of emptying, of waiting, of solitude, of humor, and of chastity, which the *via negativa* teaches us. If we have not learned lessons of solitude we should not be playing around with the power of sexuality. It is so powerful a mystical experience that approaching it without discipline is like holding a weapon in our hands: we may self-destruct, or we may ruin our own lives and others' not only by spreading disease but also by parenting children before we are ready. How readily adults' and children's lives can be damaged by the immature use of our sexual powers!

We need rites of passage that initiate us into the mystery and the responsibility of our sexual power, for only ritual teaches us to honor the sacred. And if Robert Bly is correct when he says that males learn

"only by ritual," and if ritual is as rare as it appears in our culture, then we must indeed have a culture filled with ignorant and dangerous men.

The Inuit peoples' term for making love means "to make laughter together." And we need much laughter in these troubled times. Sexuality can contribute to that laughter, but only to the extent that its greatness is set within the larger context of the Great Work. There lies its origin, its purpose, and its beauty and grace. To reeducate about sexuality; to lift it out of commercialization, consumerism, escapism, or addiction; to remove it from moralisms and guilt where so many religious traditions have relegated it—this would be a way to reinvent work in our time.

Renewing sexuality will require workers of many kinds to educate, to perform rites of passage, to lead discussion groups, to help people adjust to mistakes made, to teach healthy solitude, to raise consciousness about homophobia, to strengthen marriages and committed partnerships, to help people explore alternative forms of intimacy, to teach healthy celibacy when appropriate. In short, honesty is a whole field of work that we could develop if we wished to, and it is what the upcoming generations deserve regarding the practice and theory of sexuality. There is good work to be done on sexuality and on linking the Great Work to sexuality for all ages.

The transforming of our sexual awareness is important not only for the young but for the youth in all of us. The return of Eros is an important energy source in any cultural renewal. The fear of sex that exists today—both because of disease and out of a deeply ingrained dualistic ideology that pits matter against spirit and that fundamentalist religion has always taught in the West—can interfere with the return of healthy Eros. Without a passion for living and an integration of all our passions, our species will not have the energy to overcome its inertia and to reinvent itself. The generativity that we need in our lives will not happen if we run from the generative powers with which we have been blessed. By rediscovering healthy and honest sexuality, the young may prove to be spiritual directors to the elders, who sometimes find it more comfortable to ignore the whole subject. The demands that youth put on the elders for wisdom about

sexuality can contribute to better and deeper communication between generations and bring more joy in everyone's lives.

Part of putting our inner houses in order is reestablishing the connection between our sexuality and the Great Work of the universe. The failure of so many marriages and relationships and the serious crimes committed against sexual minorities because of fear and ignorance also point up the need for greater honesty. *Real work,* important work, and much work awaits those who can teach us about sexuality and spirituality.

Population control is an especially pressing issue today. Birth control technology alone cannot limit the human population. I think we also need mystical practice. In the Taoist spiritual tradition and in certain yoga traditions of India, men can be taught to regulate their acts of sexual intercourse so that no sperm is ejaculated at orgasm, and yet the delight of the couple is in no way diminished. Wouldn't it be appropriate to teach these mystical practices to *every young man in the world?* Such education is *not* just about sex; it is at base about spirituality, about inner discipline and mystical experience. People who have been teaching this kind of mystical eros and sexuality inform me that while people originally are attracted to it because of its sexual dimension, what actually is taught and most deeply appreciated is the spiritual discipline. The key to the Taoist practices is breathing, which, after all, is what all prayer is about. Hildegard of Bingen in the twelfth century said that prayer is nothing but inhaling and exhaling the one breath of the universe. Working at erotic energy and spirituality is work that truly puts our inner house in order and will assist our overly crowded outer houses as well.

Conclusion: Is It Time for a New Spiritual Order?

In this chapter we have explored three areas wherein we humans have much unfinished business. The work to be done is, clearly, *on the human species by the human species.* Yet we are by no means alone in our efforts to educate adults and then children about cosmology; nor are we alone when it comes to working with and learning from the youth; nor are we alone in reeducating ourselves, young and old

alike, about sexuality. The entire creation cheers us on in this important work, for all of creation has a stake in our species' efforts to put our own inner houses in order.

The young have a special need today to be gifted by the elders. Why not a sabbatical for young people—a year off from the strife of adolescence (which psychologists tell us lasts until age twenty-seven in our culture)—to engage in spiritual exploration? This sabbatical year would relieve the job market as well as teach the young new ways of being themselves.

I believe that what is demanded of us in these times has its nearest parallel in the founding of new religious orders in the past. The orders came about during a time of cultural and religious paradigm shifts— indeed, at times of religious decadence analogous to our own times. In Sheffield, England, the youth today are creating an order dedicated to the important work of making rituals that work for the upcoming generation. They are learning ways to live community while respecting privacy—living in neighborhoods rather than under one roof, for example. They are learning lessons of sacrifice for a greater cause, for example, in pooling the resources of those who work jobs for money so that other members are available to give their full-time energies to the ritual work of the community for free. What is key to the energy of this new spiritual order is its clear and compelling common task: making rituals that work. I sense that many young people around the world today would jump at the invitation to join such a community— communities that exist for a nontrivial purpose.

Today we do not so much need a religious order as a spiritual order, one that will teach spiritual praxis especially to the young and pay special attention to the wounds of the young. Healthy spiritual practice, ways to pray and meditate, the art of being silent and experiencing solitude—all these are *rights* that all humans ought to inherit from their elders. The problem is that our elders today have been so tainted by the antimystical attitudes of the modern culture in which they have been immersed that it is rare to be able to learn spiritual ways from them. Thomas Berry, in his midseventies, recently confessed, "My generation has been an autistic generation." Our elders have not been listening to the revelations of nature either around

them or within them. Wisdom is scarce. A new spiritual order is required to bring forth whatever wisdom still remains in our collective memories.

The new spiritual order will not be Piscean; that is, it will not indulge in dualisms of being in the world or out of the world; of lay or ordained; of male or female; of homosexual or heterosexual; of old or young; of denominationalism. Its spirituality will be creation centered, which is to say it will honor the Divine wherever it is found. The new spiritual order will be about training and sustaining persons who will serve the Earth community—spiritual warriors dedicated to bringing about the environmental revolution. The healing of the wounded child will allow the full adult to both *play* in the universe (mysticism) *and work* in the universe (prophecy).

Where there is a living vision, one based on service to the Earth community and to unborn generations, there is life. Such an order would bring life, hope, and energy. With that awakening anything can happen. It is not money we lack as a species today (though granted, all our patriarchal institutions are in debt). What we most lack is energy, vision, awakening. We lack Spirit. When the human species wakes up it is capable of great things. It is this call to greatness that would emanate from this community like a beacon of hope. By unlocking our imaginations new work would abound.

Reinventing Work: Health Care, Psychology, and Art

The curricula of most Western medical schools has not incorporated the developing world of ideas and feelings into their structure. The world has moved on and medicine is in danger of being left behind.

DR. PATRICK C. PIETRONI[1]

Our society has eliminated many of the traditional methods of evoking the Relaxation Response. Prayer and meditation, as practiced by the ancients, have become part of our historical memory.

HERBERT BENSON, M.D.[2]

In the last analysis, the psychological roots of the crisis humanity is facing on a global scale seem to lie in the loss of the spiritual perspective.

DR. STANISLAV GROF[3]

Psychology is searching for a substitute for the cosmic unity which the [humans] of Antiquity enjoyed in life and expressed in [their] religion, but which modern [humans have] lost—a loss which accounts for the development of the neurotic type.

OTTO RANK[4]

> To see our interdependence and interconnectedness is the
> feminine perspective that has been missing, not only in our
> scientific thinking and policy-making, but in our aesthetic
> philosophy as well.
> SUZI GABLIK[5]

In this chapter we will consider how the paradigm shift from a machine era to a green era assists in reinventing our work worlds of health care, psychology, and art.

Health Care

It is no secret that medicine and health care are in a crisis. The issues concerning health insurance—who gets it? who doesn't? who pays for it? what kind of medical care is covered?—are closely related to what we think medicine is all about. The fact that health insurers rarely cover such alternative treatments as massage, vitamin supplements, meditation, acupuncture, or herbal treatments, while they do cover CAT scans, laser surgery, and other high technology medicine, tells us much about how we conceive of medicine in the West. Most people still define medicine on the basis of the Enlightenment concept of the human body as a machine. This is how Descartes defined it:

> I consider the human body as a machine. My thought compares a
> sick man and an ill-made clock with my ideas of a healthy man and a
> well-made clock. I say that you consider these functions occur naturally in this machine solely by the dispositions of its organs not less
> than the movement of a clock.[6]

What happens when we believe our bodies are machines in the way that a clock is? British biologist Rupert Sheldrake warns that in the Cartesian model of the world,

> Souls were withdrawn from the whole of the natural world. All
> nature was inanimate, soul-less, dead, rather than alive. The soul
> was also withdrawn from the human body which became a mechanical automaton, leaving only the rational soul, the conscious mind in
> a small region of the brain.[7]

In his probing book *The Greening of Medicine,* Dr. Patrick C. Pietroni, a senior lecturer in general practice at St. Mary's Hospital Medical School in London, sees the crisis in medical education as a paradigm shift to which the medical profession responds or fails to respond.

> The intellectual framework underpinning the curricula of most Western medical schools has not incorporated the developing world of ideas and feelings into their structure. The world has moved on and medicine is in danger of being left behind. Medical students are still taught that medicine is, by and large, about the body and its functions; that the body is made up of bits and pieces which are studied as separate and distinct entities. They are still taught about the mind as a separate entity from the body. They are still taught that treatment comes either in the form of a prescription or a surgical operation. They receive little or no training in communication skills and leave medical school with an understanding of disease but no knowledge of health.[8]

Yet Pietroni sees hope for the health care of the future. He espouses the principles of "harmony, balance, the interconnectedness of natural phenomena and the search for inner awareness," which he says will characterize a revolution in medicine of the twenty-first century. He believes that a change in consciousness has already begun, as evidenced in such books as *Love, Medicine and Miracles,* which "suggest that the possibility of effecting change in one's state of well-being derives from altering one's consciousness of self and one's relationship with the environment."[9]

The question of health versus medicine affects not only patients but also medical professionals, who are stressed by excessive work hours and addictive work relationships. Clearly, good work awaits those who commit themselves to changing the approach of Western medicine. Part of this good work will be relieving the health care workers who are overworking in their profession and underexploring their own inner lives. Health care workers need spiritual practice as much as anyone else and perhaps even more so: their work brings them into close daily proximity with the mysteries of life and death.

They could well benefit if spiritual directors and ritual makers were committed to the well-being of health care providers as well as patients.

We see the beginnings of this movement in many hospitals, where chaplains are moving beyond a psychological model of pastoral care to a spirituality model that includes imaging, meditation, and ritual. At the Pacific Presbyterian Medical Center in San Francisco, the Reverend Barbara St. Andrews, a chaplain who has been an Anglican priest for fourteen years, has started a series called "Program in Medicine and Philosophy." Each month she invites a lecturer to speak about the paradigm shift and ancient ways of healing. Results are significant. In response to a lecture on Eckhart's theme of driving money lenders from the Temple, for example, she told me that the room full of doctors was crying. She went on to say that she is concerned with "putting the care back into health care" and the need to bring "heart-centered gifts to the forefront in our society."

A similar lecture series, called "Innovations in the Hospital Setting," has begun in Marin General Hospital, in Marin County, California. The philosophy of that program emphasizes the difference between treating a disease and treating a person:

> The impact of a medical crisis in a person's life touches their emotional, mental, and spiritual experience, as well as affecting family, friends, and work relations. For many, it becomes an opportunity to reexamine priorities and lifestyle choices, and it can be a chaotic and frightening time. But this time also holds the potential for weaving a new life view that serves new needs and promotes growth. This weaving together of life experiences with hope and meaning is essential to the healing process. It is a creative endeavor that requires courage and is enhanced by the nonjudgmental support of others. The blend of hope and realism, compassion and technology, imagination and tradition requires a dynamic balance for true progress.[10]

Working actively with the new paradigm, the hospital is opening a Cancer Care Center, where artists who have experienced cancer have helped plan both the space and the artworks. Its garden will house only plants that are chemotherapy agents.

In the healing community, immense passion and interest that could be used for its own regeneration and healing presently lie fallow. Clearly, much good work can be done within the healing professions, and everyone will benefit from it—the patients no less than the professionals, and the insurance companies no less than the financial stewards of the hospitals. Some managers may be threatened by the introduction of spiritual ways, however, for their training seldom alludes to a cosmology or a spirituality or indeed to a value system beyond the "bottom line." This is one more indication of the need to transform education itself, including education in business and management. We will consider this topic in chapter 8.

Part of the language and consciousness shift needed in medicine is a change from patriarchal war imagery to a more compassionate mode. We speak of "fighting disease," "the war against cancer," "stamping out infection," "cutting out the growth," finding the "magic bullet." These images hardly conjure up responses of "loving one's enemy." But the body's capacity to respond to gentle and loving touch, to exercise and healthy nutrition, to healthy water, air, and food is part of erotic living. Much dis-ease happens because the erotic wholeness of a healthy environment is being destroyed. As the Earth's health goes, so goes our own. In no way, then, can our efforts at health be separated from the health of the other species on this planet and indeed of the planet itself. Perhaps environmental work is most appropriately understood as the work of preventative medicine. An environmental consciousness also allows us to value again the importance of relationships as the key to all healthy living.

Prayer and meditation have their role to play in healing. Herbert Benson, M.D., in his book *The Relaxation Response,* has documented by scientific testing the clear positive results of meditation on slowing metabolism and lowering blood pressure and blood-lactate levels.[11] What Benson calls an "epidemic of hypertension" in our society can be relieved by meditation practices or what he calls the "relaxation response," practices that have "always existed in the context of religious teachings" and have been "a part of the cultures of [humankind] throughout the ages."[12] Benson sounds like Meister Eckhart when he talks of a "cessation of the intellect" and a "relaxation of the will" to

induce a condition of stillness of the mind, or when he distinguishes between the outer self and the inner self:

> Our usual thinking is concerned with events outside ourselves. Through our emotional attachments, our social feelings, our ideological beliefs, our sensory contacts, we are constantly diverting our thinking toward external factors. Any attempt to redirect this outwardly directed consciousness requires a different mental process.[13]

Benson emphasizes the *physiologic* dimension to meditation, and this alone could bring about a revolution in health care—a revolution that would lower health care costs, and consequently insurance premiums, dramatically. Our capacity for the relaxation response is not high-tech, and it is not something we get from an expert. Indeed, it "resides within all of us."[14] To elicit this inner work—with its capacity for physiological as well as emotional healing—would demand a new philosophy of work in our culture and particularly in the health care field:

> *The Relaxation Response can be evoked only if time is set aside and a conscious effort is made.* Our society has given very little attention to the importance of relaxation. Perhaps our work ethic views a person who takes time off as unproductive and lazy. At the same time, our society has eliminated many of the traditional methods of evoking the Relaxation Response. Prayer and meditation, as practiced by the ancients, have become part of our historical memory. . . . Is it unreasonable to incorporate this inborn capacity into our daily lives by having a "Relaxation Response break" instead of a coffee break? You can choose any method of eliciting the response which best fits your own inclinations: a secular, a religious, or an Eastern technique.[15]

Everything I read about doctors' lives sounds like a conspiracy to flee from the relaxation response. I know a priest who lives in a medical students' dorm in a major medical complex in New York. His primary responsibility is to prevent suicides; there were four suicides in the dorm the year before he was hired. The compulsive and addictive work habits of the medical profession begin in medical school, and for many they continue until retirement. The old dictum, "Doctor, heal thyself!" has never been more appropriate. We will not have

sound medicine until doctors and nurses are allowed and encouraged to do spiritual practice.

One doctor who has stepped out of the current medical paradigm to envision a new one is Patch Adams, M.D., whose heretical notions about science include giving away health care for free. Founder of the Gesundheit Institute in northern West Virginia, he and other health care providers have treated more than 15,000 people without payment or malpractice insurance. His book, *Gesundheit!* is a veritable medical manifesto that urges professionals to "move medicine from a hierarchy of power and prestige to one of a friendly team spirit." He urges a "drastic rethinking" of health care:

> Rather than quick-fixing the failing health care system, we need to create solutions that will excite both patients and caregivers. We must, in a mutual, multidisciplinary effort, tear down what hurts us and heal a profession of healers. We must take medicine out of the business sector and recognize that greed and selfishness have placed society and its health care system in great peril.[16]

Adams wisely calls the depressed to service as a form of therapy, calling it "one of the greatest medicines ever discovered." Service is, he maintains, "the great fatigue killer, the destroyer of depression and boredom, the way to end immobility caused by fear."[17]

Another doctor who has dared to move beyond the present paradigm is Larry Dossey, who, in his book *Healing Words: The Power of Prayer and the Practice of Medicine,* brings together science and spirituality in a powerful synthesis of support for the power of prayer to heal.[18]

Another avenue to revisioning health care is to step out of an exclusively Western way of seeing the body and consider how the East treats health and disease. The purpose of Chinese medicine is to restore the harmony that is believed to exist in all beings in the universe but that can be disrupted by accidents or infections. In the West, medical schools emphasize the study of cadavers. In traditional Eastern schools of medicine, students study living bodies. In so doing they examine not just parts, but the wealth of interactive relationships

within the body: emotions, feelings, organs, shapes of the body, the relation of heart to liver. Chinese medicine excels at reading the signs of imbalance in the body before structural damage occurs and thus preventing disease before it develops; the West excels at finding malignancies and bacteria that cause infection and in removing damaged organs.

Harriet Beinfield and Efrem Korngold run a clinic based on Chinese acupuncture and herbal medicine in San Francisco. In their book, *Between Heaven and Earth: A Guide to Chinese Medicine,* they offer a view of medicine that is decidedly different from the mechanical model. They contrast the Western image of "doctor as mechanic" to the image of "doctor as gardener," which they feel symbolizes the Eastern approach. The doctor is a gardener who respects the processes of nature, for "the gardener does not make the garden grow. Nature does. The gardener is an ally who prepares the soil, sows the seeds, waters, and removes the weeds, placing plants in the proper relation to each other and the sun." The human body is not unlike the Earth body, for "both the garden and the human body are microcosms of nature." Patterns of harmony permeate the human garden. "The body is to nature as a violin is to an orchestra,"[19] and the theory of correspondence teaches that in order for a larger system to be in balance as a whole, each smaller system within it must also be balanced.

Health, in this tradition, is defined as "the ability of an organism to respond appropriately to a wide variety of challenges in a way that insures maintaining equilibrium and integrity"; and disease is "a failure to adapt to challenge, a disruption of the overall equilibrium, and a rent in the fabric of the organism. . . . The source of disease is any challenge to the body with which it is unable to cope, whether it is a harmful substance or a bad feeling. Disease is a manifestation of an unstable process, a pattern of disharmonious relationships."[20] To me this definition of disease sounds like the definition of injustice itself—disharmonious relationships.

Despite Western skepticism, Chinese medicine works. One Chinese doctor said to me, "We have been practicing this medicine for

thousands of years. Obviously it would not have lasted this long if it didn't serve us well!" Good work aplenty awaits not only practitioners of this tradition, but also those who can make this medicine more available in hospitals and community clinics and urge insurance companies to support it. In fact, insurance rates connected with these holistic practices should be lower for at least three reasons. First, they involve little or no expensive technology; second, positive results mean that the insurer does not have to pay repeated claims; third, overhead is low.

I recently met a medical doctor in Syracuse, New York, whose passion is to bring together *all people and traditions* working to heal, including Western medical doctors, Eastern health care practitioners, chiropractors, homeopaths, herbal healers, and so on. This kind of *medical ecumenism* is long overdue: no one tradition holds all the answers, and each can learn from the skills and wisdom of the others.

The health care field can also receive infusions of new energy by including *artists* in the work of healing. Art offers us ways to heal, ways to bring alive the inherent powers of passion for living that dwell in all of us. For example, wonderful things happen at the Spiral Garden of Toronto's Hugh MacMillan Rehabilitation Center, a facility for children with cancer. In this garden children with cancer leave the hospital building and gather outdoors to play, plant gardens, and do rituals involving masks, puppets, music, and games. At first the medical staff was skeptical of the garden's reason for being, but the results in terms of raising the spirits of the children have spoken for themselves. Begun by artist Paul Hogan, the garden is supervised by a core group of six to ten artists, who

> help make or find connections between the children themselves, the
> environment, and the people and situations which are part of daily
> life in the hospital. Culture is seen as a bridge back to community and
> away from the alienating effects of illness. As one visiting author put
> it, "In the Spiral Garden art is put to the ultimate test: its capacity to
> heal the spirit."[21]

Robert Rice founded and directed the Artworks project at San Francisco's Institute on Aging. In that program professional musi-

cians, writers, visual artists, and actors visit disabled and elderly persons at an adult day care center and in their homes, engaging them in drawing, painting, music, creative writing, drama, and other forms of artistic expression. The results are deeply inspiring—for client and artist alike. One elderly person said, "You artists have saved my life." Another wrote that the artist

> gave me a very worthy treasure to add to my experiences during the
> long years of life on this Earth. He was able to awaken all the senses
> in my weakening system to enjoy the things that I see around me.
> Before this, my time seemed to be dragging slowly, but now the hours
> seem to be running from some hidden forces out in space, flashing
> fearlessly like a comet soon to end, but never knowing when.

The artist, in turn, said, "I am discovering a growing sense of spirituality and a deeper level of communication."[22]

Art truly can be a spiritual discipline for us all. When the artist is included in our health paradigms, healing often takes place at different levels and in far less expensive ways than when technology alone is used.

Recently, a Canadian physicist who is a member of the Ministry of the Environment in Ontario told me, "Here in Ontario there is a serious effort going on at the government level to achieve a *healthier* society as opposed to a *more medicated* society.... We have had a medical system and not a health system." The paradigm shift in health care we have been discussing in this chapter is a movement from a *medical model* to a *health model*. When one visits a doctor and is treated for an illness, one is being "fixed up." But at the end of the session, when one sits down and the doctor asks, "Tell me how you are doing," the doctor is doing health work.[23]

A health system pays attention to work and to education because, according to available data, these are health expenditures; the unemployed and undereducated are at the highest risk of health problems. Environmental health and child development are both investments in health. In addition, data demonstrates that a key determinant of average life expectancy is the difference in income between the rich and poor in a given society. Where the gap is relatively narrow—as in

Costa Rica, for example—the entire society is healthier physically and emotionally. But where the gap is wide, the society as a whole is diseased. Persons with less income indulge more in alcohol, cigarettes, and food in order to cope, and these are identified as health problems rather than the poverty that is their root cause.

A recent study has found that unhealthy habits and violence cost the United States about 43 billion dollars in direct medical expenses every year. "Violence, drugs, alcohol and tobacco are wreaking havoc on our health system," says Dr. Daniel Johnson of the AMA's House of Delegates.[24] An investment in justice and spirituality would seem to be a wise investment, since it would lower health costs.

Another example of art that heals by bringing forth a new cosmology and a conscious spirituality can be found in the work of the Dutch architect Ton Alberts, whose design for the ING Bank in Amsterdam is based on environmental consciousness and spiritual principles. As he puts it, "Nature is the source of inspiration for my work. The beauty of nature is linked with organic architecture." The greatest possible use of the sun is guaranteed by using solar collectors, sloped walls, and a ceramic energy retrieval wheel that draws heat from the air. No air conditioning is needed. Plants and water fountains within the building provide the needed humidity. The results are that the building saves two million dollars annually in electrical costs and the atmosphere is so friendly to the 2200 employees that a 25 percent reduction in absenteeism is reported. This demonstrates that creation-centered architecture is a sound financial investment.[25]

Psychology

Emotional health is an integral dimension to reinventing the work of health care. Traditionally, the word *psychology* referred to the study or exploration of the soul, and traditional thinkers understood healing to take place with the help of spirituality. For example, in the thirteenth century, Thomas Aquinas connected mysticism and awe to psychological healing when he said that wonder actually cures the soul:

> Wonder was the motive that led people to philosophy. Philosophy
> is to the cure of the soul what medicine is to the cure of the body.
> Wonder is a kind of desire in knowing. It is the cause of delight
> because it carries with it the hope of discovery.[26]

Notice what Aquinas tells us will accompany wonder: cure of the soul, desire, delight, and hope. Psychologist Otto Rank understood well the pathos of our having abandoned a cosmology and the suffering this loss inflicted on our souls: "Psychology is searching for a substitute for the cosmic unity which the man of Antiquity enjoyed in life and expressed in his religion, but which modern man has lost—a loss which accounts for the development of the neurotic type." The modern era robbed us of our cosmology, and it robbed psychology of soul itself, according to Rank. "Psychology is the last and youngest offspring of religion, more specifically of the age-old belief in the Soul. Yet . . . in order to appear rational, psychology had to deny the very existence of its parent, the belief in the soul. . . ."[27]

Rank's psychological theory expresses the creative fluidity of the psyche and the cosmos.

> This psychology that I have arrived at is absolutely dynamic, there
> is nothing static at all. The static may exist, but if the individual
> [patient] is confronted with a new situation, in other words with
> life. . . . [the patient's task] is to create himself and then to go on
> and create externally. . . . I consider psychology a science of relations
> and interrelations, or if you prefer a more modern term, a science of
> relativity.[28]

Today, more than fifty-three years after Rank made these observations, we are finally beginning to think differently about our "soul diseases" and their cures. Many people trained in a secular and even mechanical approach to the psyche are feeling called to practice therapy as something akin to spiritual direction. They are moving from a fall/redemption model that begins by asking, "What is your problem?" to a creation-centered spiritual direction that begins with the more far-reaching question, "What is your divine grace and how can it be better freed to express itself?"

After decades of separation and mutual hostility, several psychological movements are actively juxtaposing the psychological and the spiritual. The Common Boundary movement, begun by Anne and Charles Simpkinson and whose sole purpose is to gather together therapists interested in spirituality, is one example; and the transpersonal psychology movement redefines the role of the therapist in light of a heightened consciousness of spirituality and its possibilities. Stanislav Grof, from the perspective of the latter, speaks of the neglect of spirituality in the West:

> In the last analysis, the psychological roots of the crisis humanity is facing on a global scale seem to lie in the loss of the spiritual perspective. Since a harmonious experience of life requires, among other things, fulfillment of transcendental needs, a culture that has denied spirituality and has lost access to the transpersonal dimensions of existence is doomed to failure in all other avenues of its activities.[29]

This is a prophetic and apocalyptic warning—that "all other avenues" of our activities (in other words, all our works) are "doomed to failure" in a culture that has lost touch with spirituality.

Another movement promising new work in psychology is that of ecopsychology. In *The Voice of the Earth,* Theodore Roszak decries the anthropocentric bias of Western psychology beginning with Freud, "ever the urban intellectual," who gave us a psychotherapy "that separated person from planet." Roszak believes that how clearly we understand the world depends on the emotional tone with which we confront the world. "Care, trust, and love determine that tone, as they do our relationship to another person. Our sense of being split off from an 'outer' world where we find no companionable response has everything to do with our obsessive need to conquer and subjugate."[30] In other words, cosmology heals. It puts us into right relationship and frees us from conquest mentalities. Roszak also believes that Freud's anthropocentrism created a "despairing vision of life" that "continues to haunt the major schools of mainstream psychiatric thought."

> It is a sort of negative presence, unmentioned but always there in the background: the image of a cosmos too alien to take into conscious-

ness. The decision modern psychiatry has made to cut itself off from nature at large and minister to the psyche within a purely personal and social frame of reference follows from Freud's courageous but failed effort to find a humanly acceptable connection between the inner and the outer worlds.[31]

Roszak recognizes that the "biomedical model of the psyche was patterned upon a preexisting biomedical model of the body." In the paradigm of the Enlightenment, the body was a "disenchanted object" that was "nothing but a machine."And a machine can be "analyzed into springs, levers, pumps, pistons. This is the distant origin of our conviction that the body can be improved upon by spare-parts surgery. The psyche came to be seen as nothing sacred because the body to which it was attached was nothing sacred." Roszak urges a replacement of our machine paradigm for psychology with a sense of the sacramental character of reality—an understanding of the psyche that ancient psychologies cherished. He believes that sanity itself is "a matter of balance and reciprocity between the human and the non-human. . . . The natural realm is infused with divinity; to break faith with it is not only crazy but sacrilegious."[32]

The industrial revolution became the model by which we understood our souls. It offered us a "bellicose model of the organic world" wherein, for example, Darwin projected "the ethos of industrial capitalism into the jungle, concluding that all life had to be what it had become in the early mill towns: a vicious 'struggle for existence.' " In contrast, we now understand more of the complex relationships of interdependence and cooperation that characterize species and their interrelationships. Conscience is part of human nature. We need to move beyond "our secularized psychology" to learn from the ancient societies that stressed trust and the "claim of the nurturing planet upon our loyalty."[33]

Ecopsychology, Roszak believes, expands our understanding of the self and includes the mystery and wonder, the omnipresent mind and purpose, of the eighteen-billion-year-history that we share with all beings on this planet. He offers eight principles for revisioning the self:

1. The core of the mind is the ecological unconscious. Ignoring this results in collusive madness in our society.
2. The contents of the ecological unconscious represent the living record of cosmic evolution and today's ecopsychology draws on the new cosmological story.
3. The goal of ecopsychology is to awaken the inherent sense of an environmental reciprocity that lies within us in order to heal the alienation between persons and the natural environment.
4. The crucial stage of development is childhood, and ecopsychology "seeks to recover the child's innately animistic quality of experience in functionally 'sane' adults." It turns to sources such as the healing techniques of primary peoples, nature mysticism as expressed in religion and art, the experience of wilderness, and the insights of deep ecology.
5. The ecological ego matures in a sense of ethical responsibility with the planet.
6. Ecopsychology critiques the compulsively "masculine" ideologies of domination of nature and incorporates some of the insights of ecofeminism and feminist spirituality.
7. Ecopsychology opts for small-scale social forms, which empower and personalize the ecological ego, and resists large-scale domination models of society and urban-industrial culture, which undermine this ego. Ecopsychology is postindustrial but not antiindustrial.
8. The needs of the planet are the needs of the person, and the rights of the person are the rights of the planet. The human and the divine are linked in a common synergy of planet and personal well-being.[34]

Another effort at remaking our worlds of psychology in light of the environmental revolution is that of Australian Warwick Fox in his book, *Toward a Transpersonal Ecology*. In this book Fox urges a link between transpersonal psychology and deep ecology:

> A transpersonal approach to ecology is, then, precisely *not* an anthropocentric approach to ecology. . . . Rather, a transpersonal approach to

ecology is concerned precisely with *opening* to ecological awareness; with realizing one's ecological, wider or big Self; or, as I have already expressed it, with the this-worldly realization of as expansive a sense of self as possible.[35]

He sees remnants of a Newtonian parts mentality in most psychological approaches to the self, but he credits transpersonal psychology with moving beyond these restrictions. "Whatever their qualitative differences, the desiring-impulsive self, the rationalizing-deciding self, and the normative-judgmental self all refer to a narrow, atomistic, or particle-like conception of self whereas the transpersonal self refers to a wide, expansive, or field-like conception of self."[36]

In this context "ethics is rendered superfluous" because to expand the self is to expand the field in which one lives, moves and has one's being. In other words, mysticism and relatedness rather than duty or stewardship ought to characterize an era of ecological justice. He cites Joanna Macy:

> It would not occur to me, for example, to exhort you to refrain from cutting off your leg. That wouldn't occur to me or to you, because your leg is part of you. Well, so are the trees in the Amazon Basin; they are our external lungs. We are just beginning to wake up to that. We are gradually discovering that we *are* our world.[37]

Again, Joanna Macy has the sense of cosmic mysticism that articulates clearly the mind-set of a transpersonal ecology when she says,

> All concepts setting boundaries to what we term the self are arbitrary. In the systems view, we consist of and are sustained by interweaving currents of matter, energy and information that flow through us interconnecting us with our environment and other beings. Yet, we are accustomed to identifying ourselves only with that small arc of the flow-through that is lit, like the narrow beam of a flashlight, by our individual subjective awareness. But we don't *have* to so limit our self-perceptions. . . . It is as plausible to align our identity with [the] larger pattern, interexistent with all beings, as to break off one segment of the process and build our borders there.[38]

Here Macy is speaking out of her spiritual praxis as a Buddhist who meditates regularly as well as out of her passion for ecological

justice. In her book *World as Lover, World as Self,* Joanna Macy calls for a return to World as Lover—a theme found in our ancient spiritual sources such as Hinduism, Sufism, the Kabbalah, Goddess, and Christian traditions. This willingness to be embraced by "the primal erotic play of life" would, she believes, contribute to our healing. "The world itself has a role to play in our liberation. Its very pressures, pains, and risks can wake us up—release us from our bonds of ego and guide us home to our vast, true nature."[39]

But the world is also self, Macy insists, for "the way we define and delimit the self is arbitrary," and the cause of our planet's suffering is "our stance in relation to our world. What is destroying our world is the persistent notion that we are independent of it, aloof from other species, and immune to what we do to them." Macy offers a threefold way of envisioning the evolution of human consciousness: first came our infancy as a species, when "we felt no separation from the natural world around us. Trees, rocks, and plants surrounded us with a living presence as intimate and pulsing as our own bodies. In that primal intimacy, which anthropologists call 'participation mystique,' we were as one with our world as a child in the mother's womb."[40]

The second stage was that of self-consciousness, which gave us distance from the world. Being banished from the Garden of Eden tells the story of that distancing, the emergence of free will, and "the lonely and heroic journey of the ego." Macy calculates that from the Fall up through the period of the Enlightenment, humanity learned to excel in distancing itself from nature "in order to make decisions and strategies, in order to measure, judge and to monitor our judgments." We should not see this period as entirely negative, for "it brought great gains for which we can be grateful. The distanced and observing eye brought us tools of science, and a priceless view of the vast, orderly intricacy of our world. The recognition of our individuality brought us trial by jury and the Bill of Rights."[41]

But now we are embarked on the third movement of our species; we are "ready to return."

> Having gained distance and sophistication of perception, we can turn
> and recognize who we have been all along. Now it can dawn on us:
> we are world knowing itself. We can relinquish our separateness.

We can come home again—and participate in our world in a richer, more responsible and poignantly beautiful way than before, in our infancy. . . . It [the world] can appear to us now both as self and as lover.[42]

We see in this powerful way of naming our journey and revisioning our heritage—our animistic heritage, our biblical story of the fall, and our heritage from Western science—a rich way of reinventing our psyches. Good work will be found in the re-envisioning that Macy proposes; we all must be about it in all of our institutions. Thomas Aquinas recognized the inherent power of cosmology to heal the soul seven centuries ago when he said that wonder "is to the cure of the soul what medicine is to the cure of the body."[43] In our commitment to wonder there is both delight and hope. Once again, we find there is good work, and a lot of it!

Artists As Healers

Artists have been most deeply wounded by the paradigm of the industrial age. Just as a machine has no place for mystics or children, so too it has no place for the artist, who was banished to the margins during the industrial era. What a price all of society and all of our work worlds have paid for this exile! And artists have paid a dear price as well—identified by society as crazed or addicted, denigrated as beatnik or hippie.

Although modern society denies art its proper role, Thomas Aquinas recognized that the work of the artist is essential to all substantive work. He saw the artist as the intellectual—that is, the idea giver—that he or she is. "Imagining goes with thinking so long as we are in this present life, no matter how spiritual the knowledge. Even God is known through the images of the divine effects." Artists awaken our images in order to take us to our mystical origins, for "an image implies the idea of origin." Moreover, we cannot think without art, for "the image is a principle of knowledge. It is that from which our intellectual activity begins, not as a passing stimulus, but as an enduring foundation."[44] Yes, art provides the *enduring foundation* for

all our intellectual activity. At least that is what people believed before the modern era.

Artists can also be our link to the mystical. Courtney Milne, a photographer who recently published a book called *The Sacred Earth,* tells what his art led him to discover:

> Ironically, my most profound revelations have not occurred at specific sacred sites, but rather they have surfaced as a realization of what it is I am doing. . . . I have come to realize how you and I—anyone who enjoys making images—are responding to the mystic that lives within each of us. . . . All joyous photographers are artists, and all artists are mystics. . . . Knowing this gives me permission to nurture amazement, to leave the camera in my bag and fully experience a new place—to allow me to be a child again and to discover the newness of an old place or the inherent familiarity of a new place.[45]

In her book, *The Reenchantment of Art,* artist and cultural critic Suzi Gablik offers a stirring challenge to the art world to let go of the modernist values of alienation and social antipathy and to welcome a new vision that will include a sense of community, an ecological perspective, and a deeper understanding of the mythic and archetypal underpinnings of the spiritual life. Gablik is opting for a creation-centered spiritual renewal of art itself.

Gablik speaks of the previous paradigm of the Enlightenment period and what it has meant to artists: "Individualism, freedom and self-expression are the great modernist buzz words." The notion that art could serve collective cultural needs rather than a personal quest for self-expression seems almost "presumptuous" in that worldview. Yet this assumption lies at the base of a paradigm shift in art, a shift "from *objects* to *relationships.*" Gablik challenges her co-workers not to settle for abstract theorizing in making this paradigm shift. She personalizes and therefore grounds the transformations that must be undergone when she insists that "the way to prepare the ground for a new paradigm is to make changes in one's own life."[46] Spirituality is about praxis, she is saying, not just theory.

Gablik puts the issue of letting go directly to her profession, the art world itself.

We live in a toxic culture, not just environmentally but spiritually as well. If one's work is to succeed as part of a necessary process of cultural healing, there must be a willingness to abandon old programming—to let go of negative ideas and beliefs that are destructive to the planet and to life on earth. But what does this mean for art?[47]

One thing it means to Gablik is letting go of the notion of "art for art's sake." This idea implies an "inherent purposelessness" and therefore betrays itself as a dimension of the anthropocentric cosmology of the Enlightenment. "Modernism was the art of the industrial age," she points out, and among other things it served up a *patriarchal idea of "value-free aesthetics."* And yet Gablik does not wallow in the destructive aspect of letting go. Indeed, she challenges those who would make a religion of deconstruction alone. "Healing is the most powerful aspect of reconstructive postmodernism, whereas for the deconstructivist, it would seem that art can only deconstruct. There is no future beyond deconstruction." The artist must choose whether to follow a path of demystifying alone or a path of being instead "cultural healer."[48]

It is clear which path Gablik is pursuing. In her naming of the two paths that art can take she is conjuring up the ancient prophetic vocation as named by Jeremiah himself: "To tear up and to knock down, to destroy and to overthrow, to build and to plant" (Jer. 1:10). The deconstructionists want only to tear up and destroy, but that is not enough for Gablik. Nor is it enough for the prophetic tradition of work: "By their fruits you shall know them," advised Jesus. One's work will be judged by what one gives birth to—"cultural healing," in Gablik's words—not only by what one lets go of.

In this context Gablik calls for artists to become "participating co-creators" in an "active mode of reconstruction." The goal is the healing of the planet.

Transformation cannot come from ever more manic production and consumption in the marketplace; it is more likely to come from some new sense of service to the whole—from a new intensity in personal commitment. . . . The great collective project has, in fact, presented itself. It is that of saving the earth.[49]

We find in Gablik's efforts to revitalize her profession all four paths of the creation spiritual journey: wonder at the cosmos; letting go (deconstruction and even the letting go of deconstruction); co-creating (reconstruction); and transforming society based on the inherent value of interdependence (compassion). Gablik believes that to bring interdependence back is to bring the feminine back to art: "To see our interdependence and interconnectedness is the feminine perspective that has been missing, not only in our scientific thinking and policy-making, but in our aesthetic philosophy as well."[50]

Many artists are opting out of the art-for-art's-sake mentality—the consumer mentality—to rediscover art as a spiritual discipline, a way of regenerating a lifeless culture. The new cosmology reminds us that instead of art being *for art's sake,* art is *for creativity's sake,* that is, for the sake of evolving and for healing people and the Earth: "that the people (all creation) might live," as the Native Americans pray.

It has been my privilege over the years to meet many artists who are on spiritual journeys and to invite a good number of them to teach art as meditation in our programs in Creation Spirituality. Invariably they express a deep gratitude, a feeling of "coming home" when they are able to teach art as spirituality and to draw the Spirit from individuals and groups.

Over twenty-five years ago an inspired woman wrote what I still consider to be the bible on art as meditation. I am speaking of potter, poet, philosopher, and painter M. C. Richards and her classic work, *Centering,* wherein she celebrates the process of centering "in pottery, poetry, and the person." The author speaks out of her profound depths as potter and poet to the creative process itself as the ultimate spiritual work of our lives. "We have to realize that a creative being lives within ourselves, whether we like it or not, and that we must get out of its way, for it will give us no peace until we do."[51] She leads us through a creative process—by putting us "on the wheel"—and shows us the way both to art and spiritual praxis. She brings the body back to our spiritual practice, as all art does. And she connects us again to the natural elements, the cosmos, the moral imagination, fun, and the passion that leads to effective compassion.

Richards honors the "intelligence" of clay, tools, color, the body, fire, paints, words, silence—and the Spirit that may surprise us by springing up within them at any time. In her book Richards names the *via positiva* of the mystics as the key to opening up our perception: It is a matter of "acceptance" which is "devotion to the whole." Acceptance is Richard's philosophy of non-action.

> When the doctrine of acceptance speaks of doing away with the categories of good and evil, it is not in order to turn everything into good, nor to turn everything into nothing. Rather it is to prepare a meeting between the human and phenomena at a level free of category, of evaluation. This is a preparation for the acceptance of the "is-ness" of each thing.[52]

Here she sounds like Meister Eckhart, who tells us that "isness is God." And how energizing to hear artists speak of the artistic experience in such a profoundly mystical way! Richards also names the *via negativa*. Suffering too is included in the art of centering.

> I am brought to a crisis because I am committed to acceptance and to the suffering it entails. I have to accept the separation in order to keep contact with the shape experience is taking. I must keep my clay centered.[53]

Richards also relates art to social justice. "Perception itself yields moral insight," for compassion "is a mode of perception." True art develops our moral capacity: "From the child's capacity to imagine grows as well the adult's capacity for compassion: the ability to picture the sufferings of others, to identify."[54] Art serves, Richards insists. Art is not meant to be a "trade" but a "spiritual discipline," an "absolute and primal encounter to which we must devotedly surrender." And it is incarnational.

> It is in our bodies that redemption takes place. It is the physicality of the crafts that pleases me: I learn through my hands and my eyes and my skin what I could never learn through my brain. . . . All art is a bodying forth. The bodying forth of the living vessel in the spheres of clay.[55]

Richards raises questions of morality and even holiness when she looks at her own profession.

It is always the prime question: Where is the moral source? How are the laws to be learned in the human will? How may intellect and sanctity marry?[56]

M. C. Richards has lived her life as a work of art and of perception and participation. For the past nine years she has lived in a community for mentally retarded adults based on the philosophy of Rudolf Steiner. It is also a biodynamic agricultural community. She has honored our efforts at reinventing education by teaching at our institute and in Creation Spirituality programs on three continents. She has had the courage and moral imagination herself, not just to question the slogans of the art world but to offer alternatives and to live them. In her lifetime she has reinvented artistic life and work. There is much good work awaiting other artists who wish to live in an authentic way, as she does.

Another example of reinventing the work of art is the recent study called *Art & Physics: Parallel Visions in Space, Time & Light,* by surgeon Leonard Shlain. Shlain argues that the revolutionary artists of the West anticipated the paradigm shift brought about in this century by visionary physicists such as Einstein. In general terms, he sees the work of the scientist *qua* scientist as left brained or analytic and the work of the artist *qua* artist as right brained or intuitive. Yet he acknowledges that the artist needs technique and knowledge and the scientist needs intuition and creativity. Shlain explains how he dared to write this study bringing together physics and art: as a surgeon, his left brain is deeply disciplined in the science of anatomy and the technique of his craft. But in the practice of surgery, his right brain's passion for beauty and intuition also plays a critical role.

Shlain believes that first "the artist introduces a new way to see the world, then the physicist formulates a new way to think about the world."[57] First comes the seeing (the artist); next comes the paradigm shift in thinking (the scientist). His arguments for his case, drawing examples from Giotto, da Vinci, Manet, Monet, Cézanne, Picasso, and others, are not only convincing; they also grant artists the recog-

nition due them as authentic intellectuals, as stirrers of ideas in a culture. By implication he also challenges persons who make art their living to accept the moral responsibility of their deepest intuitions.

Shlain is quick to point out that the artists of whom he writes did not know Einstein or the new physics. They "have mysteriously incorporated into their works features of a physical description of the world that science later discovers."[58] They intuited it by listening to the depths of self and society around them.

In many ways this thesis parallels that of biologist Rupert Sheldrake, who believes that memory exists because we share a common morphic field and that memories are present in that field. Memory is resonating with memories already in that field. Thus, we could say that Shlain understands artists to be persons who are more sensitive to the resonances emerging from the field around them. Artists have the skills to speak that truth in colors, music, story, or shapes that reveal the contents of our collective memory. Shlain believes that when artists do their work and physicists do theirs, "only later do the other members of the civilization incorporate this novel view into all aspects of the culture."[59] He expects much from the artist's work:

> When the vision of the revolutionary artist, rooted in the Dionysian
> right hemisphere, combines with precognition, art will prophesy the
> future conception of reality. . . . It most likely issues forth from the
> right hemisphere, since the artists and mystics, expressing themselves
> in images and poetry, are more attuned to this type of consciousness.[60]

The artist is open to new images just as a child is. "The radical innovations of art embody the preverbal stages of new concepts that will eventually change a civilization. Whether for an infant or a society on the verge of change, a new way to think about reality begins with the assimilation of unfamiliar images. This collation leads to abstract ideas that only later give rise to a descriptive language.[61]

Imagination lies at the heart of the artist's work, and it lies also at the heart of anticipating a new paradigm. Imagination begins in infancy but is soon overcome by words in our culture. "Because the erosion of images by words occurs at such an early age, we forget that in order to learn something radically new, we need first to imagine it."

It is the artist's task to "create the new images" and to be a "Distant Early Warning system of the collective thinking of a society." Shlain believes that by naming the complementarity of art and physics, their integration "will kindle a more synthesized awareness which *begins in wonder and ends with wisdom.*"[62]

One hopes that he is correct and that artists everywhere will take a newly found pride *and responsibility* in their calling. His vision also demands that both artist and physicist pay more attention to their ancestors among the mystics who, perhaps, see and perceive even in advance of the artist (or, if you will, who are artists *par excellence*). Interestingly, Shlain completes his book with, among other things, a quote from Meister Eckhart: "When is a person in mere understanding?" I answer, 'When he or she sees one thing separate from another.' And when is a person above mere understanding? That I can tell you, 'When he or she sees All in all, then a person stands beyond mere understanding.'"[63]

The work of the artist is not to be piecemeal but is to help us see "all in all." This is also the work of the mystic. Shlain's book fills out the elements of a living cosmology. Mysticism is necessary for a living cosmology, but so too are art and physics; and Shlain, by concentrating on the relationship between these two, has heightened the presence of the mystical as well. In fact, his work underscores how mysticism is common to the revolutionary artist and the visionary physicist (and, I might add, to the thoughtful surgeon as well!).

Conclusion: Art and Social Healing

Art without spirituality is cynical, manipulative, commercial and consumer oriented, pessimistic, ego centered, competitive, tired, afraid to die because it has not lived, fame seeking, exclusive, elitist, expensive, anthropocentric, and self-serving—just like politics without spirituality, health care without spirituality, or religion without spirituality.

On the other hand, art with spirituality is inclusive, celebrative, joyous, courageous, capable of taking us into grief and beyond, energizing, open to the community in all its diversity, playful, justice ori-

ented, compassionate, honoring of other art worlds, nonsentimental, surprising and therefore spirit filled, youthful, fresh, and always "in the beginning." Such art heals. I am reminded of Aquinas's teaching that there are two kinds of water: living and stagnant. Living water is connected to its source; stagnant water is not and is therefore dead and putrefying. Spirituality is art's source—as it is the source of all good work. If art is no longer connected to spirituality it dies. When it is connected to its source, living waters of wisdom flow and refresh and make new.

Art that is reconnected to spirituality has the potential for employing the hard-core unemployed. Let me give some examples. Eleven years ago Imelda Smith, a Catholic sister from Ireland, attended ICCS. On graduating, she returned to Ireland and moved into Tallaght, a suburb of Dublin, where there is 80 percent unemployment. Despair was everywhere, along with much drinking and child and spouse abuse. One resident told me her two teenage sons were on drugs and she herself was practically without hope. Imelda started organizing the women, leading them through body prayer, art as meditation, and sharing of their stories. They took over an abandoned mansion in the area and remade it as their center, renovating it twice (it was burned down once), and collecting outside funding. Today the center offers over 300 courses, and the vast majority of them are taught by the residents of Tallaght themselves. These same women, whose formal education is minimal, organized and administered a two-week international gathering of Creation Spirituality persons this summer outside Dublin.

This is not a story about people who have solved all their problems, but it is a story of hope risen from ashes of despair. The young and the male residents of Tallaght are now availing themselves of the power and hope that Kiltadown House and Creation Spirituality have brought to the area. When hope returns, work and the desire for work returns, and with it the creativity to make good work and start the healing processes.

This is not the only story of hope. In El Salvador a nationally known artist, Fernando Llort, began teaching art to the peasant citizens of La Palma, a town besieged by the civil war that has dominated

that country for a decade. Seven years ago two friends, Rolando Erroa and Fernando Herrera, founded a workshop to train young artisans and named it after Saint Francis of Assisi. Whole families are involved with the various aspects of this small business, which now exports its colorful craft projects around the world. Where previously there was mass unemployment, now the two artisan cooperatives and twenty workshops in the town employ more than 3,000 people out of a total population of 15,000. The results are more than financial, however. "This activity has promoted the human dignity of our poor people," Llort observes. "It is a very significant cultural awakening that has helped the country a great deal in a very positive sense."[64] When some citizens were tempted to flee during the most difficult days of the war, it was the commitment to the artwork that kept them in the community and kept the community going.

I believe that where life is most desperate—whether among the unemployed of Ireland or El Salvador or the United States—art is the answer. Let me propose a wild and necessary idea: a series of art/entertainment universities set up in the inner cities of the United States. Consider these facts: The number one export from America around the world today is not automobiles; it is entertainment. America makes more billions of dollars exporting entertainment than it does from any other single industry. Instead of trying to pump life into car factories, we should wake up to how many people around the world want inspiration, vision, storytelling, humor, dance, music, and beauty from the American soul. These universities would not be modeled on the bloated, bureaucratic, politically dominated state university systems we now have—systems that are in no way connected to the spiritual source that nourishes all art. Rather, their bureaucracy would be radically simplified, like the medieval university where students paid the instructors directly.

I believe such universities would succeed. Why? Because many unemployed persons would attend, drawn by art's natural attraction. While there they would learn they have a place in the universe. Teachers would discuss the new cosmology, and the arts would be taught not just as technique but as spiritual practices (for there is no

cosmology without spiritual praxis). History, geography, ethnic studies, science, psychology, and business would all take on new meaning in the context of art/entertainment universities. Skills of reading, writing, and communicating would be absorbed swiftly because the motivation would come from the students' enthusiasm to create. The high that young people would get from the hope that such universities offer would displace the high that crime, gangs, and dope selling can promise.

These universities would be prison-preventive education. As such, they would be a financial bargain. The United States is now spending 23,000 dollars per prisoner per year. Take half of that money yearly and invest it in each student in this university, and you would be investing in a lifetime of good work, renewed hope, and pride. This university would get kids off the street and ready for work and citizenship in society.

Who can predict what new work awaits us as we apply green paradigms to the fields of health care, psychology, and art? Only time will tell. What is clear, however, is that an environmental revolution demands new work of us and a reinvention of our old work, its patterns, its assumption and ideologies, its philosophies, its science, and its skills. In this chapter I have presented just a few examples of individuals who have seen the need to redo work worlds and who in so doing challenge us to do the same.

8 | Reinventing Work: Economics, Business, and Science

To me, this concept of GNP [Gross National Product] means nothing at all. . . . GNP being a purely quantitative concept, bypasses the real question: How to enhance the quality of life.

E. F. SCHUMACHER[1]

That human well-being could be achieved by diminishing the well-being of the Earth, that a rising Gross Domestic Product could ignore the declining Gross Earth Product; this was the basic flaw in this Wonderland myth [of progress].

BRIAN SWIMME AND THOMAS BERRY[2]

GNP values very highly bullets, tanks, and cars; and it values at zero the environment, clean air, clean water, etc. It also values at zero our children, who really are our future wealth. . . . The raising of children, managing household activities, serving on the school board, and many other activities are not considered to be part of the formal economy. . . . In so many countries in the world, the contribution of unpaid workers is far larger than the GNP.

HAZEL HENDERSON[3]

The community supports that business that supports the community.

BEN COHEN[4]

Primitive and even colonial women played a much more integral role in the business of survival. Their identity as workers and managers was taken for granted. . . . Women were relegated to an inferior caste . . . most dramatically with the coming of industrialization.

MADONNA KOLBENSCHLAG[5]

The model that presents the business organization as a cold, impersonal machine denies humanness. People have needs in three areas: body, mind, and spirit. Yet most companies, if they acknowledge people have needs at all, act as if there are only two requirements for producing good work: money and job security.

RICHARD MCKNIGHT[6]

The primary purpose of a company is to serve as an arena for the personal development of those working in the company. The production of goods and services and the making of profits are by-products.

ROLF OSTERBERG[7]

As more about the fundamental role of consciousness in the universe is revealed and the new ideas promulgated, a basic change in science will eventually occur. . . . It is even possible that eventually a new science will be born, a science that accommodates the whole human with fully realizable capabilities of body, mind, and spirit.

BEVERLY RUBIK[8]

In this chapter we will discuss how we might reinvent the work of economics, business, and science.

Economics

I do not derive a great deal of confidence from the words of economists—and neither, apparently, do many economists. Paul Krugman, an economist at the Massachusetts Institute of Technology, confessed in a recent newspaper report, "We don't know a lot about what's going on." Another economist says, "Quite candidly, I don't know if we as economists know an awful lot about what it takes to improve

long-term economic performance." As economic writers Peter Gosselin and Charles Stein suggest, humility "is becoming more common in the economics profession these days."[9] Maybe it's time for economics to let go of its faith in an outmoded paradigm.

I recently spoke to a new graduate of economics from a respected state university. He told me that he had studied the economic theories of the old paradigm—Adam Smith, Milton Freedman, and a bit of Karl Marx—but he had been asked to read nothing whatsoever of new-paradigm economist E. F. Schumacher. This is a shame, because Schumacher is an economist worth reading. First of all, he knows as much as anyone can know of the mysteries of our economic systems. Born in Germany, he came to England in the 1930s as a Rhodes Scholar to study economics at New College, Oxford, and later taught economics at Columbia University in New York. He served as economic adviser with the British Control Commission in Germany from 1946 to 1950, and from 1950 to 1970 he was the economic adviser of the National Coal Board of England. He has advised many developing countries on the problems of rural development and is author of *Small Is Beautiful* and *Good Work,* as well as *A Guide for the Perplexed.* Yet, as we have seen already, Schumacher also pays attention to the inner life of the self and society. This dimension gives him the authority to bring the new paradigm into his own profession.

About the economics profession Schumacher is severely critical. He proposes, for example, that the great litmus test of economics, the GNP or gross national product, is essentially meaningless. "To me, this concept of GNP means nothing at all. . . . GNP, being a purely quantitative concept, bypasses the real question: How to enhance the quality of life." Instead of GNP, Schumacher proposes that we critique our economic system from the viewpoint of meaningful work for everyone. Perhaps FE (full employment) should replace GNP as the yardstick of a healthy economy. "Let us ask then: How does work relate to the end and purpose of [humanity's] being? It has been recognized in all authentic teachings of [humankind] that every human being born into this world has to work not merely to keep himself alive but to strive toward perfection."[10]

Schumacher sees a threefold purpose in human work:

As a divinely arrived being [the human person] is called upon to love God in traditional language. As a social being he is called upon to love his neighbor. And as an incomplete individual being he is called upon to love himself. The social organization ought to reflect these three absolute needs. If these needs are not fulfilled, if he can't do it, he becomes unhappy, destructive, a vandal, a suicidal maniac. The social, political, and economic organizations ought to reflect these needs. But they do not.[11]

Schumacher observes that "joyful, constructive labor" completes us, makes us feel that we are created "as a child of God." Yet most jobs are organized to be so dull that they cannot serve this purpose. Notice how thoroughly Schumacher fits in the tradition of the mystics who speak of the joy of work and of our being children of God.

One problem that Schumacher names in the GNP mania is the notion that an economy must always be growing to be healthy. This does not make sense when the Earth itself is finite. At whose expense will the economy grow? How can we have infinite growth on a finite planet without someone or something having to pay a dear price? And isn't that exactly what industrial societies have subjected the planet to—an infinite plundering of limited resources of fossil fuels, forests, water, air, plants, animals, people?

Brian Swimme and Thomas Berry concur. They recognize the doctrine of the GNP to be the dominant myth that drives our anthropocentric civilization in the name of progress. They believe that the "terminal phase" in which the Earth finds itself today "was caused by a distorted aspect of the myth of progress. Though this myth has a positive aspect in the new understanding that we now have of an evolutionary universe, it has been used in a devastating manner in plundering the Earth's resources and disrupting the basic functioning of the life systems of the planet."[12]

What stands behind this destructive myth? "That human well-being could be achieved by diminishing the well-being of the Earth, that a rising Gross Domestic Product could ignore the declining

Gross Earth Product; this was the basic flaw in this Wonderland myth [of progress]."[13]

Schumacher believes that one of the great evils of current economic theory is the idea that bigger is better. The truth is that impersonal bigness disempowers the worker, leaving him or her out of touch with the decision-making level of the work world. Americans of late are beginning to grasp this fact as we wake up from the greed-driven eighties to a nightmare of unemployment, loss of tax base, widening gaps between the wealthy and the middle class, and increased poverty.

Smallness is the path Schumacher says will put most people to good work. "It is only in a small organization that we can meet people face to face and make decisions face to face," he observes.[14] *Intermediate technology* is his term for a conscious effort to displace and let go of the giant technology that so dominates our economic world and the way we think about it. We can see in Schumacher's work a movement from the technology of giant industrialism to a human-sized or green technology that once again fits into the Great Work of the universe. The former technology was part of the anthropocentric exaggerations and arrogance of the Enlightenment era. About smallness and technology Schumacher writes, "I can't see anything that [humanity] really *needs* that cannot be produced very simply, very efficiently, very viably on a small scale with a radically simplified technology, with very little initial capital, so that even little people can get at it."[15]

Schumacher believes that consciously returning to smallness is not a romantic return to tribal ways; reinventing ways of doing things on a smaller scale will in fact require all our resources of creativity and imagination. He gives the example of metal rims needed for wooden oxcart wheels in developing countries. In the old days persons knew how to make these rims, but at some point the art was lost.

Having found a two-hundred-year-old tool in a French village, the Schumacher team took the challenge to the National College of Agricultural Engineering in England. These people reinvented this old tool and came up with a rim-maker that costs only thirteen dollars, doesn't require electricity, and can be operated by anyone. Prior

to this, the cheapest machine for making rims in the modern West cost $1100 and required outside power and electricity to operate. After putting the word out to inventors that such a thing was needed a new way of creating these wheels emerged. A return to smallness will create new and good work for people, Schumacher believes.

> Experience shows that whenever you can achieve smallness, simplicity, capital cheapness, and nonviolence, or, indeed, any one of these objectives, new possibilities are created for people, singly or collectively, to help themselves, and that the patterns that result from such technologies are more humane, more ecological, less dependent on fossil fuels and closer to real human needs than the patterns (or lifestyles) created by technologies that go for giantism, complexity, capital intensity, and violence.[16]

Notice how often Schumacher speaks of *needs*. Needs are not the same as wants or desires. A healthy economy satisfies needs first; it does not indulge in satisfying wants for a few before it satisfies the needs of the many. In this regard our entire industry of advertising must be subjected to a spiritual critique. Is its purpose not to pump up the wants of those who have extra means? And does this economy not then oppress those whose true needs are not yet met? "What is the great bulk of advertising other than the stimulation of greed, envy, and avarice? It cannot be denied that industrialism, certainly in its capitalist form, openly employs these human failings—at least three of the seven deadly sins—as its very motive force."[17]

An economic system built on titillating and stimulating greed, envy, and avarice as its "very motive force" cannot or ought not long endure. *People* are at the heart of our work, even when business ideologies and narrow conceptual litmus tests (such as the abstraction known as GNP) cover up this fact. "Business is not there simply to produce goods, it also produces *people,* so that the whole thing becomes a learning process."[18] In other words, business must be critiqued from a qualitative point of view and not merely from a quantitative perspective.

Schumacher is not alone in offering a new paradigm that could help reenchant the profession of economics and eventually our worlds of business. Hazel Henderson is an economist committed to a

new worldview as described in her books *Politics of the Solar Age, Creating Alternative Futures,* and *Redefining Wealth and Progress.* She criticizes the worldview of "industrial economics" by pointing out that the debate between communism and capitalism

> was actually a trivial argument. Both Marx and Smith devised a discipline that led to industrialism and materialism. Unchecked production, consumption, and continuous economic growth are common in their thinking. . . . It is high time to give Adam Smith and Karl Marx a decent burial.[19]

Henderson also criticizes the ideology of the industrial revolution for its abuse of the Earth and its reductionism in holding up the GNP as the measure of a healthy economy. "GNP values very highly bullets, tanks, and cars; and it values at zero the environment, clean air, clean water, etc. It also values at zero our children, who really are our future wealth." Nor are women counted in the GNP. "The raising of children, managing household activities, serving on the school board, and many other activities are not considered to be part of the formal economy. . . . In so many countries in the world, the contribution of unpaid workers is far larger than the GNP."[20] Henderson finds hope in the G-15, the group of developing countries that represents twice as many human beings as the G-7 (the seven industrial countries that meet yearly to determine the future of the world's economy). She finds hope in the contribution that women, who have been largely excluded from industrial economics, can make to the reinvention of the global economy.

Henderson pictures the total productive system of an industrial society as a "three-layer cake with icing." The icing is the official market economy of cash transactions or the "private sector." The GNP-monetized section of the cake represents the officially measured GNP that generates all our economic statistics (even though 15 percent of that is "underground" or illegal and therefore pays no taxes); this is the "public sector." The layer that holds up the public sector is the nonmonetized production of the social cooperative countereconomy. This includes "sweat-equity," do-it-yourself work, bartering, parent-

ing, volunteering, caring for old and sick, use-subsistence agriculture, and other activities. And the bottom layer is nature's layer—the natural resources base so jeopardized by pollution, deforestation, and toxic wastes.[21] This picture of society's economy appears far more inclusive than the male-dominated and anthropocentric definitions we have been given by custodians of the GNP ideology.

Henderson consciously applies the new scientific paradigm to her work as an economist. She speaks of "the end of economics," because "economics (from left to right) was primarily concerned about industrialism as a *method* of producing material goods efficiently and with ever greater technological virtuosity." She names the new paradigm as "the dawning of the Solar Age," meaning a shift to renewable resources management and sustainable forms of production. The new paradigm rejects the idea that the Earth is inert—the foundational idea of industrial science and technology—and opts instead for the view that the Earth is Gaia, a living planet, whose systems are living, dynamic, and self-organizing. "The Solar Age is an image that reminds us that the light from the sun is what powers our extraordinary blue planet and it is the sun's stream of photons which drive all of Earth's processes: the cycles of carbon, nitrogen, hydrogen, the water cycles, and climate. . . ." In addition, the Solar Age will include a new appreciation of mystical or right-brain experience. "The wisest of us recognize that our Earth still has much to teach us—if we can humble ourselves and quiet our egos long enough to really listen, see, hear, smell, and feel all of her wonders." This newly found sense of spirituality will, in turn, end the cycle of avarice on which modern consumer economics is based; we will find our quest for the infinite or for Spirit in places that truly satisfy. "As we re-integrate our awareness in this way, we no longer crave endless consumption of goods beyond those needed for a healthy life, but seek new challenges in society for order, peace, and justice, and to develop our spirituality."[22]

Economist Herman E. Daly has long been conscious of the need for paradigm shift in his profession. Author of *Steady State Economics,* he has not only taught in academia but is a member of the Environment Department of the World Bank. Recently he teamed up with

process theologian John Cobb, and together they published a book called *For the Common Good: Redirecting the Economy toward Community, the Environment, and a Sustainable Future.* In this book they explicitly recognize the need for a paradigm shift in the profession of economics and in academia itself. Their book, they say, is meant to outline an alternative to both capitalism and socialism, which founder on the myths of growth-based economics. They acknowledge that economics today cannot be done in isolation from other disciplines, including even cosmology. "To conceive of such a radically different economy forces us both to think through the discipline of economics as well as beyond it into biology, history, philosophy, physics, and theology. Part of the assault of the wild facts has been against the very disciplinary boundaries by which knowledge is organized (produced, packaged, and exchanged) in the modern university."[23]

They trace the accomplishments of industrialization over the past few centuries, whereby "the standard of living has soared from bare subsistence to affluence for most people" in the northern hemisphere. But they also deplore the price that has been paid in the souls of the people who have most profited from this wealth, wherein individual egoism and a "spirit of social irresponsibility" reign. They underline how little attention has been paid by economists of industrialism to "the exhaustion of resources or to pollution." The suffering of the biosystem is seldom if ever calculated in this kind of economic thinking; nor, might we add, is the suffering calculated of preindustrial economies whose land and labor are so readily abused by northern countries. The authors call for a "paradigm shift in economics," citing a poll of economics professors at fifty major universities that showed two-thirds of respondents felt economics had lost its moorings. "Instead of *Homo economicus* as pure individual we propose *Homo economicus* as person-in-community." The changes they are proposing to their own profession, they insist, "will involve correction and expansion, a more empirical and historical attitude, less pretense to be a 'science,' and the willingness to subordinate the market to purposes that it is not geared to determine."[24]

Daly and Cobb point out that the industrial revolution was a revolution "from harvesting the surface of the Earth to mining the sub-

surface," and thus a shift "from dependence on energy currently coming from the sun to stored energy on the Earth." This is vitally important, because what occurred was a shift from dependence on relatively abundant sources "to the relatively scarce source of the ultimate resource: low-entropy matter-energy." Both capitalism and socialism remain uncritical about their commitment to "large-scale, factory-style energy and capital-intensive, specialized production units that are hierarchically managed." Invoking the poet-farmer Wendell Berry, the authors praise the "Great Economy—that economy that sustains the total web of life and everything that depends on the land. It is the Great Economy that is of ultimate importance."[25] This phrase, the "Great Economy," sounds much like the phrase used in this book and borrowed from the poet Rilke: the "Great Work."

The authors acknowledge their Protestant roots and decry its overemphasis on individual salvation, inherited from Augustine's question of whether he was saved or not. Left out has been the community perspective, a perspective they credit medieval feudalism and Roman Catholicism with having celebrated better than Calvinism and the Enlightenment philosophy. They envision an economic order that would be "just, participatory, and sustainable." Invoking the prophetic tradition of Israel and sounding the trumpet for economic change, they call for "an economics for the common good" that interferes with "an ideology of death," which is "destroying our own humanity and killing the planet."[26]

While the authors address the academic discipline of economics, they also lay out practical applications of their work. Prophetic and apocalyptic in tone at times, this study nevertheless communicates a spirit of hope and challenge: "Humanity is not simply trapped in a dark fate. People can be *attracted* by new ways of ordering their lives, as well as *driven* by the recognition of what will happen if they do not change."[27] They conclude the book with a statement of their belief that a spiritual vision is necessary to sustain the struggle for a paradigm shift in economics. The work of Daly and Cobb, embracing as it does the work of other economists invoking a paradigm shift in their profession, is a fine example of how the profession of economics could be reborn.

Geologian Thomas Berry is challenging economists to renew their profession by throwing off anthropocentrism and waking up to cosmology and ecology. He warns, "When nature goes into deficit, then we go into deficit," and he bluntly states the facts: "At least in its present form, the industrial economy is not a sustainable economy.... An exhausted planet is an exhausted economy."[28] Perhaps this helps to explain why industrial nations are so deeply in debt today. Our economics are not working. Even our economists are exhausted! While economists often wring their hands over this reality, Berry has some suggestions for moving on:

> The earth deficit is the real deficit, the ultimate deficit, the deficit in some of its major consequences so absolute as to be beyond adjustment from any source in heaven or on earth.... For the first time we are determining the destinies of the earth in a comprehensive and irreversible manner. The immediate danger is not *possible* nuclear war, but *actual* industrial plundering.[29]

To go beyond this situation, we must change our *vision*. The impetus behind our economics is not facts but ideology or vision; therefore it can be altered by a truer vision. Berry writes, "However rational modern economics might be, the driving force of economics is not economic, but visionary, a visionary commitment supported by myth and a sense of having the magical powers of science to overcome any difficulty encountered from natural forces." The economic visions we have been granted over the past few hundred years—socialist, free enterprise, mercantile, physiocrat, or supply-demand theories—all are "anthropocentric and exploitive" in their programs. "The natural world is considered a resource for human utility, not a functioning community of mutually supporting life systems within which the human must discover its proper role."[30] Berry points out the kind of pseudomysticism that the industrial age ran on:

> The industrial age itself, as we have known it, can be described as a period of technological entrancement, an altered state of consciousness, a mental fixation that alone can explain how we came to ruin our air and water and soil and to severely damage all our basic life

systems under the illusion that this was "progress." But now that the trance is passing we have before us the task of structuring a human mode of life within the complex of the biological communities of the earth. This task is now on the scale of "reinventing the human," since none of the prior cultures or concepts of the human can deal with these issues on the scale required.[31]

It would follow that we need new visions to replace those that dominated our ways of seeing the world during the industrial era. Berry does not hesitate to challenge the power brokers of our culture to look at their souls.

> For the past hundred years the great technical engineering schools, the research laboratories, and the massive corporations have dominated the North American continent, and even an extensive portion of the earth itself. In alliance with governments, the media, the universities, and with the general approval of religion, they have been the main instruments for producing acid rain; hazardous waste; chemical agriculture; the horrendous loss of topsoil, wetlands, and forests; and a host of other evils the natural world has had to endure from human agency. The corporations should be judged by their own severe norms. What exactly have they produced? What kind of world have they given us after a century of control?[32]

Clearly, there is much work to be done by economists within their own profession.

Business

Just as religion depends on theology for an ideological support system, so business depends—often uncritically—on the economic ideology that underpins it. One can expect that a new wind will sweep over business when economics is subjected to the critique that it deserves as we move from the industrial era to a green era. Business is a practical application, a praxis, of an economic theory. As that theory undergoes transformation, so too will business.

However, transformation works the other way around as well. That is to say, as the *praxis* changes, so too might the theory change. As

business people attempt to do business more from a creation-centered model, they will feed into the theoretical world of economics some new and refreshing approaches.

Examples of New Paradigm Approaches to Business

Schumacher offers examples of new and *small* businesses that have sprung up, making intermediate technology available to people. One African village began manufacturing egg cartons in relatively modest numbers, with the result that an entire cottage industry of making egg cartons was established. (All previous manufacturers of egg cartons made them in quantities too great for small villagers' needs.) In Khurja, India, a town ninety miles from Delhi, there sprang up within a period of twelve years three hundred pottery factories employing 30,000 people to produce pottery and hospital and electrical porcelain.[33] This is an example of how people are already working with the new paradigm—putting people to work in small businesses that remain simple and people centered.

Another example closer to home is the business of Ben Cohen and Jerry Greenfield, the inventors of Ben and Jerry's ice cream. Their corporation, which has grown into a ninety-million-dollar business, is committed to donating 7.5 percent of pretax earnings to nonprofit organizations. (Most corporations give less than 1 percent of pretax earnings to charity.) They deliberately support family farmers by paying more than the government recommends for milk; they use their packaging to advertise value-oriented issues pertaining to peace and the environment. They consciously contribute to defending the rain forest by purchasing Brazil nuts from people in the rain forests and calling their product "rain forest crunch" in order to raise consciousness about the rain forest.

Ironically, Cohen and Greenfield were at first so taken aback by their success that they were ready to sell their business. Instead, they took up the challenge of changing business. Along the way they ran into the business world's perhaps inevitable resistance. (All persons wishing to reinvent work can expect to encounter such resistance. It ought not to discourage us, as it did not discourage Ben and Jerry.

Thomas Kuhn points out that resistance is one of the signs of a paradigm shift.)

Cohen and Greenfield deliberately changed their way of doing business. Instead of the old-paradigm definition of business, "An entity that produces a product or provides a service," they coined a new slogan: "Organized human energy plus money will produce power." Business may be "the most powerful force in the world," Ben proposes, and as such it needs to accept the responsibility that goes with power. Business is a focused energy, like a laser, that in fact sets the tone for a society. He asks the question: "Does business have a value *beyond* maximizing profits?" After all, individuals have values but are often told on coming to work to leave their values at the door. At work "we are prevented from acting on our values," he contends. "If individuals have a responsibility to help the community, we cannot possibly suspend that responsibility just when we're at our most effective, that is, when we are at work." Ben asks why it is that business lacks values. It is because of an ideology we carry with us from the old paradigm, namely that one "can't make profits and help the community at the same time." The result of such a dogma is that the environment, the workers, and the community all suffer at the hands of the workplace.[34]

It is the experience of Ben and Jerry that this tired shibboleth creating a dualism between work and values simply no longer works.

> As long as we operate within this old paradigm, we are separated
> from our heart and values and feel powerless. We cannot suspend our
> values during the workday and think we will have them back when
> we get home. We're all interconnected. There is a spiritual dimension
> to business just as to individuals![35]

Notice how Ben is invoking one of the new laws of the universe (an old one to mystics): interconnection. He sees the suffering we rain on one another as due to a lack of interconnection. Like Schumacher, Ben and Jerry criticize business for being so insular and narrowly focused on one ingredient: the quantitative. "The only measure for business," Ben points out, "is quantitative. It is only about profit and

loss." In this regard Ben is critiquing the mechanistic and quantitatively-oriented worldview of the Newtonian era when what counted was exclusively what was quantifiable.[36]

In a conscious effort to break out of this confining and unrealistic paradigm, Ben and Jerry have redefined the bottom line in business. Instead of asking *only,* "How much profit do we have at the end of the year?" they now also ask, "How much have we helped the community of which we are a part?" The question is decidedly *not* an issue of philanthropy but "the way we do business." And so they have introduced into their business a yearly report called an "Audited Social Statement." They undergo two audits each year—a financial one and a social one. They have found that the latter "is good for business," for "the community supports that business that supports the community." Profit is a regulator of business *but not the only one.* Other human factors must also be taken into account. When these are lacking, then business takes a "narrow, selfish" stand on political issues. Business, says Ben, "needs to integrate community care into its way of operating." In other words, business must join the revolution taking place around the Great Work of the universe—the work from which business, and all human endeavor, will derive its meaning and its rules. Business must become interdependent; that is, it must relate to the greater community around it, listening to its pain and its joys.[37]

Some ways in which Ben and Jerry's have reached out to the greater community are as follows:

They went public with the company in order to invite the community to become co-owners of the business. They did this by offering stock at 126 dollars per share so that ordinary folks could afford it. The result has been that one of every one hundred families in the state of Vermont, where the business is located, owns stock in their company.

The materials they use in their product are chosen from communities that support the oppressed. For example, baked goods are ordered from Buddhist communities that hire the homeless and train them to be bakers; coffee is bought from a Mexican coffee

cooperative; blueberries come from next-door small farmers in Maine; nuts come from the rain forest.

Their shops are used as polling places, and their managers are authorized as notaries to do voter registration, so as to get persons to vote on the spot when they come in for ice cream (when you register you get a free ice cream cone).

They hire homeless to sell their products.

They intend to reduce their energy consumption by 25 percent within ten years by solar power and other ways.

They chose the South Shore Bank of Chicago as their bank. That bank, located in a decaying urban area, is committed to *greenlining,* or putting its money into the local neighborhood. Recently Ben and Jerry's has announced that they will build a factory in the heart of South Central Los Angeles. This factory will employ over two hundred local citizens.[38]

Ben is the first to point out that other businesses are also following this path: Patagonia, makers of outdoor clothing; Seventh Generation, manufacturers and distributors of environmentally healthy products; Working Assets, a socially responsible investment firm; Levi Strauss; Stridrite Shoes; Aveda, makers of hair and beauty products; and others. In addition, networks are developing around these new business paradigms: One Per Cent for Peace (to which over one hundred groups belong); Social Venture Network (over two hundred businesses); New England Business Association for Social Responsibility (one hundred members); and the national Business Association for Social Responsibility in Washington, D.C., which is launching an alternative chamber of commerce.

These organizations are dedicated to encouraging businesses to take responsibility for healthy and productive workplaces, for quality and environmental impact of their products and services, for community involvement (New England Businesses for Social Responsibility), and to use business to "create a more just, humane and environmentally sustainable society" (Social Venture Network). The approximately 2,000 committed companies in the social responsibility

movement here and abroad have combined annual sales of $2 billion. This represents only one-hundredth of 1 percent of the sales volume of business enterprises worldover.[39] It would seem that business people are not all lagging behind in the effort to reinvent their work.

In England the fastest growing holistic business is The Body Shop. Anita Roddick and her husband, Gordon, began the business in a small shop in 1976; it now has three thousand employees and a gross annual income of $241 million dollars. Its goals are to sell natural body products that are environmentally friendly. Its guidelines include simplicity, natural products, minimal packaging, no animal testing, and ingredients that can be grown in the so-called Third World. About her work Anita Roddick says,

> The individual is forcing the change. People are shopping around, not only for the right job but for the right atmosphere. They now regard the old rules of the business world as dishonest, boring and outdated. This new generation in the workplace is saying "I want a society and a job that values me more than the gross national product. I want work that engages the heart as well as the mind and the body, that fosters friendship and that nourishes the earth. I want to work for a company that contributes to the community."[40]

In her remarkable autobiography, *Body and Soul,* Roddick virtually redefines the meaning of business:

> The trouble is that the business world is too conservative and fearful of change. All this talk about free enterprise, innovation, entrepreneurship, individuality . . . it's nothing but hot air. . . .
>
> I am still looking for the modern-day equivalent of those Quakers who ran successful businesses, made money because they offered honest products and treated their people decently, worked hard themselves, spent honestly, saved honestly, gave honest value for money, put back more than they took out and told no lies. The business creed, sadly, seems long forgotten.[41]

In the excellent chapter entitled "The Transformation of Business" in his book *After the Crash: The Emergence of the Rainbow Economy,* Guy Dauncey points out that the idea of worker cooperatives

and worker-owned businesses is growing rapidly. From 1971 to 1975, there were only ten worker cooperatives registered in England; by 1986 there were 1,500, with a per annum combined turnover of about 380 million dollars. "This remarkable growth-rate of around 58 percent per annum illustrates the growing desire that workers have to be in control over their own livelihoods, and to be able to create a harmony between their values and their working lives," he comments.[42] In Florida, the largest retail food chain, Publix Super Markets, is completely owned by its employees and makes a profit per dollar of sales that is twice that of Safeway, America's largest food retailer. In 1976 a total of 843 companies in the United States had employee stock option plans (ESOP) that covered a half-million people; in 1984 more than 5,700 such plans covered some 9.6 million workers or 7 percent of the U.S. workforce—a growth rate of 27 percent per annum. Were America to continue this growth rate, by the year 2004 the entire American workforce would be working under an ESOP plan.[43] The results are equally impressive. Studies show that these companies outperform their nearest competition time and time again.

Dauncey delineates the evolution of business in three stages: First was the era of Dickens and Marx, when there were no laws controlling or regulating businesses. Next came the organization of workers and laws against child exploitation; organizers and unions fought for and won benefits related to health, safety, living wage, and limits to working hours.

But today we are moving into a new era, when a "huge evolution" is taking place. What will characterize this era?

> Nurturing creativity, worker self-management, participation and teamwork, setting up profit-sharing and employee-shareholding schemes, promoting the role of women and meeting childcare needs, encouraging work-sharing and flexi-work patterns, supporting employees' own personal journeys of growth and self-empowerment, breaking down hierarchical organizational structures and authoritarian modes of management . . . pursuing environmental excellence, encouraging community involvement—these are some of the signs which mark a company's evolution into the Third Era.[44]

This evolution cannot be described by the inherited dualistic language of "right wing" versus "left wing." Its values include initiative, individuality, and enterprise, but also caring for the workforce and the community as a whole. Green movement values of environmental concern and human-scale organization are incorporated, as are human potential movement values of caring for personal growth and fulfillment; spiritual values of honesty and integrity; and values from the movement for global development of international justice, cooperation, and interdependence.

Recently John Denver's Windstar Foundation in Aspen, Colorado, sponsored a conference entitled "Establishing a Socially Just New World Environment." A panel of progressively minded business people gathered to emphasize that a new paradigm in business must include encouraging employees to do good work in the community and paying more attention to how the employees themselves need to grow and develop in the workplace. If these values are encouraged, the workplace, far from being a foreign or isolated world, can become the microcosm of what the world should be. Once again we see here the theme of interconnection replacing the laws of rugged individualism and dualism that characterized the industrial era. As one panelist put it, the employees will treat the community the way they were treated. One must build a community based on humane values within the work world if one is to reach the greater community "out there."

Another panelist proposed that business pay attention to its *inner* self and not just be content with outer, market forces. Impact on the community must be factored into business as well as cost, quality, and delivery time of a product. Businesses might adopt a school in an inner city, and they might give employees time off to work in that school, thereby encouraging workers to give time to the community. A woman told the story of how, in a small town in New Mexico, small shop owners put signs in their windows if they supported a protest taking place against waste dumping in their community. Thus businesses had an opportunity to express something of their value system to the greater community.

Spirituality and Business

Richard McKnight is an organizational psychologist who has worked extensively with stress management and leadership personnel in business. He comments about his work:

> For most workers, managers, and executives I have worked with in the last 10 years, business organizations are seen as cold, impersonal machines that take raw materials, capital, and people in one end, perform some transformation, process, or service, and produce money out the other end—or should. . . . In the prevailing model, the ideal business posture is characterized by words such as "competition," "aggression," and "winner." "Our business is only about making money," one executive said to me, "and the only way we can do that in our industry is by keeping everybody uncertain and mean—inside the company and outside it."[45]

McKnight regrets the physical illnesses and emotional traumas that result from such a model of business-as-machine. Such results "are harmful to employees, to society, and ultimately, to the 'bottom-line.'" Talking unselfconsciously about the absence of Spirit in the prevailing machine model of doing business, he calls for a greater sense of spirituality, which he defines as "an animating life force, an energy that inspires one toward certain ends or purposes that go beyond self." Having a transcendent purpose in one's work, he believes, "results in being in love with the world" and allows for integration and direction in our life and work. The other model, business as a cold, impersonal machine, "denies humanness." He says, "People have needs in three areas: body, mind, and spirit. Yet most companies, if they acknowledge that people have needs at all, act as if there are only two requirements for producing good work: money and job security."[46]

His experience reveals that most workers suffer from one of two spiritual syndromes at work: "Either they are devoted only to non-transcendent materialistic purposes such as career advancement; or they have a transcendent purpose that doesn't mesh with the purpose of the company they work for."[47] Creativity, enthusiasm about life, acceptance of self and others, lives lived gracefully, being perpetual

students of life, giving more than taking, optimism, peacefulness, courage regularly demonstrated: these are the characteristics of a spiritual person according to McKnight, who believes that businesses can and ought to assist the development of this spirituality.

McKnight is not alone in his call for spirituality and a paradigm shift in business. Peter Vaill, professor of human systems in the School of Government and Business Administration at George Washington University, calls for "a new appreciation of the spiritual nature of [the human] and a determination to keep it in any new formulation of the nature of organizational life." He values paying more attention to the human being as "a creator of phenomena," to the "performing art" that management is, and to the experience of "awe," as well as to what it means to "be in the world with responsibility." He sees the new paradigm as offering "refreshing, even thrilling new interest in ethics, morality, and the spiritual nature of [humanity]," wherein a sense of "process wisdom" and the value of "relationality" will flourish.[48]

Management consultant Linda Ackerman addresses the questions of management in the new paradigm. She names three kinds of management styles: fear state management; solid state management; and flow state management, and she feels the latter is what the new cosmology calls for. She traces its imagery to the concept of Tao in Chinese philosophy and its embodiment in Mohandas K. Gandhi. She sounds like she is defining the mystical experience when, borrowing from the research of psychologist Mihaly Csikszentmihalyi, she defines flow as "the holistic sensation that people feel with total involvement." A person in such a state "experiences a unified flowing from one moment to the next, in which he is in control of his actions, and in which there is little distinction between self and environment, between stimulus and response, or between past, present, and future."[49]

Rolf Osterberg has served as CEO of Scandinavia's largest film company and has been chairman of the board of over twenty companies and trade associations. But after his many achievements in business, he underwent a kind of *metanoia* experience wherein he questioned the direction his life in particular and work in general was evolving. He came to a point of realizing there must be more to

work than the pure mechanics he was seeing in the workplace, where people are seen as mere "tools, units of negotiations, cost factors. There is no real life in the whole enterprise." He felt that others were also awakening.

> I became more and more convinced that something great, something much greater than I had ever believed, is happening, and it is happening to all of us. We are indeed changing our beliefs . . . The terrain (the systems in which we live) no longer corresponds with the map (our minds). The map is changing and the terrain must be adjusted accordingly.[50]

In his book, *Corporate Renaissance,* he calls for a major revolution in the way we envision work and business. He writes,

> Work, as every other aspect of life, is a process, through which we acquire experiences. . . . The primary purpose of a company is to serve as an arena for the personal development of those working in the company. The production of goods and services and the making of profits are by-products.[51]

Like Juliet Schor, whose analysis of consumerism we saw earlier in this book, Osterberg has come to realize that human beings have become prisoners on a treadmill of consumerism. "Like a hamster on a wheel, their role is to keep the wheel spinning: by productive work in mass production as well as by consumption—mass consumption." He decries how developing countries are being instructed to use these models of "economic growth" (meaning increased production and increased consumption) as a goal for their development. Only the ruthless exploitation of human and natural resources has been able to keep the wheels of "economic growth" spinning.

> We have taken advantage of the precarious economic situations of developing countries—situations for which we are largely responsible— and simply moved the exploitation there. Growth has not improved or augmented anything. It has drained, consumed and devoured, and continues to do so.[52]

Osterberg believes that we have to look on work in a radically different way. "There is only one way to remove these problems, and

that is to fundamentally—deep down in the farthest nooks of our souls—change our thoughts about work." He feels that work has become for many in our society a way to flee one's deeper self and avoid one's deepest feelings. "Work has become one of the drugs we use to deaden and block the emotional aspect within us," he says, a process that has "gone so far that we can not enjoy our leisure time. We cannot relax."[53] Without using the term *Creation Spirituality*, Osterberg is clearly speaking of what we have called the "inner work" of the *via positiva,* the *via negativa,* and the *via creativa.* He sees the real agenda in business today as altering our way of seeing work itself:

> In the new thought, life is seen as a developmental process in which we grow as human beings. Life has no specific goal beyond the process itself. The process—life itself, if you want—is the meaning, not the possessions, position and fame gathered along the way.... One who works does not contribute more than one who has chosen some other arena for personal growth.[54]

Many of our culture's brightest individuals go into business. Some of these persons will be able to see the pain inflicted by the business world, and they will be ripe for opening to the new opportunities that will arise from redefining business so that it serves the greater needs of both the human and nonhuman worlds. Perhaps this reinventing of the *quality* of the workplace will also contribute to reinventing the *quantity* of work available. When workers have integrated spirituality with their work, their values, and their creativity, addictions such as overwork and the practice of overworking employees might give way to more shared work. Those without work or with too little work can then be invited to participate in the work world.

What we hear from listening to these prophetic voices within the business world is a growing awareness that business itself (and the economic philosophies that underlie it) has an inner house to be put in order. Some are responding to that challenge today. In this challenge work is being reinvented. And a new kind of work is being created as well—the work of putting the inner houses of our work worlds in order. Hope lies in this kind of reconstruction. The reenchantment of work is indeed under way.

Meister Eckhart on Driving Moneylenders from the Temple

Much of the critique of economics and business that we have discussed in this chapter was anticipated by Meister Eckhart. He saw the dangers of an exclusively money-based economy and anticipated the addictive potential of money making as an exclusive criterion for our values. In a stunningly powerful sermon—one that did not endear him to the merchants of Cologne, the trade capital of all of Europe at the time, Eckhart took the passage from the Gospels about Jesus driving moneylenders from the Temple. Eckhart asks,

> Why did Jesus throw out those who were buying and selling, and why did he command those who were offering pigeons for sale to get out? He meant by this only that he wished the temple to be empty, just as if he had wanted to say: "I am entitled to this temple, and wish to be alone here, and to have mastery here."
>
> What does this mean? This temple, which God wishes to rule over powerfully according to his own will, is the soul of a person. God has formed and created the soul very like God's self, for we read that our Lord said: "Let us make human beings in our own image" (Gen. 1:26). And this is what God did.[55]

Eckhart critiques what he calls the "merchant mentality" and what it does to the soul, which he understands as the temple of God *par excellence,* for "neither in the kingdom of heaven nor on earth among all the splendid creatures that God created in such a wonderful way is there any creature that resembles God as much as does the soul of a human being." What does a narrow definition of business—one that is bottom-line profits only, one that pays homage only to the quantity in life and not the quality—do to the vast soul of the human being? It clutters the soul. It distracts the inner person. It interferes with our great capacity to be emptied so that the Divine can fill us. "In all truth no one really resembles this temple except the uncreated God alone. [It] gleams so beautifully and shines so purely and clearly," in all its splendor. Above all, a value system based on quantitative profit alone trivializes the reason we exist and the reason we work: to be connected to all beings and their Creator, that is, to participate in the Great Work. "For this reason God wishes the temple to be empty so that nothing can be in it but the God's self alone. This is

because this temple pleases God so and resembles God so closely, and because God is pleased whenever God is alone in this temple."[56]

Wonderful things happen in this temple that cannot happen if it is cluttered by a merchant mentality, a mentality of buy and sell, of cause and effect, of quid pro quo. God is revealed in this temple, provided it is empty of whys and wherefores. For in this temple Jesus "reveals himself and everything that the Creator has declared in him in the way in which the Spirit is susceptible." In this temple, the Holy Spirit "gushes out, overflowing and streaming into all sensitive hearts with an abundant fullness and sweetness." Creativity and wisdom come together in this temple, and there "God becomes known to God" and the soul discovers its own "essential original being in one unity without distinction." But the soul must be emptied for these marvels to occur.

Furthermore, for Eckhart a merchant mentality kills the spirit of gratitude and replaces it with a compulsion of ownership for attachment (*Eigensschaft*) that "leaves the mind stupefied and forms an obstacle to receptivity." A spirit of clinging kills our capacity for experiencing the infinite riches of Divinity. Only by driving such attitudes from our souls or temples can we "newly receive God's gift in an unencumbered and free way" and return it "with grateful praise."[57]

In this amazing sermon, delivered when capitalism was just making its entrance onto the stage of European history, we have a deep and penetrating critique of what a narrowly defined economic philosophy does to our souls. But we also have a critique of what a moneylending, that is to say, an anthropocentric view of wealth, does to our relationships to the Earth and the cosmos. For the divine *temple* is the universe itself. We can no longer "con-temple," that is to say, contemplate or pray the universe if we overwhelm it with our agendas. All play and all gratitude are then banished. Contemplation dies. Furthermore, the reductionism we commit on the cosmos will come back to haunt us. If we cannot enter into right relationships with the Earth and Earth systems we are simply cluttering the temple of God. An emptying process is needed, and that emptying begins with our own psyches.

For all these reasons then, we are encouraged to pursue a new paradigm of business and economics such as has been outlined in this chapter.

Science and Technology

The work of science also needs to be reinvented in our time. Much of what we presented in chapter 2 flows from scientists who have dared to bring the paradigm shift to their own discipline. Rupert Sheldrake, Gregory Bateson, Beverly Rubik, Brian Swimme, David Bohm, Erich Jantsch, Paul Davies, and many other scientists are opened heart and soul to the mysteries of the universe once again.

I say "once again" because many scientists have told me that they became scientists in the first place because of mystical experiences that they had as children. Recently I took part in a discussion group at the University of Pennsylvania, and a physicist in his midsixties asked me a very convoluted scientific-religious question. I replied by saying, "You know, many scientists I know tell me they became scientists because of the mystical experience they had with the night sky as children." He immediately replied, "That's it! That's why I'm a scientist. I haven't thought about this for forty years." His face became that of a ten-year-old boy. He was reminded of the heart attraction that first led him to his vocation. It is this heart dimension that is so lacking in the modern era's definition of science and in scientific education. Thomas Aquinas says that "science puffs up"—that it becomes arrogant—when it lacks the dimension of the heart. When Brian Swimme and Thomas Berry point out that "science deals with objects. Story deals with subjects," they are reminding us that to be a scientist alone is not enough. A fully human person deals with story, where the heart is nourished, as well as objects, where facts are discovered.

Ironically, it is through science's devotion to objectivity in the past few centuries that we have been gifted with a new story, one that truly awakens our hearts. Science today has come full circle; that is, it has come around to demonstrating that the objectivity it once so highly prized does not, in fact, exist, and that the world cannot be

explained in materialistic terms alone. Mind lives in the universe at all levels. This means that science itself is implicated in the results of its own findings. Science, because it is human, carries moral responsibility with it. This is a new idea in the West, for since the Renaissance, scientists have considered themselves morally detached from the consequences of their findings. A certain myopia has dominated in science, as if scientists wore moral blinders out of necessity in order to penetrate reality more deeply. In light of the realities that face our planet today, these blinders have to be discarded. E. F. Schumacher cites Albert Einstein, who said, "Almost all scientists are economically completely dependent"; and, "The number of scientists who possess a sense of social responsibility is so small" that they are in no position to determine questions of the direction of research.[58]

Even Leonardo da Vinci, who loved creatures so much that he was a vegetarian, nevertheless invented instruments of war that increased the violence of human against human—and indeed against the nonhuman creation as well—and that set new standards for destruction. The new science will include moral responsibility for one's findings. Science can no longer pretend to be morally objective any more than economics or business can. The scientist operating out of the new paradigm will ask: What are the moral consequences of my work? Who is profiting from it? And at whose expense will some profit and others lose? When J. Robert Oppenheimer remarked, on the first successful detonation of the atomic bomb that he had helped to create, "Now we have known evil," he was announcing a new era in science—an era of interconnection, of moral responsibility. The alliances that scientists often make with mass industry, mass academia, or mass government with its mass military can no longer be winked at. Money does not excuse the immoral consequences of one's work. It is, after all, the praxis of science, that is, technology, that has contributed the most to the plunder of this planet. We must acknowledge this reality. The new paradigm scientist will see the facts for what they are: a warning that our technology must be shaped by our values. If we have no values other than profiteering or ego-tripping on our work, in this case our scientific work, then we are a menace to the planet.

Another dimension to the new science is its rediscovery of wisdom. Wisdom includes morality, but it also includes awe and creativity. Wisdom therefore flows from mysticism. The mystical scientists of our day, many of whom were cited in chapter 2 of this book, are witnesses to the depth and power of their vocation. As Thomas Aquinas put it, "A mistake about nature results in a mistake about God." If scientists are truly devoted to listening to the revelations of nature and to passing these on to the rest of us, then they are indeed involved in spiritual work. Their learning and discipline amounts to a kind of yoga; it helps to awaken the mysticism inherent in the rest of us. But the scientist is so near to the powers of the universe and the decision-making apparatus of our culture that she or he must practice spiritual disciplines along with the rest of us. Otherwise the addiction to power can easily overtake the scientist, whose temple, to use Eckhart's image, can be overrun with buyers and sellers.

New paradigm scientists will engage in spiritual praxis, which keeps the soul young and generous and helps it resist merchant mentalities. New paradigm scientists will participate (participation being a key virtue in the new paradigm) in the quest for a spirituality both mystical and prophetic such as our times demand. They will do the dances and undergo the rituals that open the heart and delight the divine child in us all. They will learn to resist anthropocentrism and will ask questions about how their knowledge can be put to the service of ecological and social justice and how their hearts can expand by way of the wisdom they imbibe daily in encountering nature's mysteries. This daily eating and drinking of the mystery of the transubstantiation of atoms, elements, molecules, cells, organisms, galaxies, planets, plants, animals, beings of all sorts—these encounters with the sacrament of creation—must be acknowledged for what they are: sacred encounters.

One scientist who has been committed to bringing about a transformation in her profession is Dr. Beverly Rubik, founding director of the Center for Frontier Sciences at Temple University in Philadelphia. Her center publishes a semiannual journal, *Frontier Perspectives,* and invites visiting scholars from around the world to openly exam novel scientific claims. The journal serves research and education in

areas of science that are not yet mainstream and maintains a growing database of frontier scientists worldwide. Recently it published a book, *The Interrelationship between Mind and Matter,* a collection of papers presented at an international roundtable, sponsored by the center, bringing together distinguished scientists from six countries. Rubik introduces the volume this way:

> The notion of separability between consciousness and matter within science may be considered faulty, as certain interpretations of quantum theory maintain that the observer interacts fundamentally with the quantum system in the act of observation. . . . A case can be made for the interrelationship between consciousness and matter from medicine, anthropology, and other disciplines. Can the question of their relationship be addressed by novel scientific approaches?[59]

Rubik decries the virtual stranglehold that the old paradigm of science holds on research grants and academic advancement:

> There are formidable, extraordinary obstacles for those who move outside of the boundaries to explore unorthodox terrain or even tributaries to the mainstream. These include a possible loss of camaraderie and respectability, loss of funding, and loss of scientific credibility with an inability to publish in mainstream journals; even a loss of one's position may result.[60]

But she sounds like she understands the prophetic vocation that is demanded of those who will stand up for a new paradigm in whatever profession they are committed to, when she says it is a difficult path, "only for the most adventurous, courageous, pioneering individuals who are driven by an inner quest to know what lies beyond." She points out that historically science was usually changed by those who dared to stand outside the dominant theories of the day. Rubik speaks up for those areas of science that are neglected—one might say for those without a voice, whom the Bible calls the *anawim*—when she says that scientized medicine simply does not address the intimate relationship of the mind and body and the importance of consciousness in the healing of a patient. Science in general, she says, refuses to address "the subtler, unquantifiable dimensions of innate mind, such as states of consciousness, self-awareness, and volition. . . . Nor are

meaning, value, and mind's teleological character considered relevant to the present practice of science."[61] Rubik has hope for her profession, however, provided the academic system that is behind it can change.

As more about the fundamental role of consciousness in the universe is revealed and the new ideas promulgated, a basic change in science will eventually occur. This change may be bigger than just a paradigm shift, as the results at present already challenge the epistemological foundations of science.... Multiple approaches to the study of consciousness need to be supported. It is even possible that eventually a new science will be born, a science that accommodates the whole human with fully realizable capabilities of body, mind, and spirit.[62]

As science transforms, Rubik believes, society will be blessed.

As science has powerful influences on society and the environment, this new science will undoubtedly have bountiful effects. A new cosmology, a reunion of science and spirit, may manifest.... It can propel us toward a conscious evolution. It can engender a new sense of awe and wonder about ourselves and the cosmos. And, if the vision is great enough, it may lead to a global renaissance.[63]

We can pray that she is correct; and more, we can work for such a transformation. The Nobel prize-winning scientists and the medical doctors who present articles in Rubik's book give evidence that this hoped-for transformation is already well under way.

Today the soul of the scientist is being emptied of secularism—the flight from the mystery that is greater than us. This resacralization and reenchantment of the scientist's work might well begin with his or her university education, where the spirituality of science might be included along with other courses. As things now stand in our secularized academic systems, the education of the scientist parallels that of the doctor, minister, and priest for its lack of mystical awareness. This is no way to make good work for good scientists of the future. Reintroducing the mystical dimension as well as the dimension of values to scientific education will, among other things, create good work for many within and outside of the scientific profession.

Ritual: Where the Great Work of the Universe and the Work of the People Come Together

Accomplish the great task by a series of small acts.

TAO TE CHING[1]

The story of the universe has been told in many ways by the peoples of the Earth. . . . In all these various circumstances the story of the universe has given meaning to life and to existence itself. The story has been celebrated in elaborate rituals.

BRIAN SWIMME AND THOMAS BERRY[2]

Worship does not exist for God's sake but for ours. God has no need of human worship. It is we who need to demonstrate our gratitude for what we have received.

THOMAS AQUINAS[3]

When a civilization lacks rites of passage, its soul is sick. The evidence for this sickness is threefold: first, there are no elders; second, the young are violent; third, the adults are bewildered.

MELADOMA SOME[4]

Is there any institution that holds out a greater hope for humanity's progress than the Sabbath?

RABBI ABRAHAM JOSHUA HESCHEL[5]

O f all the ways to reinvent work one is more crucial to our time than all others. It is crucial because it has been most roundly neglected during the industrial era. I am speaking of ritual.

In Greek the word *liturgy* means "the work of the people." Liturgy or ritual may be the human work *par excellence*. Ritual is the primary means by which a people get their inner houses in order, both as individuals and as a community. It is the primary tool by which macrocosm (our relation to the whole of the universe) and microcosm (our personal and more local relationships) come together, by which, as the Tao Te Ching puts it, we

> Accomplish the great task
> by a series of small acts.

Ritual puts our "small acts" to use in assisting the accomplishment of the "great task"; it is the way by which we reconnect our daily lives of time and space (and therefore of work) to the Great Work of the universe. It is the surest way by which to bring forth the gifts *as well as* the grief and suffering of the community. If we lack the means to allow the latter to happen, the former will never occur at any level of depth and honesty. Ritual is the primary means by which a community names itself and comes to life, responding to the deep mysteries of life, whether these be mysteries of joy and hope or of sorrow and angst. Ritual is the primary means by which the elders pass on to the young the gift of their own stories and especially a Big Story—the creation story by which the young see how they got here,

what "here" is, what they might be doing here, how to get there, and what the vision of "there" might be. It is through ritual that the young can become excited enough about their existence to throw themselves into the adventures of living, learning, relating, forgiving, letting go, and letting be. Ritual puts them in touch with generosity of heart, with the courage and gratitude that will energize them for the journey. Brian Swimme and Thomas Berry see the role of ritual among the ancients in the following manner:

> The story of the universe has been told in many ways by the peoples of the Earth, from the earliest periods of Paleolithic development and the Neolithic village communities to the classical civilizations that have emerged in the past five thousand years. In all these various circumstances the story of the universe has given meaning to life and to existence itself. The story has been celebrated in elaborate rituals. It has provided guidance and sustaining energy in shaping the course of human affairs. It has been our fundamental referent as regards modes of personal and communal conduct.[6]

In ritual we say thank you for the gratuitous gift of existence, as Thomas Aquinas teaches. "Worship does not exist for God's sake but for ours. God has no need of human worship. It is we who need to demonstrate our gratitude for what we have received." It is through ritual that the passages of life, from birth to puberty, from marriage to parenting, from sickness to repentance, from leadership to death are named as sacred moments for the individual and the community to behold and celebrate. It is through ritual that we are reminded of a deeper time than everyday time; we can truly enter timelessness, where past, present, and future are one and where the ancestors are truly present as a viable communion of saints—communing with us and imploring us to accept their gifts of courage, grace, and imagination. Through ritual we are also reminded of a deeper sense of space, of how interconnection and relationship are the "essence of everything that is" (Eckhart).[7] In ritual we reinvigorate our sense of connectedness to all things: to our pain and grief; to our joy and dreams; to others' holy existences; to beauty, grace, zeal, moral indignation, outrage, play, creativity, and healing.

Ritual occurs when all persons become human again, childlike again, equal again, dancing Sarah's circle instead of climbing Jacob's ladder. Physicists and mathematicians do circle dances and chant heart songs next to janitors and mechanics, seventy-year-olds alongside seven-year-olds, white with black, employee with employer, teacher with student, student with teacher, homosexual with heterosexual, parents with children, deceased ancestors and descendants still to come. All the spirits of God's creation join the dance of creation: that is the theory *and* praxis of ritual.

It is in ritual that the people praise. And people need to praise. Without praise we have no energy to live deeply. This is ritual's task, as Rabbi Heschel puts it: to "preserve single moments of radiance and keep them alive in our lives."[8] Ritual takes us to the deeper levels of our beings, into the experiential dimensions of cosmology, where we taste our connection to all things. As shamanistic teacher Joan Halifax puts it: "When you reach very deep states of consciousness, you see that the mind includes not only the entire nervous system, but the entire cosmos. Our mind in its extended form can actually perceive anywhere, anything and any time."[9] Is this really different from Aquinas saying that one human mind can know "all things" and that each mind is *capax universi,* that is, "capable of the universe"? But these are things that must be experienced and not just talked about. They are the things of ritual.

A Newtonian era that was antirelational was of necessity antiritual. It almost killed ritual, and indeed, when the Europeans invaded the lands and cultures of native peoples, rituals were often destroyed. In the United States, for example, the Lakota people were forbidden their Ghost Dances and Sundances, and in church-sponsored schools on Indian reservations young people were forbidden sweat lodges and other traditional rituals. Deep ritual is a great threat to the guardians of the machine civilization, for who would want to remind the workers in a machine that the *cosmos,* and not the machine, is our true home? To this day the Roman Catholic Church honors the liturgical rites of Byzantium and Antioch, Moscow and Coptic Egypt, but has steadfastly refused to honor the rites of North American peoples who have prayed for thousands of years in the land of the Americas.

"We have lost any sense that ritual is important," warns Suzi Gablik, and "the loss of myth, the assumption that the only valid ways of knowing are logical and linear, has resulted in a profound loss of moral orientation and meaning for life." And yet, Gablik also names the promise that ritual offers: "The remythologizing of consciousness through art and ritual is one way that our culture can regain a sense of enchantment."[10] Indeed, ritual is a means of once again experiencing the enchantment of the universe.

We cannot do without ritual. If by ritual we mean, in the broadest sense, the patterned activity by which a community accomplishes its greatest tasks, then I propose that all beings engage in rituals. Ants and bees have their rituals, as do all mammals who go about courting, mating, and nest making in a quasi-ritualistic fashion. All human tribes have had their rituals too—except, that is, the humans of the industrial West of the past few hundred years, who were taught that our left brains alone could resolve all problems.

Ritual is the core element of African (and most native) communities. Without ritual a community rapidly loses its soul. Meladoma Some, an African spiritual teacher who underwent a forty-day rite of passage in the jungle as a teenager, believes that without rites of passage, a civilization is sick: "When a civilization lacks rites of passage, its soul is sick. The evidence for this sickness is threefold: first, there are no elders; second, the young are violent; third, the adults are bewildered." The young lack tools for survival if they have not experienced some forms of initiation or rites of passage as a child. The grounding of a person's life depends on the kinds of rites of passage she or he has experienced; therefore we all need some rituals to help us pass from one stage of life to another. Ritual ferries us across to a realm higher than the one prior to it. Elements of ritual include invocations; attitudes toward the spirit world; our response to our spirit allies; and symbols and metaphors by which we penetrate other worlds. Rituals are both individual and communal.

In this part we will first discuss how the new cosmology offers us insights about ritual; we will also discuss principles for bringing about effective ritual today, including insights from the Jewish tradition of *Shabbat* or Sabbath, with its mystical *and* prophetic overtones.

Then I will offer examples of effective rituals I have participated in, with the hopes of awakening in the reader some possibilities of good work around ritual that she or he may participate in as well. *We can reinvent work by reinventing ritual.* The reinvention of ritual will grant us the energy and open our hearts and minds to carry on the task of reinventing work of all kinds.

9 | The Reenchantment of Ritual: Reinventing Work by Rediscovering the Festive

In our culture, every one works four hours a day and the rest of the day we make things.

ABORIGINAL WOMAN OF AUSTRALIA

Be not lax
in celebrating.
Be not lazy
in the festive service of God.

Be ablaze with enthusiasm.
Let us be an alive,
burning offering
before the altar of God!

HILDEGARD OF BINGEN[1]

The Sabbath is not for the sake of the weekdays; the weekdays are for the sake of Sabbath. It is not an interlude but the climax of living. . . . Call the Sabbath a delight: a delight to the soul and a delight to the body. . . . To sanctify the seventh day does not mean: Thou shalt mortify thyself, but, on the contrary: Thou shalt sanctify it with all they heart, with all thy soul and with all thy senses.

RABBI ABRAHAM JOSHUA HESCHEL[2]

If we are to have a chance at leisure, we'll need to resurrect the public debate that ended in the 1920s. . . . We can redirect our concern with material goods toward redressing the inequalities of their distribution—and realize the promise of free time which lies before us. This time, let's make the choice for leisure.

JULIET SCHOR[3]

When everything we create is far in spirit from the festive, in the midst of our turbulent days let us think of what festivals *were*.

RAINER MARIA RILKE[4]

We can hope that [the new creation story] will soon be finding expression . . . in poetry, music, and ritual throughout the entire range of modern culture, on a universal scale.

BRIAN SWIMME AND THOMAS BERRY[5]

The preliterate peoples understand ritual as "the work of the people." The Aboriginal woman quoted at the beginning of this chapter said, "In our culture everybody works four hours a day and the rest of the day we make things." What is it that they are making? Rituals and preparations for rituals: gathering feathers and paints to adorn the body so that the human body in ritual might be as splendid as the birds and reptiles they admire; gathering and preparing food for the feast that always accompanies a ritual; making the musical instruments that will accompany the ritual; fasting and doing quiet work in order to center the heart and bring it full to the ritual; teaching the young their roles in the ritual. This woman is teaching us that in ritual there is work *for the whole community*. The creativity of the community is released in communal rituals, as Willis Harman and John Hormann observe: "In traditional societies, particularly those of indigenous peoples, the creation was collective, and participation was through ritual and communal work. One of the great disservices of the modern paradigm is that it obscured the fact of our creative urge, and persuaded us that we really are economically motivated and work for economic reward."[6]

In our culture we feel lucky if even one person, the preacher, prepares for a liturgy. The congregrants themselves are rarely involved.

Sadly, they may never be true participants in the ritual if they have not put time, sacrifice, and creativity—that is, work—into the event. By work I mean especially the heart-work, the art as meditation that, in its deepest meaning, *prepares the heart for ritual*. When I talk of liturgy as "the work of the people," it is not just a turn of phrase. I am talking about *work* and about creating work *for the people*. This work may be the most important of our time, for it is the work that can heal our species.

In the past few years I have asked many lecture audiences the following question: "Having heard the words of the Aboriginal woman, can you say that you could get your work done in four hours if you were sure that the rest of the day you could 'make things' together? That is, to make ritual in particular?" Usually about 90 percent of the employed members of the audience raise their hands. Economist Juliet Schor backs this up with scientific data. Her finding that our workers are already producing twice as much per day as we did in 1948 means that we could easily stop work after four hours and do something else, provided we were willing to settle for a simpler and less consumerist lifestyle. Perhaps ritual could be so much fun and so empowering that it would help us actively create work for one another.

The recovery of ritual will indeed make work happen for many who cannot find industrial-style employment today. In our postindustrial era we need postindustrial ritual, which is postindustrial work. We need ritual that awakens heart, mind, body, and imagination; the child, the mystic, the prophet, the healer, and the people. "The harvest is great but the workers are few," Jesus said in the Gospels. Nothing could be truer today regarding the sorry state of ritual. Learning to participate in ritual will awaken people to living more simply in a postindustrial, deeply ecological, and cosmologically aware world.

Ritual and the New Cosmology

The whole purpose of ritual is to connect us to the Great Work. Yet many persons' experience of ritual today resembles what art historian Peter Halley calls an "engineering ethos of modern technology and bureaucracy [transferred] to [one's] personal consciousness and emotional

life."[7] Liturgy as engineering: it's a strange idea, but it names the experience of many, and it explains why so many have walked away from ritual in our time. When I first heard Rupert Sheldrake's description of the paradigm shift in science, which we explored in chapter 2, I was struck by how much it said about my own experience in religious rituals. For example:

1. If the primary metaphor for our universe during the Newtonian era has been the machine, then in what way do our rituals resemble machines? How about the language and the attitude of "dispensing" the sacraments? Or the theology of *ex opere operato,* which suggests that we expect right actions to automatically guarantee grace? If sacraments are mechanical, our ritual leaders need not embody spirit or be prayerful. And since machines are highly anthropocentric—humans make them and use them—has this encouraged our ritual makers to be anthropocentric as well? Or vice versa: do anthropocentric ritual leaders and forms of worship sustain an anthropocentric society, lending it religious legitimization?

2. If the universe and its creatures are regarded as inanimate and without purpose, even soulless, it follows that humans will be satisfied with rituals that are themselves inanimate, without purpose, soulless, and boring. Did enduring the sheer boredom of ritual become a virtue in our soulless universe?

3. If inert atoms are understood to make up all of matter, it follows that inertness itself will be honored in our rituals, perhaps even raised to the level of ritual. The leaders of ritual will be expected to be inert themselves rather than lively and spirited. Seminary training of our would-be worship leaders today is more attuned to inertness than to spirit making, to memorized prayers rather than to prayers from the heart, to reading texts rather than to celebrating holy passion and pathos.

4. If the Earth is also inert, then surely it need not be represented in our worship. Earthiness is missing from ritual. Ritual so often seems *anemic,* lacking in the iron that comes from the Earth. The absence of earthiness plays itself out in the absence of our bodies, which are made of the clay of the Earth, from worship. With few exceptions, notably in African American churches, there is no place in

liturgy for moving the body, there is no dance, and there is no sweat. The benches are screwed eternally to the floor to prevent our bodies from moving and coming alive.

5. If the universe lacks spontaneity and freedom, then so do our rituals. Our rituals in the machine era are determined by books, laws, committees, and languages from thousands of miles away—or by local decision makers. Neither spontaneity nor silence are regarded as virtues in the rituals of the modern era.

6. If our ways of knowing are to be "objective" and "from the outside," then our rituals should mirror these activities. The architecture of churches built during the modern era usually sets up worshipers as spectators to what the ordained ones are doing up front. Participation is not a value—distance is. And the presider is often projected upon from afar as bearing all the perfection that we ourselves lack.

7. If the God of modernity is the supreme engineer or mathematician, pronouncing eternal, absolute, unvarying laws, then God requires this kind of worship as well. The questions of *what kind of God is being worshiped* and *what images we bring to God in worship* are obviously of central importance to our rituals.

I am not denouncing all ritual during the modern era. Nor am I saying that each and every worship experience falls into this diseased state. I am saying, however, that the boredom that characterizes much of our ritual in all mainline traditions today is related to the uncriticized cosmological assumptions of the machine era, which trivialize worship. Souls have shrunk terribly due to this machine cosmology. They might even be approaching the very inertness that we have been taught to so honor during the modern era.

Now if we consider the new cosmology as named by Sheldrake, we see energy emerging for new forms of ritual. For example:

1. If the cosmos is a single, developing, and expanding organism, our rituals too can be open-ended. They can connect us to the prehuman and the nonhuman and, indeed, to the entire history of fireballs, neutrinos, atoms, molecules, galaxies, supernovas, stars, and Earth with all its creatures.

2. If attraction is the key to soulfulness, and *field* is the contemporary word for soul, ritual can be reconceived as a field in which the

soul comes alive—a field where souls meet in mutual desire for life, sustainability, and beauty, and where souls of the past and the future are re-membered, re-connected to our own souls as they deepen in the present.

3. If atoms are fields of energy—structures of activity—constituting all matter, then as worshipers let's experience prayer as an awakening of energy, an awakening of all our atoms. We can invite the body back to ritual so that it can come alive there.

4. If Earth is Gaia, a living organism, it is to be honored and re-membered in all ritual. And all ritual must contribute to the task of healing Gaia as well. (This would be ritual's prophetic component.)

5. If chaos, freedom, spontaneity, and undetectable dark matter are intrinsic to our universe, they might also be intrinsic—indeed indispensable—elements in all our worship. Ritual might become an event that—instead of sanctifying control and predetermination—honors the surprise that the Spirit so often desires and encourages mystery and darkness.

6. If our universe is radically creative and participative, then creative participation of all worshipers must lie at the heart of authentic ritual.

7. If our universe is in fact made up of laws that are not eternal and absolute but that evolve like the rest of creation, and if laws might be understood better as *habits,* then what are God's habits? Let us entertain diverse images of God when we worship—for example, a panentheistic God; a God of life; a God in all things yet beyond them; a youthful God rather than a tired God made over into our own images; a God that is mother as well as father.

These are some suggestions for our ritual that grow out of the new paradigm in cosmology. Clearly good work is to be found in applying these principles to making ritual.

Other commentators on the new cosmology are also shedding light on the kind of ritual our times require. For example, in his study called *Art & Physics: Parallel Visions in Space, Time & Light,* Leonard Shlain describes the condition of passivity and atomization that characterizes many aspects of the modern era: the scientist's mind is split

off from the object of observation, the viewer of art is to think of herself as separate from the landscape, the audience is divorced from the musical performer. Shlain says, "Classical music listeners sat in neat rows that resembled the repetitive lines of type on a printing press and behaved like silent viewers standing outside the frame of a perspectivist painting.... The rules of etiquette increasingly demanded that audience members of a musical concert sit passively and not tap their feet, sing, move, or even cough."[8]

He might just as well be describing classical liturgies. Sitting passively with no audience participation is as common in church as in the concert hall. Shlain observes that "the respective citadels of art, physics, and music" were all shaken up by the startling new discoveries of this century. But unlike those other citadels, a revolution based on the startling new discoveries in cosmology has yet to take place in churches, which we might call our "citadels of ritual."

Technology also is changing our relationship to music. Shlain observes,

> Listeners no longer have to sit passively waiting for the orchestra to begin a scheduled performance. By simply choosing from their tape or compact disk collection, music lovers can recreate more music at their whim than all the orchestras that existed in the nineteenth century put together.... Now the audience can actively participate in the phenomenon of music which, of course, is identical to the core principle found in the world of the atom: observer-created reality.[9]

"Observer-created reality" is also the key to the new rituals. Ritual is nothing if it is not *participatory art,* as were the ancient rituals of the classical Greeks, the Mayans, African tribes, and other primal peoples.

Another principle for ritual comes from physicist Werner Heisenberg, who says that a real obstacle to resolving controversies in today's science is that "ordinary language [is] based upon the old concepts of space and time."[10] One could successfully substitute the word *ritual* for *language:* our rituals are still based too much on old concepts of space and time, as if church were a box into which worshipers are

poured to experience words or sacrament passively. But in this time of change we are growing restless, bored by the mechanistic rituals we are usually subjected to in institutional worship.

Perhaps we held ourselves down with these confining bonds in response to the suppositions of the industrial age about mass, density, and solidity. Gravity gets redefined in the paintings of Monet, for example; his subjects "are invested with weightlessness and a certain sense of airiness."[11] But how does ritual wrestle with gravity? Gravity is translated into human ritual by way of dance; the body in movement is a statement on mass, density, solidity, and gravity. Dance, which lifts us out of ourselves, was banished from traditional worship during the Newtonian era. How will we be able to worship, then, without a recovery of body, bodiliness, and dance? And how will we dance if our hands and eyes are tied down to books, texts, readings, and human—always human—words? The statement "This is my body" applies to *all* nature's gifts as well as to bread and to wine. The whole universe in all of its parts and in all of its history and in all of its vast space is in some fashion the body of God? If so, we should then praise and remember such divine incarnations!

A renewed ritual will be the work of the people where we truly ingest the new cosmology and make it our own, where gifts emerge and healing happens, where letting go becomes possible, and where beauty is acknowledged. All workers, we hope, will find their souls refreshed in the oasis of renewed ritual work. A renewed ritual will offer new work to millions at the same time that it offers renewed energy for the other kinds of work that we must do—new ways to educate, to involve the young, to learn about sexuality, to awaken art and enlist the artist as a worker in spirituality, to recreate economics and businesses, politics and science, to tell the story of the pain that environmental degradation is raining upon us and the planet, to bring spiritual warriors into the struggle of the environmental revolution. In short, renewed ritual will make community happen again, for a community is a group that *shares a common task together.* Ritual is an indispensable element for authentic community because in it we come together to name and celebrate, to lament, grieve, and let go,

and to create and recreate our common task: the Great Work of the universe.

I see ritual as the work of works. Above all other kinds of work, it is the *work of the people*. Ritual actually *makes a people happen*. It is the ultimate folk art, in that it actually fashions a people. Furthermore, ritual has been so scorned and trivialized during the machine age that the rediscovery that it *is work* in the fullest sense of the term is like the manufacturing of the first steam engine or the invention of the first assembly line for the first Model T Ford. We have an "industry" most ancient but new to our ways of thinking about work, healing, and creativity.

Let no one underestimate the revolution inherent in rediscovering ritual as work. Communities and educational groups that commit themselves to ritual making will not only revitalize their work worlds but also create substantive work for their citizens. I propose a conservative guess that communities who rediscover ritual as work will increase available work by 15 percent, and the energy we need to reinvent *all* our work worlds will be abundant because ritual unleashes energy. At the very least, ritual will allow us to lift long-standing burdens, including those of racism, colonialism, sexism, and militarism. In doing so it will allow us to grieve, and when this grieving happens creativity always returns, as Alice Miller has found in her years of healing work with violent youth and criminals in Germany. Until grieving happens, creativity is blocked. With this creativity, we can find solutions to the problems that divide and conquer us. The finding of solutions is also the making of good work.

E. F. Schumacher says that we need intermediate technology to overcome the alienation in the workplace. Do we also need "intermediate rituals," rituals that are truly participatory and not based on an outmoded cosmology? Consider what Theodore Roszak warns us about in *The Voice of the Earth:*

> Industrialism demands massification for its extraordinary power over nature: mass production, mass media, mass marketing. Our complex global economy is built upon millions of small, private acts of psychological surrender, the willingness of people to acquiesce in playing

their assigned parts as cogs in the great social machine that encompasses all other machines. They must shape themselves to the prefabricated identities that make efficient coordination possible.[12]

One who attends religious services can hardly read this passage without seeing its striking application to liturgy. The machine of the industrial era has truly taken over our churches and synagogues as well as our psyches. Indeed, one might argue that our rituals are *teaching* citizens to acquiesce to becoming cogs in a machine; rituals may be offering a kind of religious legitimization to the machine culture, which is, as Roszak warns us, a mass culture.

Authentic ritual will do just the opposite. It can accomplish its *prophetic* function: *interfering with* (Rabbi Heschel's definition of what a prophet does) the demands of the industrial machine—demands of massification, impersonalization, alienation, distancing, boredom, superficiality, and the legitimization of bigness. These demands of industrialization echo profoundly the warning of mystics like Meister Eckhart, who thought we ought not to live from the outer self but from the *inner self*. For the way of the outer self includes death, boredom, the stifling of creativity, despair, acedia, inertia, and lack of energy, while the way of the inner self includes new birth, youthfulness, and the shining of the image of God. In Eckhart's words,

> The soul is as young as it was when it was created. Old age concerns only the soul's use of the bodily senses. . . . My soul is as young as it was when it was created. Yes, and much younger! I tell you, it would not surprise me if it were younger tomorrow than it is today![13]

Authentic ritual helps us find our inner selves. That inner self is not just the personal self but the Self that is in communion with all the selves of the universe, from hydrogen atoms to complex ecosystems. It is the Self that Roszak seeks in his call for an ecopsychology. It is the Self that unites with all God's creation and with God. It is the Cosmic Self. It is what contacts the "light in all things," the spark of divine fire that is in our souls and in all things. We experience the "sheen" that Aquinas says God has bestowed on all beings and that Hildegard of Bingen calls a "radiance of God" that all beings carry within them.

And by reuniting with that radiance we become new again, healed and energized to "begin new things," as Thomas Aquinas put it.

What is the alternative? The disease of acedia, wherein, because of depression and despair and lack of energy, we "refuse to begin new things." Aquinas calls this state a sin, and, indeed, it is one of the capital sins. He warns that a sin of omission is always a sin against justice. In the case of poverty of ritual, our culture and its religions are sinning grievously against justice and the *right* of new generations of humans to experience effective ritual and participate in ritual making. One of the new things we need to begin is ritual itself.

Principles for Ritual

As we begin to think about reinventing the work of ritual, we must first learn the elements of healthy ritual. Let us consider principles that can help us in this reenchantment. The elements of healthy ritual include the six principles I first described in my book *The Coming of the Cosmic Christ,* which I have used when planning or leading rituals.

1. Reset all of worship in a cosmological context.
2. Bring the body back.
3. Bring play back.
4. Make room for the *via negativa*—darkness, silence, suffering.
5. Awaken and nurture the prophet.
6. Bring participation back.[14]

In addition, in reflecting on redeeming worship in that book, I discuss some lessons learned from praying with native peoples. Among them are the following:

1. Gandhi teaches that worship without sacrifice is a sin. A kind of generosity or sacrifice is required of those who will worship deeply. This may take the form of letting go of cherished forms of worship, of fasting, of taking risks.
2. Gratitude is what most motivates us in worship.

3. Bravery and heroism are part of everyone's existence, and worship ought to allow that greatness to express itself.
4. Community is a necessary part of all authentic prayer; it sustains us in our acts of sacrifice, gratitude, and bravery.
5. The Cosmic Christ (or Cosmic Wisdom) is present in all community prayer of every denomination.[15] Indeed, the renewal of ritual will come about by way of *Deep Ecumenism,* that is, by our praying together and doing heart-work together out of the deepest wisdom that our various religions can offer us.

The Jewish tradition, as practiced by Jesus and other Jewish people throughout the centuries, which forms the basis of Christian and Muslim ritual, has much to teach us about ritual. What, for example, is the relation of ritual to history? The key, according to Rabbi Abraham Heschel, is remembrance. "Much of what the Bible demands," he writes, "can be comprised in one word: *Remember.*" Indeed, faith "survives as a recollection of how we have once been blessed by the manifestation of divine presence in our life."[16] Today we need to broaden this "we" to include the entire human species. And, since our species in no way exists apart from other species and systems, our ritual ought to include all the other species, all the other galaxies and stars and supernovas, all the elements and molecules and atoms, and the original fireball that first blessed us all by preparing things for the coming of life. Ritual allows us to remember all this history and all these beings as "the manifestation of divine presence in our life."

All this is part of *remembrance,* in our lives of faith today and in our ritual life together. Much work remains to be done in making these connections and stories come alive today. If, as Heschel teaches, "faith is faithfulness, loyalty to an event," then all these events, from the beginning of the universe to today, require our faithfulness and loyalty. Remembering also is required because we have become ignorant of the facts of our being blessed by creation. (Many people do not notice their bodies until they become sick.) When we were all taught we lived in a machine, there was nothing to remember. Machines have no history. They do not evolve. They only break down.

To do ritual is to tap into the collective memory of our ancestors, our shared morphic fields. If it is true, as Rupert Sheldrake claims, that "the fields are the means by which the habits of the species are built up, maintained, and inherited," then ritual power includes this power of building up, maintaining, and inheriting. Furthermore, the hypothesis of formative causation—the idea that self-organizing systems at all levels of complexity become organized by morphic fields—teaches us that rituals may be that personal and social experience by which communities organize themselves and individuals connect to larger memories of past and perhaps even future. Habits and repetition are key to this self-organization, as they are to many of our inherited rituals. We inherit not only genes but also morphic fields, and we inherit these fields "by morphic resonance, not just from direct ancestors but also from other members of the species. The developing organism tunes in to the morphic fields of its species and thus draws upon a pooled or collective memory."[17] Perhaps ritual constitutes this "tuning in" that is so deep a part of remembering. Ritual tunes in to the future as well as the past. Remembrance has two faces.

Heschel's image of ritual is, appropriately, a cosmic image. "Reminders of what has been disclosed to us are hanging over our souls like stars, remote and of mind-surpassing grandeur. Heedfully we stare through the telescope of ancient rites lest we lose the perpetual brightness beckoning to our souls." Ritual somehow allows us to make contact with awesome grandeur and perpetual brightness, which seeks out our souls. Liturgy for the Jewish people "in text and song is a spiritual summary of our history"; Heschel teaches that ritual keeps events of the past alive so that they "never become past." In doing this they keep our souls alive, for "days of spirit never pass away." We have a past and therefore hope for a future.[18]

As Heschel puts it, "the authentic individual is neither an end nor a beginning but a link between ages, both memory and expectation."[19] I would change one word and say, The authentic *species* is a link between ages. For our species to become authentic, we must link past and future. And we do this primarily and most playfully in ritual. We must bring about this linking today for *all peoples* and especially for

the young, who must hear in story and song of the "surpassing grandeur" and "perpetual brightness" that have brought us all to this holy moment and that awaken in our hearts the days of Spirit that can never pass away.

Judaism's consciousness of time—of past and future—may be unique among the religious traditions of the ancient peoples of the world. This time-consciousness gave us the prophets, including Jesus, who felt called to challenge the times, to criticize the times, to insist that while cyclical time has its place, it is not the only time we know. Time is subject to other forces such as justice and light; divine justice and compassion can break through time, healing and renewing it. Concern for time and light gave us in our century a Jewish prophet named Einstein, as the concern for time and justice gave us in the last century a Jewish prophet named Karl Marx. Heschel says, "Judaism is a *religion of time* aiming at the *sanctification of time.*" Ritual assists in the art of sanctifying time: "Jewish ritual may be characterized as the art of significant forms in time, as *architecture of time.* Most of its observances—the Sabbath, the New Moon, the festivals, the Sabbatical and the Jubilee year—depend on a certain hour of the day or season of the year."[20]

Notice how time and space—indeed, time and *light*—come together in ritual. Those who say that Judaism is traditionally anthropocentric do not understand the very basis of its ritual. As Heschel clearly states in this passage, it is the universe's time—the solar time, the season's time, the sun-moon-light-dark time of the day and night and seasons—that dictates the festivals of ancient Israel. How much of this sense of the sacredness of nature's time we have lost in our urban living and our "Enlightenment" inventions! Our machine consciousness has banished darkness, and capitalism has desacralized time (in capitalism "time means money.") In contrast, ritual time is always about nature's time—including human nature—and therefore history's time.

We need to redeem time and sanctify it. How shall we sanctify the times today? Surely the times we celebrate in our respective religious traditions are part of the answer. But they are not enough.

In Search of Sabbath

In discussing work and the *via negativa,* we reflected on the decline of leisure in our civilization as articulated by economist Juliet B. Schor. She ends her book with the following plea:

> If we are to have a chance at leisure, we'll need to resurrect the public debate that ended in the 1920s. For despite the major transformations our nation has gone through since then, the basic alternatives remain surprisingly the same. On the one hand, commitment to an expanding material standard of living for everyone . . . entails our continuing confinement in the "squirrel cage" of work and holds the potential for ecological disaster. Or, we can redirect our concern with material goods toward redressing the inequalities of their distribution—and realize the promise of free time which lies before us. *This time, let's make the choice for leisure.*[21]

But as we shall see, the decline of leisure was not as unexpected as Schor points out, for at least one philosopher, Josef Pieper, predicted a leisure crisis amid the compulsive work ethic of post–World War II capitalism. In his classic work, *Leisure the Basis of Culture,* Pieper critiques what we now refer to as addictive work. He explores our lack of a festive attitude and our incapacity for non-activity or leisure.

> The soul of leisure, it can be said, lies in "celebration." Celebration is the point at which the three elements of leisure come to a focus: relaxation, effortlessness, and superiority of "active leisure" to all functions. . . . [Its] basis is divine worship.
> The meaning of celebration, we have said, is the [human] affirmation of the universe and [our] experiencing the world in an aspect other than its everyday one.[22]

Our spiritual tradition has another word for *leisure,* namely *Shabbat* or *Sabbath,* a day of rest. In considering more closely the meaning of this tradition, we may recover a rich basis for reflecting on the work of ritual in a postmodern era. What does Sabbath mean?

In my childhood, while learning the catechism, we memorized the Ten Commandments, of which one is: "Remember to keep holy

the Lord's Day." But the instruction was about what one ought *not* to do. We were told, for instance, that we ought not to do "servile work" on the Lord's Day, for servile work, we were instructed, was the work slaves did. This did not have much meaning for kids growing up in the 1950s. I remember long lists of tasks that we were told not to do because, presumably in another place and time, slaves might have done them. The point of this story is that we were not instructed in what *Shabbat* meant in any positive sense. (We were told it meant going to church on Sunday, but since that was set in the context of: "If you don't go to church on Sunday you commit a mortal sin," it could hardly count for an affirmative precept of keeping the Lord's Day holy.)

Nevertheless, Sunday was a kind of holy day in our family. It included a special family breakfast, which we ate in the dining room instead of the usual breakfast nook. It included reading the Sunday papers together, and in the winter it often meant a family outing to toboggan or ice-skate. In the summer it meant a visit with friends at a cottage or a trip to the beach; or, at holiday times, it meant a trip to Chicago to visit grandparents. No mention was made of a Jewish teaching that we ought to make love on Shabbat. But in their fashion my parents taught us that Shabbat was about lovemaking—about delighting in the joys of creation. *About doing something without a why.* Because Sundays for us always began with going to mass, there was a kind of sanctification to the day.

Shabbat in its origins meant a kind of redemption of the Garden of Eden, a celebration of the garden in the Song of Songs—thus the command to make love on that day—a cosmological awakening to the original blessing in our lives. Add the Easter garden story from Christianity, and Shabbat does indeed seem a day of delight and remembrance. The primary reason we are driven to thanks, according to Thomas Aquinas, is creation itself. He writes, "The sanctification of the Sabbath [is] in memory of the creation of all things." It is nothing less than "the creation of all things" that urges us to praise and thanks. For Aquinas, creation is "the first and foremost of all the divine gifts" that we commemorate at the Sabbath.[23]

Rabbi Heschel reminds us that the first time the word *qadosh* or *holy* is used in the Bible is in the book of Genesis at the end of the story of creation: "And God blessed the seventh day and made it *holy.*" Creation is holy, and therefore time is holy; and the holiest of all times is the seventh day of creation, the Shabbat. Thus "the meaning of the Sabbath is to celebrate time rather than space. Six days a week we live under the tyranny of things of space; on the Sabbath we try to become attuned to *holiness in time.*" Sabbath is at least that one-seventh of our lives in which we let go of labor and toil and come to realize that from one point of view "the world has already been created and will survive without the help of [humanity]."[24]

Sabbath is a day, a time, an attitude of letting go of work in order to reexperience the holiness of existence, including our ability to work and cocreate. "There is a realm of time where the goal is *not to have but to be, not to subdue but to be in accord.*" While some would envision the rest of Shabbat as a preparation for work, the opposite is meant. *Work is a preparation for Shabbat.* "The Sabbath is not for the sake of the weekdays; the weekdays are for the sake of Sabbath. It is not an interlude but the climax of living."[25]

What characterizes the Sabbath? God is said to have done three things on the seventh day: God rested, God blessed, and God hallowed the seventh day (Gen. 2:2–3). And so "the blessing of delight and the accent of sanctity" constitute the heart of the Sabbath: "Call the Sabbath a delight: a delight to the soul and a delight to the body. . . ."[26]

The seventh day is created all over again when we celebrate Sabbath. The holy play of Sabbath preceded creation and completes creation. There is something panentheistic about the Sabbath; it is in us, but even more are we in it. "The primary awareness is one of our being *within* the Sabbath rather than of the Sabbath being within us." The seventh day marked a very special creation: that of *Menuha* or happiness, stillness, peace, and harmony, of tranquillity, serenity, and repose. Divine repose is the heart of Sabbath; we can all participate in it, and in doing so we taste "eternal life."[27] Heschel points out that Sabbath prayers are prayers of *praise,* not prayers of petition, fasting, mourning, or grief.

But the Sabbath is not anthropocentric; it is not for humans only. It

> is a day of rest for all creatures. It is a day of harmony and peace, peace between [humans], peace within [a person], and peace with all things. On the seventh day [the human] has no right to tamper with God's world, to change the state of physical things. It is a day of rest for [*the human] and animal* alike: In it thou shalt not do any manner of work, thou nor thy son, nor thy daughter, nor thy man-servant, nor they maid-servant, nor thine *ox,* nor thine *ass,* nor any of thy *cattle,* nor thy stranger that is within thy gates; that thy man-servant and thy maid-servant may rest as well as thou.[28]

The Sabbath is a reminder of the harmony in the universe and the harmony that is to come. It is a celebration of cosmic peace, cosmic joy.

> The Sabbath, thus, is more than an armistice, more than an interlude; it is a profound conscious harmony of [humanity] and the world, a sympathy for all things and a participation in the spirit that unites what is below and what is above. All that is divine in the world is brought into union with God. This is Sabbath, and the true happiness of the universe.[29]

Sabbath teaches us what to do with leisure time other than become couch potatoes. We can fill our time with Spirit, as Heschel puts it. In Israel Sabbath is personified as a bride, as a lover. "To sanctify," as "to sanctify the Sabbath," means to consecrate a lover, to betroth. Thus God promises the Sabbath—which is lonely for love—a partner; that partner is the community of Israel, promised as a mate. "The Sabbath is a bride, and its celebration is like a wedding."[30] A consummation occurs between the lovers—the Sabbath and us—and with that consummation a repose. The divine repose follows.

When we work hard six days a week the spirit can be neglected. But on the seventh day the Spirit makes love with us unabashedly, all the time seeking us out. This is why the chanting of the Song of Songs, the "greatest of all songs," the ultimate lovers' song, is part of the Shabbat. So too is the lighting of the candles, the renewal of creation, since light was the first gift of Creator to creation. The fact that

the new creation story also suggests that the universe began with light—that is, as a pinpoint of fire—only embellishes this story. In the ecstasy of Shabbat we find intimations of eternal life, a tending of the seed planted within us that will not die, an anticipation of "the day which will be all Sabbath and rest in the life eternal." It is an occasion wherein "a seventh part of our lives may be experienced as paradise."[31] There are deep hints of resurrection—resurrection of spirits and of hope—in this theology of Sabbath.

Prophetic and Political Implications of the Sabbath

I propose that Heschel's deep teaching about the Sabbath be broadened in our day to encompass all religions and all peoples. The Sabbath is the day of mysticism *par excellence:* a day for *being* and not doing, a day of *mystery,* not problem. In this teaching we have a solid answer to the more secular questions: What do we do with leisure time? Why are we so afraid of it? And therefore we can answer also the psychological question: Why do we succumb to work addiction? We succumb because we know so little about Sabbath, about enjoying life and savoring its blessings. The Sabbath teaching answers also the economic questions: Why do we always want more? When is enough enough? Because the Sabbath—and only the Sabbath—satisfies. And it answers the question of deep ecology: How can our species slow down and cease its compulsive destruction of other species?

By observing a seventh day of rest. The Sabbath, as Jewish theologian Arthur Waskow points out, has deep *political* and *prophetic* implications. The Sabbath can be called a "mini-Jubilee: no one works, everyone shares." The Jubilee, like the Sabbath, is a safety valve for humanity's greed and power, a reminder that justice must be regained at least every seventh year for the community, as it must be regained at least every seventh day for the individual. The tradition of the Jubilee requires "that in every seventh year loans must be forgiven and the poor lifted from the desperation of debt, but that once in every generation there must be a great transformation—and that each generation must know it will have to be done again, in the next generation."[32] And thus, in the tradition of the Jubilee, we find

an answer to the political question southern (poor) nations are asking northern (rich) ones: When will you lift the yoke of debt from our nation so that we can resurrect and become a partner and not a slave in trade and in status with you?

The poor and the wealthy must relate anew every seventh year and whole new relationships must happen by a complete forgiveness of debt. Not only humans but all creatures are released from labor every seven years; even the land itself is meant to go untilled every seventh year. The result? "Nature itself would be transformed along with the society; everyone would have a sense that doing something so basic as sharing the wealth could change something so basic as how the plants grew. Everyone would learn that the 'biggest' action of all was to not act."[33] The rich as well as the poor, human as well as non-human, would be forgiven or released from debtlike relationships. In the fiftieth year—the seven-times-seven-plus-one-year—a total redistribution of land was mandated.

The rest that the Sabbath promises is not just a personal rest; it is a prelude to the rest that all just relationships and all acts of interconnection are about. Therefore it is about *hope.* What would the Sabbath mean?

> That everyone must know *for sure* that neither poverty nor charity will last forever . . . that decent work, a decent economic independence, is coming to everyone. That there must be hope—not the hope of fantasy, but the hope of sure knowledge. That hope is both spiritual and economic.[34]

A Jubilee consciousness would make it possible for the reforms of work that we have enunciated in this book to come about. Without stopping the work we are doing, it is unlikely that we will be able to address the work that needs doing. This stopping, this ability to let go and let be, is a spiritual act. In Buddhism, it is called non-action; Eckhart called it letting go; Paul called it emptying. The Jewish tradition called it Shabbat. Today we might all call it common sense. Or survival. We will do it together or we will perish together.

In an article on the Sabbath, Arthur Waskow points out that two traditions exist in Judaism around the theme of the Sabbath: One sees

Sabbath as a reflection and expression of cosmic rhythms of time embedded in creation—this is found in Genesis and Exodus in particular and focuses on birth, creation, and nourishing. The second tradition sees Sabbath as an affirmation of human freedom, justice, and equality, and is found emphasized in Deuteronomy and the prophets Jeremiah, Ezekiel, and Second Isaiah. "The biblical tradition regards these strands not as contradictory but as intertwined," he points out, and in Leviticus 25 they especially come together:

> Deuteronomy, Leviticus, and the prophets felt no contradiction between this theme of liberation and justice and the theme of cosmos and creation. Cosmic creation and social re-creation were seen as analogous, even in a sense isomorphic. . . . What moderns call social justice is, in this biblical outlook, treated as one form of rest—as social repose or social renewal.[35]

Another application of Sabbath has already penetrated our work world to some degree, but not deeply enough. This is the idea of human workers taking a sabbatical. At present sabbaticals are almost exclusively a privilege of the academic world, but notice the implication. Taking a sabbatical means getting away from one's work every seven years in order to be refreshed and, perhaps, to return to one's work with more insight and enthusiasm. What if *all* workers could take a sabbatical—could go back to school every seven years or spend a year at home with the family or travel or read or do volunteer work or help with the young, the prisoners, or the aged? How would that affect the souls of us all when we returned to our workplaces? How would it affect our attitudes toward the workplace itself? How might this contribute to eliminating unemployment? If 14 percent of the workforce is not at work any given year, that ought to mean that there would be work for about 14 percent more people. What about the idea proposed in chapter 6 that all young people get a year's sabbatical for spiritual exploration and training?

A universal sabbatical is not as extreme as it may sound. German theologian Geiko Müller-Fahrenholz has analyzed what it would mean.[36] Müller-Fahrenholz asks why a sabbatical should be an elitest thing for professors alone. He sees it as analogous to a pregnancy

leave (in Europe pregnancy leaves are given with pay). "This free year gives time for specific necessities, for professional and other personal development and not least of all for the development of an understanding of life, not just the characteristics of work life." To the question "who pays for it?" he responds that sabbaticals should be understood as flexible pension years occurring in regular intervals throughout one's working life. The first free year comes around thirty years of age; the second between thirty-five and forty; the third in the mid-forties; the fourth around fifty years of age; and the fifth at the end of one's fifties. Employers actually benefit because the person returns to work better educated and more highly motivated. If we keep the work week at forty hours instead of cutting it to thirty-five, this alone would make up for five free years of sabbatical leave.

The sabbatical idea holds great advantages in addressing two pressing issues: unemployment and the pension crisis. Think of the many people who retire and do not know what to do with their leisure time. By having five leisure years during their working years they will have learned something about leisure activity. In addition, work that benefits the soul, such as adult education, artwork, meditation, gardening, parenting, community building, and political organizing, would flourish. I would add that rituals would also flourish—rituals marking rites of passage and rituals marking our seven-year phases, including parenting, grandparenting, menopause, and old age. Such a practice would probably mean lower medical expenses and fewer stress-related diseases, and it would revitalize our attitudes toward old age since we would continue to develop our creativity through our sabbatical leaves. A built-in sabbatical year for everyone could create the spiritual vacuum from which a renewed sense of soul and Spirit might arise.

Reinventing a Spirit of the Festive

Asks Heschel, "Is there any institution that holds out a greater hope for [humanity's] progress than the Sabbath?" The hope and empowerment that the Sabbath promises is just what we need to underpin a

spirituality of work in a postmodern era. At the heart of the Sabbath joy is the healing of dualisms—and who would deny that the dualisms within the human psyche and social structures are at the heart of our problems the world over? The promise exists that every seven days and every seven years something will happen to break through these dualisms, that grace will bless us. This news is just too good to keep under wraps! In the ritual of the Sabbath the former separations of male/female; masculine/feminine; yin/yang; day/night; north/south; east/west; human/divine; human/Earth and Earth creatures; right brain/left brain; mysticism/prophecy; sky/Earth; *via positiva/via negativa;* personal/social come dancing together.

No wonder Heschel names the crisis of creation and the crisis of human work as being a crisis of Sabbath: "In the language of the Bible the world was brought into being in the six days of creation, yet its survival depends upon the holiness of the seventh day."[37] If the survival of creation in fact depends upon keeping the seventh day holy, then we really ought to be about making it holy. Letting go, letting be, letting our projects go every seventh day, every seventh year, and every fiftieth year. *This* work would truly connect our inner work to our outer work and our daily lives to the Great Work. *This* work would truly render all our other work holy.

Writing early in this century, when the industrial revolution dominated our horizon, Rainer Maria Rilke begs us to remember another spirit than that of the Enlightenment: the spirit of festivity. He almost despairs of our ever being able to be festive again when he says, "When everything we create is far in spirit from the festive / in the midst of our turbulent days let us think of what / festivals *were.*"

Perhaps he was prophesying the making of war that has been so developed in the twentieth century as the ultimate art form. With this plea in mind—to reinstate the "spirit of the festive"—let us consider some examples of the ways in which the elements of ritual making can move us in our time. The postindustrial work world, where work entails first of all the putting of our inner houses in order, is a world where ritual can be welcomed once again. And festivals might return.

Some Examples of Effective Rituals

Over the twenty-five years that I have been an ordained priest and a leader of ritual in retreat settings, ecumenical settings, educational settings, and occasionally parish settings, I have had the opportunity to participate in a number of effective rituals. Two particular moments that speak of the power of ritual are etched in my memory.

Once, I led 550 adults in a spiral dance on a beach at a retreat center on the Pacific Ocean in California. Three teenagers who were surfing at the time quit their surfing and parked their surfboards in order to watch us do. I thought it was amazing that anything adults did, much less ritual, would interest adolescents. But it drove a point home to me that I have observed time and again: if adults are doing ritual effectively, it is intrinsically alluring and the young *want* to join in. Desire is aroused when appetizing ritual is put before us, just as it is by good food or drink when we are hungry or thirsty.

Another time, a large group of us did circle dances on the first floor of a large building that had floor-to-ceiling windows. During our dance, I happened to glance at the windows and saw three men lined up with their noses and hands pressed against the windowpane. Two were homeless persons, and the third had a briefcase (I imagined him to be a lawyer or a banker). It was like a scene from a Dickens novel: The *hunger* was explicit—hunger for ritual, hunger for community, hunger for letting go and for being part of the circle dance of the spheres, hunger for cosmology. For me that hungry trinity seemed to represent our entire species, which is so hungry for ritual.

The effective rituals I have experienced have always employed the principles I laid out earlier in this chapter. Remember, when doing ritual, that consciousness is as much changed in ritual as it is in the struggle for social justice. Also remember that compassion is *the* alternative way of seeing the universe, and compassion is fifty percent about celebration and fifty percent about healing and social justice making. To put it differently, the struggle for justice takes place in our language and forms of ritual no less than in our struggle with economic and political systems.

The key to recognizing effective rituals is the awareness that *ritual is not performance art—it is participatory prayer.* This is the wisdom of base community ritual wherever it is entered into: that all participants are the prayers, all are the breathers, the dancers, the delighters, the thankers. There is a role for leadership in coordinating and inspiring and helping form the emergent gifts of the community.

Now I would like to share with you some effective rituals I have participated in.

Ritual of Lamentation: Stations of the Cross

If you visit any Roman Catholic church you will find on the walls fourteen figures that represent fourteen stations of the cross. Catholics, especially in the time of Lent, stop before each of these stations to meditate on the journey of Jesus from his condemnation by Pontius Pilate (number one) to his taking up his cross, falling underneath it, and eventually being crucified and buried (number fourteen). This medieval pious practice has been renewed for me in two especially powerful experiences through refocusing it from a prayer about the historical Jesus to a meditation on the Cosmic Christ. When the crucifixion and death of Jesus are entered into from the perspective of a theology of the Cosmic Christ, that is, as the suffering of the Earth and her creatures—all of them Cosmic Christs being crucified in our midst—a whole new reality unfolds. The gospel of compassion that Jesus preached comes alive and real, and the temptation to sentimentalize him in the privacy of a pious heart is avoided. Let me describe these two experiences.

In the spirit-filled lands of Findhorn retreat center in northern Scotland, amid the wind-swept hills on a cold Good Friday afternoon in April 1991, about two hundred and fifty of us gathered to pray in an ancient format. The form we chose was that of the stations of the cross, but we did them differently; instead of concentrating on events in the life of the historical Jesus, we focused on the suffering of the Cosmic Christ in the Earth and her creatures.

The worshipers included co-leader Joanna Macy (a Buddhist, though the daughter of several generations of Calvinist preachers)

and persons who had come to the retreat during Holy Week dedicated to experiencing the paschal mystery of the life, death, and resurrection of Mother Earth. We were Swedish and American, Canadian and German, Scottish and English, Irish, French, and Dutch. All religious persuasions were represented, including some still in the churches—Protestant, Anglican, and Roman Catholic. There were Jews, New Age persons, and persons wounded by their church upbringing ("Recovering Christians").

We divided the group into fourteen "home groups," and each of these groups determined for itself what area of suffering in the world it felt called to represent in the ritual. Groups made placards, gathered chants, created banners, and collected musical instruments for the procession.

The procession began around noon, with everyone gathered around a rock to hear a brief reading of the Gospel story of Jesus' journey to Golgotha. Drums rolled, and a somber mood filled the air as we processed to the first station, where Joanna and Fran Macy led us in a mourning ritual for the victims of Chernobyl. In response to a litany of pain the large group was instructed to sing a Russian "Kyrie eleison," "Lord have mercy."

On the way to the next station the procession continued with a somber drumbeat and the ongoing chant of the Russian Kyrie. The second station commemorated the crucifixion of the air. This was enacted by a circle of people who began by breathing deeply together and then choking on the air they were inhaling. The deaths of forests and the choking of our children were invoked.

The third station commemorated people afflicted with AIDS. At this station worshipers were invited to call out the names of those who had died of AIDS. Everybody knew persons with AIDS. The children of Romania and Africa were also invoked and the millions of others who were nameless to us. We were reminded of the immune deficiency that the Earth itself is experiencing today with mining, the testing of nuclear weapons, and the destruction of the ozone layer. Appropriately were the words of the Gospel invoked: "As long as you do it to the least of these you do it to me." Somberly, with

drum beating, we moved along the road and through a grove of trees to the next station.

The fourth station commemorated the sacred web of creation. All were asked to kiss, in silence, the web of creation woven with yarn.

The fifth station was named "oppression." There a litany of oppressions was recited, including racism, homophobia, anti-Semitism, classism, ageism, sexism, ableism, speciesism. We were invited to enter into the pain of oppression, "not through the lens of guilt but the lens of truth" and to realize how one act of oppression is connected to all the others. We were reminded that none of us was born racist, for example, and that we were instead born curious about one another. We were asked to break into pairs and to name a lie that we had somehow been taught during our lifetime about another person or group. Our partner was instructed to say, "This is a lie," and together we released this lie to the universe.

The cold and wind were growing more bitter as we made our way over the hills to station number six. There we were invited to approach a stick with a mirror mounted on it, and we heard a chant ringing in our ears: "Behold the crucified, behold the crucifier"—a chilling reminder of how we ought to resist projecting our own violence onto others.

The seventh station was for releasing memories of abuse. Women in recovery from abuse led us in a prayer, announcing that the force that tried to separate them from creation and their deepest selves and that temporarily committed soul murder would no longer hold sway over them.

The eighth station commemorated the abuse of animals, fish, whales, and soil.

At the ninth station, we were reminded of the crucifying of the Earth, air, water, and fire. Passing around a ball of the Earth, each person was asked to pray over it as an expression of his or her commitment to its healing. A gospel text was read that carried immense weight in the present context: "Daughters of Jerusalem, do not weep for me. Weep for yourselves and your children." Other creatures,

each a Cosmic Christ, spoke out with a similar message. The whale exclaimed, "Weep not for me but for your children and your children's children, for I cannot give you my gifts if the poisoned ocean destroys me." Real grief was expressed at this station.

The theme of the tenth station was naming and recognizing our fear. All the leaders at this station spoke to something that made them afraid: "I fear being separated from all I love," said one. "I fear that we are not going to make it as a species," said another.

At the eleventh station a skit was performed in the sand dunes on the topic of waste. In the skit the group threw a party, then threw its trash all around. People coughed, tripped, and fell into the junk that piled up. A Tibetan horn played sonorously. There was a lightness but also a deadly seriousness to the story that was told and the mood that was evoked.

At the twelfth station we meditated on disconnections before a large map of the Earth that commemorated forests, the children, humanity, and other species losing their connections with one another. A chant was sung: "I am Gaia, I am scared."

The thirteenth station named the "crucifixion of the feminine." We invoked the nameless women who were killed during the burning times (witch trials of the sixteenth and seventeenth centuries). People broke into a discomforting wailing. An older woman, who was dressed like a wise sage, spoke: "Earth speaks to us and tells us to go into the void, the darkness, and find who we are before it is too late."

The fourteenth and last station took place on a sand dune within sight of the North Sea. The wind was howling, the air was cold, and we were weary of all this processing, which had been going on for almost three hours. But our attention was reawakened by a tortuous sound: a man dressed in a hooded outfit was whipping the ground with a large fir branch, scourging the Earth. He addressed us and told us that he destroys what he does not understand. The whipping brought back memories of Jesus' being scourged at the pillar. Other persons spoke out: "I am a lizard. My home is in the rain forest. Where is my home?" Another spoke: "I am a fish. Where is my

home, since the lakes have died of acid rain?" "I am an unborn child. Is there a home for me?" The theme of homelessness took on a more poignant and even cosmic dimension.

Then the participants took a map of the Earth and, nailing its four corners to a cross, erected the cross on the top of the sand dune, as the wind howled through us. With the nailing to the cross, the pounding echoing along the beach, the morphic field, the memory of Jesus crucified awakened. Participants wailed—even those who had never heard of this medieval prayer called stations of the cross drink in its meaning. The wailing was spontaneous. The keening was real. Silence followed. We walked back, defeated and tired, to our living quarters a mile from the dunes. Later I learned that the group that led this last station were themselves so moved by what they had reenacted there that they all stayed at the foot of the cross for half an hour in silence, unable or unwilling to move.

Clearly the Spirit was at work in this retelling of the stations of the cross. A deeply prayerful attitude permeated the work. People experienced discomfort—as did their forebears in their march to Golgotha. Genuine creativity emerged from each group as it took responsibility for its station. Each group was a kind of "priest" in the ceremony, leading others to prayer. We held no rehearsal, for it was not a production; it was prayer. There was complete participation of body, soul, and spirit on the part of all participants. The outdoor march and the cold wind demanded the body's attention, and with it the heart's ample participation. We named the real pain in our lives and the real pain of our times and our societies. And we invited simple chants by using portable musical instruments like drums and whistles.

It was a time for children—serious and grieving children, but children nonetheless. Francis of Assisi, whom history credits with having invented the stations of the cross, would have been at home with our prayer. Indeed, I'm sure he was there. The spirits of many of our ancestors were there. It was an authentic remembering.

I encourage you to develop your own version of the stations of the cross on Good Friday in your community, perhaps borrowing some of

the ideas from this reenactment. The Cosmic Christ deserves to be represented in our churches and beyond. If we commemorate only the historical Jesus, we probably risk sentimentalism, which is a certain way to destroy the message that Jesus taught. With the issues of homelessness and rape of the land, joblessness and lack of health care, greed and fundamentalist fear, youth in despair and addictions in abundance, a politics of trivia and of resentment, there is no lack of stations that deserve to be named and prayed in our own land at this time.

During Lent, 1992, at the Institute in Culture and Creation Spirituality, we did our own version of the stations of the cross. We divided the seventy students into fifteen teams—fourteen to create a particular station and the fifteenth to coordinate the entire ritual. One group took us down to a ravine on campus where deep foliage blooms and in that setting reenacted the plight of the rain forests, the pollution of the rivers, and the crucifying of the trees. (This group was led by a student who had been living and working for over twenty-five years in the Amazon rain forest.) We climbed to the center of the campus, where a group of women and men wearing pink triangles and telling stories and statistics of the abuse of gay men and lesbian women acted out the crucifixion of homosexuals in startling and dramatic fashion. Another station commemorated the religious wars of Europe and the killing of so many millions of Protestants by Catholics and Catholics by Protestants (a leader in this group was a student who had been recovering his French Huguenot roots during his studies at ICCS). Another station commemorated the abuse of children; this station met at the day-care center on campus, in front of the children's slides and play toys. The leaders created a litany about child abuse, and its simple refrain, "Children are precious to me," was repeated by the whole group.

Another station named racism as the crucifixion of Christ in our time. And so it went, a three-hour walk, tiring, demanding, uplifting, enlightening, daring, and very, very serious. It was real prayer of a very mixed group of persons entering into the passion of the Christ in the world today. At the final station the team erected a large cross in the ground and slowly, painstakingly, nailed a picture of the Earth

to it with four nails. Once again, everyone got the message. No eyes were dry. We had entered into Good Friday, 1992. Remembrance had happened. Ritual had done its work.

Ritual of Lamentation: Mourning War, Reconciling in Peace/ Vietnam Ritual, January 1992

Ritual helps us pay attention to our hearts when they have broken. Loss of soul and life can take place on a national scale as well, for example in wars, and we need rituals to grieve these events also.

The Vietnam War still tears at the fabric of the American heart. A nation cannot fight a war, lose 60,000 of its citizens in death—and hundreds of thousands more in damaged bodies and spirits—kill hundreds of thousands of human beings on the other side of the world, and devastate their land without remorse. Forgiveness needs to happen on both sides. The Vietnam memorial wall in Washington, D.C., is a brilliant evocation of our grief, but the wall is not enough. Many politicians since that war have continued the denial in our souls by telling us we won the war (as if that really heals wars' hurts) and assuring us that the "war is behind us" since America and its allies defeated Hussein's armies in Iraq in 1991. Some psychologize the Vietnam War, calling it a "syndrome" that was "healed" by the Persian Gulf War. But a war is not a syndrome. Fifty percent of America's homeless are Vietnam vets. War is a serious and massive undertaking, and it affects men's and women's souls. It does not go away through political posturing or individual therapy alone. It requires spiritual and communal healing as well. It requires ritual.

With that in mind, Vietnam veterans approached poet Robert Bly, Celtic ritualist Michael Meade, and me, asking us to lead an event to mourn the war and reconcile in peace. Swords to Plowshares, a Vietnam veterans group, and Friends of Creation Spirituality, a nonprofit group committed to teaching creation spirituality, sponsored this public ritual to mourn and grieve the Vietnam War. Many groups representing Vietnamese as well as American survivors of the Vietnam War in the San Francisco Bay Area met over many months to plan the event. Over 115 volunteers worked to bring about the ritual.

The ritual took place in San Francisco at Fort Mason in a vast hangarlike space that was remade for the ritual. On entering, participants walked through a long, dark tunnel built entirely of Earth, which was intended to evoke memories of trenches and feelings of doubt and of not knowing what lay ahead. Leaving the tunnel, one encountered a field of campfires—simple, flickering lights with trees—and at each campfire a storyteller told his or her story of the Vietnam War, repeating it continuously as participants drifted from campfire to campfire. One storyteller remembered looking into the face of a dying man who had begged to be excused from his last assignment because he was due to go home in two weeks. "Just one more," his commanding officer had said. That one more killed him. A young Vietnamese man grieved because his mother still lay unburied at the bottom of a river. It was the anniversary of her death, and according to their religion, food should be brought to her. But that was impossible. "She will be hungry," he said. An older woman recalled the war of 1940 and the grandchildren who came back maimed or dead.

Three portable altars were set up. One held snapshots of dead American servicemen; "They looked like ten-year-olds, dressed up, playing the schoolboy games of soldier," commented one observer. Tangerines, flowers, and a skull filled the rest of that altar. Another altar was a black-draped coffin with just a single flower on it. Another altar, draped in white, contained elements of the Buddhist faith—rice, flowers, Buddha statues, garlands. An American journalist who helped design it told me that, when she was in Vietnam, the only place she could go for sanity and peace was a Buddhist temple. Though she was not Buddhist, she was grateful for that sacred space and was moved to build the altar in gratitude. From there, participants walked into an arena, where on-stage dancers performed a kind of tai chi, miming fear and killing and death. An African American woman sat keening a wordless song, the grieving voice of the ancient mother. The backdrop was an ancestral wall of black drapery with pictures of human faces on it, a reminder of the "other side" that our separated ones find themselves in.

The mourning event itself consisted of three stages, symbolized by three colors: red for rage; black for sorrow, and white for transcendence. Robert Bly led us in rage. "Only boys keep their eyes dry," he declared. "Only boys are afraid to cry. But men—thank God for their tears." Bly invited to the stage a huge puppet representing war itself. The crowd was invited to rage against the puppet: "I hate you, War! Fuck you, War!" people screamed. Michael Meade led us through the stage of sorrow, drawing the parallel between the Vietnam War and the Persian Gulf War. "Our grief has to be wept away," he exclaimed. My task was to lead us in the stage of transcendence, which is won only by passing fully through the other two paths of grief. I recited a medieval poem called "The Falcon," which tells of a wounded knight whose wounds bleed "day and nite," while his maid weeps all night long. The poem reminds us what happens when grief is not attended to: nothing happens! Nothing is changed until we journey into grief. But as we become emptied of rage and sorrow, we bottom out; peace comes; light reappears. Thus, mourners in the East wear white—instead of black—to funerals.

We made some mistakes in this ritual: too few women leading; too much action on the stage and not enough circle dancing to involve all participants; too many words—always a risk if you invite poets. But every one of the 1400 participants left the hall in silence, and good prayer always raises silence. I know it was good prayer because nature joined in. When we left the hall we processed with candles to the waterfront, chanting an African dirge. Then we all placed our candles on an altar by the water. The very second that the last candle was in place, the skies opened up and a deluge descended. That was a sign. The heavens themselves were crying, shedding those tears over Vietnam that we had all been holding in for far too long.

The numbers who attended were impressive, and among the 1,400 participants were both young and old; a mixing of generations always makes for healthy ritual. It was deeply moving to see young persons observing their elders in grief over the shadow side of war—something our jingoistic politics seldom allows. Some of these young ones were sons and daughters of Vietnam vets, who had paid a price

for growing up in a veteran's family. Many ethnic and racial groups were represented, though I would have wished for more African American participation, given the large percentage who served and suffered in Vietnam. It was significant to me that the event brought together those who resisted the War twenty-some years ago with those who fought in it—a dualism that had not been reconciled over the years.

Recently I received the following letter of response to the ritual from a Vietnam Vet who helped organize it.

> A platoon sergeant who was with the 101st Airborne Division in Vietnam in 1969 had been able to keep all his men alive during the first part of his tour. He went on rest-and-relaxation leave about halfway through his tour. While he was gone his unit was sent to "Hamburger Hill," the most bloody battle of the war on the American side (another battle where we "took" a hill, then almost immediately "gave it up"). All his men were killed. This guy had carried guilt about this for twenty-three years. He couldn't let it go. He told a friend of mine two weeks ago that he was finally able to forgive himself as a result of our event.

Reports from Swords to Plowshares and other Vietnam veterans' groups in the Bay Area indicate that the ritual raised public awareness of their services. Indeed, according to the director of Swords, inquiries about the organization increased 100 percent after the ritual. I received another letter written by the wife of a Vietnam vet; she was not present at the ritual but had heard me speak of it in a public lecture. She wrote,

> Your lecture made me realize that one of the big components of the whole Vietnam experience has been the lack of grieving. My husband was very seriously wounded, and most of his squad was killed that day. I realized that he must miss those men (actually they were boys), but after your talk it dawned on me that he was never able to go to a funeral for any of them. He was in the hospital, and those funerals were all across the U.S. He has not and was not able to mourn their deaths. Plus there are many other grief losses: loss of youth (he was considered the old man at twenty-two years old), loss of the use of his

right arm, etc. I know he has issues he needs to resolve about Vietnam, but he doesn't fit in the Post-Traumatic Stress Syndrome category. But when you mentioned grief issues I really thought about that, and I feel that grief defines much of those issues.

Without rituals of grieving, where does our pain go? Surely it gets stored inside, where it can easily fester into violence and bewilderment.

What would happen if every city in America planned a ritual to mourn the losses of war? What about Europeans, who are still haunted by shame and by being shamed in wars of this century? Planning and carrying out such rituals might provide good work for many. And it might free persons—and relationships of marriage and family no less than of work and profession—so that our lives and our livelihood might flow together more readily. Instead of denying that we underwent a Vietnam War together, and instead of replaying issues of whether we were for it or against it, why not grieve it together?

Cosmic Masses

I propose that we put dance and chanting and body back into the part of the Christian liturgy dedicated to the word of God, for they are the cosmic words that come to us if our hearts are silent. I believe that resetting the Catholic Mass in its *proper,* that is, cosmological and nonanthropocentric context, will bring new life to worshipers and to liturgy itself. The key shift in consciousness is to realize that *"Liturgy of the Word" does not mean human words.* This thinking is arrogant and it puts people to sleep. Meister Eckhart said, "Every creature is a word of God and a book about God," and Thomas Aquinas said that "one has every right to call God's creatures, God's 'words.' "[38] The Quakers have not forgotten that the true origin and source of the word is silence. Silence too is a word of God and often a channel through which other words of God—spirits and angels of God—can be allowed to enter our worship once again. I believe that Protestants made a mistake in eliminating or minimizing the role of the Eucharist in worship, as if bread and wine, food and drink, are not

words of God as much as is biblical wisdom. The sacrifice of bread and wine by the ancient priest Melchisadech, as recounted in the Bible, occurs not only prior to the Catholic Church but even prior to the formation of Israel itself. It is an ancient ritual and may even be prepatriarchal. All worshipers ought to be invited in some way to this holy eating and drinking.

I recently participated in a Liturgy of the Word that centered on the theme of wisdom and the return of the feminine principle. It was mid-August, and the occasion that sparked our liturgy was the feast of the Assumption of Mary into heaven. Four persons stood on chairs in four corners of the room and held aloft a large cloth, which they made billow by slowly waving it up and down. The rhythm that they followed was the reading of the text from Sirach 24 about Wisdom roaming the vaults of the sky and walking the depths of the ocean. As this musiclike reading progressed, participants (two-thirds of whom were Jewish and one-third Christian) processed and danced under the billowing canopy. Delight shone on everyone's faces. It was good. It was Sabbath. It was a time for forgetting ego, self-consciousness, denominationalism, and worry. It was a taste of the realm of God; it touched on the eschatological. It was ritual. It was simple and nonelitest and participatory; no one was excluded from dancing this dance of Wisdom, with Wisdom. It was memorable, and in it we remembered our lost ancestor, Wisdom, and gave her a place to reenter our world and dance there again, just as she had at the beginning of creation. "I was by God's side, a master craftsperson, playing day after day, ever at play in God's presence, delighting to be with the daughters and sons of the human race" (Prov. 8:30–31). When planning ritual it is important to think: movement, space, color, motion, wind, spirit, form, for all of these invisible elements form the wonder of prayer and worship. It's one more reason for calling on artists in creating rituals that work.

One contribution that Creation Spirituality might make to the Catholic liturgy would be a Preface that truly celebrated the universe we now know, thanks to the new creation story. In this way liturgy could begin to make a deeper contribution to disseminating and cele-

brating the new story. Such a Preface appears at the end of this book as an appendix.

Pelting with Flowers: A Ritual for Honoring One Another

On the occasion of the twenty-fifth anniversary of the publication of M. C. Richards's classic book on art as meditation, *Centering: In Poetry, Pottery and the Person,* Friends of Creation Spirituality honored the author through a conference entitled "Freeing the Imagination." On a Friday evening, friends gathered on stage to tell their stories about M. C. Richards. Among them were John Cage, who read a poem for M. C., and Merce Cunningham, who told stories and did a bird dance with his hands. The culminating event of the weekend was the Pelting with Flowers ritual of the Papago people of Arizona, led by Jose Hobday. In it all participants gathered in concentric circles and pelted one another with flowers that had been moistened and softened ahead of time through careful preparation. The philosophy of this ceremony is that we are all here on Earth to strike one another with beauty. Our leaders must be more struck with beauty than anyone else, and so, as a climax to the event, baskets of flowers were showered unexpectedly on M. C. Richards. She was deeply moved by the event, as were we all. Later she recalled being "engulfed by the multifloriate rapture" and "pulverized by beauty . . . in a magical ecstasy moving the body into a new behavior." She was moved to compose the following poem to commemorate the event:

PELTED BY BEAUTY
(after an American Indian Flower Ritual)

The power of love received in the body:
this was the Festival!
how we stood and faced one another
and we took hands
and the love came.
And all the flowers swarmed about our heads:
deep deep the sting goes.
Let love be welcomed the moment it seeks us.

In my flesh I feel it still,
the surprise and awe, the joy,
warming and swelling in my limbs and belly,
O miraculous conception O angels tumbling through
the air!

How real it is, the Christscript branded across our lips:
that we shall love one another—as if the world
could ever be the same.
Over the edge, into the well, the abyss,
idiotically amorous,
nibbling at the green fronds and flinging them!
Pelted by beauty and peace,
a cellular reordering, each tiny vessel
lovecrazed, opening.
The fountain erupts, cascades,
and we wish to die in it, be other,
be one in an alchemy of eros,
that lad with the arrows who shoots blind.

Ritualizing Our Creation Story

Since we have been given a new creation story in our time, the surest way to get to know it and to pass it on is to ritualize it. In doing so we will tap into the collective memory or "morphic field" of our ancestors, who invariably told their creation myths by way of ritual. One such ritual might take the following form. Gather a group and divide it into a number of teams, each team representing a particular sacred moment in the history of our universe. For example, one team could represent the original fireball, another the birth of hydrogen, another the birth of other elements, another the birth of galaxies, another supernovas exploding, another the birth of the sun, another the birth of the Earth, of water on the Earth, of life on Earth—such as eukaryotes, who invented both sex and eating—of trees, of flowers, of animals, of mammals, of humans, and so forth. Each group is responsible for creating a simple drama or expression of this moment for the

whole worshiping group, in hopes of enlisting the participation of all the other worshipers as well.

Simple objects—portable musical instruments, placards, costumes, cloth, chants—can help in recreating and remembering these sacred moments. The service is best done outdoors and possibly at night with candles (or perhaps some scenes outdoors and some indoors). The group gathers and begins the procession in silence (except for the chants or prayers), moving from moment to moment in the order in which the universe unfolded. There is no limit to the variation and creativity that might emerge from such a recounting of the creation story The ritual could include children and adults of all ages. It might also be a fine way to teach a science class on evolution, one that is committed to the reenchantment of science and the Earth.

This spring we created such a ritual at our institute, and what stood out the most was the immense amount of *delight and unselfconsciousness* that emerged from the ritual, as well as the amount of creativity that was elicited. A bonfire represented the fireball, but the eukaryotes, understandably, stole the show. It is appropriate that Brian Swimme and Thomas Berry, authors of *The Universe Story,* express their hope that the new creation story "will soon be finding expression ... in poetry, music, and ritual throughout the entire range of modern culture, on a universal scale."

Of course there is a shadow side to our creation story as well: the peril that the Earth finds itself in today because of humanity's arrogance and forgetfulness. Ritual can and ought to help us cut through the denial of this reality and thereby release energy and creativity for transforming our ways of living on the Earth. A ritual that could assist us is a Ritual of Lamentation for the Earth. Drawing on grieving and lamentation rites from many traditions, such a ritual would allow us to drum, chant, wail, or keen our way into the grief that is in our hearts over the pain of Mother Earth. Such a ritual requires safe boundaries so that participants can experience their pain without fear; plans should include ways of taking care of individuals who might be swept away by the ritual's power. For example, individuals

who might temporarily lose control can be ushered to a special room where they can be held and comforted. It is easy to underestimate the power of ritual, which is to say the power of the grief and passion we carry within us, since lamentation has become such a lost art in our culture and in our churches and synagogues.

Another ritual that allows us to remember the plight of the planet is the Council of All Beings, as developed by Joanna Macy and John Seed.[39] In it, a circle of humans faces another circle of people wearing simple masks they have created, representing individual species that are endangered today. These creatures each speak to the human circle in turn; they speak as oracles; they speak as pray-ers, reciting their heart-concern about their fate to the humans.

Still another ritual put forward by Joanna Macy to remember endangered species is what she calls a Bestiary, or a reenactment of Noah's ancient drama in reverse. "Like a film running backwards, the animals [are] exiting."[40] Participants recite a litany of the animals that are going extinct in the world today. Macy reproduces this list in the book, *Thinking Like a Mountain,* along with other rituals designed to reconnect us to Earth's suffering and healing. In a chapter called "Taking Heart: Spiritual Exercises for Social Activists," Macy offers a series of meditation exercises that individuals and groups can do, thereby healing psyche and society alike. Themes treated include death, loving-kindness, compassion, mutual power, and mutual recognition. "No belief system is necessary" for these rituals, she points out, "only a readiness to attend to the immediacy of your own experience."[41]

Conclusion: Ritual As Prayer, Not Performance

My experience in participating in and organizing rituals is that participants do not require a great deal of detailed organization; indeed, they do it best themselves. Ritual ought to follow the example of the self-organizing universe that we learn to know in our new cosmology. Too much worship in the West is still based on Newtonian ideologies of push and pull, force and coerce. Listening to the collective

wisdom of the group(s) is the key to letting the Spirit in on the preparation as well as the ritual itself. One ought not *over*prepare either. I think that one meeting to establish theme, basic form, guidelines of time, space, geography, and the makeup of the groups is adequate. The groups may then need to meet on their own and collect necessary materials, talent, and so forth. And then comes the ritual itself. It is important that ritual not be confused with performance and with the ego concerns of performance anxiety that constantly arise. It is always good to emphasize that *ritual is prayer, not performance.* This is the way to guarantee that prayer is the *result* of the ritual as well as the *way* of the ritual.

There are personal rituals as well as community rituals. Indeed, there are as many forms and occasions for ritual as there are occasions in our social, personal, and cosmic histories. Humanity is the species with a larynx; we are the ones who can do ritual, who can praise, who can remember, who can celebrate an infinite number of sacred moments in our lives and in the lifetime of the universe itself, who can truly "preserve single moments of radiance and keep them alive in our lives," as Heschel puts it.

What an opportunity! What a responsibility! What a source of good work! We have the chance to reinvent work and to celebrate the reinvention of work taking place in all our other works. In this way our inner and outer work come together and, in Rilke's words, our daily lives do indeed reconnect to the Great Work. In this way too the festive returns to human living. In the words of the ancient prayer, "As it was in the beginning, is now, and ever shall be world without end." Amen.

Work As Sacrament, Sacrament As Work

G ive us this day
our daily bread.

JESUS

A s long as the marvelous effects of Christ lie hidden in
anyone's heart, Christ is not honored by it, except in that
heart, but not in regard to others, until it breaks out into
external, visible actions.

AQUINAS[1]

T he universe oozes with power, waiting for anyone who wishes
to embrace it. But because the powers of cosmic dynamics are
invisible, we need to remind ourselves of their universal presence.
Who reminds us? The rivers, plains, galaxies, hurricanes, lightning
branches, and all our living companions.

BRIAN SWIMME[2]

W ho in all one's work sees God,
that one in truth goes unto God:
God is that person's worship,
God is that one's offering,
offered by God in the fire of God.

BHAGAVAD GITA[3]

E verything in nature,
the sum total of heaven and of earth,
becomes a temple and an altar
for the service of God.

HILDEGARD OF BINGEN[4]

In this book I have sought to contribute to the current debate on work by offering an outline of a spirituality of work. During the Newtonian era, when we defined work primarily as industrial work, we experienced little mysticism and little connection between spirituality and work. As I see it, the most important work of our time is *work on the human species itself.* This is how we will both reinvent work and redeem the work worlds in which we operate. This is how we become participants in the evolution of our species. As Rolf Osterberg puts it, "A new way of thinking is developing naturally within humankind. It is a result of human evolution and not of any organized activity with religious or political overtones."[5] Yes, both work and our understanding of work are evolving.

In the first part of this book I laid out a spirituality of work; it includes the following elements:

- a cosmology wherein we learn again to see our human work as part of the ongoing work of the universe and all the species in it
- a commitment to the *inner work* that we need so desperately at this critical juncture in our history
- a recognition of the inner work as nothingness and as enchantment
- an exploration of how our inner work can feed our outer work, which, to be authentic, must increasingly express the inner so that the two are joined—just as they are in all authentic creative work.

In the second part of the book I discussed persons and movements that are already applying this spirituality to our work worlds today, in areas ranging from health care to economics, from business

to farming, from education to youth at work, from psychology to art. Throughout the book I urged us to reinvent work, for unemployment is unacceptable. Solving the problem of unemployment will mean revisioning the paradigm that feeds work—and presently ours is the dying paradigm of the industrial era. If a spirituality of work cannot assist the critical need to reinvent work in our time, then it is a failure. I believe that a Creation Spirituality can contribute substantially to creating new and needed work. The environmental revolution is one example of an area where new work is being created today. In addition, a healthy spirituality of work has implications for those who are overworked or involved in compulsive or addictive work habits.

Another area for new work is in ritual, which we treated in the third part of this book. Ritual heals and celebrates and brings the microcosm into relationship with the macrocosm, joining the work of our daily lives and the Great Work of the universe. I think ritual will be the growth industry of the 1990s. Without a new commitment to ritual, we will slide ever more deeply into a psychologized and privatized effort at healing our deep wounds. (Thus, the title of psychologist James Hillman's book, *We've Had a Hundred Years of Psychotherapy and the World's Getting Worse;* thus, too, Otto Rank's observation that psychology was invented to heal the neurosis that occurred when religion and science split in the West.) Such psychologizing is doomed to failure, for it ignores the good news of our time: we have been given a new creation story that can unite us all, just as creation stories have always united human communities from as far back as we know. Our new story can also give us the energy to get on with our work—including its reinvention—so that all can work and feel that they are contributing to a Great Work.

We spoke in this book about the resacralization and reenchantment of work; about bringing ecstasy and mysticism as well as prophecy, the quest for justice, and compassion back to work. Not only is this possible; it is necessary. Dualistic work—work that separates our lives from our livelihood, our personal values from our work values, and human work from the universe's work—is passé. This very dualism constitutes the heart of the problem of our Earth

crises and youth crises and poverty crises the world over. Just as the industrial revolution defined work for us for two hundred years, so the environmental revolution—and the Creation Spirituality it presumes—will usher in a new definition and therefore new opportunities for work for the next historical era. No small amount of our work will be related to cleaning up the excesses brought about by the industrial era's reductionist ideas about work—excesses toward the planet, its forests and soil, its waters and sky, its species, and its climate. The dualism between life and livelihood is itself a lie, for life is all about Spirit, and there is only one Spirit; it manifests itself in both life and livelihood.

Work As Sacrament

Another way of speaking of the resacralization of work is to talk of sacrament. A sacrament is a holy revelation of the hidden mysteries of the Divine—mysteries so sacred they require metaphor and symbol if we are to talk about them. Our work is a metaphor and symbol for what we cherish; it is a sacrament within the ongoing sacrament of the universe. By our work we bestow sacraments on one another— healing sacraments and teaching sacraments, physical sacraments and spiritual ones, forgiving sacraments and initiatory ones, sexual sacraments and prophetic ones. Aquinas underscores the lush generosity of the universe as it bestows sacramental grace through our work: "It is from an abundance of divine goodness that creatures have been endowed with the dignity of causality."[6] Our creativity is vast indeed, for it is endowed with the *abundance* of divine goodness as its source. Priests we are all, dispensers of sacraments, awakeners to sacrament. Everywhere, sacrament.

As Aquinas puts it: "Every creature strives, by its activity, to communicate its own perfect being, in its own fashion, to another; and in this it tends toward an imitation of the divine causality."[7] *Every* creature is sacrament to others, trying its best to "communicate its own perfect being" to others. Aquinas links work with cosmology, for no being is excluded from this priestly work of communicating its perfect being and thereby imitating the divine causality. The sacraments are

avenues of grace; so too is our work. A sacrament is classically defined as a symbol that accomplishes what it signifies. If we are engaged in our work at a deep heart level, then our work is truly sacrament: it accomplished what it signifies. Workers are grace givers, grace elicitors, grace granters in the community. The community is graced by our work. Sacrament occurs.

Of course if the work that we are engaged in is not what the Buddhists call a "right livelihood," if it is harming others instead of gracing them, then it is not sacramental at all. In this case we need to critique that work, let it go, and move on. Only that work can be truly sacramental which flows from the heart to the heart, which comes from an inner place, which makes common cause with both light and darkness, enchantment and suffering. Sacramental work serves the cause of the Great Work of the universe, a work of interdependence and of compassion.

The universe is Sacrament. All of its work is sacramental, and every creature in it is an expression of the Divine, a Logos or Divine Word. There is no unemployment in the universe—except, of course, where humans mesmerized by machinery have put each other out of work by shutting down our capacity for inner work and therefore our potential for real work in our communities. Think of it: no galaxy is out of work; no ocean; no star; no atom; no porpoise; no tree; no blade of grass. They are all working, though they are working first of all *inwardly*. "No creature lacks an inner life," Meister Eckhart tells us. We too are always working inwardly; our body is at work, our heart is pumping blood, our lungs are inhaling air and expelling it, our minds tap into ideas and images and memories, and our feelings are undergoing both joy and grief, anger and wonder. Who dares to settle for less, to allow a machinery-oriented worldview to close down our systems of inner work and, therefore, our creativity?

E. F. Schumacher observes that if we teach one another that we are the outcome of "nothing but utilitarianism—we only come to a utilitarian idea of work." In that case we don't want work; "the less there is of it the better."[8] If, however, we can place work in its cosmological context, it becomes our pleasure and joy; it is plentiful; it is

abundant; it is everywhere in the universe. Then we have the energy as a species to link ourselves to that work. The problem is that our civilization has settled for such a narrow and restrictive definition of work that we are trying to pour human energy into a skinny little funnel that in turn pours into a puny little machine called "industry" or "jobs available." The energy of the unemployed is flowing over from this narrow funnel; even those who have jobs are so squeezed in the process of getting them that when they do finally arrive at the workplace they have often lost their sense of wonder and amazement and their capacity for grief. Their inner life has been squeezed out of them; their work is too small. They have no energy to create good work and thereby help others join the work world and thus participate in the Great Work.

Clearly the funnel needs to be transformed. Both education for work and work itself need to be revisioned. The Indian mystic Kabir says, "I laugh when I hear that the fish in the water is thirsty." How is it possible that humans can be experiencing a lack of grace in our grace-filled universe? Grace is everywhere—wherever the universe is freely working. Yet we are a grace-starved generation. But it need not be so. The Sacred is everywhere.

What we give birth to—the Great Sacrament of ongoing creation—is more than what is visible to the naked eye. Parents can easily underestimate the surprises their children have in store for them. So too we can underestimate the surprise (the contemporary word, I believe, for transcendence) that our creativity has in story for us. We know that what we give birth to is bigger than us, more mysterious, and essentially out of our control. It is the work of the Spirit; it is the image of God operating through us; it is Sophia—Wisdom—the Cosmic Christ born from within us. Aquinas sees Christ as "wisdom incarnate." He applies Paul's statement, "for me to live is Christ and to die is gain," to work that comes from the depths of our being.

> That seems to be at the root of one's life which is the principle of one's activity. Hence, some call that by which they are roused to activity their "life." Hunters, for example, call hunting their life, and friends their friend. So, Christ is our life, because the whole principle of our life and activity is Christ.[9]

Thus the Cosmic Christ is at work when we are at work from our depths. Hildegard of Bingen teaches, "There is wisdom in all creative works."[10] Our work—to the extent that it is creative work—is a source of wisdom, a tool by which wisdom can operate in the world; it is a friend of wisdom walking in the streets, in the factories, in the offices and schools, and in government.

Work and the Traditional Seven Sacraments

As workers in creation, as cocreators, therefore, we are part of the great Sacrament of the universe; indeed, we are its progeny. Is there a way to conceptualize the immense and limitless work that humans are called to do? The tradition of the seven sacraments might assist us. For example:

1. Baptism. The sacrament of welcoming us into the universe. This sacrament lies at the heart of the new creation story and even the environmental revolution, for we need a new way to be welcomed into the universe—a new way to see our relationship with the Earth and all creatures and to take responsibility for that relationship. Thus all efforts at cosmology, including science and art and the telling of the story through rituals and other forms of education, and all efforts at environmental justice are kinds of *baptismal* work. They are the *wetting* of the green revolution. All efforts that help us move from machine to green are expressions of a new theology of baptism.

2. Penance or reconciliation. The grief work that our society is finally coming around to. It includes healing the wounded child, racial abuse, sexual abuse, religious abuse, unemployment abuse, military abuse, gender abuse, sexual orientation abuse, sadomasochistic abuse, the abuse of native peoples by colonialism, the abuse of nonhumans by humans. All of this work is a kind of *penitential* work. All persons involved in this kind of healing—parents and teachers, friends and lovers, coaches and counselors, artists and dramatists, ritual leaders and writers—are ministers of the sacrament of reconciliation in their work.

3. Confirmation. The rites of passage that our society so sorely needs for its young. Preparing rites of passage for adolescents—and for the adolescent in all of us, who has not been challenged to con-

front solitude and death—is all a new way of expressing the sacrament of confirmation, of coming of age, of being *confirmed*. In rites of passage or confirmation we are strengthened and anointed—made wet not as neophytes or beginners, as in baptism, but as young adults emerging into the arena of adulthood and generativity. We learn to turn our attention not only to our own ego's necessities but also to the future and the children of the future. Anyone who works with youth administers the sacrament of confirmation. This includes: teachers and school superintendents, principals and police, coaches and driver's education instructors, filmmakers and video makers, musicians and rock stars, parents and grandparents, ministers and priests and rabbis and ritual makers and politicians.

4. Eucharist. The sacrament of food. The word *Eucharist,* from the Greek word *eucharistein,* or "thank you," is about food—not just any food but thank-you food, food that is deeply spiritually nourishing. Nourishing for what? For the journey into the Great Work of which we are a part. It is spiritual food to invigorate our sacred work, which is all our work once we reconnect life and livelihood. All work that nourishes our journey is a kind of eucharistic work. All commerce (business, economics, and politics) that is entered into *not* to provide unessential goods but to provide *necessary and needed goods for the journey*—is eucharistic work. All such workers are ministers at the holy banquet of life, whether they are providing the food (farmers and transporters) or preparing the food (homemakers and chefs) or providing clothes or housing or waste disposal (those who lay sewers and pick up garbage) or supplying the joy of living (artists, entertainers, and ritual leaders). "Give us this day our daily bread." All that is necessary for life is our daily bread. All is eucharistic work.

5. Marriage. The sacrament of relationship. All friends, all spouses, all lovers, all parents, all grandparents, uncles, aunts, brothers, and sisters are called to bestow the grace of relationship on one another. All such relationships are sacred work, graced work. All efforts at communication—at honest sharing of feeling and vision, commitment and hope—are summed up in the archetype of the sacrament of marriage. All those who assist these relationships in any way are workers in the field of the sacrament of marriage. All those

who learn to honor the power of sexuality in themselves and are therefore ready to minister the sacrament of sexual grace to another are workers in the field of the sacrament of marriage. All those who work at befriending the lonely and instructing the young about both the mysticism and ecstasy of sexuality and its risks are bestowers of the grace of marriage. All those who know how to practice the art of celibacy and teach it to others are grace givers of the sacrament of marriage. Monogamy is not that different from celibacy, insofar as both practices are ways of guarding one's sexual energy for the right partnership. In our day, the population explosion, the spread of sexual diseases, and the ever-present commercializing and addiction making of sex require *every* adult to practice celibacy at some times in their lives. Celibacy, instead of being a vow for a few professionals, needs to become an art for everyone, beginning when we are young in order to ensure that relationships can endure and that lovemaking can be a mystical gift generously given and received. All parenting and grandparenting is part of the bestowal of the marriage blessing that we extend to one another.

We should not underestimate how deeply relationships are affected by the worldview of the persons involved. If couples wake up one day and find that they are bored and that their relationship is boring, they may well be correct. Persons and relationships that are anthropocentric are indeed boring; if we lack a cosmology our soul is stale and small. If we are probing a universe of one trillion galaxies, our souls will not be small and our relationships will not be boring. In a Newtonian model, a relationship may rely on a promise made, perhaps years ago, in a deterministic and machinelike fashion. Relationships are not machines; they are organic, living beings. The new cosmology insists that every relationship be remade every day, just as the rest of the universe is constantly birthing and rebirthing. In this cosmology, monogamy makes sense, not as a duty but because, if our souls are as large as the universe, it could take an entire lifetime just to *begin* to explore the deep soul of another.

6. Ordination. The sacrament of leadership. Recognizing leadership and devising appropriate training for it in all our professions and communities corresponds to ordaining spiritual leadership. Alterna-

tive training of leaders in all our professions—including religious ones—is required if we are to move from one paradigm to another. True leadership—leadership that is sacramental and sacred—is always for the people, "that the people might live." It is not for ego's sake or fame or money or power for the individual; it is leadership for the empowerment of the greatest number. Such leadership is prophetic; it is justice oriented; it holds a vision for the future and does not just legitimize the status quo. It shares the power and instructs others in their capacity for leadership. It builds participation and empowerment.

Priestly leadership is more present among us than we imagine. It is among twenty-year-olds who have never set foot in seminary systems, for example, and among all those who can lead us in effective ritual.

7. Healing the sick. The sacrament of making whole. Healing the sick is obviously the work of health-care givers. Nurses and doctors, therapists and hospital administrators are all instruments for the grace of healing. But so too are teachers who heal the sickness of ignorance and internalized oppression. So too are journalists, artists, anthropologists, and historians who heal the abyss of superstition and inspire minds to think for themselves and enjoy the ecstasy of thinking. So too are those involved in preventive medicine: the city workers in sanitation departments, the farmers who grow healthy food, the inventors who move us from cars and factories that pollute to ways of living more lightly on the planet. Prophets of any kind who awaken our consciences to injustice, which is always and everywhere the greatest cause of sickness and disease on this planet, are also healers. The victims of oppression who rise up to cast off their oppression and submit no longer, the environmental activists and thinkers who call us to heal the Earth by changing our ways—all such persons are bestowers of the graced sacrament of anointing the sick. Healing a sick society is part of the ministry of making whole.

Some might see this list of seven sacraments as somewhat arbitrary, and from a certain perspective it is. However, the concept of seven

sacraments is archetypal. It taps into what Rupert Sheldrake calls the morphic field or the collective unconscious of our ancestors, who likewise theologized about how the sacred comes to humans and how humans encounter the sacred. One ought not to dismiss lightly the advantages of envisioning one's own work within the framework of seven sacraments. Here the tradition of the lay priesthood receives the honor it deserves. Our work takes on meaning again. Your work, whatever you do—secretary or taxi driver, firefighter or ambulance driver, doctor or teacher, lawyer or banker, journalist or dancer—under which of the seven sacraments does your work most likely fall? And how can you explore your work world to reinvigorate it with the new cosmology, with a sense of the sacred, which is always a path of celebration and justice?

In this list of sacraments we have a practical guide for reinventing and revisioning work in our time. There is also a hint here of how to revitalize sacramental theology by placing the sacraments back in a cosmological context. When we do this their power returns. Work—ours and the universe's—provides the best possible matrix for a theology of sacrament. Hildegard of Bingen put it this way in the twelfth century:

Everything in nature,
the sum total of heaven and of earth,
becomes a temple and an altar
for the service of God.[11]

In our time, physicist Brian Swimme has written movingly of a theology of sacrament that derives its power from the universe itself. He says,

We sometimes fall into the delusion that power is elsewhere, that it belongs to a different group, that we are unable to find access to it. Nothing could be further from the truth. The universe oozes with power, waiting for anyone who wishes to embrace it. But because the powers of cosmic dynamics are invisible, we need to remind ourselves of their universal presence. Who reminds us? The rivers, plains, galaxies, hurricanes, lightning branches, and all our living companions.[12]

It seems, then, that the paradigm shift we have applied to our work worlds in this book can be stated another way. It is not only a shift from machine to green; it is also a shift from machine to sacrament, a shift from the colorlessness of gray industrialism to the hope that is intrinsic to living, that is, green, things. Eight centuries ago Hildegard of Bingen pictured Christ as the "green man" or the "green figure itself" who "brought lush greenness" to "shriveled and wilted" humanity.[13]

Will we be green and our works green? Will we be living and our works living? Can it not be said that our primary work is *living?* If the great gift of the Spirit is to give us spirit, breath (*ruah*), or life, our primary work is preserving that life and passing it on with all its splendor and grace. When we awaken to the facts of life in our time we realize how poorly we are working, for our current facts of life are not about life so much as about death. We have ozone holes in the sky; soil is disappearing on the Earth; consumerism is our national economic system; and everywhere we see violence, addictions, and empty souls. All this demonstrates that human work is never neutral, never without moral implications. If we are not carrying on the universe's holy work, we are resisting it, cutting it short, trying to deny its glory. The choice is ours: to join the Great Work or to continue working ourselves to self-hatred and destruction. If we knew the universe as sacrament the choice would not only be simple; it would be joyful. As Aquinas assures us:

> Everything gives pleasure to the extent that it is loved. It is natural for people to love their own work (thus it is to be observed that poets love their own poems): and the reason is that we love *to be* and *to live,* and these are made manifest in our *action.* Secondly, because we all naturally love that in which we see our own good.[14]

To be, to live, to "see our own good"—is this not what a sacramental consciousness does for us? Is this not the source of all good work—to make manifest our being and our loving in our livelihood? And the joy that we are promised by starting work all over again will itself give us the energy to carry on the task. The universe is asking a great task of us today; it is extending to us a pressing invitation to

reconnect our daily lives to the Great Work of the universe. New vocations, new callings, new roles are everywhere in the air. New work awaits. The harvest is greater than the number of laborers. Are we listening? Are we willing? Can we say to the beloved, "I am here. I am willing"?

A Spirituality of Work Questionnaire

The following questions constitute a Spirituality of Work questionnaire that flows from themes treated in this book. Individuals or groups might examine their attitudes toward their spirituality by answering the questions and then sharing answers. This sharing may provoke rich discussion and searching.

1. **Do I experience joy in my work?**
 —When, and under what circumstances?
 —How often?
 —How can the joy be increased?
 —How does this joy relate to the pain and difficulties at work?

2. **Do others experience joy as a result of my work?**
 —Directly?
 —Indirectly?
 —How can this joy be increased?

3. **Is my work actively creating good work for others?**
 —How?
 —How might this be improved?
 —How does my work prevent others' working?

4. **When did I first feel drawn to the kind of work I am doing?**
 —What did it feel like?
 —Has this feeling increased or decreased over the years?
 —Have I lost touch with this feeling over the years?
 —How can this feeling be regenerated?

5. **Is my work smaller than my soul?**
 —How big is my soul?
 —How big is my work?
 —What can I do to bring the two together?

6. **How can I simplify my work?**
 —Can I simplify my getting to and from work?
 —How is my work play?
 —How can I learn to confuse work and play?

7. **Is my work real work or a job?**
 —Is it a vocation, calling, or role that the universe is asking of me?
 —How do I know the answer to this question?
 —How can I increase my awareness of the mystery and role my work plays in the world?

8. **How does my work connect to the Great Work of the universe?**
 —How is it contributing to the one work, the ongoing work of the universe?
 —When am I most aware of this connection?

9. **How is my work a blessing to generations to come?**
 —In what way is my work connected to the needs of young people today?
 —How am I participating in "fashioning a gift for the young"?

10. **How am I emptied at work?**
 —How does nothingness happen at my work?
 —What is my response to nothingness at work?

11. **What inner work have I been involved in over the last five years?**
 —What inner work do I expect to be involved in over the next five years?
 —How is this inner work affecting my outer work?
 —How does my outer work affect my inner work?

12. **Could my work be more creative than it is?**
 —If so, how?
 —What is holding me back?
 —How does my work encourage the creativity of others?
 —What is the most creative work I do?

13. **Who profits from my work?**
 —Where does the money that my work generates go?
 —Where does the money that I am paid in my work come from?

14. **What does my work "interfere with"?**
 —How effective is this interference?
 —How can this interference be more effective?

15. **What allies have I made within my work world?**
 —How do I sustain my vision through base communities and in other ways outside my work world?

16. **What enemies do I make because of my work?**
 —Whom does my work disturb?
 —What do I learn if certain groups or persons are disturbed by my work?

17. **How does my work affect the environment?**
 —How is it a gift to the animals that are not two-legged?
 —How does it contribute to bringing about the environmental revolution?
 —How can I improve environmental consciousness in my workplace?

18. **Which of the ecological virtues (vegetarianism, recycling, bicycling, etc.) am I practicing the most?**
 —Which of the ecological virtues have I paid the least attention to?
 —How can I spread the word about the need for ecological virtues in our time?
 —What ecological virtues can I add to the list presented in chapter 5?

19. **What do I learn at work?**
 —In what ways is work a learning experience for me?
 —In what ways is it a learning experience for others?

20. **Are awe and wonder experienced in my work?**
 —If so, when?
 —If so, by whom?
 —If not, why not?

21. **Am I growing younger every day?**
 —Why?
 —Why not?
 —What can I do to stay young in heart and spirit?
 —Am I emptying myself of bitterness, resentment, and self-pity?

22. **If I were to leave my work today, what difference would it make to:**
 —my spiritual growth?
 —the spiritual development of my colleagues at work?
 —the spiritual development of my family or significant others?

23. **If I suddenly received an inheritance of 300,000 dollars, would I immediately cease my work?**
 —What would I do instead of the work I am doing?
 —What would I do with the money itself?

24. **What ways of doing Sabbath—of resting and letting go of work— do I engage in?**
 —What rituals do I engage in?
 —What rituals do I most need to participate in?

25. **What am I doing to reinvent the profession in which I work?**
 —How am I bringing justice, compassion, and celebration to the world by way of my work?
 —How am I returning my profession to its origins as a sacred or sacramental work?

26. **Which of the classical seven sacraments most characterizes the work that I do?**
 —Does this mean I am a priest and midwife, bringing into being the grace of the sacrament of the universe?

27. **What is the funniest thing about my work?**

28. **Am I afraid of time off?**
 —What do I do with leisure time?
 —If I had a year off every seven years what would I do with that year?

29. **How can my family and I lead a simpler lifestyle, get along on less, and enjoy life more?**
 —Do I work in order to spend?
 —Why do I do the work I am doing?

30. **What is sacred about the work I do?**
 —Were any references to the sacredness of my work made in my education or training for the work?
 —How might the dimension of the sacred be included in the training for the work I do?

A Preface of Creation

It is fitting and right to give you thanks in all places
and at all times,
Creator of space,
Creator of time,
Creator of the universe and of this holy Earth.
We praise and thank you for
its rocks, its plants, its trees,
its forests, its animals and fishes,
its birds and flowers,
its systems of weather and wind,

of gravity and electromagnetic fields;
its peoples so diverse
and so colorful and so hungry for your beauty.
We thank you, Creator and parent of all,
for your gifts of the Sun,
of photosynthesis and the making of chlorophyll
and of blood;
for the colors of the flowers
and the waves of the oceans.
For the moon and the planets,
for this galaxy
and all one trillion galaxies,

we give you thanks.
For our minds and hearts that can know this world
and be stretched in the process,
we give you thanks.
We thank you for the holy history that has brought us here:
For the stars and the supernovas,
for the elements of carbon and hydrogen,
of sulfur and magnesium,
of oxygen and nitrogen
that make our beings live.
For the gifts of swirling galaxies
as well as molecules and atoms,
and for the mystery of Light.
For the darkness of the sky and the dark matter of the universe.
For the black holes and white holes and all that is mysterious.
For the fireball
from which all being emerged.
And for the bringing of wisdom, the incarnation of your Fire,
your spirit of Pentecost and the spirit of Christ,
the photons and fire energy in every atom
and in every star and person and being
in the universe.
And so, with all the angels and archangels, the inhabitants of
the heavens and the Earth,
we join our humble voices in praise:

Holy, Holy, Holy, God of hosts. Heaven and Earth are
filled with your glory. Hosanna in the highest.

Notes

Introduction: Job Crisis or Work Crisis?

1. *Sum. theol.* I–II, q. 57, a. 5.

2. Gabriele Uhlein, *Meditations with Hildegard of Bingen* (Santa Fe: Bear & Co., 1982), 54; Matthew Fox, ed., *Hildegard of Bingen's Books* (Santa Fe: Bear & Co., 1987), 35.

3. Madonna Kolbenschlag, *Kiss Sleeping Beauty Good-bye* (New York: Bantam, 1981), 72.

4. Rupert Sheldrake, *The Rebirth of Nature* (New York: Bantam, 1991), 207.

5. Vaclav Havel, *Living in Truth* (Boston: Faber and Faber, 1989), 12.

6. Havel, *Living in Truth,* 12, 13.

7. Havel, *Living in Truth,* 11.

8. Quoted in Matthew Fox, *Sheer Joy: Conversations with Thomas Aquinas on Creation Spirituality* (San Francisco: Harper San Francisco, 1992), 186.

9. Jack Miller, "Why Bosses Live Longer," *Toronto Star,* Dec. 8, 1990, D1. A ten-year (1970–1980) Danish study found a 40 to 50 percent higher death rate among the unemployed than the employed. See *Nurturing Health: A Framework on the Determinants of Health* (Toronto: Premier's Council on Health Strategy, 1991), 7.

10. Barbara Killinger, *Workaholics: The Respectable Addicts* (Toronto: Key Porter Books, 1991), 7.

11. Diane Fassel, *Working Ourselves to Death* (San Francisco: Harper San Francisco, 1990), 123, 46.

12. E. F. Schumacher, *Small Is Beautiful* (New York: Harper & Row, 1973), 32.

13. Kolbenschlag, *Sleeping Beauty,* 76.

14. Personal correspondence, July 6, 1992.

15. Robert Bly, in "Backtalk: Reinventing Iron John," *Mother Jones,* May/June 1993, 5.

16. Larry Dossey (address to Mystics and Scientists Conference, Winchester, England, April 3, 1993).

17. "Job Stress Characterized as 'Global Phenomenon,' " *Oakland Tribune,* March 23, 1993, D-11.

Part 1. The Great Work and the Inner Work: Revisioning Work

1. E. F. Schumacher, *Small Is Beautiful* (London: Abacus, 1973), 297.

2. Kabir, quoted in Sehdev Kumar, *The Vision of Kabir* (Concord, Ontario: Alpha & Omega Books, 1984), 92.

3. *The Bhagavad Gita,* trans. Juan Mascaro (Middlesex, England: Penguin Books, 1962), 58, 59.

4. Brian Swimme and Thomas Berry, *The Universe Story* (San Francisco: Harper San Francisco, 1992), 1.

Chapter 1. The Pain of Work: Work as Nothingness and Lamentation

1. Studs Terkel, *Working* (New York: Ballantine, 1985), xiii.

2. Meister Eckhart, quoted in Matthew Fox, *Breakthrough: Meister Eckhart's Creation Spirituality in New Translation* (New York: Doubleday, 1980), 216, 217.

3. *Tao Te Ching,* trans. Stephen Mitchell (New York: Harper & Row, 1988), 9, 24.

4. Diane Fassel, *Working Ourselves to Death* (San Francisco: Harper San Francisco, 1990), 2.

5. *The Bhagavad Gita,* trans. Juan Mascaro (Middlesex, England: Penguin Books, 1962), 62.

6. Cited in Matthew Fox, *Sheer Joy: Conversations with Thomas Aquinas on Creation Spirituality* (San Francisco: Harper San Francisco, 1992), 289.

7. E. F. Schumacher, *Good Work* (London: Abacus, 1980), 120.

8. Personal correspondence, May 19, 1993.

9. Schumacher, *Good Work,* 121.

10. Schumacher, *Good Work,* 3.

11. Schumacher, *Good Work,* 27.

12. I am thinking of such books as Juliet B. Schor's *The Overworked American,* Diane Fassel's *Working Ourselves to Death,* Anne Wilson Schaef's *The Addictive Organization,* Barbara Killinger's *Workaholics: The Respectable Addicts,* Dorothee Soelle and Shirley A. Cloyes's *To Work and to Love: A Theology of Creation,* Susan Wittig Albert's *Work of Her Own: How Women Create Success and Fulfillment Off the Traditional Career Track,* Madonna Kolbenschlag's *Kiss Sleeping Beauty Good-Bye,* Suzi Gablik's *The Reenchantment of Art,* and Anita Roddick's *Body and Soul.*

13. Paul Kivel, *Men's Work: How to Stop the Violence That Tears our Lives Apart* (New York: Ballantine, 1992), 111.

14. Kivel, *Men's Work,* 172.

15. Schumacher, *Good Work,* 25.

16. Schumacher, *Good Work,* 118, 119.

17. Schumacher, *Good Work,* 3, 4.

18. Cited in Juliet Schor, *The Overworked American* (New York: Harper-Collins, 1991), 149.

19. Schor, *Overworked American,* 122.

20. Schor, *Overworked American,* 123, 124.

21. Schor, *Overworked American,* 125.

22. Fassel, *Working Ourselves to Death,* 2, 23.

23. Fassel, *Working Ourselves to Death,* 46.

24. Fassel, *Working Ourselves to Death,* 123.

25. Barbara Killinger, *Workaholics: The Respectable Addicts* (Toronto: Key Porter Books, 1991), 7, 6.

26. Schor, *Overworked American,* 126, 132.

27. Schor, *Overworked American,* 142.

28. Schor, *Overworked American,* 147.

29. Schor, *Overworked American,* 2, 3, 5, 10.

30. Jose Hobday, OSF, "Neither Late Nor Working," *Creation Spirituality,* May/June 1992, 20.

31. *Bhagavad Gita,* trans. Mascaro, 66, 67.

32. *Tao Te Ching,* trans. Mitchell, 9, 24.

33. Rainer Maria Rilke, *The Selected Poetry of Rainer Maria Rilke,* trans. and ed. Stephen Mitchell (New York: Vintage Books, 1984), 155.

34. *Bhagavad Gita,* trans. Mascaro, 62, 63.

35. Kivel, *Men's Work,* 1.

36. Kivel, *Men's Work,* xiii, xv.

37. Kivel, *Men's Work,* xxii, xxiii.

38. Cecil Williams, *No Hiding Place: Empowerment and Recovery in Our Troubled Communities* (San Francisco: Harper San Francisco, 1992), 3.

39. Williams, *No Hiding Place,* 4.

40. Havel, *Living in Truth,* 163, 159.

41. Havel, *Living in Truth,* 159.

42. Havel, *Living in Truth,* 160.

43. Lester Brown, *State of the World: 1992* (New York: Norton, 1992).

44. *Tao Te Ching,* trans. Mitchell, 40.

45. *Tao Te Ching,* trans. Mitchell, 11.

46. Rilke, *Selected Poetry,* trans. Mitchell, 231.

47. Rainer Maria Rilke, *The Sonnets to Orpheus,* trans. and ed. Stephen Mitchell (New York: Simon & Schuster, 1985), 97.

48. Quoted in Fox, *Breakthrough,* 71.

49. Quoted in Fox, *Breakthrough,* 217.

50. Quoted in Fox, *Breakthrough,* 71.

51. Quoted in Fox, *Breakthrough,* 475.

52. Rumi, *One-Handed Basket Weaving,* trans. Coleman Barks (Athens, GA: Maypop, 1991), 106.

53. *Tao Te Ching,* trans. Mitchell, 3.

54. Fox, *Breakthrough,* 492.

55. *Bhagavad Gita,* trans. Mascaro, 52.

56. *Bhagavad Gita,* trans. Mascaro, 117, 57.

57. Rilke, *Sonnets to Orpheus,* trans. Mitchell, 33.

Chapter 2. From Machine to Green: How a New Cosmology Helps Us Revision Work

1. Rainer Maria Rilke, *The Selected Poetry of Rainer Maria Rilke,* trans. and ed. Stephen Mitchell (New York: Vintage Books, 1984), 87.

2. *The Bhagavad Gita,* trans. Juan Mascaro (Middlesex, England: Penguin Books, 1962), 58.

3. Quoted in Matthew Fox, *Breakthrough: Meister Eckhart's Creation Spirituality in New Translation* (New York: Doubleday, 1980), 475.

4. Quoted in Matthew Fox, *Sheer Joy: Conversations with Thomas Aquinas on Creation Spirituality* (San Francisco: Harper San Francisco, 1992), 257.

5. Madonna Kolbenschlag, *Kiss Sleeping Beauty Good-bye* (New York: Bantam, 1981), 76.

6. Brian Swimme and Thomas Berry, *The Universe Story* (San Francisco: Harper San Francisco, 1992), 14.

7. Leonard Shlain, *Art & Physics: Parallel Visions in Space, Time & Light* (New York: William Morrow, 1991), 425.

8. M. D. Chenu, *The Theology of Work: An Exploration* (Dublin: Gill and Son, 1963), 68.

9. *Bhagavad Gita,* trans. Mascaro, 66.

10. Erich Jantsch, *The Self-Organizing Universe* (New York: Pergamon Press, 1980), 308–10.

11. Quoted in Fox, *Breakthrough,* 184.

12. Quoted in Fox, *Breakthrough,* 217.

13. Rainer Maria Rilke, *The Sonnets to Orpheus,* trans. and ed. Stephen Mitchell (New York: Simon & Schuster, 1985), 97.

14. *Tao Te Ching,* trans. Stephen Mitchell (New York: Harper & Row, 1988), 14.

15. *Tao Te Ching,* trans. Mitchell, 16.

16. Quoted in Fox, *Breakthrough,* 475.

17. Quoted in Fox, *Breakthrough,* 420, 109.

18. Quoted in Fox, *Breakthrough,* 420, 441.

19. Quoted in Fox, *Breakthrough,* 494.

20. Quoted in Fox, *Sheer Joy,* 289.

21. Quoted in Fox, *Sheer Joy,* 292.

22. See Fox, *Breakthrough,* 471.

23. Cited in Shlain, *Art & Physics,* 85.

24. Swimme and Berry, *Universe Story,* 36.

25. Cited in Shlain, *Art & Physics,* 84f.

26. Swimme and Berry, *Universe Story,* 75.

27. Shlain, *Art & Physics,* 296.

28. Paul Ricoeur, *The Symbolism of Evil* (New York: Harper and Row, 1967), 12, 13.

29. Kabir, quoted in Sehdev Kumar, *The Vision of Kabir* (Concord, Ontario: Alpha & Omega Books, 1984), 92.

30. Gregory Bateson, *Steps to an Ecology of Mind* (New York: Ballantine, 1985), 492, 493.

31. Shlain, *Art & Physics,* 425.

32. Quoted in Fox, *Breakthrough,* 466.

33. Otto Rank, *Beyond Psychology* (New York: Dover, 1941), 263, 264.

34. Quoted in Fox, *Breakthrough,* 464–65.

35. Quoted in Fox, *Breakthrough,* 464, 471, 472.

36. Quoted in Fox, *Breakthrough,* 201.

37. Quoted in Fox, *Breakthrough,* 205.

38. Quoted in Fox, *Breakthrough,* 472, 473, 466.

39. Quoted in Fox, *Breakthrough,* 466.

40. Quoted in Fox, *Breakthrough,* 473.

41. Quoted in Fox, *Breakthrough,* 475.

42. Quoted in Fox, *Breakthrough,* 475.

43. Quoted in Fox, *Breakthrough,* 71.

44. Quoted in Fox, *Breakthrough,* 71.

45. Rumi, *One-Handed Basket Weaving,* trans. Coleman Barks (Athens, GA: Maypop, 1991), 38.

46. *Tao Te Ching,* trans. Mitchell, 53.

47. *Tao Te Ching,* trans. Mitchell, 46.

48. Kolbenschlag, *Sleeping Beauty*, 67, 68.

49. Kolbenschlag, *Sleeping Beauty*, 69, 70.

50. Kolbenschlag, *Sleeping Beauty*, 71.

51. Quoted in Fox, *Sheer Joy*, 106.

52. Quoted in Fox, *Sheer Joy*, 104.

Chapter 3. Exploring Our Inner Work: Work as Enchantment

1. Studs Terkel, *Working* (New York: Ballantine, 1985), xiii.

2. *Tao Te Ching*, trans. Stephen Mitchell (New York: Harper & Row, 1988), 8.

3. *The Bhagavad Gita*, trans. Juan Mascaro (Middlesex, England: Penguin Books, 1962), 119.

4. Quoted in Matthew Fox, *Sheer Joy: Conversations with Thomas Aquinas on Creation Spirituality* (San Francisco: Harper San Francisco, 1992), 295.

5. Cited in Terkel, *Working*, 470.

6. Matthew Fox, *Breakthrough: Meister Eckhart's Creation Spirituality in New Translation* (New York: Doubleday, 1980), 165.

7. *The Poems of St. John of the Cross*, trans. John Frederick Nims (Chicago: University of Chicago Press, 1979), 9.

8. Terkel, *Working*, xiii.

9. Dorothy Soelle with Shirley A. Cloyes, *To Work and to Love* (Philadelphia: Fortress Press, 1984), 73.

10. Madonna Kolbenschlag, *Kiss Sleeping Beauty Good-bye* (New York: Bantam, 1981), 76.

11. Henri Arvon, *La Philosophie du Travail* (Paris: Presses Universitaires de France, 1960), 10.

12. Soelle, *To Work and to Love*, 72.

13. Soelle, *To Work and to Love*, 81.

14. Quoted in James Clarke and John V. Skinner, *Meister Eckhart: Selected Treatises and Sermons Translated from Latin and German with an Introduction and Notes* (London: Faber & Faber, 1958), 134.

15. Terkel, *Working*, 470.

16. Quoted in Fox, *Sheer Joy*, 327.

17. Aquinas writes, "We see that in any field of rational activity, those who enjoy their work are better able to judge detailed matters, and to make a precise investigation into those things that are accomplished with pleasure. Thus, geometricians, who take pleasure in the considerations proper to geometry, are better able to understand the detailed points in this kind of thinking because the mind is more attentive to that in which pleasure is found. And the same argument goes for all the others; for instance, for those who like musical performances and take pleasure in them, and for those who enjoy the art of building,

and for all others—because, by the fact that they take pleasure in such work, they make a great contribution to their kind of work. So, it is clear that pleasure increases activity." From Fox, *Sheer Joy,* 295.

18. Rainer Maria Rilke, *The Selected Poetry of Rainer Maria Rilke,* trans. and ed. Stephen Mitchell (New York: Vintage Books, 1984), 151.

19. Terkel, *Working,* xxx.

20. Rainer Maria Rilke, *The Sonnets to Orpheus,* trans. and ed. Stephen Mitchell (New York: Simon & Schuster, 1985), 91.

21. Rilke, *Sonnets to Orpheus,* trans. Mitchell, 41.

22. *Bhagavad Gita,* trans. Mascaro, 119.

23. Goethe, "Until One Is Committed," in Robert Bly et al., *The Rag and Bone Shop of the Heart: Poems for Men* (New York: HarperCollins, 1992), 235.

24. Quoted in Fox, *Sheer Joy,* 297. Italics mine.

25. Quoted in Terkel, *Working,* xxix.

26. *Bhagavad Gita,* trans. Mascaro, 119.

27. Krister Stendhal, *Paul Among Jews and Gentiles* (Philadelphia: Fortress Press, 1976), 7, 8, 12.

28. *Bhagavad Gita,* trans. Mascaro, 58.

29. Aquinas, *Sum. theol.* I, q. 18, a. 2, ad 2.

30. Terkel, *Working,* xiii.

31. Fox, *Breakthrough,* 283.

32. Rumi, *One-Handed Basket Weaving,* trans. Coleman Barks (Athens, GA: Maypop, 1991), 40, 41.

33. *The Poems of St. John of the Cross,* trans. John Frederick Nims (Chicago: University of Chicago Press, 1979), 9.

Chapter 4. Creativity: Where Inner and Outer Work Merge

1. Rainer Maria Rilke, *The Selected Poetry of Rainer Maria Rilke,* trans. and ed. Stephen Mitchell (New York: Vintage Books, 1984), 231.

2. Quoted in Matthew Fox, *Sheer Joy: Conversations with Thomas Aquinas on Creation Spirituality* (San Francisco: Harper San Francisco, 1992), 289.

3. *Tao Te Ching,* trans. Stephen Mitchell (New York: Harper & Row, 1988), 6.

4. Willis Harman and John Hormann, *Creative Work* (Indianapolis: Institute of Noetic Sciences, 1990), 26.

5. Quoted in Matthew Fox, *Breakthrough: Meister Eckhart's Creation Spirituality in New Translation* (New York: Doubleday, 1980), 65.

6. Rainer Maria Rilke, *The Sonnets to Orpheus,* trans. and ed. Stephen Mitchell (New York: Simon & Schuster, 1985), 135.

7. Harman and Hormann, *Creative Work,* 26.

8. Rilke, *Selected Poetry,* trans. Mitchell, 135.

9. Rilke, *Selected Poetry,* trans. Mitchell, 189.

10. Otto Rank, *Art and Artist* (New York: Agathon Press, 1975), 361, 362.

11. Rank, *Art and Artist,* 371, 368.

12. Rilke, *Selected Poetry,* trans. Mitchell, 189.

13. Rank, *Art and Artist,* 371.

14. *Sum. theol.* I–II, q. 57, a. 1, ad 1.

15. Quoted in Fox, *Breakthrough,* 61.

16. Rilke, *Selected Poetry,* trans. Mitchell, 189.

17. Rilke, *Selected Poetry,* trans. Mitchell, 189.

18. Quoted in Fox, *Sheer Joy,* 60.

19. Quoted in Fox, *Sheer Joy,* 79.

20. Quoted in Fox, *Breakthrough,* 79, 59.

21. Quoted in Fox, *Breakthrough,* 120, 365.

22. Quoted in Fox, *Sheer Joy,* 284, 291, 292.

23. Quoted in Fox, *Sheer Joy,* 256.

24. Quoted in Fox, *Breakthrough,* 371, 372.

25. Quoted in Fox, *Sheer Joy,* 289.

26. Quoted in Fox, *Breakthrough,* 374—75, 373–74.

27. Quoted in Fox, *Breakthrough,* 375.

28. *Tao Te Ching,* trans. Mitchell, 6.

29. Quoted in Fox, *Breakthrough,* 336.

30. Quoted in Fox, *Breakthrough,* 76, 274.

31. Quoted in Fox, *Breakthrough,* 275. The following citations are from the same sermon.

32. Quoted in Fox, *Breakthrough,* 407.

33. Quoted in Fox, *Breakthrough,* 409.

34. Quoted in Fox, *Breakthrough,* 411.

35. Quoted in Brendan Doyle, *Meditations with Julian of Norwich* (Santa Fe: Bear & Co., 1983), 84.

36. Quoted in Fox, *Sheer Joy,* 255.

Part 2. The Great Work and the Outer Work: Reinventing Work

1. Cited in Matthew Fox, *Meditations with Meister Eckhart* (Santa Fe: Bear & Co., 1982) 91.

2. *The Bhagavad Gita,* trans. Juan Mascaro (Middlesex, England: Penguin Books, 1962), 56, 66.

3. E. F. Schumacher, *Good Work* (London: Abacus, 1980), 36.

4. Quoted in Matthew Fox, *Sheer Joy: Conversations with Thomas Aquinas on Creation Spirituality* (San Francisco: Harper San Francisco, 1992), 184.

5. Vaclav Havel, *Living in Truth* (Boston: Faber and Faber, 1989), 144, 145.

6. Cited in Theodore Roszak, *The Voice of the Earth* (New York: Simon &

Schuster, 1992), 231.

7. The fact that since 1965 more than 1800 plants employing over 500,000 workers have been built in Mexico at the expense of closing jobs and plants in the United States is proof enough of this connection. See Donald L. Barlett and James B. Steele, *America: What Went Wrong?* (Kansas City: Andrews and McMeel, 1992), 31.

8. *Bhagavad Gita,* trans. Mascaro, 56, 66.

9. *Bhagavad Gita,* trans. Mascaro, 115, 116.

Chapter 5. The Environmental Revolution and the Reinvention of Work, Including Farming and Politics

1. *Tao Te Ching,* trans. Stephen Mitchell (New York: Harper & Row, 1988), 39.

2. Lecture (Institute in Culture and Creation Spirituality, Oakland, California, Spring 1991).

3. Lester Brown, *State of the World: 1992* (New York: Norton, 1992), 188.

4. Lecture (Institute in Culture and Creation Spirituality, Oakland, California, Fall 1989).

5. Quoted in Matthew Fox, *Sheer Joy: Conversations with Thomas Aquinas on Creation Spirituality* (San Francisco: Harper San Francisco, 1992), 394.

6. Brown, *State of the World: 1992,* 178.

7. Brown, *State of the World: 1992,* 188.

8. Brown, *State of the World: 1992,* 190, 186.

9. Robert F. Kennedy, Jr., and Dennis Rivera, "Pollution's Main Victims: The Poor," *Oakland Tribune,* Aug. 19, 1992, A-15.

10. *Tao Te Ching,* trans. Stephen Mitchell, 39.

11. Vaclav Havel, *Living in Truth* (Boston: Faber and Faber, 1989), 136.

12. Havel, *Living in Truth,* 138. Italics mine.

13. Havel, *Living in Truth,* 160.

14. Havel, *Living in Truth,* 161.

15. Quoted in Fox, *Sheer Joy,* 247.

16. John Robbins, *Diet for a New America* (Walpole, NH: Stillpoint, 1987), 352, 367, 372, 373.

17. Rifkin sees our rejection of the beef addiction and the beef industry to be a spiritual act: "Reconsecrating our relationship to the bovine is a gesture of great historical significance. By making a personal and collective choice to go beyond beef, we strike at the heart of the modern notion of economics with its near-exclusive emphasis on 'industrial productivity,' a concept that has come to replace the ancient idea of generativeness. . . . In nature, generativeness, not productivity, is the measure of sustainability. Generativeness is a life-affirming force. Its essence is organic. Its teleology is regenerative." See

Jeremy Rifkin, *Beyond Beef: The Rise and Fall of the Cattle Culture* (New York: Dutton, 1992), 187.

18. Rifkin, *Beyond Beef,* 287–89, 291.

19. Brown, *State of the World: 1992,* 148, 149.

20. Brown, *State of the World: 1992,* 148.

21. See Joanna Macy, "In League with the Beings of the Future," *Creation Spirituality,* March/April 1989, 20–22.

22. Brown, *State of the World: 1992,* 148.

23. Bill McKibben, *The Age of Missing Information* (New York: Plume, 1992), 245.

24. Brown, *State of the World: 1992,* 147.

25. Brown, *State of the World: 1992,* 144.

26. Brown, *State of the World: 1992,* 144.

27. Larry B. Stammer, "New Bulb Could Last 18 Years, Use Much Less Energy," *Philadelphia Inquirer,* June 1, 1992, F-1.

28. Al Gore, *Earth in the Balance: Ecology and the Human Spirit* (Boston: Houghton Mifflin, 1992), 3.

29. Gore, *Earth in the Balance,* 3.

30. Thomas Berry, *The Dream of the Earth* (San Francisco: Sierra Club, 1988), 73.

31. Havel, *Living in Truth,* 144f.

32. Havel, *Living in Truth,* 140–42.

33. E. F. Schumacher, *Good Work* (London: Abacus, 1980), 143.

34. Marilyn Barrett, *Creating Eden: The Garden as a Healing Space* (San Francisco: Harper San Francisco, 1992), 144.

35. Quoted in Matthew Fox, *Illuminations of Hildegard of Bingen* (Santa Fe: Bear & Co., 1985), 36.

36. Quoted in Fox, *Sheer Joy,* 75.

37. Gore, *Earth in the Balance,* 307.

38. Cited in Rifkin, *Beyond Beef,* 159.

39. Quoted in Fox, *Sheer Joy,* 394.

40. Tom Hayden, in a lecture at ICCS, Holy Names College, Fall 1992.

41. Gore, *Earth in the Balance,* 8, 11.

42. Gore, *Earth in the Balance,* 12.

43. Gore, *Earth in the Balance,* 305, 307.

44. Paul Ekins, *A New World Order: Grassroots Movements for Global Change* (New York: Routledge, 1992), 124–28.

Chapter 6. Reinventing Work: Education, the Young, and Sexuality

1. Cited in John C. Merkle, *The Genesis of Faith: The Depth Theology of Abraham Joshua Heschel* (New York: Macmillan, 1985), 203.

2. Cited in Joanna Macy, *Dharma and Development* (Hartford, CT: Kumarian Press, 1985), 96.

3. Mircea Eliade, *Images and Symbols* (New York: Sheed & Ward, 1969), 14.

4. Cited in Bill Mandel, "GOP Folly: Search for '92 Horton," *San Francisco Examiner,* March 1, 1992, B-2.

5. David E. Purpel, *The Moral and Spiritual Crisis in Education* (New York: Bergin & Garvey, 1989), xi, x.

6. Roszak, *The Voice of the Earth,* 20.

7. Quoted in Matthew Fox, *Breakthrough: Meister Eckhart's Creation Spirituality in New Translation* (New York: Doubleday, 1980), 441.

8. Quoted in Merkle, *Genesis of Faith,* 206.

9. Quoted in Merkle, *Genesis of Faith,* 203–205.

10. Quoted in Merkle, *Genesis of Faith,* 206.

11. Quoted in Matthew Fox, *Sheer Joy: Conversations with Thomas Aquinas on Creation Spirituality* (San Francisco: Harper San Francisco, 1992), 186.

12. *Tao Te Ching,* trans. Stephen Mitchell (New York: Harper & Row, 1988), 14.

13. The report is from the U.S. Department of Justice. Cited in "Editorials: Putting Some Hope into Young People's Futures," *Oakland Tribune,* April 28, 1993, A-14.

14. Bede Griffiths, *River of Compassion* (Warwick, NY: Amity House, 1987), 7.

15. Cited in "High Level of Illiteracy Found in U.S.," *San Francisco Chronicle,* September 9, 1993, A-1.

16. Macy, *Dharma and Development,* 96.

17. Quoted in Macy, *Dharma and Development,* 96.

Chapter 7. Reinventing Work: Health Care, Psychology, and Art

1. Patrick Pietroni, *The Greening of Medicine* (London: Victor Gollancz, 1991), 1.

2. Herbert Benson, M.D., *The Relaxation Response* (New York: Avon Books, 1976), 178.

3. Cited in Suzi Gablik, *The Reenchantment of Art* (New York: Thames and Hudson, 1991), 57, 58.

4. Otto Rank, *Beyond Psychology* (New York: Dover, 1941), 37.

5. Gablik, *Reenchantment of Art,* 176.

6. Cited in Pietroni, *Greening of Medicine,* 12, 13.

7. Rupert Sheldrake, *The Rebirth of Nature: The Greening of Science and God* (New York: Bantam, 1991), 49, 50.

8. Pietroni, *Greening of Medicine,* 1f.

9. Pietroni, *Greening of Medicine,* 10f.

10. From "Innovations in the Hospital Setting" (lecture series cosponsored by *The Pacific Sun* and Marin General Hospital, Marin County, April 9, 1992).

11. Benson, *Relaxation Response,* 26. Pietroni observes that meditation can indeed contribute to the slowing of the pulse and the lowering of blood pressure. There is a reduction in the breathing rate, an increase in blood flow to the extremities and changes in oxygen and carbon dioxide concentrations in the blood. Meditation can reduce lactate levels and alter brain wave patterns, for instance, increasing alpha brain wave activity and synchronizing left and right hemispheres of the brain. See Pietroni, *The Greening of Medicine,* 169.

12. Benson, *Relaxation Response,* 102.

13. Benson, *Relaxation Response,* 139.

14. Benson, *Relaxation Response,* 141.

15. Benson, *Relaxation Response,* 178.

16. Patch Adams, *Gesundheit!* (Rochester, VT: Healing Arts Press, 1993), 49.

17. Adams, *Gesundheit!* 116.

18. Larry Dossey, *Healing Words: The Power of Prayer and the Practice of Medicine* (San Francisco: HarperSanFrancisco, 1993).

19. Harriet Beinfield and Efrem Korngold, *Between Heaven and Earth: A Guide to Chinese Medicine* (New York: Ballantine, 1991), 32–35.

20. Beinfield and Korngold, *Between Heaven and Earth,* 36.

21. Paul Hogan, "In the Garden of the Treasured Ones," *Creation Spirituality,* November/December 1990, 18.

22. See Robert Rice, "The Arts as Healing," *Creation Spirituality,* September/October 1989, 21, 22, 46.

23. Personal correspondence, June 12, 1992.

24. "Bad Habits, Violence Raise Health Costs," *San Francisco Chronicle,* Feb. 23, 1993, A-4.

25. Ton Alberts, *Building with a Difference* (Amsterdam: ING Bank Communication Dept., n.d.).

26. Quoted in Matthew Fox, *Sheer Joy: Conversations with Thomas Aquinas on Creation Spirituality* (San Francisco: HarperSanFrancisco, 1992), 76.

27. Rank, *Beyond Psychology,* 37, 61.

28. Cited in E. James Lieberman, *Acts of Will: The Life and Work of Otto Rank* (New York: The Free Press, 1985), 283, 282.

29. Quoted in Gablik, *Reenchantment of Art,* 57, 58.

30. Theodore Roszak, *The Voice of the Earth* (New York: Simon & Schuster, 1992), 41, 44.

31. Roszak, *Voice of the Earth,* 64.

32. Roszak, *Voice of the Earth,* 78–79.

33. Roszak, *Voice of the Earth,* 74, 153, 154

34. Roszak, *Voice of the Earth,* 320f.

35. Warwick Fox, *Toward a Transpersonal Ecology* (Boston: Shambhala, 1990), 198.

36. Cited in W. Fox, *Transpersonal Ecology,* 215.

37. Cited in W. Fox, *Transpersonal Ecology,* 229.

38. Cited in W. Fox, *Transpersonal Ecology,* 240.

39. Joanna Macy, *World as Lover, World as Self* (Berkeley: Parallax Press, 1991), 8.

40. Macy, *World as Lover,* 12–13.

41. Macy, *World as Lover,* 13.

42. Macy, *World as Lover,* 13, 14.

43. Quoted in Fox, *Sheer Joy,* 76.

44. Quoted in Fox, *Sheer Joy,* 301.

45. Courtney Milne, "The Mystic Within," *Creation Spirituality,* July/August 1992, 30.

46. Gablik, *Reenchantment of Art,* 6, 7, 8.

47. Gablik, *Reenchantment of Art,* 24.

48. Gablik, *Reenchantment of Art,* 25, 139, 168, 169. Italics mine.

49. Gablik, *Reenchantment of Art,* 26.

50. Gablik, *Reenchantment of Art,* 176.

51. M. C. Richards, *Centering: In Pottery, Poetry and the Person* (Middletown, CT: Wesleyan Univ. Press, 1989), 27.

52. Richards, *Centering,* 139.

53. Richards, *Centering,* xii.

54. Richards, *Centering,* 115.

55. Richards, *Centering,* 15, 39.

56. Richards, *Centering,* 130.

57. Leonard Shlain, *Art & Physics: Parallel Visions in Space, Time & Light* (New York: William Morrow, 1991), 427.

58. Shlain, *Art & Physics,* 18.

59. Shlain, *Art & Physics,* 427.

60. Shlain, *Art & Physics,* 427.

61. Shlain, *Art & Physics,* 17.

62. Shlain, *Art & Physics,* 18, 24. Italics mine.

63. Quoted in Shlain, *Art & Physics,* 435.

64. Tom Hocker, "Salvadoran Artists Express Peace of Spirit," *Our Sunday Visitor,* July 6, 1986, 10–12.

Chapter 8. Reinventing Work: Economics, Business, and Science

1. E. F. Schumacher, *Good Work* (London: Abacus, 1980), 125, 126.

2. Brian Swimme and Thomas Berry, *The Universe Story* (San Francisco: HarperSanFrancisco, 1992), 242.

3. Hazel Henderson, "False Economy," *Creation Spirituality,* September/October 1992, 26, 27.

4. Ben Cohen, "Choices for the Future: Designing a Socially Just New World Environment" (address to a conference of the Windstar Foundation, Aspen, Colorado, 1991).

5. Madonna Kolbenschlag, *Kiss Sleeping Beauty Good-bye* (New York: Bantam, 1981), 68, 76.

6. Richard McKnight, "Spirituality in the Workplace," in *Transforming Work*, ed. John D. Adams (Alexandria, VA: Miles River Press, 1984), 142.

7. Rolf Osterberg, *Corporate Renaissance* (Mill Valley, CA: Nataraj, 1993), 96.

8. Beverly Rubik, ed., *The Interrelationship Between Mind and Matter* (Philadelphia: The Center for Frontier Sciences, 1992), 11.

9. Peter G. Gosselin and Charles Stein, "Candidates' Recipes for Recovery Omit Vital Ingredients," *San Francisco Examiner,* September 27, 1992, E-2.

10. Schumacher, *Good Work,* 3.

11. Schumacher, *Good Work,* 140, 141.

12. Swimme and Berry, *Universe Story,* 241.

13. Swimme and Berry, *Universe Story,* 242.

14. Schumacher, *Good Work,* 141.

15. Schumacher, *Good Work,* 21.

16. Schumacher, *Good Work,* 57.

17. Schumacher, *Good Work,* 26.

18. Schumacher, *Good Work,* 73.

19. Henderson, "False Economy," 26.

20. Henderson, "False Economy," 26, 27.

21. Hazel Henderson, "Beyond the Information Age," *Creation Spirituality,* March/April 1988, 34.

22. Henderson, "Information Age," 32–34.

23. Herman E. Daly and John B. Cobb, *For the Common Good: Redirecting the Economy Toward Community, the Environment, and a Sustainable Future* (Boston: Beacon Press, 1989), 2.

24. Daly and Cobb, *For the Common Good,* 7, 8.

25. Daly and Cobb, *For the Common Good,* 11, 13, 18.

26. Daly and Cobb, *For the Common Good,* 20, 21.

27. Daly and Cobb, *For the Common Good,* 356.

28. Thomas Berry, *The Dream of the Earth* (San Francisco: Sierra Club, 1988), 71, 73.

29. Berry, *Dream of the Earth,* 72.

30. Berry, *Dream of the Earth,* 75–78.

31. Berry, *Dream of the Earth,* 82.

32. Berry, *Dream of the Earth,* 33, 34.

33. Schumacher, *Good Work,* 136, 137.

34. Ben Cohen, "Choices for the Future."

35. Cohen, "Choices for the Future."

36. Cohen, "Choices for the Future."

37. Cohen, "Choices for the Future."

38. Cohen, "Choices for the Future."

39. Paul Hawken, "A Declaration of Sustainability," *Utne Reader,* Sept/Oct 1993, 54.

40. Quoted in Guy Dauncey, *After the Crash: The Emergence of the Rainbow Economy* (New York: The Bootstrap Press, 1989), 153.

41. Anita Roddick, *Body and Soul* (London: Vermillion, 1992), 18, 19.

42. Dauncey, *After the Crash,* 144.

43. Dauncey, *After the Crash,* 145.

44. Dauncey, *After the Crash,* 140.

45. McKnight, "Spirituality in the Workplace," 140.

46. McKnight, "Spirituality in the Workplace," 142.

47. McKnight, "Spirituality in the Workplace," 145.

48. Peter Vaill, "Process Wisdom for a New Age," in *Transforming Work,* ed. Adams, 33, 27, 25.

49. Linda S. Ackerman, "The Flow State: A New View of Organizations and Managing," in *Transforming Work,* ed. Adams, 125, 126.

50. Osterberg, *Corporate Renaissance,* 5, 6.

51. Osterberg, *Corporate Renaissance,* 95, 96.

52. Osterberg, *Corporate Renaissance,* 98–100.

53. Osterberg, *Corporate Renaissance,* 101, 103.

54. Osterberg, *Corporate Renaissance,* 104, 106.

55. Quoted in Matthew Fox, *Breakthrough: Meister Eckhart's Creation Spirituality in New Translation* (New York: Doubleday, 1980), 450.

56. Quoted in Fox, *Breakthrough,* 456.

57. See Fox, *Breakthrough,* 459, 460.

58. E. F. Schumacher, *Small Is Beautiful* (London: Abacus, 1973), 142.

59. Rubik, *Mind and Matter,* 1.

60. Rubik, *Mind and Matter,* 3.

61. Rubik, *Mind and Matter,* 7.

62. Rubik, *Mind and Matter,* 11.

63. Rubik, *Mind and Matter,* 11, 12.

Part 3. Ritual: Where the Great Work of the Universe and the Work of the People Come Together

1. *Tao Te Ching,* trans. Stephen Mitchell (New York: Harper & Row, 1988), 63.

2. Brian Swimme and Thomas Berry, *The Universe Story* (San Francisco: HarperSanFrancisco, 1992), 1.

3. Quoted in Matthew Fox, *Sheer Joy: Conversations with Thomas Aquinas on Creation Spirituality* (San Francisco: HarperSanFrancisco, 1992), 177.

4. Lecture at ICCS, Fall 1992.

5. Abraham Joshua Heschel, *The Sabbath* (New York: Farrar, Straus & Giroux, 1951), 28.

6. Swimme and Berry, *Universe Story,* 1.

7. Meister Eckhart, quoted in Matthew Fox, *Breakthrough: Meister Eckhart's Creation Spirituality in New Translation* (New York: Doubleday, 1980), 198.

8. Cited in John C. Merkle, *The Genesis of Faith: The Depth Theology of Abraham Joshua Heschel* (New York: Macmillan, 1985), 196.

9. Cited in Suzi Gablik, *The Reenchantment of Art* (New York: Thames and Hudson, 1991), 54.

10. Gablik, *Reenchantment of Art,* 50, 46, 48.

Chapter 9. The Reenchantment of Ritual: Reinventing Work by Rediscovering the Festive

1. Quoted in Gabriel Uhlein, *Meditations with Hildegard of Bingen* (Santa Fe: Bear & Co., 1982), 128.

2. Abraham Joshua Heschel, *The Sabbath* (New York: Farrar, Straus & Giroux, 1951), 14, 18.

3. Juliet Schor, *The Overworked American* (New York: HarperCollins, 1991), 165.

4. Rainer Maria Rilke, *The Sonnets to Orpheus,* trans. and ed. Stephen Mitchell (New York: Simon & Schuster, 1985), 143.

5. Brian Swimme and Thomas Berry, *The Universe Story* (San Francisco: HarperSanFrancisco, 1992), 3.

6. Willis Harman and John Hormann, *Creative Work* (Indianapolis: Institute of Noetic Sciences, 1990), 27.

7. Cited in Suzi Gablik, *The Reenchantment of Art* (New York: Thames and Hudson, 1991), 45.

8. Leonard Shlain, *Art and Physics: Parallel Visions in Space, Time & Light* (New York: William Morrow, 1991), 281.

9. Shlain, *Art & Physics,* 288, 289.

10. Shlain, *Art & Physics,* 290.

11. Shlain, *Art & Physics,* 319.

12. Theodore Roszak, *The Voice of the Earth* (New York: Simon & Schuster, 1992), 316, 317.

13. Quoted in Matthew Fox, *Breakthrough: Meister Eckhart's Creation Spirituality in New Translation* (New York: Doubleday, 1980), 113.

14. See Matthew Fox, *The Coming of the Cosmic Christ* (San Francisco: HarperSanFrancisco, 1988), 212–25.

15. Fox, *Cosmic Christ,* 224–27.

16. In John C. Merkle, *The Genesis of Faith: The Depth Theology of Abraham Joshua Heschel* (New York: Macmillan, 1985), 195.

17. Rupert Sheldrake, *The Rebirth of Nature* (New York: Bantam, 1991), 110, 112.

18. In Merkle, *Genesis of Faith,* 197.

19. In Merkle, *Genesis of Faith,* 197, 198.

20. In Merkle, *Genesis of Faith,* 198.

21. Schor, *Overworked American,* 165. Italics mine.

22. Josef Pieper, *Leisure the Basis of Culture* (New York: New American Library, 1952), 56.

23. Matthew Fox, *Sheer Joy: Conversations with Thomas Aquinas on Creation Spirituality* (San Francisco: HarperSanFrancisco, 1992), 177.

24. Heschel, *Sabbath,* 9, 10, 13.

25. Heschel, *Sabbath,* 3, 14.

26. Heschel, *Sabbath,* 18, 19.

27. Heschel, *Sabbath,* 21, 23.

28. Heschel, *Sabbath,* 31. Italics his.

29. Heschel, *Sabbath,* 31, 32.

30. Heschel, *Sabbath,* 54.

31. Heschel, *Sabbath,* 74.

32. Arthur Waskow, *GodWrestling* (New York: Schocken Books, 1978), 117, 116.

33. Waskow, *GodWrestling,* 117.

34. Waskow, *GodWrestling,* 119.

35. Arthur Waskow, "Rest," in Arthur A. Cohen and Paul Mendes-Flohr, *Contemporary Jewish Religious Thought* (New York: Scribners, 1986), 795–806.

36. Geiko Muller-Fahrenholz, "Freijahre für Alle," *Evangelische Kommentare Redaktion,* October 1988, 595–98.

37. Heschel, *Sabbath,* 76.

38. Quoted in Fox, *Sheer Joy,* 60.

39. See John Seed and Joanna Macy et al., *Thinking Like a Mountain* (Philadelphia: New Society Publishers, 1988), 79–90.

40. Seed, et al., *Thinking Like a Mountain,* 77.

41. Joanna Macy, *World As Lover, World As Self* (Berkeley: Parallax Press, 1991), 39.

Conclusion: Work as Sacrament, Sacrament as Work

1. Quoted in Matthew Fox, *Sheer Joy: Conversations with Thomas Aquinas on Creation Spirituality* (San Francisco: HarperSanFrancisco, 1992), 372.

2. Brian Swimme, *The Universe Is a Green Dragon* (Santa Fe: Bear & Co., 1985), 151.

3. *The Bhagavad Gita,* trans. Juan Mascaro (Middlesex, England: Penguin Books, 1962), 63.

4. Quoted in Matthew Fox, *Illuminations of Hildegard of Bingen* (Santa Fe: Bear & Co., 1985), 36.

5. Rolf Osterberg, *Corporate Renaissance* (Mill Valley, CA: Nataraj, 1993), 94.

6. Quoted in Fox, *Sheer Joy,* 256.

7. Quoted in Fox, *Sheer Joy,* 256.

8. E. F. Schumacher, *Good Work* (London: Abacus, 1980), 120.

9. Quoted in Fox, *Sheer Joy,* 372.

10. Quoted in Fox, *Illuminations,* 115.

11. Quoted in Fox, *Illuminations,* 36.

12. Swimme, *Green Dragon,* 151.

13. Quoted in Fox, *Illuminations,* 30, 32.

14. Quoted in Fox, *Sheer Joy,* 294.

Index

333

Bhagavad Gita (*continued*)
on renunciation and holy work, 131,
138–39; teaches us to work without a
why, 56–57; on "the great work," 61–62;
on work and our inner lives, 43
Bicycling, 153
Blue-collar workers, 15
Bly, Robert, 14, 185, 285, 287
Body Shop, The, 234
Body and Soul (Roddick), 234
Boesky, Ivan, 7
Boredom, 40–42
Brown, Jerry, 155
Brown, Lester, 3, 8, 140, 142
Bush, George, 7
Business: evolution of, 235–36; management
styles within, 238; new paradigm ap-
proaches to, 230–36; as practical applica-
tion of economics, 229; rise of
worker-owned, 235; spirituality and,
237–40. *See also* Economics
Business Association for Social Responsibility,
233

Cage, John, 291
Calling, 102–6. *See also* Role; Vocation
Camara, Dom Helder, 45
Campbell, Joseph, 94
Canadian Institute for Advanced Research, 10
Capitalism, 224, 226. *See also* Economics; Busi-
ness; Consumerism
Capra, Fritjof, 71
Cartesian reason, 49
Celibacy, 304
Center for Frontier Sciences at Temple Uni-
versity, 245
Centering: In Poetry, Pottery and the Person
(Richards), 210, 291
Chaos, 72
Chenu, M. D., 59
Chinese medicine, 196–98
Christian theology: etymological meanings of,
69; the fall/redemption tradition of,
92–93, 206–7; on the Holy Spirit, 124;
mechanical liturgy of, 264; value on
work conferred by, 93. *See also* Liturgy;
Cosmic Christ; Sacraments; Creation
Spirituality; Fall/Redemption tradition
Circle dances, 142–43, 174, 252, 278
Clinton, Bill, 166
Cobb, John, 226–27
Cohen, Ben, 218, 230–32
Cold War, 134–35, 164

Coming of the Cosmic Christ (Fox), 15, 265
Common Boundary movement, 202
Communism, 6–8, 224
Community: built on humane values, 236;
defining, 135; ecological organization of,
162–63; education for inner house of,
173; necessary for authentic prayer, 266;
ritual as core of, 250, 253, 256, 262–63
Compassion: art which increases, 211; the con-
structive work of, 175; education rein-
vented to teach, 177; essence of, 66–67; as
ICCS goal of education, 174; within
medical practice, 194. *See also* Justice
Confirmation, 302–3
Consumerism: addiction of, 35, 39, 239; based
on dissatisfaction premise, 34; driving
force of, 7–8
Corporate Renaissance (Osterberg), 239
Cosmic Christ: born from within us, 301–2;
crucified, 279; manifestations of, 124;
message of, 88; mystical tradition of, 86;
present in all community prayer, 266;
producing the, 128. *See also* Jesus Christ;
Wisdom; Word of God
Cosmic work, 106, 111
Cosmology: building a more accurate, 134; cul-
tural lack of, 48; cut off from, 128; denial
of, 145–46; ecology as functional, 141; ed-
ucation reformed using, 172–73; ele-
ments necessary for, 214; on the "Great
Work" of creation, 61–64; healing power
of, 207; incorporated within our profes-
sions, 137; rituals for, 259–60; signifi-
cance of new, 69–76, 76; for souls, 24;
violence due to lack of, 60; work from
perspective of, 59. *See also* Universe; Wis-
dom; Cosmic Christ; Science
Council of All Beings, 294
Creating Alternative Futures (Henderson), 224
Creating Eden: The Garden As a Healing Space
(Barrett), 160–61
*Creation Spirituality: Liberating gifts for the Peo-
ples of the Earth* (Fox), 15
Creation Spirituality: basis of, 149; contribu-
tions of, 298; Dublin gathering of, 215;
interest of the young in, 180; possible con-
tribution to Catholic liturgy by, 290–91;
postmodern systematic theology based
on, 15; programs of, 212; using the, 136
Creation stories: ritual to relate, 250–51; ritual-
izing our, 292–94; Sabbath ritual as cele-
bration of, 271–73; value of, 65
Creative Work (Harman and Hormann), 117

Creativity: becoming real through, 113–15; of community released through ritual, 256; learning to value, 116–18; products of, 118–19; as revelation, 121–22; through the Holy Spirit, 122–25; used with wisdom, 129; wisdom from within, 301–2. *See also* Art; Artists; *Via creativa*

Csikszentmihalyi, Mihaly, 238

Cunningham, Merce, 291

Daly, Herman E., 225–27

Darkness. *See Via negativa*

Darwin, Charles, 203

Dauncey, Guy, 234–35

Death, work and, 107–11

Deep Ecumenism, 12, 88–89, 266

Denver, John, 136

Descartes, 4, 88, 191

Despair: violence from, 45; working with, 177–78

Dharma and Development (Macy), 182

Dignity, 128–29

Discipline, 181

Display, 60, 99, 120

Divinity: expression of, 300; machine era view of, 84; as part of environmental awakening, 142; as product of work, 126; work within presence of, 53, 67–68

Dossey, Larry, 14, 196

Dualistic work, 298–99

Dysfunctional families, 36

Earth: artist's contribution to healing of, 209; environmental revolution for the, 141, 143–44, 204–5; gardening the, 159–61; gifts bestowed by the, 102; "Global Marshall Plan" for preserving the, 167; honored through ritual, 260; as a living organism, 72, 76; Ritual of Lamentation for the, 293–94; wealth measured by health of, 148–49. *See also* Gaia

Earth in the Balance: Ecology and the Human Spirit (Gore), 166

Earth Summit of 1992 (Rio de Janeiro), 143, 163

Eckhart, Meister: on addiction to work, 3; on allowing God into ourselves, 25; on the compassion of God, 174; on connecting to essence of all, 251; on creating, 114; on creatures as word of God, 289; driving away the moneylenders sermon by, 241–43; on enchantment of work, 100, 136; on God as product of work, 125–27;

on God's nature, 87, 95; on inward/outward work, 58; on the joy within work, 92, 111; on judgment based on our being, 106; on learning to let go, 37; on living in order to live, 33; on living through inner self, 264; on need for understanding, 214; on need for gratitude, 108; on the nothingness experience, 52–54; on reinventing work, 131, 137; on resistance to inner work, 77; on returning to our origins, 66; on revelation, 121; on the spirit, 122–25; teachings on body and soul, 23; on universal inner life, 300; on when becoming ceases, 55–56; on work coming from God, 67; on work and God's work, 64; on working with a why, 56, 79–82, 116

Ecological virtues: bicycling as, 153; community organizing as, 162–63; creating sustainable energy alternatives as, 154–56; defining, 147; gardening as, 159–61; making our own entertainment as, 161; organic farming/the family farm as, 156–59; planting trees as, 159; politics which support, 164–68; public transportation as, 153–54; recycling as, 151–52; responsible investing as, 168; stabilizing population as, 163–64; studying as, 161–62; vegetarianism or semivegetarianism as, 149–51

Ecology: cosmology and, 141; transpersonal, 205–6

Economics: current state of, 219–22; history of, 147–48; as ideology support for business, 229; measurement of healthy, 220; new paradigm for, 223–27; of science, 244. *See also* Business

Ecopsychology, 203–4, 264

Education: creating a new spiritual order through, 187–89; crisis in medical, 192; during the industrial era, 170; ICCS model of, 173–74; including the Spirit in, 171–72; learning as part of, 175–76; medieval university models for, 216–17; models of wisdom schools for, 173; prison-preventive, 217; reinvented to teach compassion, 177; to transform sexuality, 186–87; which best serves the paradigm shift, 169–70

Einstein, Albert, 244, 268

Eliade, Mircea, 169, 183

Emotional health. *See* Mental health

Employee stock option plans (ESOP), 235

Jesus Christ (*continued*)
as wisdom incarnate, 301; work and
pleasure imagery by, 94. *See also* Cosmic
Christ
Jewish traditions: as basis for Christian/Muslim
ritual, 266–67; regarding time, 268;
Sabbath as, 41, 101, 253. *See also* The
Jubilee
Jobs. *See* Employment
John of the Cross, 92, 112
Johnson, Daniel, 200
Jubilee, The, 273–74
Julian of Norwich, 127
Jung, Carl, 11, 138

Kabir, 74, 301
Keating, Charles, 7
Killinger, Barbara, 10, 36–37
Kiltadown House, 215
King, Martin Luther, Jr., 108
Kivel, Paul, 30–31, 45, 48
Knowledge: of machine era, 85; objective, 73;
passed through the heart, 171–72; teach-
ing left-brain, 174. *See also* Wisdom
Kolbenschlag, Madonna: on impact of indus-
trial era on women, 85–86, 219; on liber-
ation through spiritual work, 13; on the
positive theology of work, 93; on
"women's work," 58
Korngold, Efrem, 197
Krugman, Paul, 219
Kuhn, Thomas, 169, 231

La Mettrie, Julien de, 70
Lakota people, 9, 121, 252
Leadership sacrament, 304–5
Learning, 175–76. *See also* Education
Leisure the Basis of Culture (Pieper), 269
Leisure time: decline of, 39, 41; the Sabbath as,
269–73. *See also* Sabbath; Schor, Juliet B.
Levi Strauss, 233
Literacy "peace corps," 182
Liturgy: bringing back dance/chanting to
Christian, 289; described, 250, 257; as en-
gineering, 257–58; for the Jewish people,
267. *See also* Ritual
Liturgy of the Word, 290
Living water, 215
Llort, Fernando, 215–16
Logos, 114. *See also* Word of God; Cosmic
Christ
Love: drawn to work by, 95; work defined by
what we, 71
Love, Medicine and Miracles, 192

Machine era: as antiritual, 252–53; education
during the, 170; loss of creativity during,
115; mechanical rituals during, 258–59,
262; movement from, 83–89; paradigms
of, 89–90; pseudomysticism of, 228–29;
relationships within, 304; Western wor-
ship based on, 294. *See also* Enlighten-
ment period
Machine metaphor, 70
McKibben, Bill, 153
McKnight, Richard, 219, 237–38
Macy, Joanna, 152, 182–83, 205–6, 279, 294
Man the Machine (La Mettrie), 70
Marin General Hospital, 193
Marriage, 303–4
Marx, Karl, 268
Meade, Michael, 285, 287
Mechanomorphic language, 70
Mechtild of Magdeburg, 142
Media, 45
Medical ecumenism, 198
Meditation, 174, 195
Melchisadech, 290
Men: return to inner work by, 30–31; the vio-
lence of, 45–46. *See also* Women
*Men's Work: How to Stop the Violence That Tears
Our Lives Apart* (Kivel), 30
Mental health: as part of health care, 200–207;
work and, 9–11; workaholism and,
10–11. *See also* Health care; Psychology
"Merchant mentality," 111, 241–42
Metanoia, 5
Milken, Michael, 7
Milne, Courtney, 208
Montessori schools, 173
Morphic fields, 35, 267, 306
Moyers, Bill, 94
Müller-Fahrenholz, Geiko, 275–76
Mysticism: experienced by scientists, 243; inter-
connection principle of, 231–32; ridiculed
during Enlightenment, 173; to replace
Jesusolatry, 88; transpersonal ecology in
terms of, 205–6; of the *via negativa,* 32; of
the *via positiva,* 101; of work, 11–13

National College of Agricultural Engineering,
222
Native Americans, 45. *See also* Aboriginal
people; Lakota people; Papago people
New Creation: finding new work in the, 103–4;
Mary's act of, 123; the origins of, 119;
way of the, 111
New England Business Association for Social
Responsibility, 233

South Shore Bank of Chicago, 168, 233
Spiral Garden, 198
Spiral of Violence, The (Camara), 45
Spirit: of festivity, 277; yearning for the, 172
"Spiritual Canticle, The" (John of the Cross),
 112
Spiritual order, 187–89
Spiritual sins, 22
Spirituality: art as part of, 214–15; of artists,
 210; as basis of work, 79–83; business
 and, 237–40; co-creators of, 122–25; de-
 spair as first step to, 177–78; elements re-
 quired for work, 297; impact of
 workaholism on, 36; increasing our, 53;
 lack of cultural, 44–45, 202; living in
 depth as, 92; need for, 15, 41–42; ques-
 tionnaire to assess work, 309–12; signifi-
 cance of, 9–11; to create good work, 136;
 using ritual to awaken, 99–100; of voca-
 tions, 103; of the young, 178–80
Spirituality Named Compassion, A (Fox), 15
Sri Lanka, 182–84
State of the World report (Brown), 3, 153
Stations of the Cross ritual, 279–85
Steady State Economics (Daly), 225
Stein, Charles, 220
Steiner, Rudolf, 173
Stendhal, Krister, 104
Steps to an Ecology of Mind (Bateson), 75
Stipkin, Kay, 91, 95
Storytelling, 171–72. *See also* Education. *See
 also* Ritual
Suicides: Native American rates of, 45; pre-
 venting, 195
Sundances, 252
Sweat lodges, 174, 252
Swimme, Brian: on atoms as self-organizing
 system, 71; on economics vs. quality of
 life, 218, 221; on environmental damage,
 59; on expression of new creation story,
 293; on need for healing, 23; on a new
 creation story, 256; on our machinelike
 language, 70; on science, 243; on theology
 of sacrament, 306; on the universal pres-
 ence, 296; on the use of ritual, 249, 251
Swords to Plowshares, 285, 288

Tao, 25, 238
Tao Te Ching: on being in accord with the Tao,
 25; on being/non-being, 51; on creativity,
 113, 125; on enjoying work, 91; on the
 environment, 140, 144; on the essence
 of wisdom, 176; on inner work as non-

action, 56; on letting go our work, 41; on
 losing sense of Great Work, 85; on our
 common origin, 65–66; on using ritual,
 249–50
Teresa of Avila, 22
Terkel, Studs: on the basis of healthy work, 98;
 on finding the daily meaning, 91–92; on
 the pain of work, 25–27; on small jobs,
 122; on work as immortality, 107
Thinking Like a Mountain (Macy), 294
"Thriller" (Havel), 49
Toward a Transpersonal Ecology (Fox), 204
Trible, Phyllis, 93

Unemployment: as contradictory to cosmic
 laws, 59; current rates of world, 2; health
 problems and, 199–200; international
 projects lowering, 215–16; psychological
 damage of, 9–10, 60; a spiritual solution
 to, 134–35; universal sabbatical as solu-
 tion to, 276; violence resulting from, 45.
 See also Employment
United Nation International Labor Organiza-
 tion, 14
United States National Academy of Sciences,
 163
Universe, scientific viewpoint on, 70–74. *See
 also* Cosmology
Universe Story (Swimme and Berry), 293

Vaill, Peter, 238
Vegetarianism, 149–51
Via creativa: lessons of, 117, 120; natural pro-
 gression toward, 115; sexuality as part of,
 185; work as, 111
Via negativa: artistic suffering as part of, 211;
 creativity as product of, 119; denial of the
 via positiva by, 33–34; experience of, 32,
 52; learning to let go part of, 37, 40; work
 and the dark night of the soul, 43–45;
 working on our, 47
Via positiva: as basis of healthy work, 98–99;
 cultural cures through our, 47; denial of
 the, 33; lost mysticism of, 101; opening
 perception through, 211; role in cosmic
 drama as, 106; as the role of joy in work,
 92, 96–98. *See also* Healthy work
Via transformativa, 16, 33–34, 132, 245–47
Vietnam ritual (1992), 285–89
Violence: from despair and injustice, 45, 178;
 medical expenses due to, 200; organized
 sports, 182; origins of, 30–31, 60, 110. *See
 also* Hope